D1535878

Early English Art and Architecture

Early English Art and Architecture

Archaeology and Society

LLOYD AND JENNIFER LAING

SUTTON PUBLISHING

First published in 1996 by
Sutton Publishing Limited · Phoenix Mill
Thrupp · Stroud · Gloucestershire

British Library Cataloguing in Publication Data
A catalogue record for this book is available from the British Library

ISBN 0-7509-0462-3

ALAN SUTTON™ and SUTTON™ are the
trade marks of Sutton Publishing Limited

Typeset in 11/13 pt Perpetua.
Typesetting and origination by
Sutton Publishing Limited.
Printed in Great Britain by
Butler & Tanner, Frome, Somerset.

Contents

Introduction

The term Anglo-Saxon has been used in the recent past for a variety of purposes – usually to denote a kind of fundamental 'Englishness'. Paradoxically, the origins of the term lie firmly embedded in late Roman Continental Europe, when a hotch-potch of people crossed the English Channel. They intermingled with the Romano-British population, developing a new culture in what eventually became England.

Roman society, based on towns, with a highly developed bureaucracy, defence system and economy, was a complete contrast to that of both the non-Romanised British Celts and the Anglo-Saxons. The Romans called such cultures barbarian to distinguish them from the civilised (civilisation was, in its original sense simply a society based on *cives* – citizens). The one adhered to the concept of the Tribe, the other to the State.

It is to the apparently unlikely amalgamation of classical civilised, Iron Age Celtic and North European barbarian cultures that England owes its unique origins.

The Great Migrations

The Anglo-Saxon settlement of England was part of a wide pattern of population movement in Europe known as the Great Migrations.[1] Classical writings and archaeological remains demonstrate that the Anglo-Saxons belonged to a loose grouping of people known to the Romans as the *germani*. They spoke a Germanic (as opposed to a Celtic) language and shared a number of traits including religious beliefs and type of economy.

In Britain the term includes peoples from various Continental tribal origins – Angles, Saxons, Jutes and some smaller groups of settlers including Franks, Frisians and Suebians. They lived in what are now parts of North Germany, the Low Countries and Denmark. Study of them relies heavily on existing material culture rather than written records since originally they were non-literate.

The first immigrants to Britain may have been fleeing from heavy flooding, may have been attracted by the loss of Roman population with the withdrawal of the army, or may have been invited in and employed. Certainly large areas of their homelands were depopulated, as the archaeological record shows.[2]

Other barbarians settled in former Roman lands and created vibrant new cultures – the Franks in what became France and part of Germany, the Visigoths in Spain and ultimately North Africa, the Ostrogoths and Lombards in Italy. Of these, the Franks[3] were the most influential over the Anglo-Saxons who settled in England.

'Anglo-Saxons' and Rome

By the time the Anglo-Saxons arrived in Britain in the late fourth and early fifth centuries both Romans and barbarians were well accustomed to each other's ideals, attitudes and ways of life. During the early centuries AD the non-Celtic barbarians came into contact with the Romans through raiding and trading. Even as early as the time of Julius Caesar entrepreneurs were operating a trade across the Rhine, and Roman silver coins flooded north in the time of Augustus and Tiberius in the early first century AD along with silver plate and other luxury commodities.[4] The distribution of Roman merchandise beyond the frontiers of the Roman Empire shows that chiefs amassed Roman goods as symbols of status, and probably used them in complex networks of gift exchange. Despite fluctuating fortunes, Roman merchandise flowed north throughout much of the first four centuries AD.

By the fourth century Roman gold coins were pouring into Scandinavia, and provided the raw material for Migration Period jewellery. Fourth-century Germanic brooches, armlets and pendants all show the influence of Roman fashions.[5]

Germani were employed to police the frontiers of the Empire and were given concessions and land in return. Their cemeteries have yielded a range of artefacts produced in Roman workshops in northern Gaul, decorated with Roman motifs but employing such North European techniques as chip-carving.[6] In addition, Germanic people probably served in the Roman army, acquiring a taste for Roman decorative art which was taken back to their homelands. Many words were borrowed from Latin during this period of interchange.

The arrival of the Anglo-Saxons in Britain

The Anglo-Saxons came to Britain at a time when the Roman Empire was under considerable pressure, and the relationship between the two totally different cultures during the fifth and sixth centuries has been

until recently one of the enigmas of history. During this period the Anglo-Saxons gained dominance over the remnants of Roman Britannia, but even with modern methods of data retrieval, exactly how they achieved this remains elusive.

The first antiquaries and historians to consider this period were influenced by the extant written sources. Most of these were written well after the events they were describing and from highly partisan viewpoints. They depicted aggressive, disorganised rabbles. How such a force could prevail against civilisation was a source of uneasy speculation. However, given better data retrieval methods and a shift in the observers' attitude, the problem of how the Saxons triumphed becomes less acute.

They belonged to a simpler society, able to function dynamically on a basic, near self-sufficient, level without control from a central power source. The much more sophisticated society of the Romano-British was geared to central government and laws, organised military defence, mass-produced goods and a monetary system. Once these factors no longer operated, the Anglo-Saxon ways and values were, quite simply, those which worked.

Furthermore, it is now known that far from obliterating or driving to the west the Romano-British, the Anglo-Saxons assimilated a measure of Roman culture. Conversely, elements usually thought of as 'barbarian', such as a liking for feasting, the building of halls, hunting and the maintenance of war-bands, have all been recently demonstrated as present in late Roman times.[7] It was the Anglo-Saxon culture rather than the people themselves which prevailed.

The evidence

Study of the Anglo-Saxons has been particularly difficult in the past due to the lack of scientific archaeological techniques, the Anglo-Saxons' reliance on materials which rarely survive, and the confusions which arise from the fragments of contemporaneous written evidence, few of which can be accepted as authoritative. Studies have also been coloured by early antiquaries who regarded the period as primitive and unworthy of study due to the dearth of remains. Developed archaeological techniques have reversed this picture and the period once known as the Dark Ages has now yielded a vast array of data. In particular the status of women has undergone a change of perspective.

The evidence for Anglo-Saxon England comprises mostly place-names, standing buildings, architectural details, archaeological remains and a few written records including inscriptions and coins. Written evidence is varied and uneven in its coverage and very little survives in its original form. Much was produced by churchmen whose views were

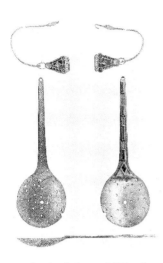

Pins found with the Crondall Hoard, Hants, and perforated Kentish spoons, from Akerman's Remains of Pagan Saxondom, *1855*

openly or subconsciously biased. A short account of the main sources, methods of dating and the development of Anglo-Saxon studies will be found in the Appendix.

This book has been written in order to tie together the now huge amount of constantly changing material that has been accumulated on the Anglo-Saxons, and to help demonstrate how an understanding of Anglo-Saxon art is firmly dependent on an appreciation of the social, religious and economic milieu in which it was produced.

In the past twenty years in particular, many of the preconceived notions about the period have been upset and reappraised, and a fuller understanding of the function of art in Anglo-Saxon society has become possible. The book spans the period from the early fifth century to the coming of the Normans in 1066, during which period the Anglo-Saxons developed from a small number of immigrants into the life-force of the English nation. It also considers the legacy of Anglo-Saxon England to the Norman world.

We are indebted to Dr Philip Dixon for reading the entire manuscript for us, and to the numerous institutions and individuals who helped us with the collection of illustrations and who are acknowledged in the picture captions.

Notes

1. The literature on Migration Period Europe and the background of the Anglo-Saxon settlements is extensive. Particularly useful for the archaeology are Dixon, 1976; Todd, 1972; Todd, 1975; Talbot Rice (ed), 1965; Musset, 1975. For the history Wallace-Hadrill, 1967 remains a classic. For late Antiquity, Brown, 1971.

2. Morris, 1973, 270.

3. For the Franks, Lasko, 1971 and James, 1977.

4. For Roman trade beyond the frontiers, Wheeler, 1956 is still indispensable. A more recent treatment in Hedeager, 1987.

5. Roman motifs were taken up; for instance a leather belt from Vimose in Jutland is decorated with a Roman dolphin. Wilson, 1972, fig.13.

6. Roman roots of Germanic art in Shetelig, 1949. Useful discussion of Roman background to Style I in Haseloff, 1974.

7. Dark, 1994 chapter 6 advances the argument for Roman survival in some detail.

The First Saxon Settlers

c. 400 – c. 600 AD

The Roman period in Britain lasted from the mid first to the early fifth century AD. The earliest form of Romano-British contact with the people we may conveniently call the Anglo-Saxons seems to have been towards the end of this period when it consisted of raiding and, paradoxically, enlistment into the Roman army in Britain, sometimes possibly in order to dispel such attacks.

The third century was a period of considerable unrest when Britannia was threatened by Germanic raiders in the south and east, Celts from Ireland and Picts from the north and west. There were regular Germanic units based in Britain (for example, one of Hnaudifridi – Frisians – at Housesteads on Hadrian's Wall in the third century, and another of Alamanni under Fraomar attested in 372).[1]

By the fourth century, the main function of the forts of the 'Saxon Shore' (built at intervals between Brancaster in Norfolk and Portchester in Hants)[2] was defence against Germanic barbarian attack. It has been suggested that the forts at Richborough, Kent and Portchester, Hants were also occupied at some stage in their history by Anglo-Saxons.[3]

In the late third century there were serious raids by Saxons and Franks on the coasts of Brittany and Belgic Gaul, and Carausius (a Menapian from the Low Countries) was put in charge of dealing with the raids by the emperor Maximian. He was notably successful, owing to his obtaining inside information about impending raids. He waited until the raiders had taken their loot before pouncing on them to keep their ill-gotten gains for himself. When Maximian ordered his execution, he set himself up as emperor and seized Britannia. Between 287 and 296 Britain was ruled as a breakaway territory by first Carausius then Allectus, before the overthrow of the latter by Constantius Chlorus.[4]

Fourth-century Roman history documents various raids on the frontiers of Roman Britain, most notably in 367 when a 'barbarian conspiracy' of Picts (from northern Scotland), Scots (from northern Ireland), Attacotti (probably from north-west Scotland) and possibly

Saxons harried the province. To what extent this was a part of a planned offensive is difficult to judge.[5]

In the late fourth and early fifth century the Imperial army was gradually withdrawn to fight on other fronts and in AD 409 Britannia was left to look to its own defences. The consul Aetius, the commander of Roman forces in Gaul, failed to respond to the 'Groans of the Britons' around the middle of the fifth century.[6]

Roman-style life did not end abruptly. There is no evidence for a flight to the west of Romano-Britons escaping rapacious Saxons, nor for massacres. This view of the period was born of eighteenth- and nineteenth-century archaeological retrieval methods and the attitudes of British Imperial expansion, reinforced by twentieth-century experience of genocide. It has, however, lingered with astonishing tenacity.

From this time on, Britannia was an independent province which still thought of itself as Roman.[7] The past twenty years in particular has brought to light irrefutable evidence that a form of Romano-British life flourished well into the fifth century and beyond, and has been instrumental in forcing a reappraisal of relationships between the native population and the immigrants.

Post-Roman society retained many elements of its Roman culture – Latin literacy, Latin inscriptions and Roman-style bureaucracy all survived, as probably did elements of Roman law.[8] The form of Latin spoken in Britain was especially pure, and there is evidence for a surviving tradition of Latin literacy through the fifth century.[9] It has been suggested that a manuscript known as the Vatican Virgil was produced in Britain in this period.[10]

Christianity was the official religion of the late Roman Empire and its fate is therefore significant in tracing surival of Roman ideals and aspirations. Church building was not a major feature of the late Roman period in Britain (worship sometimes seems to have taken place in buildings adapted from other uses such as the villa at Lullingstone, Kent), so that tracing remains is elusive. Although it seems to have declined in the fourth century in favour of a quasi-classical paganism,[11] Christianity certainly survived as late as 429 when it was strong enough for a heresy to flourish on British soil.[12] Based on the teachings of Pelagius, Pelagianism was deemed sufficiently threatening to warrant St Germanus of Auxerre (in Gaul) coming on a mission to Britain. However, by 446 Pelagianism was rife again.

The fortunes of Christianity after this remain obscure. After 461 (see p. 8) we hear no more about Romano-British Christians until the monk Gildas, writing nearly a century later, who states categorically that the Faith was well-established and organised, even though he has little time for the personnel: 'Britain has priests, but they are fools; very many ministers, but they are shameless; clerics but they are treacherous

grabbers . . . They have church buildings, but go to them for the sake of base profit' (*Ruin of Britain*, 66, 1, trans. M. Winterbottom).

In the archaeological record, there is now a fairly substantial list of seventh-century and later Anglo-Saxon ecclesiastical sites located on or near Roman cemeteries which arguably might be taken as indirect evidence for continuity of belief. Examples are the church of St Andrew, at Ilchester (Somerset), the churches at Great Dunmow (Essex) and St John's Abbey, Colchester (Essex), the mausolea at Stone-by-Faversham and Lullingstone (Kent) or underlying the Anglo-Saxon burial chapel at Wells (Somerset).[13] Some slender clues are also provided by the occurence of 'eccles' placenames (from the Latin *ecclesia*, meaning a church), for example at Eccles in Kent.[14] A church at Richborough, obliterated by early excavators, seems to have belonged to the early fifth century,[15] and it is possible that churches at Lincoln and elsewhere may be of this period in origin (see p. 89).

The secular centres of Romano-British power remained towns, although some Iron Age hillforts in the south-west were reoccupied and used probably as administrative centres. The most notable is that at Cadbury, Somerset, claimed to have been the headquarters of the Romano-British leader King Arthur who is thought to have resisted Anglo-Saxon dominance in the south-west until the early sixth century.[16]

Virtually all towns so far excavated have shown signs of being depopulated and run-down by the mid-fifth century, a factor which led to the belief that they ceased completely, since the major types of archaeological evidence were not found from levels later than the late fourth century. New coinage, for example, ceased to come in to Britain,[17] mass production of artefacts ended and pottery was no longer imported.[18]

More subtle signs of urban occupation late into the fifth century are however increasingly detectable by modern archaeological methods. This has been particularly clearly demonstrated in excavations at St Albans and Wroxeter.[19] The pattern of continued occupation now discernible through archaeology, is corroborated by Gildas in his assertion that cities flourished even in his day (around AD 540), though they were 'not populated even now as they once were' (*Ruin of Britain*, 26, 2). Twenty-eight cities were listed in Nennius' compilation of records set down in the ninth century.

Most villa buildings were abandoned between the late fourth and early fifth century,[20] though this does not preclude continuous working of the land either by Romano-Britons or Anglo-Saxons.

One out of several possible reasons for the depletion of town and country life may lie in reliable sources on the Continent, which state that around 441 a large number of the Romano-British élite moved to

Gaul. This migration was complete in 461 when a 'bishop of the British' was present at a Gallic church council. Gallic chronicles document a fighting force of 12,000 men, which with their families could have amounted to some 50,000 people.[21] This, added to the loss of the Roman army and its dependants in the late fourth century, amounts to significant opportunities for immigrants without their always needing to resort to violence or hostilities.

Mercenaries and civilians

Once Rome had relinquished responsibility for Britannia's defences, the barbarian tribes outside the empire's bounds suddenly found little hindrance to relocating. They were able to cross and recross the Channel – no Roman policing existed, no Saxon Shore forts inhibited their landings.

There is some doubt about the guise in which the Anglo-Saxons entered Britannia in this period – whether initially as mercenaries in the pay of the now independent Romano-Britons or directly as civilian settlers. Documentary records state that a certain Romano-Briton named Vortigern (a term which means 'over-king') invited the Saxons Hengist and Horsa into Britannia and that they subsequently rebelled. Vortigern certainly existed and may have ruled for some 30 years from the 420s. Earlier scholars accepted these statements[22] and archaeology might appear to corroborate them with the existence of a few graves possibly of Germanic warriors from Dyke Hills, Dorchester (Oxford), Richborough and Milton Regis (Kent), Lankhills, Winchester (Hants),

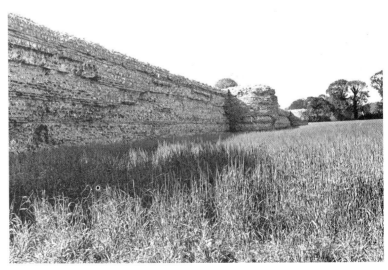

Saxon Shore Fort, Burgh Castle, Norfolk (Lloyd Laing)

Mucking (Essex) and Gloucester.[23] For a time in the 1960s and 1970s it was believed that 'civilian' Anglo-Saxons began to settle concurrently with the arrival of mercenaries, possibly even before the official withdrawal of Roman troops from Britain.[24]

However, very few objects from Anglo-Saxon cemeteries predate *c.* 420 AD, and since they could have been heirlooms there is little reason at present to believe that 'civilian' settlers arrived before this date.

Once settlement began it was substantial, though still proportionately far less than the Romano-British. One recent estimate based on sixth-century graves has put the incomers' numbers at around 50,000–100,000 inclusive of women, children and the infirm.[25] The population of late Roman Britain is likely to have been well over a million, maybe even two or more.[26]

On balance, it now seems that the earliest Anglo-Saxon civilian settlement took place in East Anglia, with that of Kent happening very soon after.[27] The process of settlement was probably protracted through the fifth and into the sixth century. The Upper Thames valley, the South Midlands, Surrey, Sussex and Hampshire were next settled, before expansion into the region south-east of the Humber/Severn, Yorkshire and further north.

Multi-cultural relations and interaction

Some slight indications that relations between Anglo-Saxons and Romano-British may not always have been amicable come from the site of South Cadbury, Somerset, which along with others in the area was certainly enclosed by banks and ditches. Whether these can be regarded as military defensive measures is debatable.[28] None of the sites have yielded convincing evidence of warfare, and in any case, any defensive measures may have been as much against other Romano-Britons as Anglo-Saxons. Gildas is outspoken on this point: 'Britain has kings, but they are tyrants . . . They often plunder and terrorize . . . the innocent . . . they wage wars – civil and unjust . . . they despise the harmless and humble, but exalt to the stars . . . their military companions' (*The Ruin of Britain*, 27, 1). Significantly, there is little evidence of defended sites outside the south-west.

Some of the earliest Anglo-Saxon settlements seem to have been (apparently peacefully) dictated by the Romano-British presence in the towns – there are early 'Saxon-free' zones around, for example, Chichester, Silchester, Lincoln and Winchester. This pattern presumably reflects the abandonment of villas beyond the immediate hinterland of the urban centres. Some areas, such as the Chiltern Zone, remained predominantly Romano-British until the Battle of Bedcanford in 571.[29]

It is possible that some Romano-British left the towns to live an

Anglo-Saxon lifestyle in the countryside since Roman objects have been found in many Anglo-Saxon graves. These items were originally interpreted as chance finds or the spoils of war. They are now seen as evidence for a cultural mixing of the population. The survival of complete Roman glass vessels or pots in graves suggests that these were treasured possessions, perhaps even inheritances.[30]

There is some evidence that the abandoned villa estates may sometimes have been directly taken over by Anglo-Saxons. At Orton Hall Farm (Northants) and Barton Court Farm (Oxfordshire), for example, timber buildings were put up alongside the old villa buildings by the new residents.[31]

Tracing the survival of Christianity is significant, not only in discovering the survival of Roman ways, but also in showing the extent to which Roman beliefs were tolerated or perhaps even adopted by the newcomers, since the Anglo-Saxons themselves were pagans, adhering to a North Germanic pantheon. Unfortunately Christian burials are typically devoid of grave-goods and orientation is only of limited inferential use, so with the present state of data retrieval, it is impossible to distinguish between the grave of, for instance, a rich Christian and a poor pagan.

Christian objects have been found in Anglo-Saxon graves of the fifth or sixth century, but have never been taken as conclusive evidence of their owners' beliefs since they could have been gifts or trade goods, for example. Yet they were clearly highly regarded and at the very least show a tolerance towards Christianity and presumably towards Christians as well.

Recent developments in DNA analysis might eventually throw light on the problem of multi-cultural interaction, but few studies have as yet been carried out. One study of skeletal material from Anglo-Saxon cemeteries in Hampshire implied that many of the deceased who had Anglo-Saxon style grave goods were in fact of Romano-British origin.[32]

Similar results were discovered from a cemetery in Kent, and a more extensive study by Dr Heinrich Härke has suggested that roughly half the skeletons found in fifth- and sixth-century Anglo-Saxon cemeteries are of native Britons, the evidence being based on the fact that they were on average between one and two inches shorter than the Anglo-Saxon skeletons and were buried without weapons. Dr Härke has also argued that by the seventh to ninth centuries Anglo-Saxon genes were swamped by British, and the overall stature of the Anglo-Saxon population dropped by about an inch.[33] (Härke's work reported in *Daily Telegraph*, 14 Dec 1995.) The general picture so far fits more readily with a process of peaceful cultural interaction rather than with aggression.

Life in pagan Saxon England

Those pagan Anglo-Saxons of the fifth and early sixth centuries who were not warriors were farmers. They lived in nucleated, undefended villages or hamlets and there is a considerable body of data about their lifestyles.

Buildings were entirely of wood: rectangular timber halls have been excavated at a number of sites, such as Cowdery's Down and Chalton (Hants), West Stow (Suffolk) or West Heslerton (Yorks). The Chalton halls[34] were built to a double square plan, with beaten earth or suspended timber floors, and were of various sizes, the largest about 11 m long. One portion of the hall was sectioned off by a partition, and there was a pair of doors facing one another in the long sides, or a single door in the long side in the case of the smallest buildings. These halls were set in fenced enclosures or yards. At Cowdery's Down[35] the buildings were similar, but here excavation was able to reveal that the walls were of split oak planking fastened together with wooden pegs, the spaces between the posts being filled with wattle coated in clay.

Apart from the timber halls, Anglo-Saxon settlements contain a variety of sunken floor buildings (often given their German name of *Grubenhauser*). Usually sub-rectangular, they served a variety of functions including as storerooms and weaving sheds.[36]

Life expectancy for adults ran out at around the age of thirty in the pagan period, and many women died by their early twenties, due to the hazards of childbirth.[37] The diet was basic but varied and reasonably

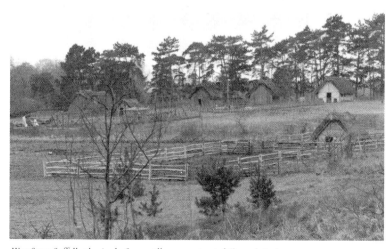

West Stow, Suffolk, the Anglo-Saxon village reconstructed (Jenny Laing)

nutritious. Analysis of the animal bones from the village of West Stow (Suffolk), for example, showed that while sheep were more numerous than cattle there, the latter provided most of the meat. Pigs took third place.[38] This is echoed on other sites, where bones also include those of horses. Barley (necessary for beer), is well represented on many sites though spelt wheat and rye were also important.

Domestic pottery was hand-made and generally plain, and although villagers possessed such items as stave-built wooden buckets and tubs, metal vessels have rarely been found. The Anglo-Saxons of the early pagan period made most of their everyday goods themselves from leather, wood or clay which have generally not survived, though a number of traces of cloth and leather as well as brooches and dress fasteners have given us some idea of fashions. Pottery and spinning or weaving equipment occasionally turns up, both as site finds and in graves. Weaponry is absent from settlement sites, but male burials are sometimes associated with spears, shields and swords.

Trade at home and abroad

In whatever guise the newcomers arrived, they kept in close touch with the Continent[39] and archaeology clearly indicates their origins,[40] supporting statements made by, for example Bede (see Appendix, p. 213). Similarities in both technology and the art and design of pottery and brooches are illuminating.

Pottery

Much pottery was plain and functional, but because it was individually handmade it displays a certain vigorous charm missing from the mass-produced, perfectly formed Roman material. The homelands of the Saxons for example, lay between the rivers Weser and Elbe, the area of modern Lower Saxony, and here types of pots and brooches have been found that are similar to some encountered in eastern and southern England.

Typical of the Saxons are urns with what has been termed *stehende Bogen* (standing arch) decoration, sometimes combined with prominent bosses.[41] The Angles lived around modern Schleswig and the island of Fyn, a region termed 'Angeln'. In this area pottery displayed rectilinear patterns, again frequently combined with bosses. This type is also found in southern and eastern England.[42] In Jutland in Denmark (the homeland of the Jutes) and between there and the Elbe, the pottery displayed linear ornamental schemes. These are also found in Kent, which along with the Isle of Wight was one of the main areas Bede informs us was settled by the Jutes.[43] Rosette-stamped pottery with

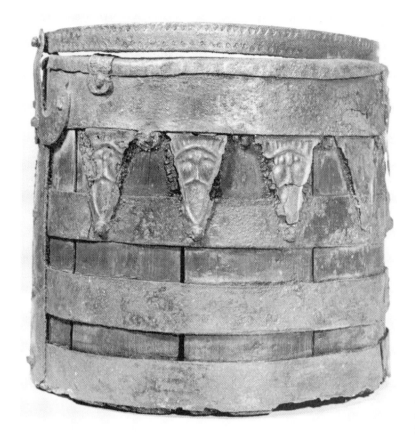

Mucking, Essex, bucket from grave 600, sixth century (Mucking Post-Excavation. Photo: Tom Jones)

zigzag or arched lines is found in the Elbe–Weser region and in Norfolk, for example at Spong Hill and Norwich. One pot from Markshall is so close to the design (of a facing mask) on a pot from Wehden that it is believed to have been made by the same potter.[44]

The stamps used to decorate pottery appear for the most part simple and not obviously symbolic. Study of pots decorated with the same stamp has suggested, however, that while the vessels appear to have been made locally, the stamps travelled. This is well exemplified by what has been termed 'Sancton-Baston' pottery, found in Sancton (East Yorks), Elsham (Lincs), and Baston (Lincs). The clays used at these places were local, but the stamps had apparently travelled up to 160 km.[45] The study showed that five sets of dies were used to decorate at least nine vessels, and it has been suggested that their use may have been in a sense heraldic. This has led to the suggestion that the stamps were family possessions, and

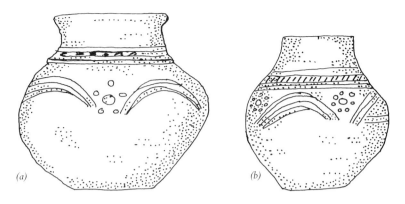

Saxon urns: (a) Zuidlaren, Saxony; (b) Caistor, Norfolk (after Myres)

travelled with families or more probably with women on marriage.[46] At Spong Hill, Norfolk, the stamps included a stamp with swastikas and the runic letters TIW – the name of the warrior god.[47]

Brooches

The shape and decoration of brooches can also be used to differentiate between the separate peoples – Angles, Saxons, Jutes and so on – though caution must be exercised, since brooch types were not exclusive to particular groups.

Brooches reflect contemporary fashions in dress.[48] Costume remained fairly static in the fifth to seventh centuries, but in the case of women underwent marked changes in the later Saxon period. After the initial period of settlement, there were regional variations:

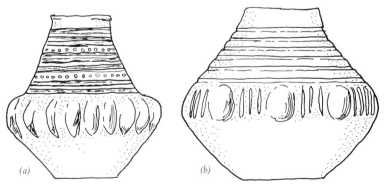

Anglian pottery: (a) Borgstedt; (b) Caistor, Norfolk (after Myres)

rich women in Kent in the sixth century dressed more in line with Frankish Continental modes. For example they wore gold brocaded fillets and possibly front-fastening gowns.[49] Women in the Anglian areas favoured slightly different fashions from those in the Saxon – for instance they occasionally wore a third central brooch as well as shoulder brooches.

Brooches were produced in pairs in order to pin a woollen, girdled shift-like dress at the shoulders – this sometimes seems to have been secured to a long-sleeved undergarment, and worn under a cloak. Various items – tools, charms and symbols of the woman's role as housekeeper – were suspended from the belt. Beads and pendants could be worn as necklaces, armlets or suspended from the belt.

Anglian women seem to have worn sleeved dresses, the cuffs of which were fastened with ornamental hooks known as dress-fasteners.

Most brooches were variants of the safety-pin fibula, first developed in the Roman period. Typically, they have a headplate, bow and footplate, though different types of round brooches are also encountered. The study of these brooches is important for dating graves and cemeteries.

Equal-armed brooches, which are relatively rare in Britain, were introduced by the first settlers.[50] The type is found in northern Germany, between Elbe and Weser (Saxon areas). A good example, of cast silver, from Haslingfield, Cambridge, has crouched animals and patterns of pairs of acanthus scrolls, with borders of egg-and-dart. A related example, again of cast silver, was found in a hut at Sutton Courtenay (Oxon).[51]

In the homelands of the Continental Saxons saucer brooches evolved,[52] which, as the name suggests, were round, saucer-shaped brooches in gilt bronze with a pin at the back. The earliest have simple

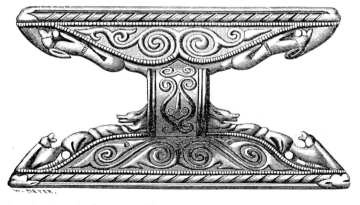

Equal-arm brooch, Haslingfield, Cambs, fifth century. Actual size (after Salin)

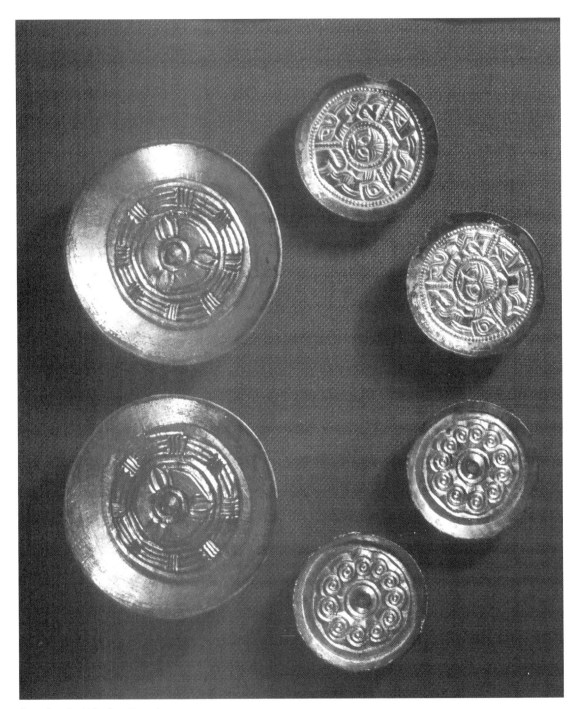

Saucer brooches (Ashmolean Museum)

designs of five running scrolls or an equal-armed cross with scroll ends, but more complex chip-carved designs and subsequently animal ornament sometimes appear on them. They are fairly common in fifth- and sixth-century England.

Applied plate brooches[53] are simple discs each with a die-stamped plate attached to its face. They have a design of a floriated cross, and were popular on the Continent in the early fifth century. They are rare in Britain, and confined to the south-east.

In both Anglian and Saxon areas cruciform brooches are found,[54] with knobs projecting from their square heads. Square-headed brooches are also found in both areas, though there are regional differences.

Some brooches were imported, of which an example from Spong Hill, Norfolk, has a design which matches one from the area of Mahndorf, near Bremen. Some fine artistic achievements are to be found on brooches (see p. 27).

Language and place-names

The language of the Anglo-Saxons was eventually adopted to such an extent that not only was it spoken widely, but very few place-names in England can be regarded as original Romano-British or Celtic. One explanation for this would be that rural Roman sites were eclipsed and eventually abandoned by those adopting the more tenable Anglo-Saxon methods of farming, thus resulting in the loss of the older place-names. Many thousands of such small farmsteads, hitherto unsuspected, have been recognised in the field during the past twenty years, mostly through aerial photography. There are also abandoned Anglo-Saxon sites (see the 'Middle Saxon Shuffle', p. 80).

Place-names have been used to trace the spread of Anglo-Saxon settlement, though the study is fraught with difficulties, compounded by the fact that most names presumably survive in a much later form than they took originally.

For long it was thought that place-names with an ending derived from -inga (meaning 'the followers of X'), seen for example in Mucking (the people of Mucca), represented the first phase of Anglo-Saxon settlement.[55] Such name forms are also found on the Continent, for example Sigmaringen (the place of Sigimar's people). It is now generally reckoned, however, that such -inga placenames did not come into use until after the spread of Christianity. It is notable that their distribution does not coincide with that of the earliest Anglo-Saxon cemeteries when it is probable that Romano-British names were still used.

Place-names with -ham and -tun suffixes (homestead and fence) came into vogue in the later Christian period.[56] On occasion these were combined with -inga elements, giving us names such as Birmingham (the ham of Beornmund's people).

A few place-names are hybrids, with a Romano-British and a Saxon element. Thus Gloucester is composed of the Roman Glevum with the Anglo-Saxon word for fort, caester.

Names containing the element wic are derived from Latin vicus, a settlement, as in Wickham.[57] Eccles placenames are also Roman in origin, from *ecclesia*, a church. *Wala* place-names, from walh, a Briton, have been claimed as indicating Romano-British enclaves.[58] London and Catterick are notable for apparently being directly and solely derived from the original Latin.[59]

Pagan religion

Anglo-Saxon religion may have had its origins in much earlier prehistory, and certainly survived into the Viking Age.[60] Early sources for it are meagre, but from the thirteenth century in Iceland has survived the *Prose Edda of Snorri Sturluson* from which it is deduced that belief was poytheistic. Odin (or Woden) was the chief god (at least by the time of the *Prose Edda*) and the Anglo-Saxon kings traced their ancestry back to him. The war god Thor (Thunor), whose name means thunder, was the chief god of the farmer and peasant. Freyja was the goddess of youth and love, and the sister of Frey. In England Freyja is not encountered, but instead her counterpart is Frig, identified with Frigg, Odin's wife, who is notably shameless. Tiw (Tyr) was a god of combat.

Apart from this indirect evidence most of our knowledge is derived from archaeology, though there is a limited amount of place-name and documentary evidence.

A few place-names contain the Anglo-Saxon word hearg (heathen temple or grove), as in Harrow, or weoh ('idol') as in Weedon (Bucks). Some contain the name of a god or goddess, such as Woden (Wednesbury, Staffs), Thunor (Thudersley, Essex), Tiw (Tysoe, Warwicks).[61]

Most of the documentary evidence for Anglo-Saxon style religion is either Continental or Viking. Bede makes a few references to paganism, as do the somewhat dubious *Penitentials* ascribed to Theodore of Canterbury (late seventh century) and Egbert of York (mid-eighth century). These relate primarily to fortune telling, but otherwise documentary sources are surprisingly silent. Woden is mentioned on a couple of occasions, most notably in the *Nine Herbs Charm* (against snake bites) which says 'A worm came crawling, it killed nothing. For Woden took nine glory twigs, he smote the adder that it flew in nine parts'. These parts each would have had a rune on them.[62]

Archaeological evidence comprises some sparse clues provided by burial rites and grave goods.[63] At Yeavering, Northumberland, a pagan temple may have been converted into a church. This building, known as

D2, was later encapsulated by a larger structure. The first, presumably pagan, building had a pit inside the east door with sporadic deposits of ox bones, mainly skulls. Hope-Taylor, the excavator, thought it was a site of 'potent religious associations'.[64] Two other sites with possible rectangular timber temples lie within pagan cemeteries at Lyminge, Kent and Bishopstone, Sussex.[65] A few other insubstantial and putative shrines have been recognised.

Pagan burials

The period of early settlement remains elusive in that graves are very poorly furnished, presumably a reflection of the low level of prosperity amongst the early settlers. Either they had few durable possessions, or they were careful not to lose them and to recycle outworn goods. A few fine objects can be assigned to the fifth and earlier sixth centuries. The Mucking Belt Set or Sarre Quoit Brooch are good examples.

Cemeteries were located some distance from settlements, and display a variety of burial practices. Although inhumation burial is fairly widespread in Anglo-Saxon cemeteries south of the Thames, particularly in Kent and the Isle of Wight, cremation burial became widespread in Anglo-Saxon England.

Some inhumations were laid directly in the soil; in others the burial pit was lined with wood or stone. Alongside these were more substantial 'chamber graves' in which the body and its effects were buried in a plank-built chamber. Some graves seem to have had a superstructure of timber, perhaps a canopy, and some graves appear to have been demarcated by a ring-ditch, perhaps indicating the edge of a now vanished barrow or mound. In cremation burials a pyre was heaped up over the body and its grave-goods. Above-ground timber structures were sometimes erected over cremation burials, which were also on occasions demarcated by a barrow or ring-ditch. Barrow burials are mostly very late in the pagan period, and, it has been suggested, may have been raised to emphasise ties with ancestors.[66] Not surprisingly, small barrows seem to have been associated with children. In inhumation cemeteries multiple burials are sometimes encountered, usually side by side, but sometimes in a manner to suggest ritual observance, for example at Welbeck Hill, Lincs, where an old man was buried with a decapitated woman lying over him in a reverse position.[67] There are a couple of possible examples of slaves being buried with their mistresses, for example at Sewerby, Yorks,[68] where it has been suggested there was live burial. In cremations the ashes were sometimes placed in the grave without a container, more usually in an urn – not all the bones were interred in this way, and many may have been grouped in cloth bags in the urn.

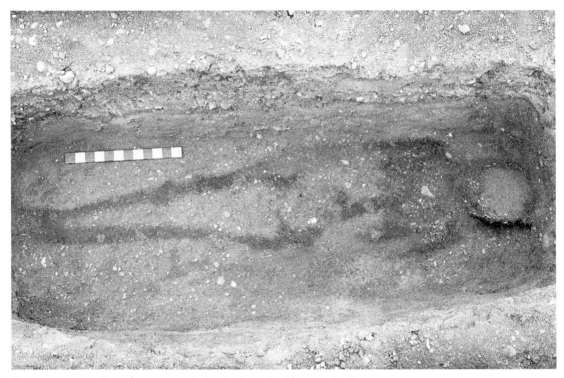

Pagan grave, Mucking, Essex, after excavation (Mucking Post-Excavation. Photo: Tom Jones)

The grave-goods accompanying burials obviously had a special significance. Animal bones are known. Some may be joints of meat, favoured pets, or symbols (these include horse burials, for example at Little Wilbraham, Cambs, where the horse was accompanied by its harness and a male burial),[69] or a Sutton Hoo burial (see p. 45). There may have been an Anglo-Saxon horse cult, and horse teeth by themselves sometimes appear in burials.[70] In a few cases entire horse skeletons have been found. At Sutton Hoo, the 'Prince's Grave' was accompanied by the burial of a pony and harness.[71] Sometimes horse burials are found without the accompanying human body. The presumed horse cult may have been connected with Tiw.[72]

Boar's teeth may also have been buried as 'charms', since they were associated with warfare and helmets — the Benty Grange, Derbys, helmet has a boar's crest, and another boar crest is known from Guilden Morden, Cambs.[73] Beaver teeth also seem on occasion to have been charms — to ensure good strong teeth in their owners, perhaps? Beads were sometimes used as charms.[74]

A possible priest's grave was discovered at Yeavering, Northumberland — burial AX was laid out on a major alignment of the

site, with a strange assemblage of grave-goods. A goat's skull lay at the foot, and traces of a wooden shaft with metal bindings ran east–west in the grave. One end of it had an iron spike, the other an animal effigy, possibly a goat. Towards this end were the traces of two wooden cross-pieces with bronze terminals, and near the other end was a short shaft with an iron spike lying obliquely under the first shaft. Given that Yeavering's name, Ad Gefrin, means 'Hill of Goats', the goat skull and possible image on the staff suggest a cult connection – the long rod has been seen as some kind of ceremonial groma (land surveying staff) used by Romans.[75]

Art in the fifth century

Apart from metalwork and the decoration on pottery, virtually no art survives from the pagan Anglo-Saxon period. There is however a very remarkable three-dimensional sculpture of a figure seated on a wicker chair, from Spong Hill, Norfolk, which adorned a pot lid. The figure wears a pill-box hat or head-dress, but no clothes. It was found in a rabbit hole but tests have shown it to be ancient. It has been suggested that the figure represents a god – there is a bronze Icelandic figure of Thor of tenth-century date which is not totally dissimilar.[76]

The contacts and interaction between Anglo-Saxons and Romano-Britons already discussed occurred within the realm of art as well as everyday matters. This is readily demonstrable through the transmission of artistic motifs and techniques in the very early part of the Anglo-Saxon period. Because of the paucity of information from other sources

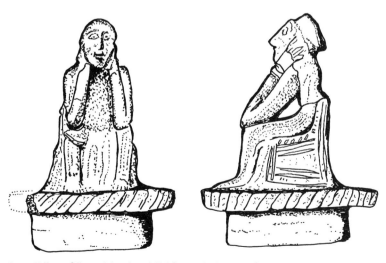

Spong Hill, Norfolk, pot lid with modelled figure (Lloyd Laing, after a photo)

from this transitional time, it is a particularly important area of evidence.

Late Romano-British art for example, displays elements which contributed to the development of Anglo-Saxon styles, corroborating the growing view that the two cultures intermingled amicably. The fourth century was a period of vigorous artistic activity in Britain, with the deposition of fine mosaics and the importation of sumptuous silverwork, as well as the production of works more to native taste. Among these was a series of small items of personal adornment such as brooches and pins, which display a resurgence of 'Celtic' style which had been partially submerged during the preceding century or so.[77] Some of this was abstract and curvilinear, employing such devices as confronted trumpets and scrolls, but alongside this art can be found a slightly stylised but still naturalistic tradition of animal ornament. Some of this is discernible in enamelled animal brooches and in harness pendants, though the animals also appear in other contexts. Frequently crouched and backward-looking, they recur in the fifth century in what has been termed the 'Quoit brooch style' (see p. 24).

Some techniques apparent in Anglo-Saxon metalwork are also to be found in late Roman Britain. The use of niello, a silver sulphide paste employed in inlays that became fashionable in Anglo-Saxon England, was one such. It harked back to Romano-British antecedents of the fourth century and earlier.[78] So too did the use of enamel, which is found on disc brooches which themselves may have been one source of inspiration for Saxon smiths.[79]

The most striking pieces of late Roman metalwork, however, are the series of belt buckles originally imported from the Continent which originally gave rise to the speculations that Anglo-Saxon mercenaries were employed by the Romano-British. These fittings were subsequently copied in Britain, with confronted dolphins or horses on their buckle loops.[80]

The styles of pagan Anglo-Saxon art

A succession of different styles is encountered in the art of the pagan Anglo-Saxons. The first manifestations of Anglo-Saxon art may be termed the Vermand style, after a cemetery in France in which examples of it are well represented.[81] The style employs chip-carving – a technique derived from woodworking, originally developed, like so many Germanic decorative techniques, around the head of the Black Sea. This became widespread along the Roman frontier in Germany, where it was taken up by Germanic troops in the Roman army. In chip-carving inverted facets are produced in the metal, either by cutting or by casting (pseudo-chip carving). The finished piece is usually gilt, to

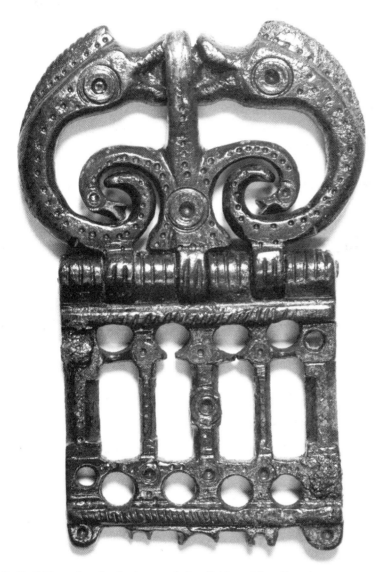

Buckle, Colchester, Essex, late fourth century. L. 6 cm (Colchester & Essex Museum)

reflect light. These pieces, often strap ends, as well as the various classes of buckle sets mentioned above, began to come in to Britain in the late Roman period. Some fine examples of chip-carving are apparent on silver, probably of East European origin, in the Traprain Law hoard (East Lothian) deposited in the early fifth century[82] and there are other examples from Richborough, Kent.[83] Where they occur in Anglo-Saxon graves they are probably late Roman survivals.

The Vermand style of chip-carved running scroll pattern appears on

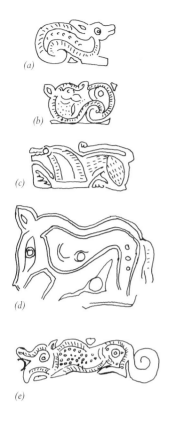

*Quoit brooch style animals: (a)
Faversham, Kent; (b) Howletts, Kent;
(c) Sarre, Kent; (d) Croydon, Surrey;
(e) Bifrons, Kent (Lloyd Laing, after
Evison)*

the mount from the scabbard mouth of a sword from Brighthampton, Oxfordshire, which had a chape with backward-looking animals inlaid in gold. The creatures have their counterparts both in the Quoit Brooch style discussed below, and in the animals that decorate some East Anglian pots. Some experts believe the sword to be an import from the Meuse area, others prefer to see the scabbard as having been made in England.[84]

The chip-carved ornament and the use of late Roman motifs, including animals, passed to the tribes in northern Europe. A Roman-derived style known after a peat-bog deposit as the Nydam style evolved in Scandinavia. Haseloff has suggested that it lasted from the early to mid-fifth century, ending *c.* 475 with the emergence of Style I, when all sea creatures disappear.

Distinctive of the post-Roman period is a discrete tradition known usually as the Quoit Brooch style because it is best seen decorating the flat, quoit-like hoops of an unusual and early group of brooches in south-east England. The Quoit Brooch style on present reckoning was current as early as the first quarter of the fifth century, and is clearly derivative of provincial Roman art styles, though whether it developed in England out of Romano-British precedents or on the Continent has been hotly debated.

The characteristic feature of Quoit Brooch style work is a fairly naturalistic type of crouching animal with hatched fur and double outline, sometimes represented looking back. Such creatures appear in processions in bands or zones, and the style is much more ordered than that of the succeeding styles. It has been suggested that it has an ancestry in the animals on the 'hound-and-hare' knife handles of Roman Britain.

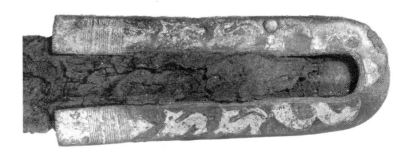

Above: Brighthampton sword chape (Ashmolean Museum)

Left: Brighthampton, Oxfordshire, sword scabbard mount, fifth century (Ashmolean Museum)

Belt set in Quoit Brooch style, Mucking, Essex (British Museum)

Combined with the crouching animals are other elements, including occasional human faces, sea horses and abstract patterns.[85]

The finest example of the style can be seen on a beautiful silver Quoit Brooch from an Anglo-Saxon cemetery at Sarre in Kent.[86] It is parcel gilt, and in keeping with other brooches of its type has a penannular brooch fastening as its central element. This has led to the suggestion that the quoits were additions to a basically Romano-British type of brooch. What is exceptional about the Sarre brooch are the three tiny three-dimensional doves, one on the pin and a pair on the quoit. One dove swivels. Three-dimensional modelling is extremely rare among the pagan Anglo-Saxons, and where it occurs may be due to surviving Romano-British or Celtic traditions. Certainly the doves are somewhat reminiscent of the three-dimensional enamelled bird brooches found in Roman Britain. A Continental origin has also been suggested for them, however.[87]

Another good example of the Quoit Brooch style is provided by a belt set found in a grave at Mucking in Essex.[88] A notable feature of the Mucking belt set is the buckle itself, which has a pair of double-headed serpents. These are confronted but in a style which recalls earlier Roman buckles with horse or dolphin heads. Other decoration on the belt plates includes fret patterns (found widely in late Roman art), swastikas, facing masks, and a kind of 'tree of life' motif. The Quoit Brooch style can also be seen on such objects as a belt hanger from Croydon, Surrey, with a pair of confronted sea-horses.[89]

Apart from a Romano-British origin for the Quoit Brooch style, suggestions have been made that it developed in Jutland and was introduced by the Jutes to Kent; that it was Frankish; or that it came from somewhere else on the Continent.[90] Various similar animals have been put forward as parallels, but the ancestors of the Quoit Brooch creatures can be found equally easily in Roman Britain, for example on a pendant from Margidunum, Notts, deposited in the late fourth or early fifth century, as coin evidence shows. Other examples of the late Roman animal style can be seen on silver rings from a hoard at Amesbury, Wilts, and on another ring from Wantage, Oxfordshire.[91]

Some Quoit Brooch style work involved the inlaying of silver in bronze, a technique pioneered on the Continent and particularly popular with the Franks.[92] A good example of the tradition can be seen on an imported buckle from Bifrons, Kent, which depicts Daniel in the Lion's Den and bears an inscription 'Long Live the Man who Made [Me]'. It was probably made in a northern Gallic workshop at the beginning of the fifth century.[93]

Soon after the time that the Quoit Brooch style was flourishing, other types of art of late Roman derivation are encountered in Anglo-Saxon England. The two main ones (named Style I and Style II by the Scandinavian scholar Bernhard Salin in 1904),[94] are derivative of those found on the Continent, though they appear in distinctively Anglo-

Buckle plate with Daniel, probably Frankish, Bifrons, Kent (Maidstone Museum)

Saxon variants. Style I is characterized by chip-carved patterns employing animals, human and animal masks and abstract devices, which are broken down into composite elements and used in all-over decoration. Instead of the sea creatures previously favoured, quadrupeds with contour lines predominate.

The origins of Style I can be traced to Scandinavia, where it seems to have developed out of the Nydam style. It first appeared around AD 475, and was introduced to England very soon after. One of the first manifestations of Style I is on Kentish square-headed brooches. The earliest were probably imported around AD 480, and include a fine example in silver from Bifrons, with a menacing head on a roundel on the bow. Early examples also have a crouching animal with a human head as a characteristic motif.[95]

The Kentish brooches have a footplate on which the design is not broken up, but in East Anglia can be found square-headed brooches with a 'divided foot', that is, with a central rib on the footplate.[96] The East Anglian brooches employ very little animal ornament.

Style I was introduced probably separately from Jutland (to Kent) and Norway (to East Anglia). It rapidly became established and appeared in native Anglo-Saxon versions on a wide variety of objects, from brooches and buckles to pins, sleeve-fasteners and mounts. It remained the dominant style through most of the sixth century.[97]

Style I motifs

Symbolism and pagan Anglo-Saxon art

Although some manifestations of pagan Anglo-Saxon art were clearly mere decoration, many of the elements of more complex designs

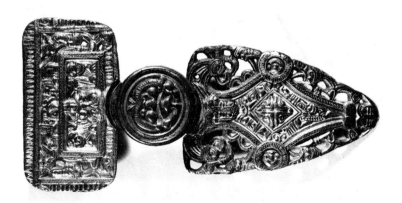

Silver square-headed brooch, of Kentish type, Bifrons, Kent, grave 41, fifth century (Maidstone Museum)

contained meanings which would have been apparent to the owners of the pieces concerned.

Much pagan Saxon art employs a basic repertoire of animal designs, and these were clearly of special significance. The Germanic peoples used animal names which were combined into single personal names – thus can be found eagle-boar, eagle-boar-wolf, or eagle-serpent. The combination of such animal motifs on personal possessions might well reflect the identity of the owner.[98]

Three animals in particular recur in pagan Anglo-Saxon art, the boar, the eagle and the serpent. These creatures were also important to the Celts (including the Britons), and they recur as motifs in ancient European art, most notably in the Bronze Age rock art of Scandinavia which in many respects anticipates the iconography of the early Germanic peoples.[99] The boar's head was a symbol of Woden (Odin), the god of death and war to whom most of the Anglo-Saxon royal families traditionally traced their ancestry. The boar was appropriate as a symbol of war, and was generally symbolic of protection and fertility. A boar forms the crest of the helmet from Benty Grange, Derbyshire, as has been noted, and boars recur in various guises in the Sutton Hoo treasure, notably on the shoulder clasps. A stylized boar's head appears in garnet on a pendant from Womersley, Yorks.[100]

More ubiquitous is the eagle, or other hook-beaked bird. The bird of prey first appears in Scythian art in the seventh century BC, and Edouard Salin traced its use through ten centuries.[101] The eagle or raven was the bird of Odin, and ravens were the birds of battle. They appear commonly as shield mounts, notably at Sutton Hoo, and are frequent elements on florid cruciform brooches. A triskele of bird heads appears in cloisonné on a gold and garnet pendant from Faversham, Kent.[102] This design is found in various forms in Dark Age Europe, including on a hanging bowl print from Sussex.[103] Both the bird of prey with a fish in its talons (an age-old symbol which was also given a Christian interpretation) and another type of bird, probably a crane, appear on a hanging bowl from Lullingstone, Kent, which may be Anglo-Saxon.[104]

The third creature favoured by Anglo-Saxon artists was the serpent. Snakes were symbols of protection for warriors, and it is extremely likely that the use of serpentiform lacertines in Style II art (see p. 69) endowed the object, and possibly the owner, with magical protection. A double-headed snake was associated again with Woden, and was used as a crest for the helmet from Sutton Hoo. It has been argued that the Sutton Hoo helmet is of Swedish origin, but it may also be pointed out that a double-headed serpent appears on the Bacton (Norfolk) pendant and on the back of the Kingston Brooch from Kent.[105] A crest in the form of horns ending in snake heads (a variant of the double-headed snake motif) appears on the gilt silver buckle from Finglesham, Kent,

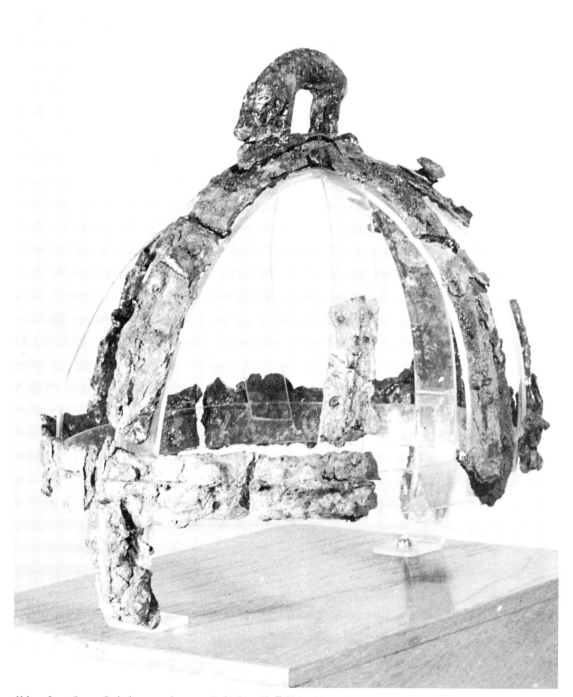

Helmet, Benty Grange, Derbyshire, seventh century. H. 24.5 cm (Sheffield City Museum)

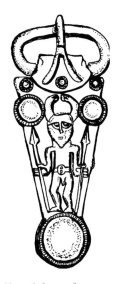

Buckle, with dancing figure, Finglesham, Kent, grave 95. L. 3.1 cm (Lloyd Laing, after a photograph)

where a warrior, naked apart from his belt and helmet, brandishes two spears, perhaps in a dance.[106]

The snake can appear in other guises – the 'Wyrm' is a serpent which was believed to cause disease. It appears on Anglo-Saxon cremation urns in East Anglia, where it is combined with a swastika, which may be associated with the cult of Thor, though could equally well be associated with Woden, god of the dead.[107]

Among other animals that figure in pagan Anglo-Saxon art, mention may be made of the deer, the horse, and the fish.

The deer appears as a stag, on the hanging bowl from Lullingstone, Kent (where it is found alongside the bird and fish), and crowning the Sutton Hoo whetstone (where it has been suggested, somewhat unconvincingly, as being Celtic), and deer appear as stamps and drawn freehand on Anglo-Saxon cinerary urns.[108]

The horse figures as a stamp on some Anglo-Saxon urns from Spong Hill, Norfolk, and a horse head adorns the footplate of cruciform brooches throughout the fifth and sixth centuries. A horse head too forms the catchplate of the Kingston Brooch (see p. 51) and horses flank the footplate on many square-headed brooches. Horses appear confronted on the Sutton Hoo shield boss.[109]

The fish is often seen as a symbol of Christianity, and a Christian significance is sometimes read into its occurrence in Anglo-Saxon art. Given the importance of the salmon in Celtic cult practice, it probably had a pagan Saxon significance as well. It appears, for example, as a decorative spine on a buckle from Crundale Down, and is the subject of a brooch from Westbere, near Canterbury, with a garnet setting in its tail.[110] It also appears in three dimensions in the base of the largest Sutton Hoo hanging bowl, but again has been discounted as of Celtic workmanship.[111]

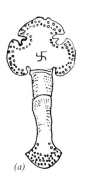

(a)

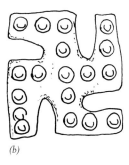

(b)

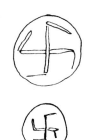

(c)

Swastika designs on pots and brooches: (a) King's Walden; (b) Alfriston; (c) Spong hill pot stamps (Lloyd Laing)

The ox, the head of which appears not infrequently in Celtic art, is generally absent from Anglo-Saxon decoration (though there were ox-head finials on the Sutton Hoo standard), and the wolf and bear are similarly not major elements in the repertoire.

Human masks appear frequently in pagan Saxon art. The facing mask is the counterpart of the Celtic severed head, and is widespread in Migration Period art. Facing masks appear on Style I brooches, and on the mounts on a bucket from Mucking, Essex.[112] In grotesque form they appear on the mounts for drinking horns from Taplow, Bucks, and in less menacing guise on a pot from Norfolk.[113] Helmeted heads may be derived from Roman images, transmitted by a very roundabout route through Scandinavia. Among these are helmeted heads with hands, which probably derived from late Roman coins.[114] Facing masks of various types were employed as borders on the head-plates of the great square-headed brooches, predominantly in the south and south Midlands. They are notably rare on the Continent.[115]

A study of the motifs on Style I brooches in Kent has shown that ambiguity was an important element in the design.[116] A number of explanations have been advanced for this. 'Shape changing', which was in particular a characteristic of Woden; visual riddles enjoyed in their own right; or a device for confounding evil spirits by creating visual confusion. The study showed that individual elements on the Kentish brooches could be interpreted differently depending on the angle from which they were viewed. Designs on brooches from Howletts and Dover use a pattern found in very similar form on a piece from Donzdorf, West Germany.[117] This employs backwards-bent animals with a human mask between. Turned at right angles, they become human profile masks with downturned mouths. On a brooch from Bifrons, Kent, two confronted profile masks turn into a single facing mask, which is either smiling or frowning, depending on which way round it is held – a device employed in Continental Celtic art as early as the Iron Age.[118]

Mention has been made in passing of the possibly heraldic symbols encountered in some of the designs on Anglo-Saxon pots. It has been suggested that the pots themselves were symbolic, and the size and shape reflected the sex, age or grouping of the person interred in them.[119] Thus it would seem that the height of the pot reflected the age of the deceased, and adults males were buried in taller pots than adult females.

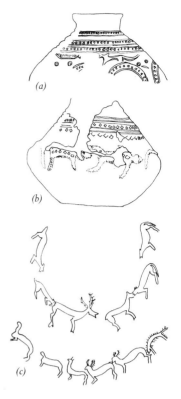

Animals on Anglo-Saxon pots: (a) Caistor-by-Norwich, Norfolk; (b) Newark, Notts; (c) Spong Hill, Norfolk (after Wilson)

The neighbours of the Anglo-Saxons

But what of the areas in Britain never reached by the fifth- and sixth-century Anglo-Saxons? In Wales (which had been within the Roman

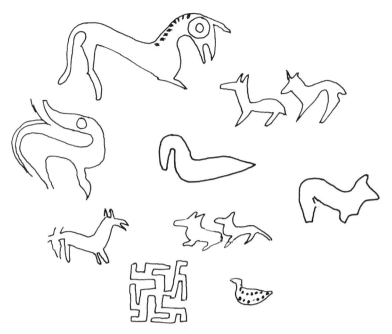

Pottery stamps on Anglo-Saxon urns (after Hills)

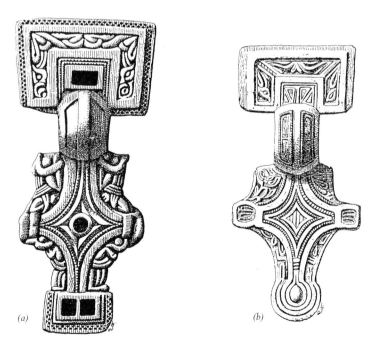

(a) (b)

Anglo-Saxon square-headed brooches, Continental and British (after Salin). (a) Herpes, Charente, France; (b) Sarre, Kent

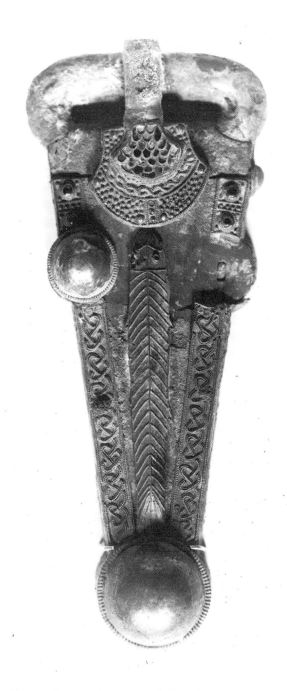

Buckle, Crundale Down, Kent, seventh century (British Museum)

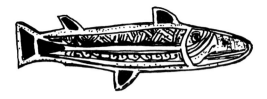

Fish brooch, Westbere, Kent, and bird brooch, Finglesham, Kent (Lloyd Laing)

Empire) and in the regions of Northern Britain never occupied by the Romans, Celtic kingdoms emerged out of the legacy of a Roman past.[120] These shared more in common with their Anglo-Saxon neighbours than is often supposed, though trade with them was surprisingly meagre. In Scotland and to a lesser extent in Wales and the south-west of England there were settlements of Celts from Ireland – these resulted in the emergence of the Irish kingdom of Dalriada in north-west Scotland from the late fifth century.[121] Contact between Dalriada and the Anglo-Saxons is attested at the Dalriadic citadel of Dunadd in the seventh

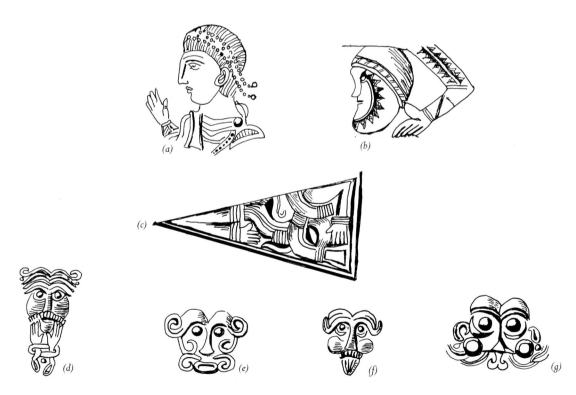

Masks in Style I art: (a) prototype, gold medallion; (b) Continental derivative; (c) Taplow, Bucks, drinking horn mount; (d) – (g) Anglo-Saxon brooches (after Leeds)

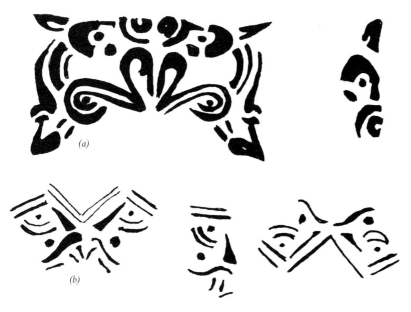

Visual ambiguity, motifs on Anglo-Saxon square-headed brooches: (a) Apple Down; (b) Bifrons, Kent (after Leigh)

century, the avenue of communication being through the Irish ecclesiastical foundations in Northumbria.[122]

Connections between Celtic lands and the Anglo-Saxons were of increasing importance after the seventh century, when both areas had adjusted to life without the Roman Empire's direct interference in Britain.

Notes

1. Salway, 1981, 667 for Hnaudifridi and 410 for Fraomar. See also Myres, 1986, 81 and Swanton and Myres, 1967, discussing a probable Alamannic brooch from Londesborough, Yorks. While the interpretation of the Londesborough find has been queried, most recent opinion seems to support its Alamannic origin.
2. Johnson, 1976; Johnson, 1979, chap. 3.
3. Portchester's Anglo-Saxon community in the fifth century discussed in Cunliffe, 1975, 301. Richborough is more problematic – Cunliffe, 1968, 250.
4. Salway, 1981, 288–90, and 300.
5. Many discussions of these events have been published; Johnson, 1979 and Higham, 1992, chapter 3 particularly useful, as is Frere, 1974, 391 and Cleary, 1989.
6. Salway, 1981, 479; Morris, 1973, 790.
7. Dark, 1994, chapter 6.
8. Ibid.
9. On the purity of Latin in late Roman Britain, Chadwick, 1959, 209.
10. Dark, 1994, 185–6. For a fourth-century Romano-British origin for the manuscript, see Henig, 1995, 157.

11. Dark, 1994, 30–39.

12. Pelagianism discussed in Salway, 1981, 462–7. See also Thompson, 1984.

13. Morris, 1983, 26; Stone-by-Faversham in Fletcher and Meates, 1969.

14. Cameron, 1968.

15. Johnson, 1979, 152; Thomas, 1981, 169.

16. Alcock, 1971; Alcock, 1972 for traditional view. Also discussed in a series of essays in Ashe, 1968. Modified view of the function of Cadbury in Alcock, 1982.

17. End of coinage in Roman Britain in Casey, 1980, 48 and Kent, 1979. For reasons why this might be due to Empire-wide factors, Reece, 1987, 23.

18. There are some indications that a few coins were used within what had been the frontiers of Britannia through the fifth century if not beyond. The production of high-status metalwork with many of its specialist techniques continued through the fifth and sixth centuries: Laing and Laing, 1990, 92–94. Pottery in Frere, 1974, 416–7 and Todd, 1981, 251.

19. Laing and Laing, 1990, 70–79 summarises. Also Arnold, 1984 discusses the fate of individual towns – there is growing evidence for continuity from London, Lincoln, Gloucester, and elsewhere.

20. Rivet, 1969, 214 states the view that has been little modified. See also Cleary, 1989, chap. 6.

21. Morris, 1973, 88–90.

22. See for example H.M. Chadwick, 1959, 22.

23. Such burials were assumed to have been Germanic in the 1960s and 1970s, see Hawkes and Dunning, 1961, but now much more caution is being expressed, cf. Cleary, 1989, 191.

24. Case for early settlement set out in Myres, 1969, 71–4 and Myres, 1986. More restrained view in Cleary, 1989, 188–93. Myres' view was based on assumptions about some types of objects with Germanic affinities found in later Roman Britain, most notably 'Romano-Saxon pottery' which was believed to have been made by Romans for Anglo-Saxon markets. These can now be seen as Roman vessels which employed decorative schemes modelled on glass and metal vessels, which were subsequently taken up by Germanic peoples on the Continent, see Roberts, 1982. It was also thought that some urns in early Anglo-Saxon cremation cemeteries in eastern England were in fact earlier than they are now seen to be; see Cleary, 1989, 189.

25. Alcock, 1971, 310–11.

26. The population of Britannia in the second century has been estimated by Frere at around two million (1974, 350). Other estimates have put it higher, see Jones, 1979, 244–5, where a total of four milllion is not ruled out. Salway, 1981, 544 even suggests five to six million.

27. Dickinson, 1983.

28. See above, n. 16.

29. Discussed Laing and Laing, 1990, chapter 4, esp. 70–9 with refs. See also Dark, 1994, chapter 4, and Davis, 1982 for a detailed study of the Chiltern region.

30. White, 1990; White, 1988, 134 for possibillity of heirloom pottery, and 136 (glass).

31. Mackreth, 1978; Laing and Laing, 1990, 87.

32. Arnold, 1984, 130 citing unpublished material.

33. Earlier studies discussed in Arnold, 1984, 122–3.

34. Addyman, Leigh and Hughes, 1972, 16.

35. Millett and James, 1983; James, Marshall and Millett, 1983.

36. Rahtz, 1976, 91–3.

37. Webster, 1986, 130.

38. West, 1985, 14.
39. Hines has argued for continuing traffic between Jutland and eastern England in the fifth and sixth centuries; see Hines, 1984; Hines, 1992.
40. The main exponent of the 'ethnic' approach to Anglo-Saxon studies in the twentieth century was J.N.L. Myres, who set his arguments out in a series of studies, notably 1969, 1986.
41. Myres, 1969, 43.
42. Myres, 1970; Myres, 1969, 51f; Myres, 1986, 64.
43. For Jutes generally, C.F.C. Hawkes, 1956; Leeds and Chadwick, 1957; Hawkes, 1982.
44. Myres and Green, 1973, 47.
45. Arnold, 1983; 1988.
46. Arnold, 1988, 78.
47. Hills, 1974, 88–9.
48. Discussed in detail in Owen-Crocker, 1986 (summary 197–201).
49. Crowfoot and Hawkes, 1967.
50. Evison, 1977.
51. Aberg, 1926, 15 and fig. 17.
52. Classic study, Leeds, 1912.
53. Evison, 1978.
54. Aberg, 1926, 28–30; Hawkes, 1956; Myres, 1986, 57–9.
55. Dodgson, 1966.
56. Dodgson, 1973.
57. Gelling, 1967.
58. Faull, 1977.
59. Rivet and Smith, 1979 for Roman place-names.
60. Turville-Petre, 1964; Davidson, 1964b; Fell, 1980 for the Continent. Branston, 1974 and D. Wilson, 1992 for England.
61. Bannard, 1945, 76–9. For *hearg* and *weoh* names, Wilson, 1984.
62. Wilson, 1992, 39.
63. Wilson, 1992; Meaney, 1964 for list of sites. Useful discussions also in Welch, 1989.
64. Hope-Taylor, 1977, 158.
65. Wilson, 1992, 48–9.
66. Shephard, 1979, 47, 77.
67. Evison, 1987, 27–8.
68. Hirst, 1985, 39.
69. Wilson, 1992, 101.
70. Ibid, 102.
71. Evans, 1994, 121.
72. Wilson, 1992, 101–2.
73. Foster, 1977, 167.
74. Meaney, 1981. It has been suggested that charms were the indicator of a wise-woman's grave, just as different types of weaving equipment etc. were also indicators of status; see Webster, 1986, 128.
75. Hope-Taylor, 1977, 202; Wilson, 1992, 176.
76. Hills, 1980b.
77. Laing, 1990.
78. Moss, 1953. For Dark Age niello's composition, Stratford, 1986.
79. Evison, 1977; Brown, 1981; Scull, 1984.
80. Hawkes and Dunning, 1961.
81. Evison, 1965, useful general discussion.

82. For Traprain generally, Curle, 1923. Also Kent and Painter, 1977, 123.
83. Hawkes and Dunning, 1961.
84. Evison, 1965, 60–61.
85. Hawkes, 1961; Evison, 1965 for examples. Hicks, 1993, 16–19 discusses the possible south Scandinavian origin of the animals.
86. Evison, 1965, 47.
87. Ager, 1984, fig.12 illustrates possible models. See also Ager, 1990.
88. Evison, 1968 for the series.
89. Evison, 1965, 60–61 and pl.13a.
90. Hawkes, 1961 (Jutish origin); Evison, 1965 (Frankish origin); Ager, 1984 and 1990, North European origin. White, 1988 for British case. See also Bakka, 1958. Ager's argument (1984) that it was introduced by mercenaries is not now convincing.
91. Laing and Laing, 1995, 85. The Margidunum pendant was found with a coin of Eugenius in the make-up of the rampart, and was likely to have been deposited in the early fifth century, Oswald, 1956. For the rings, see Henig, 1995, 172.
92. Evison, 1955.
93. Jessup, 1950, 136; Evison, 1965.
94. In *Altgermanische Thierornamentik*.
95. Leeds, 1949, 4.
96. Leeds, 1949, passim, but especially 90–107.
97. Chadwick, 1958, 50–57 for introduction of Style I from Denmark to Kent. Early introduction to England also discussed in Haseloff, 1974, 14. See too Leeds and Chadwick, 1957.
98. Speake, 1980, chap. 7.
99. Gelling and Davidson, 1969, trace the underlying traditions of Migration Period symbolism to Bronze Age rock art in Scandinavia.
100. Speake, 1970.
101. Salin, 1959, 192.
102. Speake, 1980, fig.3a.
103. From Willingden, Welch, 1983, 342.
104. Allen, 1898, 41–2.
105. Speake, 1980, pl.11d.
106. Hawkes *et al.* 1965.
107. Wilson, 1992.
108. Hills, 1983.
109. Hicks, 1993, 59.
110. Jessup, 1946, 15.
111. Hicks, 1993, 59.
112. Selkirk, 1975.
113. Myres and Green, 1973, 47 & fig.3.
114. Leeds, 1946 for Roman coin models for bracteates. Kendrick, 1938, 77, for 'helmet style'.
115. Leeds, 1949, 94–6.
116. Leigh, 1984; Leigh, 1990.
117. Ibid.
118. Megaw, 1970.
119. Richards, 1987b; Richards, 1987b.
120. Laing and Laing, 1990; Dark, 1994, passim.
121. Laing and Laing, 1990, chap. 6.
122. Campbell and Lane, 1993.

CHAPTER TWO

The Pagan Kingdoms

c. 600–c. 700 AD

By the late sixth/early seventh century the modest farming communities of the Anglo-Saxons had formed political affiliations and become part of small kingdoms under the leadership of high kings or their equivalents. The Anglo-Saxon Chronicle states that the last three Roman cities – Cirencester, Bath and Gloucester – fell to the Anglo-Saxons under one Ceawlin of the West Saxons after the Battle of Dyrrham in 577/8. It is notable that Ceawlin's name is of British origin, not Germanic, further slight evidence of the Romano-Saxon/Saxo-Roman mixing in the population and implying that political affiliations were not necessarily to be equated with genetic.

From this time on the dynamic force in society lay with an amalgam of cultures in which Anglo-Saxon was dominant. Equally importantly, however, the Saxons looked back with respect to the Roman past.[1]

The formation of kingdoms

By the end of the sixth century there were seven traditional kingdoms, called the Heptarchy by Henry of Huntingdon in the twelfth century: Kent, the kingdoms of the East, West and South Saxons (now Essex, Wessex and Sussex), East Anglia, Mercia and Northumbria (i.e. the area to the north of the Humber). The inhabitants are referred to from this time on as the English by external writers.

The larger kingdoms may have coalesced out of smaller groupings, or been created through conquest of other Saxon or Romano-British territories.[2] Within the kingdoms there were divisions and fluctuating fortunes. Northumbria was, for example, the outcome of an amalgamation of the two kingdoms of Bernicia and Deira which from time to time vied with each other for supremacy. It expanded during the seventh century into southern Scotland.[3]

Kent and East Anglia were important in the early seventh century, Northumbria rose to prominence under the Bernician king Aethelfrith (c. 593–616), and continued to thrive under the Deiran Edwin

BERNICIA
Lindisfarne
Yeavering
Ruthwell
Bewcastle
Jarrow
Hexham
Escomb
Monkwearmouth
NORTHUMBRIA
DEIRA
York
LINDSEY
Lincoln
MERCIA
Breedon
Pentney
MIDDLE
ANGLES
Spong Hill
EAST
ANGLES
West Stow
Snape
HWICCE
Brixworth
Ipswich
Sutton Hoo
Deerhurst
EAST SAXONS
Mucking
Reculver
WEST SAXONS
Taplow
KENT
Swallowcliffe
Winchester
Canterbury
Down
Chalton
Kingston
Hamwic
SOUTH SAXONS
Trewhiddle

0 50 100 150 200
miles

(616–33) and the Bernicians Oswald (634–42), Oswiu (642–70) and Ecgfrith (670–85).[4]

Mercia was important in the later eighth and ninth centuries. It originated on the Middle Trent, but by the end of the seventh century had expanded to include Lindsey (Lincolnshire). Its territory extended from London to the Severn.

Finally, Wessex grew to supremacy when one of its kings, Aethelstan, became a king of All England. It originated in the territory of the Gewisse of the Thames valley who expanded to take over first Hampshire and Wiltshire, then Dorset, Devon and Somerset.

It has recently been suggested that at least some of the Anglo-Saxon kingdoms directly replaced the Roman system of civitates.[5] Several kingdoms, for example Kent, Lindsey, Deira and Bernicia, preserved Roman boundaries. Some 'Roman' elements in the panoply of the burial at Sutton Hoo, Suffolk, for example, might corroborate this theory. The Sutton Hoo whetstone was British in inspiration. The Sutton Hoo 'standard' and the banners carried before the Northumbrian king Edwin in battle in the seventh century may have been inspired by a Roman army example. Similarly, the helmet and shoulder-clasps of Sutton Hoo look back to a Roman past.[6]

Essentially both British and Anglo-Saxon territories were divided up into large areas with a central residence, called a villa in Latin and a tun in Anglo-Saxon. In Saxon times they were the centres of royal administration, and visited by the kings. The Latin terms *provincia* and *regio* are used in later sources for the small land units that were later absorbed into the larger kingdoms. The *regiones* were discrete territories within kingdoms.

It has been suggested that kingship may have evolved in Britain following the Anglo-Saxon settlements, rather than being imported, and that the early kings may have differed from those of the seventh century and later.[7] It may be significant that kingship grew up concurrently in both the Anglo-Saxon and Romano-British communities during the fifth and sixth centuries, and the suspicion grows that the terms 'Anglo-Saxon' and 'British' were less genetic or racial than political.

Anglo-Saxon society

Almost all evidence for the structure of society relates to after the conversion to Christianity. The pattern discernible from later information is likely to hold true, however, for at least the late sixth and early seventh century when kingdoms had been properly formed, and it almost certainly endured until the Norman conquest. Anglo-Saxon society was highly stratified, with ties to the kin group and personal loyalty to the overlord playing a dominant role.[8]

Loyalty bonds

One of the most important bonds in society was that between the lord and his retainers, the *gesithas*. The bond was complex, and involved the giving of gifts by the lord to his followers while the triumphs of the gesithas were credited to their lord. This facet of life is relevant when considering the purpose of the impressive art treasures from the period. If either lord or retainer were killed, a duty of vengeance fell upon the survivor. When King Oswald of Northumbria, for example, was exiled in the seventh century, his followers went with him, and it is clear from several sources that a retainer was expected to die for his lord if the occasion arose. The bonds of loyalty ran deep and it was acceptable when, for example, a swineherd took vengeance for the killing of his lord.[9]

Wergild

Although loyalty to the lord was paramount, the duty to kin was always important. If someone were killed, it was the responsibility of the kin to exact vengeance. Retribution could be transmuted without loss of honour into a payment of compensation, known as a wergild (i.e. 'man price'), provided the payment was of the correct amount, though if the kin preferred they could decline the offer of wergild and continue the vendetta. The price was fixed by law and was originally calculated in terms of cattle. Anglo-Saxon writers speak of 'men of two hundred' or 'men of twelve hundred' meaning men whose wergild was set at two hundred shillings (or twelve, or six, depending). Vendetta was governed by a set of laws, and distribution of the wergild among the kin was also regulated.[10]

Kinsmen were by custom responsible for arranging marriages, and also continued to look after a woman's interests after she was married.

Kings

The ranking of society comprised a complex pyramid starting at the top with kings. As in early medieval Ireland, there were kings of differing status, with 'high kings' or bretwaldas (or brytenwealdas) at the top.[11] The term means, literally, 'wide ruler' or 'ruler of Britain'. It first appears relatively late in Anglo-Saxon history (in the tenth century) but it is fairly clear from various sources that ranking was apparent among kings by the late sixth or early seventh centuries.

The nature of kingship in early Anglo-Saxon society has interested recent scholars. The names of kings are known from the kinglists set down in later periods – and most claimed descent from one of the gods,

usually Woden, though the East Saxons claimed descent from Seaxnet.[12]

It was primarily as war-leaders, however, that the kings held power, and early accounts of Anglo-Saxon kings stress their prowess as such. By the beginning of the seventh century the bonds of royal lordship extended from the war-band to the members of the rest of his kingdom.

The king's word was indisputable, and did not need to be supported, as with other men, by oath.

If a king were killed by one of his people, wergild was more theoretical than practical. A late text suggests that by the end of the Saxon period a king's wergild was fifteen times that of a thane or lord.

Other social ranks

Beneath the kings were the nobles or thanes who held lands by title deed. One late source states that they owed no dues or services to the king except that of military service, the construction of defences, and the repair of bridges.

Churls (ceorls) were often referred to as the 'men of two hundred'. The churl was the ordinary freeman, who traditionally held enough land for an eight-ox plough to cultivate.

Beneath churls were peasants and cottage-dwellers or cotsetlans, and at the very bottom were slaves.[13] Some smiths and those women who fashioned embroideries could be slaves. On the Continent, a source known as the Burgundian Codex indicates that the wergild of a slave who was a skilled artificer in gold was above that of certain classes of freeman.[14] However, generally speaking, all ranks except slaves had wergild.

Fines extended to other areas of legislation. Thus in the area of sexual assault the law codes distinguished fines both on the rank of the assaulted and on the nature of the assault. If a man were to seduce the serving maid of an eorl he had to pay twenty shillings compensation, but if she were the serving maid of a ceorl, he was only liable to pay six shillings. The Laws of Alfred distinguished the different categories of assault: in the case of women of ceorl status, if a man should touch her breast, he was liable for five shillings fine, if he threw her down but did not rape her, ten shillings, and if he raped her he had to pay sixty shillings – the fines were paid to the woman, not her kin.[15]

Archaeological evidence for social structure

In recent years archaeologists have become very concerned with studying the evidence for rank in Anglo-Saxon cemeteries, though to make such social deductions from archaeological remains is fraught with difficulties.[16] Since cemeteries that can be used for this purpose are by

definition furnished and pagan, they can be used to cross-check the historical information outlined above which originates from a later period.

Archaeological evidence shows that between the fifth and seventh centuries there was an increasing gap between the rich and poor. By the seventh century, particularly in the inhumation cemeteries of the south-east, there is abundant evidence for what has been interpreted as a clearly stratified society.[17] Any statement about social grouping from cemetery evidence, however, has to be qualified by cautions. For example, the objects chosen for burial with the dead may have been selected for particular reasons connected with belief, not because they represented a true cross-section of the personal equipment of the person buried.

Nevertheless, it is clear that by the mid-sixth century a much wider range of grave-goods was being used than in the fifth. It is also apparent that women's graves were more richly furnished than those of men, though once more, what inferences are to be made from this can be debated.[18]

'Ranks' of graves at Buckland cemetery

A detailed study of the burials in the recently excavated cemetery at Buckland, Dover, suggested that there were four 'ranks' of graves for both men and women.[19] In the case of the male burials, the first rank had swords, the second a spear but no sword, the third other goods but no weapons, and the fourth were unfurnished. Their counterparts among the female graves were those with brooches, those richly furnished but without brooches, those moderately furnished and those unfurnished. Since most of the poorer female graves contained keys, the symbols of the mistress of the house, it was assumed that the women so buried were free, not slaves.

The highest ranking burials at Buckland were usually made under low mounds or barrows, or set within their own enclosures. Many of them contained imported Frankish goods, suggesting that members of the thane class were distinguished in death by their possession of weapons and imports.

Women

The rich furnishing of female graves is notable. A study of female skeletons from Anglo-Saxon cemeteries has suggested that they lived longer and attained a greater stature than their late Romano-British counterparts.[20] The wealth of some females buried in the later sixth and seventh centuries may point to the increased role of women as well as

men in building up wealth through marriage,[21] or, of course, through business exploits. For the early period there is little evidence for the latter, but in later Saxon times women owned extensive estates and could, for example, produce embroideries for sale. Thus in Domesday Book we are told that Leofgyth held the estate of Knook (Wilts), her husband having held it before the Conquest, and that she 'made and makes gold-threaded embroidery for the king and queen'.[22] In heroic literature women of social standing seem to share a similar status to that of the men, welcoming guests, pouring out drink at feasts and giving gifts.[23] An analysis of a Kentish cemetery has shown that burials of women with keys differ from those with jewellery, suggesting that a housekeeper was not necessarily the same as the lady of the house.[24]

On marriage a prospective husband had to pay *morgengifu* ('morning-gift') to his intended, which might comprise a considerable amount of money and land. This she could then dispose of as she chose.[25] According to Nennius, Aethelfrith of Bernicia gave Bamburgh in Northumberland to his wife in this way, as it was then named after her (her name was Bebbe). Within marriage the finances were the joint property of husband and wife, not the husband only, and according to the laws of Aethelbert of Kent, a wife had the right to walk out if her husband did not please her.[26]

'High status' graves

Prior to the seventh century it is very difficult to distinguish noble or 'princely' graves with any degree of certainty, but the seventh-century burials at Sutton Hoo in particular must belong to the upper echelons of society.[27]

Sutton Hoo

The richest Anglo-Saxon burial is without doubt that found in the royal ship barrow at Sutton Hoo 1 (Suffolk).[28] Although badly robbed the burials represented at Sutton Hoo 2 and Sutton Hoo 5 are also likely to have been aristocratic (as was the intact burial in mound 17), possibly even members of the East Anglian royal family.[29]

The range of trade and contacts with abroad enjoyed by the rich in the seventh century is clearly demonstrable from this burial which contained the finest extant masterpieces of pagan Anglo-Saxon art. Recent work has shown that the site was first employed as a cemetery in prehistoric times. It is notable for the variety of its burial customs, which include the interment of a body in a running position with an ard (a primitive type of plough, which survived only as a soil shadow) which may be of some ritual significance.[30] Some bodies appear to have been

sacrifices; one burial, apparently of a female in a barrow (Mound 5), was surrounded by satellite burials, arguably sacrificed slaves.

Two burials with ships at Sutton Hoo have been archaeologically investigated. Mound 2 was badly robbed, but found to contain a ship inverted over a wooden burial vault in which the dead man had been buried. Fragments missed by the tomb-robbers, however, showed that it had been richly furnished and was contemporaneous with the magnificent ship burial in Mound 1.

The main burial mound was excavated in 1939, with further excavations beginning in 1965 to solve some problems before publication of a full report. The burial deposit was laid in an oared open vessel, which would have been manned by forty men and guided by a steering paddle lashed to the starboard side of the ship. The vessel was over 27 m long, with a maximum beam of 4.5 m and had enjoyed a long active life, perhaps as a royal barge, before being used for the burial.[31]

The central burial chamber was about 5.5 m long, with a double-skinned roof and a solid timber framework to which the end walls were attached. The burial deposit was arranged with the domestic objects leaning against or hanging from the end walls and the personal objects along the central axis of the boat. There may have been a slightly raised

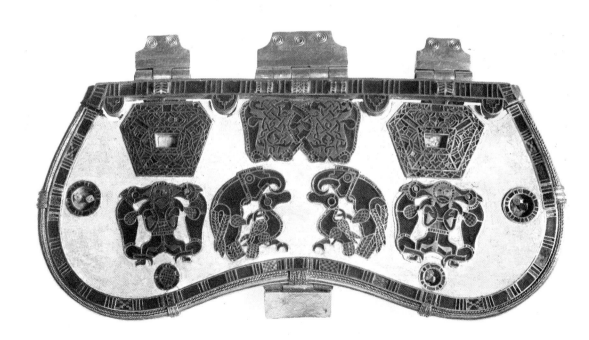

Purse lid, Sutton Hoo, Suffolk, seventh century. L. 19 cm (British Museum)

Shield, Sutton Hoo, Suffolk, restored. D. 91.5 cm (British Museum)

central dais, possibly covered with a mat, on which objects were laid.[32]

The grave-goods included a yew-wood tub, bucket, cauldron and suspension chain, iron lamp, pottery bottle and a large silver dish with the stamp of the Imperial workshops of the Byzantine emperor Anastasius (AD 491–518). Under this and adjacent to it lay a fluted silver bowl, filled with a little silver bowl, a series of burr-walnut cups, three bone combs, four iron knives, an otterskin cap, a wooden box and a mass of folded textiles, leather clothing, leather shoes, silver and bronze buckles, a wooden scoop, horn cup and two bronze hanging bowls lay below and alongside. Beneath all this on the floor of the chamber lay a mailcoat and an iron axe-hammer. To the west of these objects were the crushed parts of two drinking horns, six maplewood bottles and the piles of folded textiles.

The personal effects of the deceased included a pattern-welded sword in a scabbard, spear (five others leaned against the chamber wall), gold and garnet mounts and buckles from a sword belt, a huge gold buckle, the frame and gold and garnet settings of a purse, and the coins it had contained. At shoulder height were two gold and garnet clasps for a leather cuirass, and the remains of a richly decorated helmet. Next to it lay the remains of a limewood shield with its mounts.

Along the west wall lay a bronze bowl, probably from the East Mediterranean, a maplewood lyre in a beaverskin bag, a Celtic hanging bowl which had fallen from a nail from which it had been suspended on

the chamber wall, and three angons (barbed throwing spears) threaded through one of the drop handles of the large bowl. There were also five spearheads, further buckets, an iron standard and a ceremonial whetstone surmounted by a bronze stag.[33]

No body was recovered, but it is now considered extremely likely that any organic remains had been totally eaten away by chemical action.[34]

Who was buried at Sutton Hoo?

Most discussions of Sutton Hoo assume that this was a royal burial of one of the East Anglian kings, and tend to favour the view that it was the grave of Redwald, who died around 624.[35] However, depending on the date of the burial (which cannot be absolutely certain), it could be the grave of Sigeberht (who died in 630) or even some king unknown to history. If the current dating of the coins is correct, the burial contained none later that 613, but the collection was certainly deposited after 595.[36]

The affinities of the 'exotic' objects in the ship burial are significant. In particular there is a strong Swedish connection which recent opinion sees as over-emphasised. The sword was made in the Rhineland, the helmet is probably East Anglian, sharing a common late Roman model with those from Swedish burials. The shield could equally well be Swedish, Continental or English.[37]

The silver plate is now seen as probably a diplomatic gift, in keeping with late Roman tradition,[38] from the Byzantine world. This would explain the Christian connection of the two spoons in the collection which has long intrigued scholars. They bear the names SAULOS and PAULOS in Greek, an allusion to the conversion of St Paul, after his vision on the road to Damascus, when he changed his name from Saul. Since Redwald became Christian for a period (see p. 77), there is an argument for seeing this as his grave. Conversely, it has been argued that the inscription could have been irrelevant and the items valued merely as art treasures.[39]

It is likely that other Anglo-Saxon kings of the seventh century possessed similar plate; for example Bede reported that Oswald of Northumbria had a large silver dish.

Other high-status burials of the seventh century are worthy of detailed consideration. In a few cases, notably in the Peak District of Derbyshire, in Wiltshire and round Cambridge, the nobility were sometimes laid to rest on a bed, for example at Lapwing Hill in Derbyshire or at Swallowcliffe Down in Wiltshire.

The Swallowcliffe Down burial[40] was of a young woman, aged between 18 and 25, whose grave-goods included bronze-bound buckets,

glass vessels, and a maplewood casket with bronze fittings. Her bag was decorated with a fine openwork and die-stamped mount which showed features of both Anglo-Saxon and 'Celtic' ornamental styles.

Other richly furnished graves include examples in boats at Snape (one recently excavated example in a canoe),[41] not far from Sutton Hoo in Suffolk (the earliest datable to the later sixth century).

A fine barrow burial was excavated in 1882 at Taplow, Bucks, in which the deceased was laid to rest accompanied by three shields, several spears, a lyre, a drinking horn, buckles, an imported East Mediterranean bowl, and an assortment of other objects which have clearly come from Kent.[42] The absence of locally-made objects has led to the suggestion that this was the grave of a local ruler who had come from Kent, perhaps installed by the Kentish *bretwalda* as a local sub-king.[43]

The excavations at Snape, however, have questioned assumptions about boat burials and high status. The Snape cemetery had a mixture of inhumation and cremation burials of the later sixth and earlier seventh century. The 'canoe' burial (apparently a log boat) had a pair of cow horns at the feet of the burial, with some other, 'low-status', grave-goods. The horns might be seen as 'high status' objects if they were drinking horns, but there is little in this burial to suggest that the deceased was of high rank. One alternative explanation is that boat burial was associated with the cult of particular Germanic deities.[44]

Bag mount, Swallowcliffe Down, Wiltshire, seventh century. D. 8.6 cm (Salisbury and South Wilts Museum)

The growth of Kent

Throughout prehistory and the Roman period, Kent was receptive to ideas and influence from abroad, and was one of the first areas to be colonised by the Germanic peoples. By the late sixth century it grew to considerable prominence and prosperity.[45] Archaeology shows a period when Kentish culture was strongly influenced by the Jutes of Denmark (in the later fifth and into the sixth century) before succumbing to Frankish influence.

The culture of later sixth-century Kent was profoundly influenced by that of her Merovingian Frankish neighbours (who had grown out of an amicable amalgamation of Romano-Gallic population and incoming Frankish barbarians in the early fifth century). It is apparent that Merovingian fashion prevailed among Kentish women: the rich wore gold braids in their hair and silver and gold composite brooches in the same positions on their dresses as did Frankish women.[46] They also wore, suspended from their waists, rock crystal balls in silver settings.

Frankish types of brooches, most notably those with radiate headplates and bird-shaped brooches, were also fashionable among the women of Kent, whose menfolk were sometimes buried with a Frankish throwing axe or francisca and with Frankish wheel-made pottery.[47]

Trade with the Frankish world

The axis of Kentish commerce was firmly directed to the Frankish world, whence flowed imports from the Continent. Eventually it filtered out to the hinterland, perhaps largely though diplomatic gift, since the kings of Kent probably controlled the trade to the hinterland.[48] They may have been subordinate to Frankish kings, whose control may have been exercised in a broad swathe in southern England.

A remarkable find from a grave at Watchfield, Oxon, sheds light on Frankish control in the south. It contained a box with a runic inscription *haeriboki: pusa*, which has been read as 'the account book of the army'. The runes were of Continental not Anglo-Saxon form and the box contained a balance and set of weights (including one made from an Iron Age Gaulish coin, another from a coin struck in Antioch, and a third a weight of Byzantine design) for weighing Byzantine and Frankish tremisses. It has been suggested that the grave was of an official who had been responsible for making payments to the army, and who was probably a Frank.[49]

Mention has been made of garnets, Coptic and other bronze vessels and gold coins which arrived from the Continent. To that list may be added glassware from the Rhineland (though some glass vessels were also made in the vicinity of Faversham), amethyst beads (from Spain or

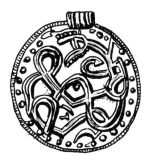

Class D Bracteate pendant, gold, Sarre 4, Kent (Lloyd Laing)

the east Mediterranean), cowrie shells (possibly from the Red Sea), rock crystal beads (probably from Switzerland and Germany), and a number of other items, including elephant ivory rings, which however seem to have reached East Anglia more frequently than Kent.[50] Amber beads too were imports into eastern and central England, though they also turn up in Kentish graves, and seem to have come from the Baltic.[51]

Alongside the coins were imported bracteates – pendants of sheet gold ultimately inspired by Roman coins.[52] In Kent the earliest come from Jutland, and have designs which include one based on Roman coin portraits. Like the coins, they were often worn in necklaces as a conspicuous form of wealth. Bracteates were also imported to East Anglia, but these seem more often to originate in Sweden.[53]

Kentish art

Despite Frankish influence, by the seventh century Kentish art had developed along its own distinctive lines and has yielded many fine treasures from the late sixth and early seventh century.

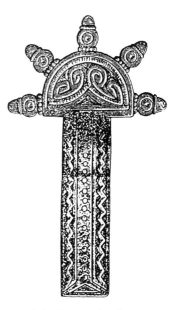

Frankish radiate brooch, Bifrons, Kent

Disc brooches

The most notable treasures are the disc brooches.[54] The idea behind disc brooches may have been native Romano-British brooches of the fourth century, which were frequently gilded and set with cabochon glass 'stones'.

Disc brooches first appeared around 550, when inlay was confined to three or four wedge-shaped garnets interspersed with panels of Style I chip-carving. In the centre was a round inlay. These are known as keystone garnet disc brooches, and were current until around 630. Plated disc brooches made their appearance around the beginning of the seventh century. The brooches were further elaborated with step-shaped settings of garnet and other materials, and inlays appeared in the border. Filigree was added to the decoration.

By the early seventh century the central inlay was surrounded by a gold plate with filigree and garnets, and step-shaped cloisons were popular.

Composite brooches

In the early seventh century composite disc brooches were produced, with a front and back plate and collar. There are about a dozen of these brooches, of which the finest are the Kingston Brooch, the Amherst (Sarre II) Brooch and the Dover Brooch.

The Kingston Brooch was found in grave 205 at Kingston Down, by

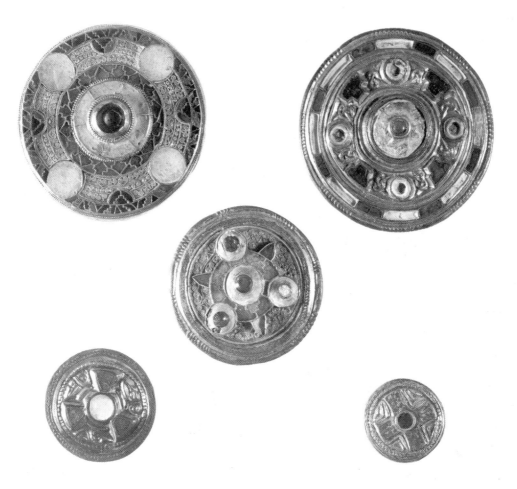

Kentish disc brooches, bottom row sixth century, the others seventh (British Museum)

the Rev. Bryan Faussett in 1771.[55] It has a slightly convex plate to prevent loss of perspective when the viewer studies its concentric design, which has a cruciform arrangement of central boss and roundels. Of gold and garnet, with blue glass and white inlays, it weighs 2.2 gm and is 8.4 cm in diameter. On the back the iron pin, the head of which had garnet inlays, is caught in a catch plate flanked by a filigree double-headed serpent. The grave was under a barrow, and was otherwise richly furnished with a pottery beaker, glass drinking cup, two gold-lined bronze bowls, a trivet stand, a gold pendant and a chatelaine, as well as two safety-pin style brooches of silver.

Buckles

There are some notable buckles from Kentish workshops. Two fine examples from Faversham have interlacing lacertines executed in filigree and granular work. Even finer is the set from the Taplow burial, similarly with filigree Style II work. Possibly a later example is a buckle from Crundale Down, which has a restrained border of filigree and a central rib in the form of a fish. The cloisonné work is confined to the pin plate, perhaps because by the time of its execution garnet was becoming scarce.

The fish and the cruciform arrangement of the design of some of the composite disc brooches may also be due to Christian influence in the later seventh century.

Crafts

Anglo-Saxon craftsmen belonged to the churl class, though status depended to some extent upon the craft practised.

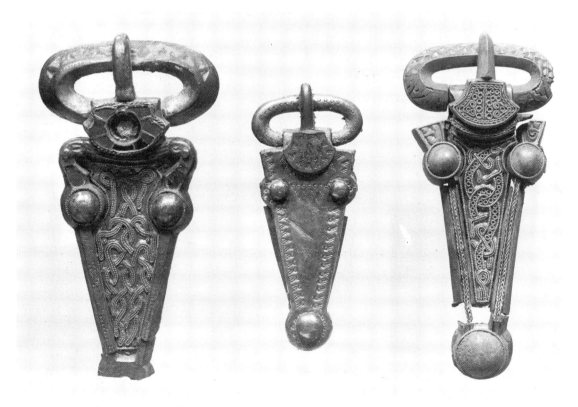

Seventh-century buckles, Faversham, Kent (British Museum)

Goldsmiths

The élite among craftsmen were the goldsmiths, and the highest among these were the goldsmiths of a 'mighty king', who received 'broad lands in recompense', as a later text asserted.[56] One reason for the high status of goldsmiths was undoubtedly the importance of gold in Anglo-Saxon society. Gold was prized not merely for its qualities and appearance, but for its financial value. In the Anglo-Saxon poem *Widsith* the minstrel who was rewarded with a gold arm-ring from his lord was as interested in its value as its appearance – it contained six hundred shillings' worth of gold.[57]

One reason why gold was so highly prized probably lay in the fact that in the immediate post-Roman period, no new sources were being mined, and most was recycled. The main source at first was probably Roman gold coins known as solidi.

Analysis of seventh-century Anglo-Saxon goldwork shows that its composition reflects that of Merovingian Frankish coins issued outside Provence.[58] So closely do the compositions of coins and jewels match, that it can be suggested that the beautiful Amherst Brooch was made from coins struck between 596 and 613, while the cruder Monkton Brooch may not have been made until the 640s.[59]

Later still, gold was replaced by silver for much precious metalwork and the transition from gold to silver is reflected in the decline from relatively good gold coins (shillings) in mid-seventh-century England, through base gold in the later seventh, to the silver sceatta (penny) of the early eighth.

Reused material, however, cannot account for all the Anglo-Saxon precious metalwork and it is probable that some new metal was mined, though in what circumstances and where is not known.

Metalsmiths

Smiths other than goldsmiths were admired.[60] The earliest Anglo-Saxon law code, that of Aethelbert of Kent, compiled probably as early as 602–3, stipulates that smiths in the king's service were protected by a special wergild. The laws of King Ine of Wessex, compiled towards the end of the seventh century, indicate that a nobleman was deemed to have a special need for a smith, whom he was allowed to take with him (along with his children's nurse and his reeve) when he left his estate.[61]

Of particular status was the weapon-smith. Wayland Smith was prominent in legend – in Anglo-Saxon tradition he kept his smithy near the Uffington White Horse in Berkshire (in fact a Neolithic chambered tomb) and he figures in the Anglo-Saxon poem *The Complaint of Deor*, composed perhaps around the same time as *Beowulf*. Later Scandinavian

tradition had him married to a Valkyrie, and forced to work for a king who cut the sinews of his knee to prevent him escaping. In *Beowulf* (see p. 152), the helmet of the hero Beowulf was just as 'the weapon smith had wonderfully made it' while his 'spiral hilted, serpentine bladed' sword was made by 'marvellous smiths'.

Weapon-smiths are mentioned in laws, and King Aethelstan made a bequest to Aelfnoth, his sword-polisher, of an inlaid sword.[62]

Textiles

Scraps of textiles have survived from the pagan period to attest that the early Anglo-Saxons produced decorative textiles. Tablet weaving (which involved passing warp threads through pierced plates or tablets) was employed in the production of braids – examples have been found at Fonaby (Lincs), Mucking (Essex), Berg Apton (Norfolk) and Portway (Hants). At Fonaby the narrowest braid (about 2 cm wide) had blue, green and red threads. At Mucking a braid had blue and possibly yellow, bordered by red, and a strap end with a braid-belt fragment found at Cambridge had white, pale blue-green and indigo threads.[63]

Among the fabric fragments found in rich burials are some patterned twills, exemplified at Sutton Hoo and Broomfield, Essex.[64] Some debates surround whether they were imported from Frisia or made in England.[65] English cloth tended to be of wool, but silk was being imported by the seventh century, a fragment being found in a child's 'relic casket' at Updown, Kent.[66]

Status symbols from the sixth century on

The presence of art in graves is significant. Some archaeologists have suggested that even the position in which objects are placed in the grave has a statement to make. Thus, it has been argued, it might have mattered whether a sword was laid to the right- or the left-hand side of the body.[67]

The giving of gifts by a lord to his followers is well attested in later literature.[68] Some objects which appear for the first time in Anglo-Saxon graves of the late sixth century may be interpreted in terms of status symbols acquired, probably, through gift exchange.

Swords

The sword was a very special object in Anglo-Saxon society, and is a relatively rare find in graves – there is less than one sword to every twenty male burials. At Bidford-on-Avon, Warwicks, a rich cemetery in which at least twenty-six males were buried with weapons, not a single

sword was found.[69] Swords were frequently given to young men as a mark of their attaining manhood – this could have been a family treasure, or could have been won by some heroic deed. However it was acquired, the sword held the 'luck' of its previous wielders, and was a symbol of continuity.[70] The king had a special sword, worn on ceremonial occasions, for the swearing of solemn oaths, and for duels. When he approached death, he usually handed it on to his son or a near kinsman. In the words of Hilda Ellis Davidson 'Thus the sword was closely associated with much of what was most significant in a man's life – family ties, loyalty to his lord, the duties of a king, the excitement of battle, the attainment of manhood, and the last funeral rites. It was something from which its owner was never parted throughout his life, from the moment he received it and had the right to wear it.'[71]

Although swords sometimes were broken to be laid in the grave (for example at Sarre, Kent), they were often buried with great care, usually in their scabbards, laid beside or on the body, less frequently worn.[72]

A feature of many swords is a pattern-welded blade, produced by twisting bars of iron together then hammering them flat, a technique employed from at least the second to the ninth century in Europe. The cutting edges were welded separately on to the core. The result was highly accomplished – 'I do not know of finer smiths' work anywhere, at any time' was the comment made by Herbert Maryon, who attempted to recreate a pattern-welded sword.[73]

Some swords from Kentish cemeteries display hilts with loose rings attached. These 'ring swords' have been found, for example, at Faversham, Bifrons and Gilton, and date from the later sixth century.[74] Later fixed rings or knobs were employed in the same way, or a bead attached to the hilt, the latter probably as charms. Ring-hilts may have originated in Kent, and then been spread to other areas in Europe. It has been suggested that the ring symbolised the gift of the sword from one warrior to another, and Davidson has gone further to suggest that ring-hilted swords were owned by kings or leaders who gave out swords to followers.[75]

Runes were occasionally employed on hilts, for example on one from Gilton, Kent, where it has been read as 'Sigimer named the sword'.[76]

Metal bowls

These objects were notable status symbols, originally made in Romano-British workshops from the end of the Roman period onwards.[77] They were also copied by the Anglo-Saxons in the seventh century. Of spun bronze, they were suspended from chains from three, sometimes four escutcheons for the rings, and often also had a basal mount or 'print'

both inside and outside the kicked-up base. Although plain escutcheons are found, the finest bowls have escutcheons and prints decorated with designs in enamel and sometimes even with millefiori glass insets. On the whole the bowls are small, but were sometimes repaired (as in the case of the largest bowl from Sutton Hoo).

So highly were they prized, that the escutcheons were kept and on occasion buried in graves even after the bowl had perished. Whatever their original function (and many suggestions have been put forward), it is fairly clear that it was not necessarily the same as their function in graves. They appear to have had a similar purpose as the imported East Mediterranean vessels, known as 'Coptic vessels' (some came from Christian Egypt), which were traded over the Alpine passes and by way of the Rhine valley to south-east England (examples were found in both Sutton Hoo 1 and at Taplow).[78]

Also occurring in Anglo-Saxon graves of the early seventh century in the south-east were beaten bronze vessels which originated in the Meuse and Rhine areas.[79] Such objects were used in gift exchange and in status building at a high level in society, and it is not impossible that the hanging bowls were native 'substitute' status symbols in areas outside Kent where the European imports were difficult to obtain.[80]

The role of exchange mechanisms in the accumulation of wealth and power in early England must not be underestimated, nor the importance of certain types of object in this connection. Artists were producing items that were not merely pleasing and more costly versions of more mundane objects, but symbols that had a variety of functions in society. This fact alone must have elevated the artist in society, and also invested the art employed in decoration with added significance.

Gift exchange

Anglo-Saxon literature abounds in accounts of gifts distributed to dependants – the greater the generosity of the giver, the more he was admired and elevated in society. In a modern society it is difficult to appreciate the subtle nuances of exchange mechanisms, and the network of relationships that can lie behind what might at first appear as simple 'trade'.

Anthropological studies have shown some of the exchange mechanisms that operate in modern non-literate societies.[81] Gift exchange can accompany trade, to establish good relations between trading partners, and the process of giving enhances the status of the giver and creates obligations. Exchange mechanisms can lead to the accumulation of 'repositories' of status items in the possession of individuals or groups. Unless buried with the dead, these possessions

are usually only temporarily removed from circulation. Such depositions of grave-goods are in effect 'gifts to the gods' – while they are not repaid by the gods in kind, they are repaid insofar as the donor is increased in status in society, and the gods will regard his people more favourably. By honouring the dead through placing valuable items with their bodies, the status of the kin is increased in the eyes of their contemporaries.[82] To this end, objects were sometimes created expressly for the grave.

Smiths in pagan Saxon England

Little is known about the artists themselves in Anglo-Saxon England, though it has been suggested that some smiths were itinerant, which would account for the rapid dissemination of ideas and goods in Dark Age Europe. Metalworking may have been a seasonal activity; smiths in Helgö, Sweden, for example, also farmed as the seasons demanded.[83] There is some reason to believe that much of the finest metalwork in the Sutton Hoo ship burial was the work of a single smith or workshop, and it has been suggested that a single workshop produced the fine gold-and-garnet work found in the neighbourhood of Faversham, Kent.

In theory it should be possible to distinguish distinctive workshop products and plot their distribution (or the travels of the smith), but due to the unique character of the pieces this is rarely possible. A square-headed brooch from Luton, Bedfordshire, was cast in the same mould as another (badly fused) from a cremation urn at Abingdon, Berks, while a square-headed brooch from Bidford-on-Avon, Warwicks, is virtually the same as brooches from Baginton and Offchurch, Warwicks, and Cherbury Camp, Pusey, Berks.[84] A pair of saucer brooches from Abingdon may have come from the same mould as one from Bishopstone, Bucks.[85] Examples of one type of square-headed brooch were concentrated in East Anglia, with outliers in Kent, Lincolnshire and Nottinghamshire. Two types of saucer brooch were current in the Thames Valley area, with different distributions concentrated in the Lower and Upper Thames. Work by David Leigh on a group of some thirty sixth-century brooches mostly from Kent led to the conclusion that they were the product of the same workshop, and some progress was made towards recognising the hands of individual craftsmen. An extensive study of sixth-century square-headed brooches by John Hines defined three phases: (1) individualistic brooches made *c.* 500–20 which were widely dispersed; (2) large numbers of similar brooches in smaller groups trying to imitate a prototype, made in the period 510–50; (3) large numbers of brooches in smaller groups made between 530 and 570 representing the mass-production of copies of a single type.[86]

Workshops and techniques

In Ireland and Celtic Britain there is abundant archaeological evidence for workshops that produced ornamental metalwork – almost every site of any size has produced some moulds for casting bronzes or fragments of crucibles.[87] In Anglo-Saxon England the situation is reversed, and evidence for ornamental metalwork workshops is extremely sparse at all periods. It is possible, however, to build up a picture of how artists worked from evidence derived from the Continent, and by studying the artefacts themselves.

Lead model for brooch, East Anglia (after Mortimer)

As in Celtic Britain, some bronze objects were cast in two-piece or more rarely multiple-piece clay moulds using the *cire perdue* or lost-wax process, by which a wax model was coated in clay and the wax then run out. Some debate has surrounded how the moulds were made. While wax models may explain some, it has been suggested that others were made by stamping with a die, either of the complete object or of part of the design. Lead castings may have been either trial castings or dies for making moulds. They are best known from the Celtic areas, but one of a saucer brooch was reputedly found at Cassington, Oxfordshire, and a pewter cruciform brooch has been recorded from a cemetery near Reading, Berks.[88] Lead castings of a fragmentary cruciform brooch, and another brooch fragment probably from East Anglia, along with a lead casting of a footplate of a cruciform brooch for Norfolk, have recently been published. It has been suggested that these were cast from moulds made from previous models.[89]

It has been suggested that master models were made at Helgö of wood or bone (bone master models for pins are known from sixth-century Scotland), and/or that wax models may have been made from a master. It is certainly the case that surviving castings, even where they appear the same, show minor variations, sometimes the result of using similar but not identical models or sometimes from working over the casting to 'clean it up'. Despite the fact that such moulds normally appear to have been used only once, the only fragmentary moulds that have survived in England are for a sixth-century square-headed brooch from Mucking, Essex, found in a sunken-floor building,[90] and some as yet unpublished moulds from Yeavering, Northumberland.[91] Moulds similar to that from Mucking have been found at Helgö, in Sweden, where the evidence points to a permanently based community of smiths mass-producing a range of objects for trade.[92]

Smiths' graves

There is occasional evidence relating to smiths from their graves.[93] A very remarkable smith's hoard of tools, apparently from a grave, was

Mould for part of a square-headed brooch, Mucking, Essex (Mucking Post-Excavation. Photo: Tom Jones)

discovered at Tattershall Thorpe, Lincolnshire.[94] This was dated by pieces of seventh-century glass from a Kentish bag beaker, though there were also fragments of Roman glass in the grave. The interment, which was seemingly isolated on a site occupied in the Neolithic and Roman periods, contained snips (shears), punches, tweezers, hammerheads and tongs, a file in an alder handle, an anvil, an iron bell, lead models, probably for making moulds, small tools for fine work (including what may have been a needle file), and scrap metal, apparently contained in a scrap box, with limewood base and copper alloy linings. The anvil had a heavy spike for driving into a wooden block, and is the first to be found in England. Both it and the other tools are reminiscent of depictions on the eighth-century Northumbrian whalebone box known as the Franks Casket (see pp. 124–5.)

Alongside these objects was an openwork bronze disc of a type found in the Upper Rhine area and a bronze scale pan, without however the second pan or the balance arm. There were some Roman coins that may have been used as weights, with tiny quantities of gold and silver. Additionally, there were traces of silk, possibly on a button.

A quirk of the burial was the total lack of personal objects. The burial could have been that of a woman since weights and balances are usually associated with female burials[95] – but the scale pan might have been simply scrap.[96] If the tools were the equipment of the smith, it suggests that smiths might have worked both in iron and more precious metals.

One suggestion is that this was the grave of a Frank who had travelled from his native land.[97]

There are a few (English) Anglo-Saxon graves which have been found to contain pairs of scales and sets of weights,[98] often made from Roman coins. In one of them, investigated by James Douglas at Ash in 1771, was a gold-and-garnet disc brooch, a Coptic bowl, glass cup, bronze dish, a bronze-bound wooden bucket and a Frankish throwing axe. Clearly the owner was of high status, possibly a merchant or goldsmith. Another possibility is that here was an assessor who weighed out payments for wergild, or oversaw transactions in which the weighing of metal played a part. A man from Gilton, Kent, had a piece of touchstone in his richly furnished grave as well as scales – the presence of a weapon suggested high status.

Techniques
Niello

Some of the techniques used by pagan Anglo-Saxon smiths derived from Roman Britain. One of these was niello work, which involved insetting a black silver-sulphide paste, probably in powder form, into grooves in the base metal.[99] It was used quite widely on brooches (including the disc variety) and became very popular in Christian Saxon times as a contrasting inlay in silver.

Gilding

Another technique, Roman in origin, though also found on the Continent, was gilding.[100] Gold in a powdered form was mixed with mercury to make an amalgam, which was painted on to the brooch which was then heated to drive off the mercury (a deadly process, since mercury fumes are highly toxic). That this was the method commonly employed is shown by a brooch which has been carelessly gilded, with drips spreading on to the back.[101] A second method might have involved painting a mercury amalgam on to the brooch, on which was laid gold leaf, the mercury again being driven off.[102]

Dies

A study of sixth-century square-headed brooches suggested that an interchangeable set of dies were used to build up designs, but although the design elements were essentially the same on different brooches, there were subtle variations indicating that the same dies were not used each time.[103]

Icklingham, Suffolk, bronze dies. L. 6.8 and 6.5 cm (Moyse's Hall Museum, Bury St Edmunds)

Similarly, a study of fifty-two pairs of saucer brooches showed that each brooch was made from a different model, despite the identical designs of the pairs.[104] It has been suggested that, as later pairs of brooches show a greater variety of design elements and experimentation in their arrangement, by the time these brooches were being produced the craftsmen were grouped together in larger workshops.[105]

Cloisonné

From the later sixth century onwards sophisticated techniques of ornamental metalworking spread from the Continent. The first was cloisonné jewellery making, which involved setting inlays into cells soldered on to a base plate. In Gaul this type of work is first documented in the tomb of Childeric, King of the Franks (d. 482), though it had probably originally been developed in the area to the north of the Black Sea. The inlays in this type of work included glass (frequently blue, in imitation of lapis lazuli, sometimes derived from

reused Roman glass), a white substance (sometimes called shell or meerschaum, but actually a composition compounded of a variety of minerals including cristobalite, magnesite, kaolinite, calcite, aragonite, strontianite, or cassiterite – the aragonite was derived from crushed cuttle-fish bone),[106] rock crystal, amber and, most commonly, garnet. The white substance in the Kingston Brooch and in St Cuthbert's Cross was identified as shell, but it was pointed out that it was 'most unlikely that pieces as large as those in the Kingston Brooch can be derived from any species normally found in temperate or Mediterranean waters'.[107] Cabochon settings are often found on the Continent, where polished but uncut stones are set in individual cells. In England this mostly appears on imports, such as the Frankish pendant from St Martin's, Canterbury, or in necklace pendants or sometimes as special settings on disc brooches.

Garnet inlays

Although garnet is found in Britain, it is likely that much of the garnet used in jewellery was imported from the East, by way of Byzantium and Frankish Gaul. It is believed that much of the garnet was imported ready cut and polished, but that the supply dried up around the same time that the gold coins were becoming scarce, which led to the reuse of stones in mid-seventh-century jewellery.

For purposes of cloisonné work, the garnets had to be split, cut and polished. The cutting may have been done on an abrasive wheel (which produces the sloping or facetted edge that most garnets display in Anglo-Saxon jewellery), though it is likely that some were cut by grooving with a hard point (another garnet might suffice) then snapping.[108] Sometimes the cells may have been shaped to fit the garnets rather than vice versa, but there can be no doubt that the garnets used in the Sutton Hoo shoulder clasps were specially cut for the complex shapes into which they were set.[109] It has been estimated that cutting one garnet would have taken between one and three days. In Sutton Hoo alone there were some 4,000 garnets, the cutting and polishing of which would have involved up to 12,000 days – nearly eleven years at the lowest estimate and thirty-three years at the highest – of full-time work for one person. Another estimate reckoned that the 450 garnets in the Milton disc brooch would take between four and five months to cut, assuming a five hour day (dictated by the light). Alongside this can be set the estimate by an Amsterdam jeweller that the Kingston Brooch would take between eleven months and a year to make.[110]

Paillons

The garnets used in cloisonné work were made to reflect the light by being set on top of a patterned gold foil known as a paillon. These foils appear to have been stamped with a hatched pattern, using a die made of fine-grained wood or bone.[111] Detailed technical study of the foils suggests that there was a progression from foils with larger boxed patterns to those with finer, and that the grids of the boxes may have been set out using a fixed unit of measurement. Different foils were chosen for different parts of the same piece, to bring out features in the overall design, and to maximise the effect. One type of boxed foil was particularly favoured around Faversham, Kent.[112] One brooch from Dover used a pattern of circles within squares. Large sheets were stamped, then cut up for the purpose.

The cells were filled with a white material until they were about two thirds full, before the paillon was laid in place. Where this white material has been examined on the Continent, it seems to have been a mixture of wax and calcite or wax and quartz, and served as a kind of cement.[113]

It is not known how the stones were secured in their settings. In England, in contrast to the Continent, the tops of the cells were not hammered over to grip the settings. It is possible that some kind of glue was used round the edges of the stones.[114] It is also possible that the bevelling of the stones held them in place.

Different craftsmen were probably responsible for different parts of the work, and thus the quality may be uneven. Some brooches show signs of carelessness. The Monkton Brooch, from Kent, found in 1971, was patched together from at least one other brooch, and had a design for another composite disc brooch engraved on its silver backplate. The gold is poor, and the garnets and glass are set in bronze cloisons rather than gold.[115]

Filigree and granular work

Cloisonné work was often used in combination with filigree and granular work, both of which are found widespread in Antiquity, including in the Roman and Byzantine worlds. Filigree involves the production of cables of twisted gold wire, which is soldered on to a base plate. Granular work employs tiny beads of gold, again soldered to the base plate. Different techniques were employed in the production of filigree, most of which are also found on the Continent.[116] The wire was commmonly produced by block twisting, which involved taking a rod of square or rectangular section which was twisted and subsequently rolled between two flat surfaces. Beaded wire was made by stamping the wire

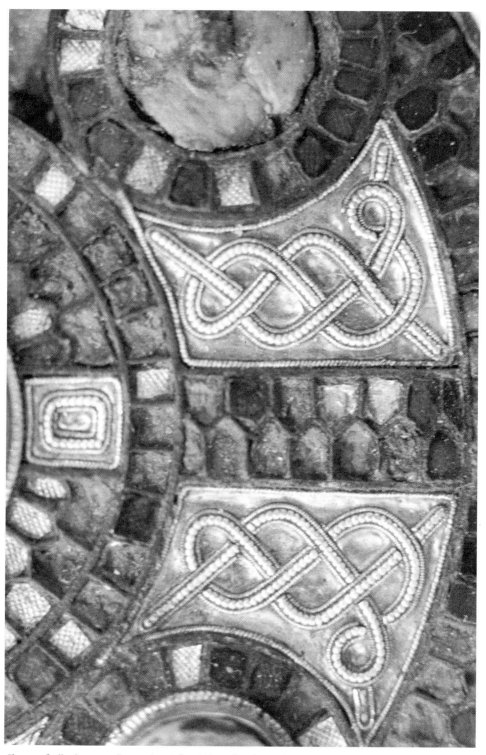

Close-up of cells, showing paillons, on brooch from Milton, Abingdon, Berks, in Ashmolean Museum, Oxford (Niamh Whitfield)

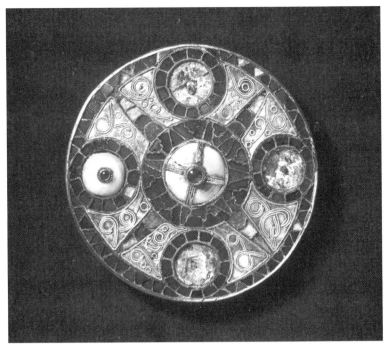

Monkton, Kent, composite brooch, seventh century (British Museum)

(a)

(b)

Filigree and hollow platform work, Faversham, Kent: (a) pendant, showing block twisting; (b) bird buckle (arrow points to hollow platform) (Niamh Whitfield)

with a grooved tool, sometimes with a multiple cutting edge, sometimes with a double-edged tool with a single groove. Plaited wires are also found. Granules of gold were sometimes used to infill areas, to highlight the tips of curvilinear patterns, and to form the centres of collared granules, where the bead of gold is enclosed in a filigree collar.

Wires were notched to fit them into the space available, and filigree designs were sometimes set in a tray which was in turn inset into the piece of metalwork. In the most sophisticated work two back plates were put together, the upper one worked in relief with depressions cut out to take the filigree. This 'hollow platform' work is well exemplified on buckles from Faversham, Kent.[117] Filigree and granular work was used to create a variety of designs, including interlace and animal patterns.

Solder

This was used to fasten the filigree. It was made of a gold-copper alloy, which may have been mixed on the surface of the object itself, a technique rediscovered and patented this century. This involved using an animal or vegetable adhesive mixed with a copper compound, which was used to stick each gold granule or wire in place then was heated with a blow-pipe. This required a melting point of 878 degrees C, 185 degrees below that of pure gold.[118]

Pressblech (die-stamped foils)

From the later seventh century come a few dies used in the production of *pressblech* work, in which a thin foil of metal was laid over a die and hammered into the design. These include two dies with ribbon animal ornament not dissimilar to that found at Sutton Hoo, discovered in Suffolk, perhaps at Icklingham,[119] and a recent find (of bronze) from Rochester, Kent.[120] A die has also been found in a grave at Barton-on-Humber, Lincs, where it was reused as a weight.[121] It has been suggested that the foil was worked into the die with a stylus. In a few cases it is possible to point to different foils from the same die, for example from the two ship burials at Sutton Hoo.

Enamel

There is some doubt whether the Anglo-Saxons produced much of their own enamel work before the late Saxon period, though a mount for a hanging bowl from Barton, Cambs, has been suggested as the product of a Midlands workshop producing enamelwork under Romano-British influence in the sixth–seventh century.[122] Analysis of the yellow enamel suggested that it may have been made by melting down glass beads. There are about twenty Anglo-Saxon objects with small amounts of red enamel, concentrated in central East Anglia, with one outlier in Kent and another in Sussex. The composition of the enamel is similar to that on hanging bowl escutcheons, and perhaps points to a survival of

Romano-British workshop traditions in this part of England.[123] Another technique used on less sumptuous metalwork was stamping with a simple punch to build up repetitious patterns. This could be done with simple rings, ring-and-dot, or with patterns composed of triangular shapes. It is commonly seen as a border on simple cruciform brooches.[124]

Master smithery

The most ornate pieces of metalwork show a mastery of a whole range of these techniques. To make a Kentish disc brooch it was necessary first to cast the silver 'core' of the brooch using a two-piece mould, which would incorporate the cells for the cloisons and some of the additional relief ornament, which included the basic 'chip-carved' animal and other details, though this could be tidied up later with a graver. It was polished, and a rim pattern inlaid in niello, applied as a powder. The rim would next have been soldered on, the unit gilded, the paillons made and inset in the cells, the inlays cut polished and set, an iron pin hinged on at the back, and the whole piece finally polished. The range of skills needed in producing a composite disc brooch was even more extensive since it also required a back plate, a collar and interior mastic infilling.

Detailed technical study of the Sutton Hoo goldwork has shown that broadly speaking the same range of skills seen in disc brooches was also employed in the Sutton Hoo workshop. It has been suggested, not unreasonably, that 'It is no exaggeration to refer to the Sutton Hoo master goldsmith, assisted by a gem-cutter or lapidary of altogether exceptional gifts, as the most brilliant of his age.'[125] The purse, the shoulder clasps and the pyramids were almost certainly made by the same person in the East Anglian royal workshops. They employ millefiori, a type of glass made by fusing rods of different colours together then slicing them. This may have been produced for them by a British craftsman working in the workshop, or less probably by a Saxon copying the technique. They also employ the device of the lidded cell and the use of a limited amount of openwork. In the case of the Sutton Hoo goldwork, however, no pastes were used to build up the cells under the inlays – stones were set on foils cut out to the same shape but slightly larger, then wedged in the cells and held by pressure alone. The garnets were cut and polished on the spot. It was estimated that each stone for the the complex shaped settings on the boars' heads and bodies on the shoulder clasps would have taken the best part of a day, and due to the brittleness of the stone would have resulted in considerable wastage. To avoid the wastage more time would have been needed, perhaps two days.[126] The facetted stones used on the pyramids were

regarded as 'astounding' by gemcutters from the Goldsmiths' and Silversmiths' Company.[127] The filigree of Sutton Hoo is also of exceptional quality and range.

The goldwork from Sutton Hoo compares closely in composition with the gold of the coins in the purse, suggesting that Merovingian coins were the most probable source of the material.

Metalworking tools

These are as rare as the moulds and waste materials. There are metalworkers' tongs from Sibbertswold, Kent, a crucible and an iron stake (for planishing) from Sarre, and handled spatulas of iron, possibly for mixing cement or niello, from Barfreston and Kingston in Kent. A few miniature bronze axe-hammers, for example from Aylesbury, may have been jewellers' tools.[128]

Pagan art of the seventh century – Style II

With such a range of techniques available, and the variety of art styles in vogue in the preceding centuries, the artists of the seventh century displayed a wide and varied repertoire. It was extended principally by the additional use of Salin's Style II. The origins of this have been even more hotly debated than those of Style I (see p. 26), but it appears to have evolved after the middle of the sixth century. The dominant feature of Style II is a snake-like animal with interlacing body, often termed a

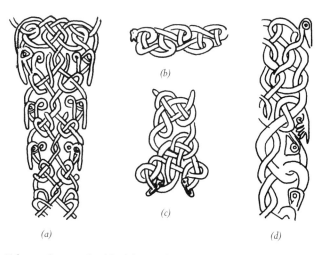

(b)

(c)

(a)

(d)

Style II designs, Continental and English: (a) Valsgärde, Sweden; (b) Farthingdown, Surrey; (c) Sutton Hoo, Suffolk; (d) Vendel, Sweden.

lacertine. Interlace without animal features does occur at the start of this tradition, but essentially Style II is zoomorphic.

Simple, geometric interlace was widespread in the Roman world, and occurs in Roman Britain. In Germanic Europe it appears to have evolved out of the earlier Style I, but some experts incline to the view that there was also input from the Classical Mediterranean, transmitted to the Franks and others by the Lombards in the mid-sixth century. Others discount the importance of the Lombard contribution, and argue that creatures with bodies of multi-strand interlace were already evolving in different parts of Northern Europe in Style I.

Style II has been identified in the find of what is believed to be the grave of the Merovingian Queen Arnegunde at St Denis. If it is her grave (and there is some doubt) it can be dated to around 565–70.[129] Simple interlace is also found among the Franks somewhat earlier, in the second quarter of the sixth century.

In England there is interlace without animal features on a sword pommel from Coombe, Kent, datable to soon after the mid-sixth-century.[130] Non-zoomorphic interlace is also found on a belt mount from Bifrons, Kent, and on a few other pieces of around mid-sixth century date, including a number of square-headed brooches, among them a fine brooch from Nettleton Thorpe, Lincs. In addition, a group of pieces of East Anglian provenance with non-zoomorphic interlace belongs to the later sixth century and has links with Sutton Hoo. It seems likely, therefore, that interlace, both zoomorphic and non-zoomorphic, was being developed in England from the middle of the sixth century, probably under stimulus from the Continent. In East Anglia this stimulus may have come from both Sweden and other Scandinavian sources, in Kent from Frankish and Scandinavian sources.

Not surprisingly, both Style I and Style II coexisted for a time before Style II became dominant. In the Taplow grave, Style I is apparent on a drinking horn mount where, on the fittings for the mouth, a helmeted head with hand in 'thumbs up' form is an obvious element in the decoration. Sir Thomas Kendrick derived this from late Roman gold coinage portraiture and its derivative in Scandinavian art; the terminal of the same Taplow drinking horn has a hooked-beak bird head and Style II lacertines, in a manifestation which Kendrick termed the 'Fusion Style'.[131] Style II in its purest form also appears on a buckle set from the Taplow grave.

The Crundale Style

The Crundale Style[132] is distinguished by a more compact creature with long biting jaws that grip itself or a similar dragon. It is clearly a derivative of Style II, and appears in the Sutton Hoo ship burial, in an

Crundale Down, sword pommel, seventh century (British Museum)

engraved form on the back of a composite disc brooch from Faversham, and on a sword pommel from Crundale Down. It is a type of creature which passed into Christian art to cavort on the pages of the Book of Durrow in the mid- to late seventh century. Its origins lie in East Scandinavian Style II art; apparent in Sutton Hoo by the early years of the seventh century it was assimilated into the repertoire of English art in the seventh century and it takes the story of Saxon iconography out of the pagan period and into the Christian era.

Taplow drinking horn (British Museum)

Notes

1. Exemplified by the poem *The Ruin*, about Bath, tr. Kershaw, 1922 and discussed in Cunliffe, 1984, 213–4. For Anglo-Saxon reverence for the Roman past generally, Higgitt, 1973.
2. Bassett, 1989, 24–5.
3. For convenient account, Smyth, 1984.
4. Higham, 1993, passim.
5. Dark, 1994.
6. Webster, 1993 discusses the regalia in the context of contemporary princely burials.
7. Bassett, 1989, 4.
8. Whitelock, 1952, chap. 2; Seebohm, 1911.
9. Thus in *Beowulf*, when the hero's followers are not deemed worthy of him, one Wiglaf says:

 > He who wishes to speak the truth can say that the lord who gave you those treasures, that war gear you stand up in – when he often gave to men on the ale-benches in the hall, as a prince to his thanes, the most splendid helmet and corselet that he could find, far and near – entirely threw away this war-gear, when battle befell him.

 These bonds of loyalty persisted throughout the Anglo-Saxon period – in the late Anglo-Saxon poem commemorating the Battle of Maldon (ad 991) it is chronicled that the hero was quickly:

cut down in the fight; yet he had carried out what he had promised his lord, when he vowed to his treeasure-giver that both together they should ride safely home into the stronghold, or fall in the army, die of wounds on the field of battle. He lay as befits a thane, close by his lord.

10. Vengeance, for example, could not be sought if a man had killed another while defending his lord or his kinsman from attack, or if a man had killed another in anger at the time of finding him raping his wife, mother, daughter or sister. Nor could a blood feud be waged if the dead man had been executed for a crime. In all cases of blood feud, guilt had to be established. The kin were responsible for bringing a guilty man to trial.

11. On kingship, Yorke, 1990 and Loyn, 1974; Loyn, 1992.

12. Yorke, 1990, 15.

13. Pelteret, 1981; Pelteret, 1995.

14. Jessup, 1950, 38.

15. Fell, 1984, 62–3.

16. Arnold, 1988, chap. 5 and Welch, 1992, chap. 6.

17. Welch, 1992, chap. 7.

18. Hodges, 1989, 40.

19. Evison, 1987.

20. Hodges, 1989, 40.

21. Fell, 1984; Klinck, 1982.

22. Fell, 1984, 42.

23. Fell, 1984, 35.

24. Fell, 1984, 60.

25. Fell, 1984, 57.

26. Ibid.

27. Welch, 1992, 92–3.

28. Bruce-Mitford, 1975–83; summary account in Evans, 1994; older account in Green, 1968; review of recent thinking in de Vegvar and Farrell, 1992.

29. Carver, 1992 useful summary. See also Carver, 1986 and Carver, 1988.

30. Carver, 1986; Carver, 1992.

31. Evans, 1994, 27.

32. Evans, 1994, 33.

33. Evans, 1994, 33–6. Of the many recent studies of the finds from Sutton Hoo, mention may be made of Neuman de Vegvar, 1992; Whitehouse, 1992; Wilson, 1992.

34. Evans, 1994, 39–40.

35. Wilson, 1992, 5–12.

36. Stahl and Oddy, 1992.

37. Wilson 1992.

38. Whitehouse, 1992.

39. Evans, 1994, 61.

40. Speake, 1989.

41. Filmer-Sankey, 1990; 1992.

42. Bruce-Mitford, 1974.

43. Webster, 1992.

44. Filmer-Sankey, 1990.

45. Hawkes, 1982, for summary.

46. Crowfoot and Hawkes, 1967.

47. Evison, 1979.

48. Huggett, 1988.

49. Scull, 1986.
50. Huggett, 1988.
51. Ibid.
52. Hawkes and Pollard, 1981; this view disputed in Hines, 1984.
53. Gaimser 1992.
54. Leeds, 1936; Avent, 1975. Avent's scheme was slightly modified by Leigh, 1984b.
55. Hawkes, 1990; Rhodes, 1990 for site. Brooch, Avent, 1975, 53–4.
56. Whitelock, 1952, 105.
57. Dodwell, 1982, 24.
58. Hawkes, Merrick and Metcalf, 1966; Arnold, 1988, 56.
59. Hawkes, 1984, 142.
60. Dodwell, 1982, 47.
61. Attenborough, 1922, 34.
62. Attenborough, 1922, 60.
63. Owen-Crocker, 1986, 179–80.
64. Owen-Crocker, 1986, 184.
65. Owen-Crocker, 1986, 185.
66. Owen-Crocker, 1986, 187.
67. Welch, 1992, 81.
68. For example in *Beowulf*; see Whitelock, 1952, 30–32.
69. Davidson, 1962, 9.
70. Davidson, 1964, 213.
71. Davidson, 1962, 214.
72. Davidson, 1962, 12.
73. Davidson, 1962, 29; Anstee and Biek, 1961.
74. Evison, 1967 on ring swords and the use of beads on hilts.
75. Davidson, 1962, 77.
76. Davidson, 1962, 79.
77. The literature is extensive, but see in particular Brenan, 1991, and Laing, 1993.
78. Arnold, 1988, 62–3.
79. P. Richards, *Byzantine Vessels in England and Europe*, Cambridge PhD (1986).
80. White, 1988.
81. Gregory, 1984.
82. Useful discussion in Cowie and Clarke, 1984, esp. chaps 2–3.
83. Holmqvist, 1972.
84. Jessup, 1950, 40.
85. Jessup, 1950, loc.cit.
86. Dickinson, 1982. For Leigh's work, see summary in Arnold, 1984, 88–9; for Hines's conclusions, Hines, 1984.
87. Laing, L. and J., 1995, 99–103.
88. Jessup, 1950, 47.
89. Mortimer, 1994.
90. Jones, 1977, 119; Jones, 1975.
91. Welch, 1992.
92. Literature on Helgö workshops is extensive, but see especially Holmqvist, 1972.
93. One was found at Poysdorf, Austria, where grave furniture included 'models' or trial castings of brooches. Welch, 1992, 111.
94. Hinton and White, 1993.
95. Scull, 1990.
96. Scull, 1986, for graves with weights.
97. Hinton and White, 1993.

98. Scull, 1990.
99. Moss, 1953.
100. Oddy, 1979.
101. Avent, 1975, 14.
102. Ibid.
103. Leigh, 1990, 107–24.
104. Dickinson, 1982.
105. Dickinson, 1982, 36.
106. Evison, 1951.
107. Battiscombe, 1956, 542.
108. Bimson, 1984; Arnold, 1988.
109. Bruce-Mitford, 1978. See also Bimson, La Niece and Leese, 1982.
110. Jessup, 1950, 39.
111. Several studies of these exist, most notably Avent, 1975, Avent and Leigh, 1977, East, 1984, and Meeks and Holmes, 1995. Particularly interesting is Meeks and Holmes, 1984, where it is suggested that a mechanical jig was used in their production: 'There are . . . no principles, materials or techniques used in the proposed method for producing foils from jig-cut dies that were not already appreciated or in use by Anglo-Saxon times. . . . The alternative can only be to accept that their craftsmanship was supreme' (Meeks and Holmes, 1984, 157).
112. Avent and Leigh, 1977.
113. Arrhenius, 1971, 66–70.
114. Avent, 1975, 16.
115. Hawkes, 1974.
116. Whitfield, 1987.
117. Whitfield, loc.cit.
118. Hodges, 1964, 95–6.
119. Capelle and Vierck, 1971.
120. Hawkes, Speake and Northover, 1979.
121. Ibid.
122. Brown, 1981. Other studies of enamel in Evison, 1977 and Scull, 1984.
123. Romano-British enamelling in Bateson, 1981.
124. Leigh, 1984.
125. Bruce-Mitford, 1978, 597.
126. Bruce-Mitford, 1978.
127. Bruce-Mitford, 1978, 597.
128. Wilson, 1976, 268.
129. Werner, 1964; date discussed in Speake, 1980, 27.
130. Davidson and Webster, 1967.
131. Kendrick, 1938, 87.
132. Speake, 1980, 45.

The Beginnings of Christianity

c . 6 0 0 – c . 8 0 0 A D
(T H E M I D D L E S A X O N S)

The political background of developing kingdoms was punctured by the rearrival of Rome – this time not with legions, but with Christian priests. The Anglo-Saxons in Britain had sophisticated trade contacts with the Continent, had prevailed over and integrated with Roman civilisation and had formed kingdoms with relatively high standards of living. But in the eyes of the 'civilised' world they were to be feared, pitied and targetted – they were pagans. A major offensive was carried out. Once conversion had taken place, links were fostered and influence absorbed from a wide variety of places including Byzantium, North Africa, France, Greece, Italy and Armenia. The entire period is coloured by the fact that England was closely tied to France and an enormous amount of control was exerted by the Franks, particularly on southern England.

Both Christianity and overseas contacts had considerable impact on society in general and on art and artists in particular, bringing new architectural features, new loyalties and new art forms.

Kent – St Augustine's mission

In 597 St Augustine led a high-profile mission, involving nearly forty missionaries – more Italian clergy than ever again came to Anglo-Saxon England.[1] It was designed to impress the Anglo-Saxons with the might of Rome and its Church, and impress it did. As Bede tells us, the clerics came in procession, preceded by a silver processional cross and 'the image of Our Lord and Saviour painted on a board'. The target of the mission was Aethelbert I, the King of Kent. He was already married to a Christian Frankish princess, Bertha, who had brought over from Gaul

her own priest, Liuhard. Its purpose was probably as much political as religious since the Frankish kings had been endeavouring to keep control in south-east England, and the kingdom of Kent, powerful and pagan, was difficult for them or the Pope to manipulate.

In July 598 Pope Gregory announced in a letter to the Patriarch of Alexandria that more than 10,000 English had been baptised at Christmas. Once brought in line with the Christian Continent, influence in England could be more readily exerted. But this Christian offensive impressed only some of the Anglo-Saxons, and many decades were to pass before paganism was finally obliterated.

The history of the spread of Christianity after the late sixth century is reasonably well-documented, as it was a topic of fundamental interest to Bede and other early chroniclers. The apparent ease with which it was achieved in many areas may denote two possibilities – first that Christianity had indeed survived, and second that political motives prevailed over religious. In either case it should be remembered that it is relatively easy for polytheistic pagans to accept what they initially see as simply another god in the repertoire. To Christians, Christ's teachings are exclusive of any other beliefs, and conversion to paganism is a greater and far rarer jump.

The archaeological record provides little more than a sidelight on the process, but is is quite clear that St Augustine planned to institute a diocesan organisation, based on urban sees. The first sees were established at Canterbury, Rochester and London, notably old Roman towns, for new Saxon towns had not yet been established. Aethelbert of Kent persuaded Redwald of East Anglia to the new faith (see p. 48), and a bishop was consecrated for London and Essex.

By around 640, when St Augustine died, the early advances had received serious set-backs. Essex had lapsed back into paganism by 617, and Redwald's faith had proved to be fickle. Moreover, Aethelbert's pagan son was not converted until after his accession in 616.

Northumbria and Celtic Christianity

While the Franks were important in the conversion of the Anglo-Saxons, in Northumbria the Celts also played a role. In 625 one of Augustine's followers, Paulinus, left Canterbury and began converting the Northumbrians to Roman Christianity – the wife of the Northumbrian king, Edwin – was a Christian. Christianity was quite rapidly established and the faith spread to the adjacent region of Lindsey. Edwin's death in battle in 633 meant a setback, for his successors lapsed back into paganism, and Paulinus withdrew to Kent.

Edwin's successor, Oswald, who had been an exile on Iona, sent to the Irish monastery there for a missionary to begin the conversion of the

Northumbrians to the Celtic form of the faith. Through the support of Oswald, the Irish form of Christianity (and its attendant art) was disseminated beyond the bounds of Bernicia and Deira[2]. In 635 St Aidan came to establish a monastery on the island of Lindisfarne.

At the Synod of Whitby in 664 the Roman Church (championed by St Wilfrid) and the Irish (supported by St Aidan) came into conflict. This reflected the reality of divisions within the Northumbrian royal family. Rome triumphed, but the legacy of Iona was of long duration.

Despite these vicissitudes, Christianity spread to most of the Anglo-Saxon kingdoms during the first half of the seventh century. Wessex was first evangelised by Birinus, a Frankish priest in the court of King Kenwalh. His successor, Agilbert, was also Frankish, and was eventually succeeded by his nephew. This would seem to support the view that Frankish overlordship may have extended through much of southern England in the seventh century. The last pagan Anglo-Saxon king ruled in the Isle of Wight, which became Christian when Caedwalla took it over around 686.

By the early eighth century the power of Northumbria was waning, to be succeeded by the rising star of Mercia over which Aethelbald, Offa and Coenwulf held sway from 716 to 821. Mercian power was extended from the Welsh Marches in the West to East Anglia, Sussex and Kent in the East. The imposing remains of Wat's Dyke and Offa's Dyke, constructed by Aethelbald and Offa, visibly attest the might of Mercia. The 193 km of Offa's Dyke, extending from Treuddyn in Clwyd to near Chepstow on the Severn, greatly exceeds the 117.5 km of Hadrian's Wall. This period of Mercian leadership did not extend to conquest since the objective was to increase wealth through tribute, tolls and trade. Disputes between the Mercian kings and their underlings were frequent, with clashes in particular with Kent. Despite this, through the century of Mercian supremacy the church in Southumbria (as the region south of the Humber is occasionally called) was notably unified, and Mercian cultural influence pervaded widely.[3]

Changes in society: kings, lords and estates

With the coming of Christianity, there were a number of changes in Anglo-Saxon society: for example, it becomes possible to point to estate centres such as that at Yeavering, Northumberland (which was mentioned by Bede as *ad Gefrin*[4]), which were definitely rather than putatively for royal or noble use. Bede tells us that Edwin visited this centre in the 620s with his wife, and stayed there for thirty-six days, while Paulinus baptised the locals. The earliest buildings at Yeavering were shown on excavation to be similar in size to those at West Stow, and were probably built in the time of Aethelfrith, at the end of the

Yeavering, Northumberland, Saxon palace complex reconstructed (Lloyd Laing, after Hope-Taylor)

sixth century. A huge hall was next built, with an even larger hall adjacent to a smaller one. These buildings were burnt down but the two halls were replaced, to be fired again and rebuilt before the settlement was abandoned, probably before the end of the seventh century.

Associated with the complex at Yeavering were a cattle compound (first erroneously identified as a fort) and a wedge-shaped timber structure which seems to have had tiers of seats and to be modelled on a Roman theatre. This grandstand may have been used by Paulinus in preaching to the Anglo-Saxons. Other buildings on the site include a putative church with its associated cemetery.

Similar halls are now known from aerial photography and limited excavation at a variety of places, such as Atcham in Shropshire or Hatton Rock near Stratford, Warwicks.[5]

A substantial timber hall with annexes, probably of the mid-eighth century, was excavated in Northampton. It was found to have been replaced in the ninth century by a stone one that was reminiscent of Carolingian buildings.[6] As it was adjacent to the church of St Peter, it has been surmised that it may have been part of an ecclesiastical complex. Certainly it stands out as an exceptional example of secular stone-building which does not otherwise occur until the very end of the Anglo-Saxon period.

Land ownership

There are signs that wealth was increasingly calculated in terms of land ownership.[7] Gifts of land to the Church were inalienable, and laymen could not give land to the Church without the king's permission. In contrast, land given by the king to his subjects reverted to him on the subject's death. Increasingly, from the seventh century, the Church recorded gifts of land to it in the form of charters, and soon the laity started to follow suit, demanding that land acquired from the king should pass into their possession to be given to their heirs. They too started to record such transactions on vellum.

By these means lords became land-owning magnates, and churchmen competed with laymen in the acquisition of land and wealth, a factor complicated by the fact that the Church now controlled funerals and had a hand in the regulation of inheritance.

The 'Middle Saxon Shuffle'

There were two side-effects of this new emphasis on land: the process of enclosure and the opening up of new territory. Archaeologists have long been familiar with what has been termed the 'Middle Saxon Shuffle', when the villages of the fifth to seventh centuries seem to have been abandoned in favour of new sites, though the village names may have been transferred to the new foundations. Given that -inga place-names belong to this period, it might be that their distribution represents the break-up of extended families migrating from former homes to new ones, or even movement from the now decaying Romano-British settlements into new Saxon-built, Saxon style villages. Such a pattern of settlement migration round a long-established focus is one which can be observed at other periods in Britain, but in the Middle Saxon period it was particularly marked.

A study of the pagan Saxon settlement at Mucking, Essex, has shown

how it 'wandered', and the same phenomenon has been noted at West Stow, Suffolk, where three farmsteads were seen as shifting over a period of two and a half centuries.[8]

It has been suggested that a major factor in this movement was a tendency to relocate from poorer to better land, though this has been disputed.[9] One view is that there was increasing nucleation that continued to take place until the Norman Conquest and beyond, and that this was connected with a gradual change from essentially mobile to static communities, perhaps related to the need for stability for the maintenance of open-field farming.[10] This may also have been in part occasioned by the need to increase production to pay tribute to the Church as well as to the secular authorities.[11]

The Church in society

The fortunes of Church and State are intertwined in Anglo-Saxon England.[12] As we have seen, the Church tolerated (or was unable to prevent) the panoply of rich pagan burials of the type represented at Sutton Hoo and Taplow. In some measure it also involved itself in the elevation of kingship and in inheritance disputes. Similarly, the Church acquired some of the trappings of secular conspicuous display.

This is well-exemplified by the pectoral cross of St Cuthbert, made in the late seventh century and buried with him.[13] It is in the tradition of gold-and-garnet jewellery of the earlier seventh century, with a central setting of garnet within a beaded collar surrounded by shell. Somewhat earlier is the pendant found at Old Westgate Farm, Canterbury, in 1983, which with its circular form, curved and step-shaped cloisons, use of garnet and shell and composite construction is clearly modelled on a composite disc brooch, while its central cross betrays a Christian millieu.[14] Datable to the early seventh century, it is probably to be associated with the early days of Christianity in the Kentish court.

Transitional in both design and dating between the Canterbury and Cuthbert crosses are the Ixworth and Wilton crosses, both of cruciform shape, with gold and garnet settings. The Wilton Cross (Norfolk) cannot be earlier than a Byzantine gold coin set in its centre – a solidus of Heraclius (AD 613–32) with a cross as its reverse type. Elements of the design of the Wilton Cross link it to the workshop tradition of Sutton Hoo.[15]

Other examples of the sumptuary arts are more ambiguous, such as the fishes (a Christian symbol) on buckles from Crundale Down, and Eccles, Kent,[16] or the cruciform arrangement of facing masks on a gold pendant from Ash in the same county.[17] No ambiguity however can be

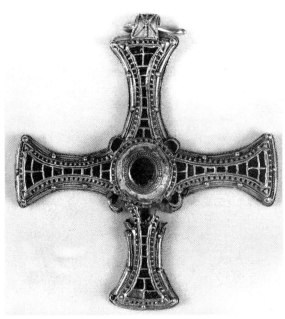

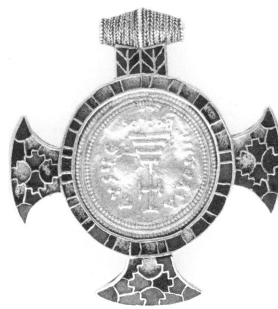

St Cuthbert's Pectoral Cross, gold, garnet and glass, later seventh century. H. 6 cm (Dean and Chapter, Durham Cathedral)

Wilton Cross, Norfolk, gold and garnet, with solidus of Heraclius I (610–41). W. 4.8 cm (British Museum)

attached to the 'hoard' usually taken to be from St Martin's, Canterbury (though more probably from the adjacent St Augustine's abbey), and deposited between *c.* 580–630. This find comprises a number of jewels probably from several graves, including a medalet imitating a coin which names Liuhard, Queen Bertha's chaplain.[18]

The medalet depicts a hitherto unrepresented form of double-barred cross, and has been seen as an issue meant to pay tribute to Bertha by alluding obliquely to her connection with Queen Radegunde of the Franks and St Helena, the mother of Constantine. It is seen as having been made for Easter offerings before it was later turned into a necklace pendant.[19]

Monasticism

From the time of Augustine, monasticism was an important element in the Anglo-Saxon church, and its strength has resulted in the many remains of what are now parish churches. It originated in the East Mediterranean in the fourth and fifth century, as a reaction against the highly organised and intellectually sophisticated urban Church.[20] It arose out of a desire to reject materialism and intellectualism and return to basic spiritusal values. The pious, such as St Anthony (fl. *c.* AD 269), 'dropped out' and lived solitary lives. The early hermits went to live in

desolate areas such as Egypt and Syria, but later groups banded together and formed remote communities in establishments that owed not a little to the model of Roman forts, well exemplified by St Catherine's on Mount Sinai.

In the late fourth and fifth centuries monasticism spread westwards from the East Mediterranean to Gaul, where institutions were established at Ligugé (near Poitiers) and Marmoutier (near Tours) by St Martin. These were followed by other foundations established by John Cassian and Honoratus. Monasticism reached Britain and Ireland from the Mediterranean, arriving independently in the Celtic West before it was separately introduced to Anglo-Saxon England.[21]

The monasteries of Monkwearmouth and Jarrow, in Northumbria have yielded remarkable monastic remains. At Jarrow there were substantial stone-built halls, with glass windows and stone tiles. One was 91.5 ft (27.8 m) long, the other 60 ft (18.2 m), both parallel to the church. The western building was probably a refectory, and a decorated stone shaft may have been a lectern for reading to the monks during meals. The eastern building seems to have been a hall, with a part sectioned off for the abbot's private quarters, perhaps used by Bede himself.[22]

The prototypes for such buildings are to be found in Gaul, for example at Jumièges or at Lorsch in the Rhineland. At Jarrow the monastic buildings occupy two sides of a rectangle, the first stage in the development of a claustral (with cloisters) plan. At Lorsch the buildings occupy three sides, and at St Gall in the ninth century four sides of a cloister were built up, marking the beginning of the full claustral plan associated with medieval monasteries.[23]

At Monkwearmouth a walkway ran from the church for over 100 ft (30 m). Its walls were plastered and painted, and it had a stone tiled roof and glazed windows. The same kind of feature is found later in the Carolingian world, at St Riquier in northern France.[24]

The close ties with the Continent are shown by the fact that we are informed that Benedict Biscop brought masons from Gaul to work at Jarrow: a fact which has been seen as an explanation for the neatly coursed masonry. It is now generally believed that the scheme of building in late seventh century Northumbria (see p. 92) was the direct outcome of influence from France, and that the models for the Northumbrian monasteries were Frankish foundations such as Vienne, St Etienne in Paris, and Jouarre. Bede notes that the Gaulish masons were to build in the *morem Romanorum* (Roman fashion). The yellow mortar and pink interior plaster at Monkwearmouth is similar to that found in Gaul, for example at Angers.[25]

Similarly, the types of shafts found in the Northumbrian monasteries have their counterparts in the Frankish world.

The Franks too may have been responsible for the innovation of stained glass, represented in the excavations at both Monkwearmouth and Jarrow, and for the appearance of architectural sculpture, from which the idea of free-standing sculpture was probably derived (see p. 105).

Coinage and foreign contacts

It is clear that during the seventh and eighth centuries the secular fortunes of Anglo-Saxon England as well as the spiritual developments were tied up in the affairs of her Continental neighbours. In the period from the 670s, for example, small silver coins known to numismatists as sceattas, modelled on those issued on the Continent, were struck in Kent and East Anglia. Around 690 other kingdoms followed suit.[26] Around 720 the production of sceattas increased, and Frisian issues circulated. This phase ended at the same time as new style larger coins were issued on the Continent by the Merovingian King Pepin. The new style of Continental coin was imitated by the East Anglian King Beonna around 760.[27]

While the designs of early sceattas seem to stress a link with the Roman and, on rare occasions, Iron Age past, the designs on the later sceattas are distinctively English. These may have been coins issued for use in special non-local trade. The designs on the sceattas represent a diversity of subjects including crosses and animals as well as the occasional facing head.[28]

The growth of new towns

Coinciding with the development of coinage came the growth of the earliest Anglo-Saxon style towns. Since the Anglo-Saxons were not primarily stonemasons, the old Roman towns which survived must by this period have been in a state of semi-ruin. New commercial needs led to the establishment of new towns. These were essentially trading bases without fortifications designed primarily for the control of resources, and royal influence (possibly control) can be detected. This is particularly apparent in Wessex, where King Ine and his successors seem to have been anxious to control both internal and overseas trade.

Hamwic (Southampton), for example, was a late-seventh century foundation, with buildings arranged along a grid-iron pattern of streets, which were the focus for a variety of crafts, notably boneworking and metalworking.[29] Pottery was both locally made and imported Frankish. It has been argued that Hamwic was a trading base controlled by the West Saxon king, perhaps Ine. Its function was perhaps to forge closer links with Continental, especially Frankish,

Sceattas: (a) 'Standard' type, Primary Kentish series, late seventh century, transitional from gold thrymsa; (b) Kentish primary type, late seventh/early eighth century; (c) 'Frisian' type, early eighth century (Ashmolean Museum)

neighbours. Other trading bases such as Ipswich and London, have been partly investigated.

In terms of urban development Northumbria lagged behind the rest of England, though there was a trading base at Eoforwic (York) in the eighth to ninth century.[30]

As counterparts of the trading centres, there were towns with a more specifically religious function. The ecclesiastical counterpart of Hamwic was Winchester, just as Fordwich in Kent was a trading base linked to the ecclesiastical centre at Canterbury.[31] These fairly modest beginnings were later developed in the urban programme of Offa of Mercia and further still in the age of Alfred the Great.

Mercia seems to have come later than Wessex to town development, but certainly fostered strong links with the Carolingian world.[32] Many towns in Mercia seem to have originated in the time of Offa, with possibly two 'tiers' of towns which included Bedford, Cambridge, Hereford and Northampton in the second division.[33] These were controlled markets, and their appearance coincided with an intensification of farming and production. Excavations at Hereford and Cricklade have produced evidence for timber-laced earth defences and timber gates of the Anglo-Saxon period, and grid-iron street plans may also have been an innovation of the time of Offa.[34]

Changes in art and architecture

Coincidental with the surge of Christianity in the seventh century and the new-found prosperity, came changes in architecture and art. While the pagan Anglo-Saxon repertoire continued on a fundamental level, Christianity increasingly influenced both artists and patrons. Kings and the nobility still undoubtedly commissioned secular works for their own aggrandisement (see p. 128) and as gifts for their followers, but they often now commissioned works to give to the Church, while the Church itself provided patronage. Clerics joined the ranks of craftsmen in the production of works of art for the glory of God.

Further, Christianity was seen as the religion of the Roman Empire, and the language of its art stemmed from Mediterranean Classical tradition. When books were copied and decorated, there were no native models to imitate, and inspiration was derived from Antique sources.

Within the Church, treasures such as relics enhanced the status of particular foundations, which vied with one another in the possession of treasures. But even as the *romanitas* of the Church was highlighted in the location of churches and in the treatment of subjects in sculpture and manuscripts, traditional Anglo-Saxon elements, many of them pagan, were skilfully adopted to Christian usage. Similarly, the political and economic links with the Frankish world provided the milieu in which Frankish artistic ideas took root in England, most notably in the Mercia of King Offa.

The trade in ideas was not all one-way. Through commerce and more particularly through the activities of English clerics such as Alcuin, Boniface and Willibord, English ideas and Insular art became familiar in Frankish lands and beyond.[35] Manuscripts, metalwork and ivories produced on the Continent in the Carolingian age attest English influence. Works such as the Tassilo Chalice from Kresmünster,[36] the cover of the Lindau Gospels from South Germany, or the ivory openwork book-cover panels from Genoels-Eideren, Belgium, are examples of this influence.[37]

The advent of Christianity to Anglo-Saxon England introduced new arts, of which the most novel is that of manuscript decoration. St Augustine and his followers had manuscripts provided by Pope Gregory, of which one, the Gospels of St Augustine, still survives, though now lacking most of its embellishments.[38] An Italian manuscript of the sixth century, it had miniatures of the four evangelists under arches, together with miniatures of scenes from the Life of Christ. Of these only one page of miniatures and one portrait, of St Luke, survives, but it is clear that this book served as a model for scribes in Canterbury in days to come. It is still used in the enthronement of the archbishops of Canterbury, although it has been in Cambridge since the sixteenth century. With the manuscripts came a new Latin literary tradition,

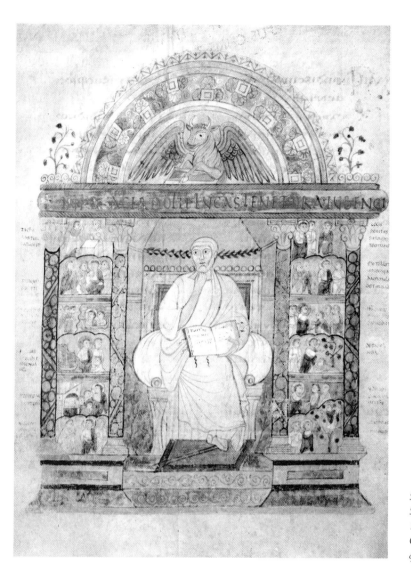

*St Augustine's Gospels, f. 129b,
St Luke, with Gospel scenes, 245 x
180 mm (Cambridge, Corpus Christi
College Library, MS 286; by permission
of the Masters and Fellows)*

though this did not extinguish a native Anglo-Saxon one that produced such vernacular masterpieces as *Beowulf*.

Just as there were two separate traditions of early churches, in Kent and Northumbria (see pp. 90–6), there were two early traditions of manuscript decoration. Of these the earlier surviving is represented in Northumbria, where books had been introduced to Lindisfarne by the Irish mission of St Aidan. The second tradition was in Kent.

The changes in architecture had greatest visual impact on the landscape – some lasting to the present day. Hitherto, Anglo-Saxon architecture had been confined to wood or wattle and daub, but the

renewed contacts with Rome called for Roman-style responses in the form of stone church architecture. The earliest architectural influence was Mediterranean, but by the 670s Merovingian Gaul became the chief influence.

Although there is a dearth of secular Anglo-Saxon buildings, well over 400 churches in England preserve some vestiges of Anglo-Saxon work, though very often these amount to little more than a section of walling, a quoin or a window.[39] Scholars of Anglo-Saxon architecture have divided the remains into three major periods: from the conversion to the time of the Danish raids (*c.* AD 600–800); the time of the Danish raids (*c.* 800–950); and from the late Saxon period into the Norman overlap (*c.* 950–1100). It has been argued that virtually all the surviving remains (83%) belong to the last period, with 14% surviving from the period covered by this chapter. However, more recent considerations suggest that these figures may be distorted due to many middle period churches having been incorrectly dated to the later period.

The majority of very early surviving churches were originally monastic minsters, and with the rare exception of churches built for royal and other estates, much religious observance was probably open-air – a further factor which has to be taken into account when searching for evidence of Christianity during the fifth and sixth centuries.

From the period between 600 and 700, about 90 churches are known from documemtary or archaeological remains, not surprisingly concentrated in Kent and Northumbria, with a few outliers in Essex, Wessex and Mercia.

The earliest churches

Since traditional Anglo-Saxon buildings were made of wood, early church buildings would be expected to have few if any distinguishing features, so it is not surprising that there is very little evidence for the earliest ecclesiastical architecture. Worship often took place around wooden and stone crosses which would have left virtually no traces (see sculpture below). It is possible, too, that pagan sanctuaries were converted to Christian use by the simple means of a cross, thus leaving no recognisable remains for the archaeological record. It is not until distinguishing features with distinctive ecclesiastical functions, such as the porticus (stone chapel), were developed that churches become easily identifiable in the archaeological record.

As we have seen (see p. 7), there is a substantial body of evidence that Romano-British Christianity may have survived the Saxon pagan period and indeed that the sites continued to be used into the Saxon period and in many cases to the present day. Recent excavations at Lincoln may have

discovered remains of a Romano-British church (if the somewhat ambiguous evidence is accepted), in which case the site could well provide the missing link in proving survival and development of Christianity between the early fifth century and the seventh.[40]

Once officially converted to Christianity however, Anglo-Saxon royalty required impressive edifices as foci for their faith. The Church cultivated its links with the Roman past, and churches were often founded on Roman sites, most notably within major administrative buildings (for example at Exeter, London, York or St Albans), or Roman forts (for example, Reculver or Bradwell on Sea). Although at least some of the earliest late sixth- and early seventh-century churches were certainly built in wood (see p. 92), it is also clear that others were adapted from ancient secular and stone-built Roman buildings. Some slight evidence of such adaptation may point to a date even before St Augustine's mission to Kent.

Bede informs us that Queen Bertha and her chaplain reused St Martin's, Canterbury, in this way. The present nave has been dated to the seventh or eighth century, but the chancel which it partly overlies is built of Roman brick with a floor which was of *opus signinum* (a Roman type of material of concrete with chipped brick). A similar building was used as a chancel at nearby Stone-by-Faversham.[41]

Recent excavations have revealed four short stretches of wall near the east end of the nave at Canterbury – part of the first church underlying the cathedral. The walls were much narrower than those of the later Saxon buildings, and had foundations of Roman materials in clay, with upper walls of Roman bricks set in mortar. The structure is dug into the kind of 'dark earth' (possibly the remains of reed or straw used as flooring and discarded into yards)[42] usually associated with the post-Roman period, and therefore it is not a Roman building. It could have been the original foundation of St Augustine, with a plan similar to that of SS Peter and Paul (see below) – Bede states that Augustine 'recovered a church which had been built of old by the work of Roman Christians'. 'Recovered' might have meant 'built out of reclaimed materials'.[43]

A possible instance of a Roman building being used as an Anglo-Saxon church is that at Much Wenlock in Shropshire. It is close to the Roman town of Wroxeter, which is known to have survived, albeit on a reduced scale, at least until the Anglo-Saxons arrived in the area.[44] Only the foundations of the Much Wenlock building survive, but it may have been used for the first priory on the site (foundations of a later Saxon building have also been found under the medieval church).

There is copious evidence for the reuse of Roman building materials in Anglo-Saxon churches – there are, for example, reused Roman arches in Corbridge, Northumberland, and at Escomb in County

Durham, while Roman material was also built into the church at Wroxeter, Salop, pointing to the survival of Roman masonry which was both a quarry and a model for the Anglo-Saxon period architects.

Kentish churches

The churches of Kent, along with the outlier at Bradwell-on-Sea, Essex,[45] which represented the extension of Kentish influence north of the Thames, share common features. They have for instance, a nave and stilted apse (one with straight sides before the curved end, the apse being entered from a triple arch). Buttresses were also used in the construction of the building. Roman brick was used in these buildings, and in some cases Roman arches were reused.

The plan for the early Kentish churches was probably derived from Italian models. The features of polygonal and stilted apses, buttresses and brick masonry are all found at Ravenna in Italy and in the Swiss Alps, while the triple arcade with altar in front of its central arch seems to have originated in Tunisia but spread thence to Italy.

Reculver survived more or less intact into the early nineteenth century when it was drawn by engravers, who also showed its magnificent triple arch during demolition (two columns survive in Canterbury cathedral). It was built within a Roman–Saxon shore fort, and, in keeping with other Kentish-style churches, had porticus added to flank the nave and chancel.

Porticus were used for a variety of purposes – at St Augustine's abbey church in Canterbury, they were the burial chapels of the royal family of Kent and of Liuhard, St Augustine and his successors. They also served functions connected with the mass or for private worship. That at Reculver was used as a sacristy.

Of other 'Kentish group' churches, the best preserved is St Peter's at Bradwell-on-Sea in Essex. Often claimed to be that built by St Cedd in 653, current opinion favours the view that it is slightly later, built after 669. For a long time used as a barn, the rectangular building originally had an apse (entered through a triple arcade), and flanking porticus.

Burials were probably laid in porticus because of the prohibition on placing them inside the body of the church. This was stipulated at the Council of Nantes in 658, for example, which stated that 'no bodies whatsoever are to be buried in church, but in the atrium or in a porticus outside the church'. By the late seventh century the prohibition had weakened, and Theodore, a successor of Augustine, was buried in the body of the church at Canterbury in 690.

Little is known about the interior features of seventh-century Kentish churches. At Reculver the main altar stood at the east end of the nave, in front of the central arch. An ornate capital from St Augustine's Abbey

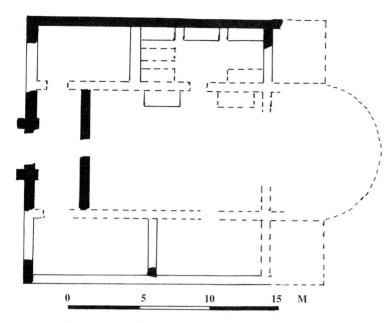

St Augustine's, Canterbury, plan of the church of St Peter and St Paul (Jenny Laing, after Taylor and Taylor)

with volutes and leaf patterns, and another similar, have been seen as belonging to free-standing columns of a general Roman-derived type current in France. Arguments have been advanced that they belong to the seventh century or to a period of Classical revival in the ninth; either is possible. One of the capitals was painted in red, yellow, blue and gold, with the acanthus leaves in Egyptian blue, a pigment found in Classical painting.[46]

Northumbrian churches

Bede informs us that when he converted Edwin, Paulinus built a timber church at York, which was soon encapsulated in stone. Bede's description of the first church at York is ambiguous, but it could be interpreted as lacking an apse.

The only complete church plan (and there is a slight doubt as to whether it is a church at all) of the seventh century is provided by the excavated timber structure with its associated cemetery at Yeavering, Northumberland.[47] This was of simple rectangular shape, with an added annexe and with entrances north, south and east. Another building at Yeavering may have been a pagan 'temple' converted into a church. The Yeavering church shows features of secular hall architecture, perhaps reflecting the taste of the patrons.

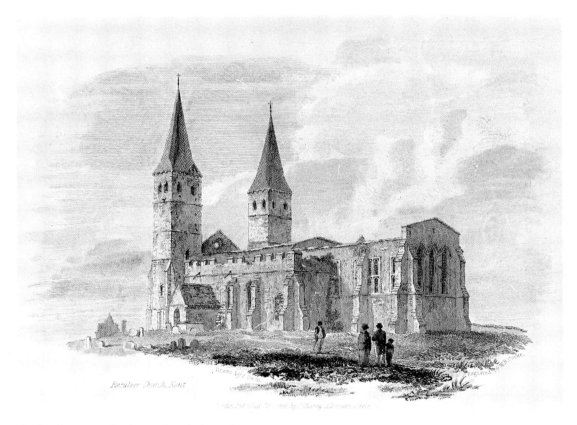

Reculver, Kent, prior to demolition in the early nineteenth century

At Hartlepool (County Durham) the first monastic foundation comprised a complex of timber buildings – living quarters and workshops – which were slighted around 700, then replaced gradually in the early eighth century by buildings on stone foundations.[48] A similar replacement of timber buildings by stone at this period has been seen at Whithorn, Galloway, which began as a 'Celtic' monastery but was replaced by an Anglo-Saxon one. This replacement of timber with stone may also have happened at Whitby Abbey (Yorks).

Very well preserved is the small church of St John at Escomb in County Durham, which presently comprises a nave and small chancel, though soon after it was built porticus were added to it.[49] The chancel is entered through a tall and narrow arch, the voussoirs of which were probably looted from a nearby Roman fort, as were the majority of the building stones, including one with a Roman inscription.

The jambs of the arch are made up of stones set alternately vertically and horizontally, a style which is sometimes termed 'Escomb fashion'

when it is applied to openings, or 'long and short work' where applied to quoins. A notable feature of Escomb are the single-splayed windows with grooved wooden frames to take glass – fragments of which were recovered in excavation. The masonry shows considerable care in its construction; the quoins and the jambs of two of the doorways slope slightly upwards, producing an elegant effect.

Escomb also possesses the earliest extant Anglo-Saxon sundial. Surrounded by a serpent which has been seen to symbolise Eternity, it is presided over by a weathered boss in the form of an animal head. The general style of the sundial recalls sculptural work at Monkwearmouth (see below). Commentators have expressed surprise that Escomb is not mentioned by Bede, but unless it had played some part in his *History*, there was no reason for him to detail every church in Northumbria. The masonry is very similar to that at nearby Jarrow, and the possibility that Escomb was built by masons from there cannot be ruled out.

The foundation of the monastery at Monkwearmouth,[50] also in County Durham, took place in 673, when a layman, Benedict Biscop, started the building on land donated by King Ecgfrith of Northumbria. Its sister monastery at Jarrow was also founded by Benedict, and there Bede spent virtually his entire life.[51] Together the two monasteries housed over 600 monks by the early eighth century.

Although the foundations of monastic buildings have been recovered in excavation at Monkwearmouth, the only building that survives above ground is the church itself – in a green open space among the clutter of modern buildings. The nave was some 20 m long, 5.5 m wide and 10 m high – like Escomb it was tall and narrow. Soon after building, a porch was added to but not bonded with the nave – it existed by Bede's time. It was two storeys high, but as with many Anglo-Saxon porches was heightened into a tower, probably in the eleventh century.

Jarrow still possesses a dedication stone commemorating its foundation:[52]

Dedication of the basilica of St Paul on the Kalends of May in the fifteenth year of Ecgfrith the king and the fourth year of Ceolfrith abbot and founder under God of the same church.

Unfortunately, this inscription does not necessarily relate to the existing church, of which the chancel is Anglo-Saxon work. By the eighth century two churches stood parallel to one another at Jarrow, of which the western example, demolished in the eighteenth century, was almost certainly the one to which the inscription related. The existing Saxon work is in many respects similar to that at Monkwearmouth, though the now destroyed church seems to have been even closer in style.

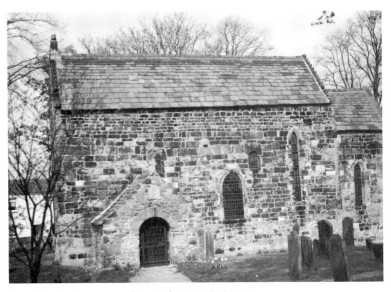

Escomb, Co. Durham, exterior of church of St John (Lloyd Laing)

Escomb, Co. Durham, interior
(Lloyd Laing)

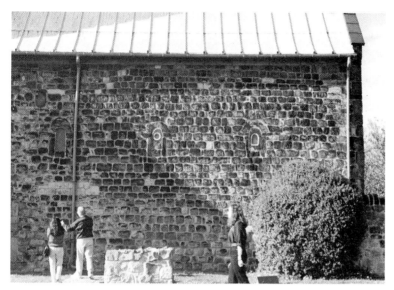

Jarrow, Tyne and Wear, exterior of church (Lloyd Laing)

Jarrow, Anglo-Saxon monastery reconstructed (Lloyd Laing, after a model)

Jarrow, Tyne and Wear, dedication stone
(Lloyd Laing)

Crypts survive at Ripon (Yorks) and Hexham (Northumberland), though the churches that they belonged to were replaced later in the Middle Ages. Both these churches were the work of St Wilfrid, at the end of the seventh century.[53]

Churches in Wessex and Mercia[54]

In Wessex the foundations of the Old Minster cathedral in Winchester have been excavated.[55] This was founded by King Kenwalh in 648, and was dedicated to SS Peter and Paul (the saints usually associated with early dedications). Excavations have shown that it was about 10 m wide and probably built of cut stone. It had a nave with an eastern altar and three porticus. It was probably begun as a palace church, and was used for coronations. It was upgraded to a cathedral in the 660s. Its layout reflects the fact that the influences at work in church building were different from those which had prevailed at the time of the Kentish mission. The Winchester church owes a strong debt to Frankish models, such as St German at Speyer. Remains of other early churches have been discovered at Glastonbury and Muchelney in Somerset.

In Mercia, church planners favoured a type of building which had developed from Roman secular public buildings – the basilica. This was essentially a rectangular structure divided into aisles with two lines of columns. Outside Mercia it can be seen in the second Anglo-Saxon church which underlies Canterbury cathedral (see p. 150). This has massive aisle foundations, with two cross-walls near the east end of the nave to take a central tower and with a narthex or oratory at the west end.[56]

The finest of the Mercian basilica style churches is that at Brixworth, Northants, which Sir Alfred Clapham reckoned was the finest building of its period surviving north of the Alps.[57] In the past it was assumed that the present building was that recorded as being founded by an abbot of Peterborough in 675. Built with brick and rubble, it has a porch heightened to a tower, of which an upper storey opened into the nave, as at Monkwearmouth. The present church is a shadow of its prototype, however, since the side aisles have been demolished, and the aisles blocked up, to form the outer walls of the building. The church comprised the basilican nave and a rectangular chancel, from which extended a polygonal sanctuary with partly subterranean ambulatory, which some have seen as contemporary with the main church but others prefer to see as an addition.

Not all scholars are convinced that Brixworth is as early as the seventh century; many prefer a date in the eighth or ninth century even for the nave. Recent work has produced a piece of wooden scaffolding

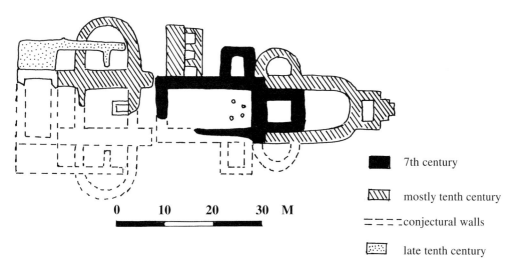

7th century

mostly tenth century

conjectural walls

late tenth century

Winchester Old Minster, plan (Lloyd Laing, after Biddle)

pole from the original building that radio-carbon dating suggests was in use somewhere between 830 and 990.[58] A similar type of basilican building, also arguably ninth century, is still relatively well-preserved at Wing, Buckinghamshire.[59]

Christian Saxon art

The advent of Christianity brought new art forms and a broadening of patronage that led to a burgeoning of artistic endeavour, designed to glorify the Christian God. The artists communicated through the traditional arts styles, expressing themselves through a complex 'language'. Art forms of which examples survive include architectural sculpture, manuscripts, interior church decoration including wall paintings, three-dimensional sculpture, memorial stones, metalwork and works in bone, leatherwork and wood.

The language of Christian Saxon art

The Anglo-Saxon Christian art that accompanied these architectural and other changes is often extremely complex to understand, since it contains allusions not only to biblical texts, but also to contemporary theological writings and details of the liturgy. To understand why particular subjects appear where they do and what message the artist was trying to convey is often difficult or even impossible for a

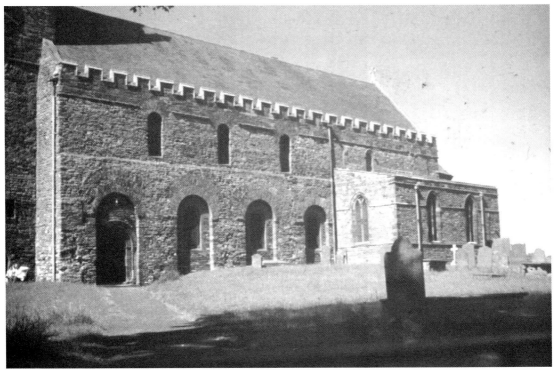

Brixworth Church, Northamptonshire, probably eighth or ninth century (Lloyd Laing)

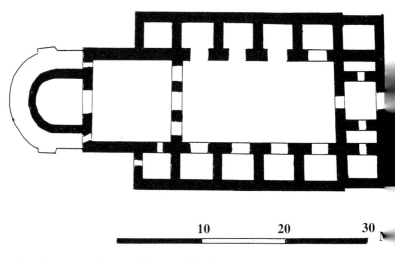

10 20 30 N

Plan of Brixworth in the mid-eighth century (after Gem)

modern observer, and it can be assumed that some of the finer points of iconography would have been lost on all but the most learned monks.

Vinescroll is one of the most common elements in Anglo-Saxon eighth-century sculpture. It first appears in Northumbria, and is ultimately derived from Roman art in illustrations of nature. In Roman art with the passage of time the plant foliage scroll became more formal. By the late Roman period the vine came to symbolise Christ's body – 'I am the true vine' (John 14:27) – and in the fourth-century mosaics in the church of Santa Constanza in Rome, birds are shown amid fruit-laden branches.

It is notable that among the sculptures at Hexham is a fragment of plant scroll, long believed to be Anglo-Saxon but now known to be Romano-British – clearly local models were familiar to the artists first adopting the vinescroll design from the Mediterranean. Apart from its symbolic meaning, the vinescroll was favoured because it could be expanded *ad infinitum* to fill long thin spaces on crosses, and because the animals cavorting through the foliage belonged to the general tradition of Anglo-Saxon animal art. Eventually, the animal bodies replaced the plant stems, as for example on the early ninth-century cross from Rothbury (Northumberland). The symbolism was not necessarily always understood, and motifs that were originally symbolic probably lost their meaning on occasions through copying.

The complexity of Christian symbolism can be seen by studying the Ruthwell Cross.[60] It is noteworthy for its depiction of the Crucifixion, a scene not much favoured by Anglo-Saxon artists, though it became more popular later, when it appeared on cross heads and was used in some Viking-influenced sculpture. Some scenes carried inscriptions identifying them; incised, as at Ruthwell or perhaps painted, as has been suggested for Otley I and Masham (Yorks). Strict iconographic conventions were adhered to, so that from the arrangement of the figures the devout would immediately recognise the reference. Christ in Majesty is always shown with a crossed halo, the right hand giving an orthodox blessing and a book in the left. The arrangement of the panels frequently reflects the liturgy, or illustrates a psalm. From the ninth century the Virgin and Child gained popularity, perhaps through the influence of Carolingian ivories, and reform iconography following the Winchester Revival in the tenth century (see p. 169) introduced new elements, such as angels. This iconography spread northwards, but was not always correct – an angel at Shelford (Notts) uses the wrong hand for a blessing.[61]

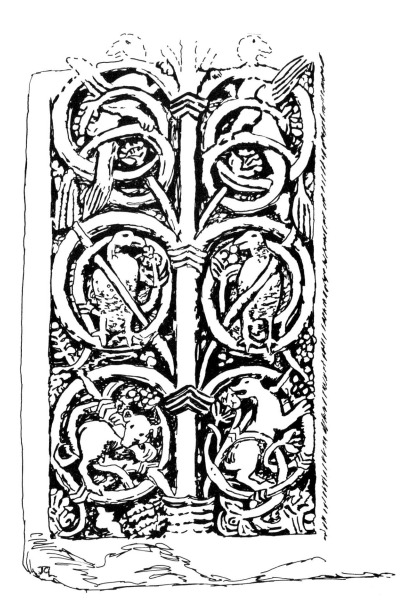

Vinescroll ornament, from a slab from Jedburgh, Roxburghshire (Jenny Laing)

The styles of Anglo-Saxon art of the Christian period

The complexities of artistic language were expressed in a number of different styles – some of which owed their origins in the pagan past. Style II and the Crundale Style (see p. 70) continued to dominate metalwork into the middle of the seventh century. The animal on a gold mount from Bamburgh, Northumberland,[62] and on an antler mount from Hamwic[63] are in a related style to the latter.

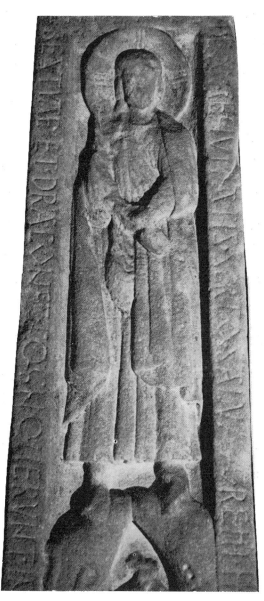

Ruthwell Cross, Dumfriesshire: (a) detail of Christ; (b) detail of vinescroll and runes (Prof. R.A. Markus)

The Crundale style of animal was succeeded by the Lindisfarne style at the end of the seventh century, represented in the Lindisfarne Gospels. The dominant creature was a long-legged bird with hooked beak, though a dog-like animal with open mouth also cavorts through the Lindisfarne pages. Out of the Lindisfarne tradition evolved in the later eighth century another type of leggy animal, sometimes with contorted body and yapping mouth, which dominated the art of Mercia. This is seen in all the media, ranging from pins, such as the set from the River Witham, through manuscripts to sculpture.

Workshops

Almost as little is known about the metalworking workshops of Middle and Late Saxon England as about those of the pagan period, though a considerable body of evidence exists for manuscript illumination techniques (see p. 113). The most informative material is some fragmentary moulds from the monastery at Hartlepool, Cleveland, where other evidence for monastic metalworking took the form of crucible fragments, at least one of which betrayed signs of having been used for melting silver.[64] The mould fragments include one with a calf evangelist symbol, a little reminiscent of the calf in the Echternach Gospels, and a richly interlaced expanding cross. A third has a backward-looking animal with interlace.

There are also a couple of examples of motif pieces. These are common in the Celtic areas, particularly Ireland, but while not known from pagan Saxon England, they do occasionally survive in Christian contexts. Although the precise function of them is not fully understood, they usually appear to have been experiments at working out part of the designs to be employed on castings. One from Bawsey, Norfolk is unusually of metal, and takes the form of a disc with sketched outlines and an animal sketched in one quadrant, and dates from the earlier ninth century.[65] From Coppergate, York, has come a bone motif piece with interlace patterns and some small, fairly naturalistic animals incised upon it. Of comparable date is the motif piece from Station Road, York, with crouched, backward-looking animals and again interlace.[66]

A bronze tear-shaped die from Canterbury,[67] intended for producing repoussé foils, is probably of the later eighth century, and is decorated with two confronted open-jawed animals, slightly reminiscent of the pairs of creatures that appear on the Coppergate Helmet (see p. 129).

Architectural sculpture

Stone-building and three-dimensional art were alien to the Anglo-Saxons and it is a mark of their renewed European attitudes after the conversion to Christianity that they began using both.

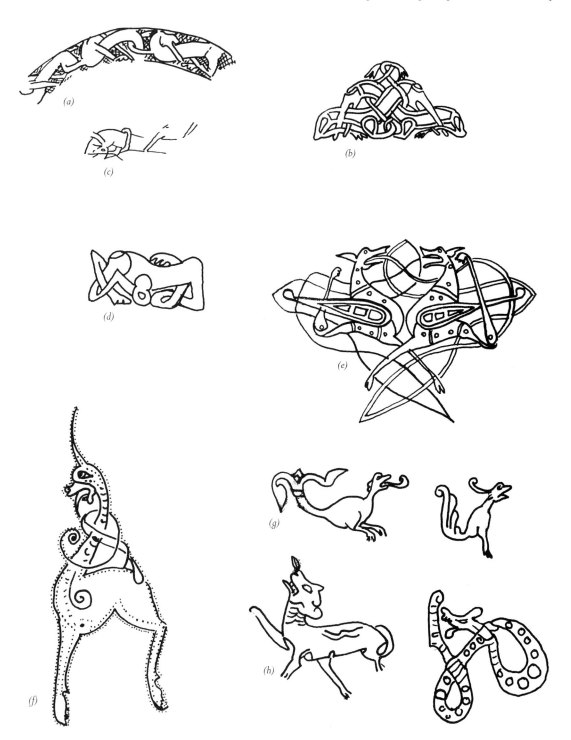

Seventh or eighth Anglo-Saxon animal ornament: (a) detail from back of a brooch, Faversham, Kent; (b) Crundale Down, Kent, sword pommel; (c) engraved detail from back of Crundale buckle, Kent; (d) Bamburgh, Northumberland, gold plaque; (e) Witham pins, Lincolnshire; (f) detail from initial L of St Matthew's Gospel, Leningrad Gospels, Leningrad Library (Cod. F.v.I.8, fol.18r); (g) Book of Cerne; (h) Sutton, Isle of Ely, Cambs., brooch.

(Above, below and opposite top): Clay moulds, Hartlepool, Cleveland, eighth century. D. of roundel with calf, 3 cm (Cleveland Museum Service)

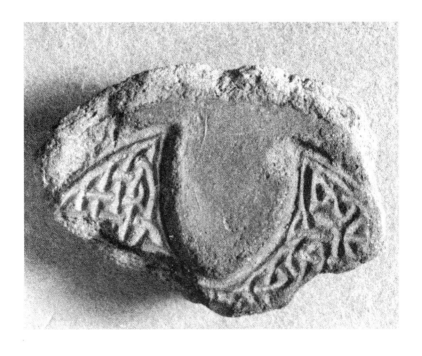

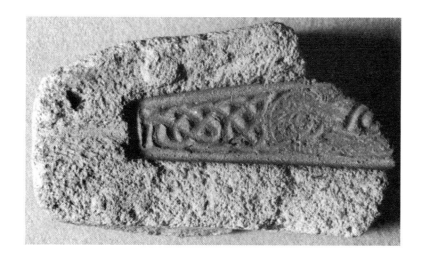

Monkwearmouth possesses notable architectural sculpture of the period. In the gable is a much-weathered sculpture probably representing St Peter, to whom the church was dedicated. A string course separating the first and ground floors was originally carved with a procession of animals, and the west porch doorway has a pair of moulded balusters with pairs of confronted lacertines, reminiscent of manuscript decoration in the Book of Durrow. All those entering the church had to pass through them, a rite of passage that is not fully understood, but seems to have been protective. Also from Monkwearmouth is a three-dimensional sculpture of an eagle head,

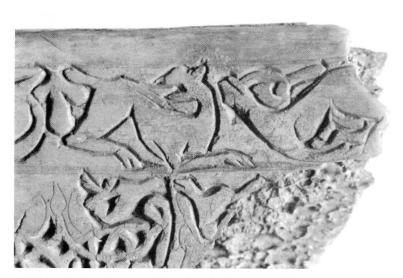

York, Station Road, motif piece. L. 11.5 cm (Reproduced by courtesy of the Yorkshire Museum)

Carving on entrance, Monkwearmouth, Tyne and Wear (Lloyd Laing)

originally probably from a stone seat. Fragments from a similar chair have been found at Lastingham, North Yorkshire, and all probably belong to the eighth century.[68]

These architectural sculptures are paralleled at Jarrow, where some of the pairs of lathe-turned balusters may have come from a screen, and where there is also a possible lectern base.[69]

The church at Hexham,[70] built in the late seventh century, boasts the Frith Stool, a stone bishop's seat carved with interlace and triquetra knots; another such seat comes from Beverley, Yorks. From Hexham also have come two fragments with reliefs of a boar, a lion, a fish and a bovine, perhaps part of a frieze, perhaps soffits. They still retain white underpaint.[71] The prototypes have been argued as coming from the Mediterranean, where such monuments as the ambo of Archbishop Agnellus at Ravenna Cathedral has rows of animals. From the outset the architectural sculpture included a variety of friezes with human figures and animals, in particular 'inhabited vinescrolls' which also appear on free-standing crosses (see p. 115). It seems probable that the idea of stone sculpture was introduced from Frankish Gaul in the 670s, and was first employed in the embellishment of such buildings, though probably its use was extended to free-standing sculpture from the end of the seventh century.

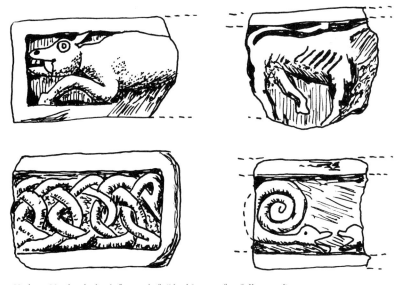

Hexham, Northumberland, frieze reliefs (Lloyd Laing, after Collingwood)

Interior decoration

From the surviving remains it is clear that some of the early Northumbrian churches were richly carved and painted, with stained glass windows and plastered and painted walls. Documentary sources provide further clues to the appearance of Northumbrian churches.[72] Bede informs us that Benedict Biscop went on pilgrimages to Rome, and brought back icons and relics.

Panel paintings were set up on boarding which extended from one wall to the other at Monkwearmouth, and included the Madonna and the Twelve Apostles. Panels on the south walls showed episodes from the Life of Christ and there were scenes from the Apocalypse on the north walls. Subsequently, pictures from the Life of Christ were installed high up all round the church.

A more sophisticated scheme of paintings was employed at Jarrow. Bede explained that Benedict:

arranged them most methodically to show the correspondence of the Old Testament and the New. For example, he juxtaposed the painting of Isaac carrying the wood on which he was to be sacrificed with one, just above, of Christ bearing the Cross on which He also was to suffer. He also matched up the serpent raised by Moses in the desert with the Son of Man raised up on the cross.[73]

Bede and other early medieval clerics had no interest in the artistic merit or otherwise of the pictures adorning the churches. Gregory the Great wrote to a bishop, 'For what writing is to the reader, painting is to the uneducated, for the perceptive can "read" a painting even if they do not understand letters. Therefore painting is especially suitable for pagans instead of reading matter.'[74]

With two late Saxon exceptions (see p. 176), wall-paintings have not endured from Anglo-Saxon England.

Apart from panel paintings and wall paintings, churches were adorned with tapestries and hangings: St Wilfrid bedecked the altar of the church at Ripon with silk interwoven with gold, while at Hexham, Acca draped his altar with 'rich stuffs'. In eighth-century Wessex, a church altar was festooned with gold textiles which 'shone with twisted thread'.[75]

Manuscript art

Manuscript art flourished in two main regions – south and north of the Humber – but there was very considerable influence and cross influence, both between the two areas and from outside, which makes study of the art highly complex.

Northumbrian manuscripts[76]

The earliest Insular manuscripts that have survived were those produced in the monastic foundation of St Columba at Iona, off the Scottish west coast. They include the Cathach of St Columba (probably early seventh century), and the more sophisticated Book of Durrow (of the mid- to later seventh century), which a number of scholars have seen as a product of Northumbria rather than Iona, due to some Anglo-Saxon features in its ornament.

Chronologically between these two Ionan books lies the Durham Cathedral manuscript A II 10.[77] Only twelve pages of this remarkable manuscript survive, and of these two are decorated. One is the opening of Mark with a strange marginal design of three stacked 'D's filled with non-zoomorphic interlace, the gaps between similarly filled and with a pelta in the bottom corner. The other has an initial letter of John. While there is a case for thinking it was also produced on Iona, the balance is in favour of its production on Lindisfarne before the Synod of Whitby, perhaps slightly before the middle of the seventh century. The use of a pelta betrays a Romano-Celtic ancestry to the ornament, though the yellow interlace has dotted infilling, probably in imitation of granular or filigree work in metal and bearing a certain resemblance to the zoomorphic interlace on the Sutton Hoo gold buckle.

By the end of the seventh century Insular art had developed by leaps and bounds, as is shown by the Lindisfarne Gospels, a complete book executed in the scriptorium at Lindisfarne by the monk Eadfrith sometime before 721, probably around 698. Current opinion favours the view that it was made for the enshrinement of St Cuthbert in that year, in the same way that the sumptuous Iona manuscript, the Book of Kells, was probably made for the enshrinement of St Columba.[78]

It is possible that a tradition of late Antique manuscript art survived in Britain into the fifth century as suggested by the possible attribution of the sumptuous Vatican Virgil to a British provenance.[79] Certainly there are decorative elements in the Lindisfarne Gospels that seem to echo some such manuscript, particularly the treatment of the draperies of the evangelist 'portraits', the tubular folds of which also recall some Romano-British sculptures. It is not impossible that some had been preserved and were used a models. It has also been suggested that the carpet pages may owe something to Romano-British mosaics. It is more certain, however, that imported Mediterranean manuscripts were providing inspiration for the Gospels.

The Lindisfarne Gospels are rightly regarded as one of the greatest achievements of Anglo-Saxon art, and indeed as one of the world's

Durham Cathedral A II 10 f.3b, decorative opening with Lord's Prayer. 385 x 250 mm (Dean and Chapter, Durham Cathedral)

finest examples of manuscript art.[80] Careful examination of the text has shown that, with the exception of the rubrics and some corrections and additions, the whole book was written by the same scribe.

There are fifteen richly decorated pages in the Lindisfarne Gospels, as well as detailed decorations in the text. Each of the gospels is preceded by an evangelist portrait page, with the accompanying evangelist symbol, followed by a cross-carpet page and a major initial page. A second major initial page was used to indicate the start of the story of the Incarnation in Matthew, with a further cross-carpet page and an initial page at the beginning the whole manuscript. Sixteen further pages set out the canon tables of Eusebius (designed to show where parallel passages in the Gospels were to be found), in decorated arcades.

The decoration is characterised by long-legged, long-beaked birds and animals (usually believed to be dogs, but including one cat) intertwined and in processions. Juxtaposed with these is a repertoire of more traditional motifs of ultimately Romano-British (and in some cases pre-Roman) origin, such as trumpet patterns, spirals, peltas and triskeles. Additionally, there are step, key, fret and interlace designs. A notable feature of the manuscript (found less liberally employed in other Insular works) is the use of red dots to provide a background stipple. There are about 10,600 of these on the initial page of Luke, and it has been calculated that working at the rate of 30 dots a minute, it would have taken six hours just to complete this element of the decoration on the page.[81]

Of comparable date but less frequently cited because it is poorly preserved, the Durham Gospels (Durham Cathedral A II 17) must have been a superb book.[82] Only two major decorated pages now survive; one is a fine miniature of the Crucifixion, flanked by seraphim and by the soldiers Longinus and Stephaton.[83] It has been suggested that it was the work of one of Eadfrith's contemporaries who was also responsible for a further manuscript now preserved in Paris, the Echternach Gospels.[84] For this reason he has been dubbed the Durham–Echternach calligrapher. The Echternach Gospels was probably made as a gift for the newly founded monastery of Echternach, now in Luxembourg, in 698.

The above-mentioned manuscripts were all decorated in an Insular tradition, which blended 'Celtic' and 'Classical' elements. The Codex Amiatinus[85] belongs to a purely Classical past, and is the only complete survivor of three Bibles produced at Monkwearmouth or Jarrow for Abbot Ceolfrith before 716, though unornamented leaves from a second survive. Ceolfrith intended it as present for the Pope, and travelled with it to Italy. When he died in France the manuscript found its way to a central Italian monastery. Its interest lies in the fact

that it is a close copy of an Italian sixth-century exemplar, and shows that such models were available in Northumbria; the 'portrait' of Ezra can be seen as a possible model for St Matthew in the Lindisfarne Gospels.

'Southumbrian' manuscripts

The second centre for manuscript production was Kent, where Canterbury has been seen as possessing a scriptorium responsible for a number of major works in a different tradition from those of Northumbria. The 'Canterbury School' as it has been termed, however, is a loose label given to the products of a number of centres, some of them in Mercia, since eighth-century Kent came under Mercian influence. Just as the term 'Insular' is now often used to obscure the fact we cannot be certain whether a manuscript was produced in Northumbria, in Ireland or Iona, so the term 'Southumbrian' is used to describe works produced south of the Humber: apart from Canterbury, manuscripts were produced at Worcester, Hereford and Lichfield amongst other places.

Of the Southumbrian manuscripts, two are undoubtedly products of Canterbury. The most extravagant of these, the Stockholm Codex Aureus,[86] partly drew upon St Augustine's Gospels, and combined 'Antique' elements with details of 'Celtic' ornament. It was probably made around the middle of the eighth century, and was looted by Vikings from whom it was ransomed back in the ninth century and given to Canterbury. It is richly coloured, its pages stained the imperial purple and richly embellished with gold.

Similarly colourful, the Canterbury (or Vespasian) Psalter is somewhat earlier, produced around 725 in St Augustine's Abbey.[87] Text and decoration were by the same hand, and drew on a range of sources – Italian, Oriental, Frankish and Insular – for inspiration. A Greek psalter seems to have been the model for the pictorial images of David, of which the most imposing is perhaps a full-page embellishment of him as harpist surrounded by scribes and musicians, in an arched frame with insular details. Oriental-looking plants fill the areas on each side of the arch, and the animal ornament owes something to Lindisfarne as well as perhaps to Continental models.

A collection of manuscripts, labelled the 'Tiberius' group (because of the bust of that emperor positioned at the end of the shelf in the Cotton Library on which a copy of Bede in this group was housed), were mostly produced in Mercia, at the beginning of the ninth century. The most famous, the Book of Cerne, was a prayer book probably produced at Lichfield for Aethelwald, who was bishop there from 818 to 830.[88]

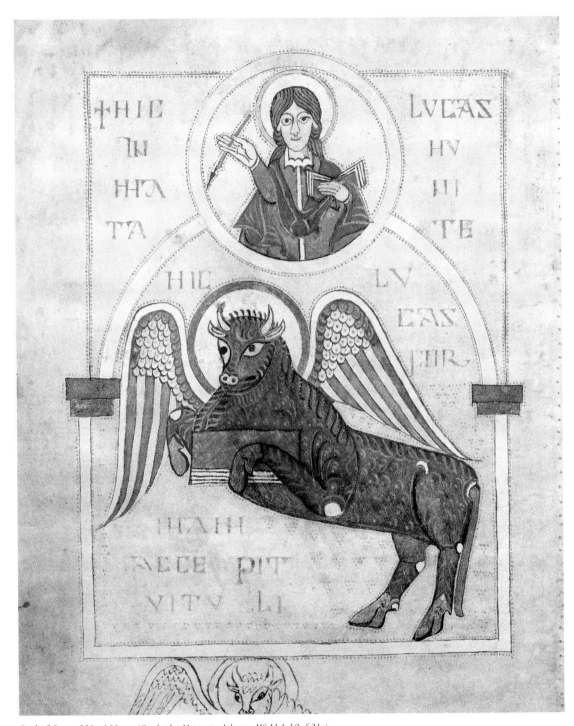

Book of Cerne, 230 x 180 mm (Cambridge University Library, MS Ll.1.10, f.21v)

Little decorative work survives in Cerne, but the page with a portrait of St Luke is of particular interest. Here the scribe seems to have tried out the upper part of the bull symbol at the bottom of his sheet of vellum, before copying it in its rightful place. Clearly, however, he had no model for the hindquarters, which appear to have been borrowed from somewhere else and inadequately added.

Techniques of the manuscript illuminator[89]

Detailed study of the Lindisfarne Gospels has enabled a picture to be built up of the techniques of the Anglo-Saxon scribe. As many as 129 calf skins were used in the Lindisfarne Gospels. The sheets were bound up in quires. On the Continent a double-sheet (bifolia) had to be contrived so that hair sides would face each other when a double page was opened. Due to the similarity of both sides in Insular manuscripts, this was not deemed necessary. Quires were usually in tens or eights, eight becoming the norm after AD 700.[90]

The Lindisfarne pages were arranged in groups of eight: four large sheets of vellum were laid on top of one another before being folded down the middle. There are 258 leaves in the manuscript, which required 129 pages of vellum. The vellum was calfskin, and as the spine of the animal ran horizontally across the book, it is likely that one animal provided each sheet, which was carefully prepared in a bath of alum and lime so that both hair side and flesh side was usable – the hair side is generally darker. Insular manuscripts differ from those on the Continent since they utilise thicker parchment with less contrast between the 'hair' and 'flesh' sides.[91]

Marking out the pages to indicate where the writing was to go, was effected by pricking with a stylus or in some cases a knife (which left a wedge-shaped hole). The pricking was vigorous enough for the marks to go through all eight sheets. Each sheet was then ruled out with a hard, round point which made an impression on the page for the writing – the two columns of text were defined by a double vertical line on the left and a single on the right; small initials went between the lines on the left. The lines of text were set out between guiding marks, through which lines were drawn with some kind of instrument in which the points were set at a fixed distance apart – only one mark was needed to position each pair of guide lines. The pens used would have been either quills or reeds.

The decorative pages were built up on a complex network of lines, and key pages seem to have been made separately and inserted. Using a pattern of prick-marks, a mathematical grid was laid out using compasses, grid lines and rulings.[92] Some of the outlines were drawn with a dry point (which shows where the scribe changed his mind), but

Lindisfarne Gospels page, back, showing pricked design (British Library, Cotton Nero D iv, f.94 r.)

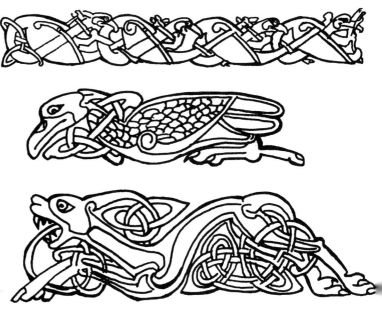

Lindisfarne style birds and dog, from the Lindisfarne Gospels (Lloyd Laing)

the detailed drawing seems to have been done freehand. Something akin to a pencil was used on the backs of the major decorated pages. Designs would have been tried out on motif pieces or on wax tablets, of which one has survived from Blythburgh, Suffolk; we know, for example, from Adamnàn (the biographer of Columba at Iona) that these were used to make sketches for his work on the *Holy Places*.

Such techniques were not peculiar to Lindisfarne: the Echternach Gospels, for example, betrays the same device of pricking, and holes can be seen where compass points were used even in building up images such as the eagle of St John.

Analysis of the pigments used in the Lindisfarne Gospels shows the binding medium to have been white of egg, though fish glue was also used sometimes. Colours included red and white lead, verdigris, yellow ochre, orpiment (yellow arsenic sulphide), kermes (red, from insects found in the Mediterranean), gall and indigo (from the Mediterranean). Pinks and purples came from folium (from the turnsole plant). The most exotic colour was lapis lazuli (blue). Gold was rarely used, the effect normally being achieved by yellow. Forty-five pastel shades were achieved in the Lindisfarne Gospels.[93]

Early manuscripts tended to employ three colours – red (red lead), green (verdigris) and yellow (orpiment) – but the range of colours was extended under Mediterranean influence. There are later medieval records of even more unusual sources for pigment such as stale urine and ear wax.[94] Ink was made from oak gall mixed with carbon (lampblack) sometimes with an iron extract.[95]

The beginnings of sculpture

Northumbria, Kent and Mercia in particular have produced some fine examples of non-architectural sculpture – notably free-standing crosses, cross-shafts, some fine friezes and some memorial stones.

Northumbrian sculpture

Some uncertainty surrounds the exact dating of the earliest free-standing sculpture, the study of which in the past has been somewhat overshadowed by the dating of the crosses at Ruthwell (Dumfriesshire)[96] and Bewcastle (Cumbria).[97] Often claimed to mark the beginning of sculpture in England, these may nonetheless represent a stage in the development of Northumbrian sculpture when the art was already well-established. Current opinion dates them to around 725–50.[98] The Ruthwell Cross is an elegant monument with tapering shaft and subtly moulded head. Panels of figural work combined with inscriptions and ornament appear on front and back, with inhabited vinescroll ornament

on the sides. The most important scenes depict St John with his eagle, John the Baptist with his Lamb (or possibly God the Father), Christ in Glory, with His feet on two animals, the hermit saints Paul and Anthony, the Flight into Egypt, the Visitation of Mary, and Christ with Mary Magdalene washing His feet. There is also a badly damaged Crucifixion and an archer. It carries a text of the Anglo-Saxon poem *The Dream of the Rood* in runes. The influence of Romano-British art in this highly sophisticated work has been seen in such details as the treatment of draperies. Some of the iconography seems to relate to the eastern hermit saints.

The Bewcastle Cross which stands in a churchyard within a Roman fort, lacks its head, but the shaft depicts in descending order John the Baptist, Christ in Majesty and St John the Evangelist. The side panels display interlace, chequer patterns and vinescroll. It too displays a runic inscription, and additionally a sundial.

We are informed that Oswald erected a timber cross before the battle of Heavenfield in 633, and there is a tradition that this gave rise to the custom of erecting free-standing crosses in Northumbria. The earliest reference to stone crosses appears in the canons of Archbishop Theodore of Canterbury (668–90), which stated that stone crosses were to be erected to mark the position of altars that had been removed.

If the cross from Jarrow (known as no. 2) is contemporary with the architectural sculpture from the church to which its decoration is closely related, then it may belong to the late seventh century.[99] A less dubious contender as the earliest cross in the Northumbrian heartlands

Bewcastle Cross, Cumbria (Andrea Crook)

is that known as Acca's Cross at Hexham, which is decorated with elaborate vinescroll ornament clearly modelled on some Mediterranean prototype, perhaps in ivory.[100] The cross bears an illegible inscription, and has been seen as one of a pair set up at the head and foot of the grave of Bishop Acca in 740, but there is no justification for this identification, and the date remains open.

Such free-standing crosses undoubtedly served a variety of purposes: as outdoor foci for prayer or for services, to demarcate boundaries, or to mark graves. Documentary sources provide a few clues. Huneberc, an eighth-century nun, noted that St Willibald was dedicated to the monastic life by his parents 'not in the church but at the foot of the cross, for on the estates of the nobles and good men of the Saxon race it is a custom to have a cross, which is dedicated to Our Lord and held in great reverence, erected on some prominent spot for the convenience of those who wish to pray daily before it.' Other functions of crosses indicated in literary sources included the marking of resting places of a saint's cortège (an Anglo-Saxon counterpart of the medieval Eleanor Crosses), the marking of a sanctuary, and possibly as a means of converting a pagan sanctuary for Christian use.[101]

Anglo-Saxon crosses are typically composed of a square, tapering shaft and free-arm head (as distinct from the ringed head of Celtic crosses, though these also occur in the later period), ranging in height from under a metre to six metres. Some are carved from a single block of stone, others assembled in sections and fastened together with tenon-and-mortice jointing, probably derived from woodworking. The head is sometimes fastened with an iron stay. The shapes of the heads vary – some have cusped arms, others are more fan-shaped.[102]

A second type of cross, encountered in the ninth century, has a round section and is generally assumed to be a stone version of a wooden rood. In one group the upper part of the shaft squared off, with swags or a moulding dividing the two parts, the latter perhaps representing a rope binding found in a comparable position on a wooden rood.

Northumbrian memorial stones

The Northumbrian monasteries have produced a series of memorial stones, probably laid recumbent on graves.[103] Good examples have come from Lindisfarne, Hartlepool and York, where slightly larger slabs may have been set up like tombstones above the graves. The smaller stones are usually termed 'pillow stones' from the earlier belief they were used under the heads of the deceased. They date from the late seventh and eighth century, and are usually decorated with a cross and

DIC INSE
PUL CRO
REQV IESCIT
COR ORC
hERE BERI
CbT PRB

Herebericht Stone, Monkwearmouth, Tyne and Wear, reconstructed (Lloyd Laing, after Bailey, with alterations)

the name of the deceased. One good example from Lindisfarne names a lady called Osgyth; another, more sophisticated example from Monkwearmouth has a relief cross framed by a pair of confronted birds of prey. The inscription requests a prayer for Herebericht.

Kentish sculpture

Outside Northumbria there is very little evidence for sculpture before the end of the eighth century. A couple of stones from Sandwich, one with a runic inscription, and a fragmentary inscription in St Martin's, Canterbury, built into a door jamb[104] can be ascribed to the last quarter of the seventh century. This is notably around the time that architectural sculpture began.

It has been suggested that fragments of a cross from Reculver, now in Canterbury Cathedral, date from the seventh century, though over the years this has been vigorously debated, and it has also been seen as a product of the late Saxon 'Winchester School' (see p.170) or of the eighth or ninth century.[105] The six fragments that survive are from a round shaft, with naturalistic figures with flowing draperies and some interlace.

Mercian sculpture

A study of Mercian sculpture must begin in the mid-eighth century with friezes and other pieces from Breedon, Leics.[106] The Breedon sculptures include a frieze which ran round the outside of the church, a device taken up in late seventh-century England from Italian or even

Fragments of cross shaft, Reculver, Kent (Lloyd Laing)

Syrian sources, via Frankish derivatives. The frieze at Breedon displays a great diversity of elements: geometric designs, animals, plant and vinescrolls. Characteristic features are undercutting and strong modelling, with deeply drilled eyes on the figures. It has been suggested that Offa may have acquired Syrian textiles from the loot which Charlemagne captured from the Avars and shared with him. These and other silks known to have been imported from the East may have been models.[107] Other sculptures from Breedon include a panel with a fine angel.

There are comparable frieze sculptures from Fletton, Hunts., and Ely, Cambs., and panels from Fletton, Castor, Cambs., and Peterborough, Cambs., from where the church at Breedon was founded.[108] Most of these belong to the early ninth century, but the Headda stone in Peterborough Cathedral is somewhat earlier. It is a stone shrine tomb (a solid replica in stone of a house-shaped shrine) and has rows of saints in an arcade down each side. This fine monument is a reminder that such shrines were found widely in Britain with the development of the cult of relics.[109]

Breedon, Leicestershire, angel sculpture (Philip Tallon)

Originally representing chapels with hipped roofs, some were constructed of panels slotted into uprights in the manner of woodworking. The finest is the Pictish St Andrews sarcophagus from Fife, but there are examples from as far afield as St Ninian's Isle in Shetland and from Ireland. Solid block shrines of the Headda stone type are also represented at Bakewell and Wirkworth in Derbyshire. The model for the Headda stone is probably, however, not one of the slab shrines but a metal reliquary.

There is a notable series of cross-shafts from Mercia, mostly of the later ninth century. A cross-shaft from Repton, Derbyshire, perhaps reflects the royal influence at work in the late eighth century. On the front is a dramatic representation of a horse and rider, while the side bears a human-headed serpent swallowing the heads of two human figures. Late Antique models have been seen as the precursors of the horseman, but his moustache and short sword are distinctively Insular.[110]

Church metalwork

Most of the metalwork surviving from Christian Saxon England has comprised stray finds, though groups of decorative pieces have come to light in excavations on monastic sites such as Whitby, Yorks.; Bawsey, Norfolk; or Flixborough, South Humberside.

There are a few very important pieces of ecclesiastical metalwork of the Middle Saxon period, which start with Northumbrian objects, such as St Cuthbert's Pectoral Cross and portable altar (see p. 81). When clerics

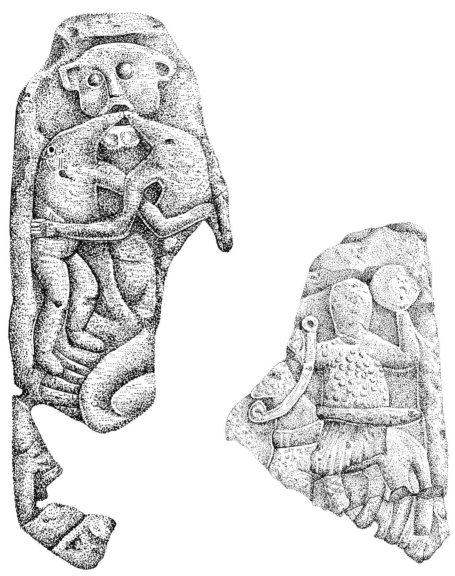

Repton, Derbyshire, shaft (Cilla Wild)

embarked on missionary activities it was impossible to take a bishop along to consecrate an altar, and so they carried a small, pre-consecrated tablet that could be set on top of an improvised altar in the field. Sometimes these seem to have been carried in a satchel round the neck, in which case some stone portable altars from the Celtic areas must have been very inconvenient to transport.

St Cuthbert's portable altar[111] which was found in his tomb was of oak, inscribed with crosses and a text, in the style of the Lindisfarne

Gospels, naming St Peter. In the eighth century it was encased in silver, though a panel was left uncovered so that the faithful could touch the altar – some seem to have removed splinters of wood as relics. The silver casing is decorated with interlace patterns and with a leaf-flower motif, and has a now very fragmentary inscription. On the back is a fragmentary figure with a halo, probably St Peter.

The monastery at Whitby, Yorks.,[112] had produced a variety of objects, including interlace-decorated chip-carved mounts from reliquaries or from book covers.

Masham, Yorkshire, shaft (Jenny Laing)

It is possible that some hanging bowls were put to liturgical use, perhaps for washing vessels for Mass, for washing hands, or possibly even as portable fonts. Some of those found in ecclesiastical contexts, such as that from a burial in St Paul-in-the-Bail in Lincoln,[113] may originally have been made in a British workshop for another purpose. Those from Whitby, however, are Anglo-Saxon products, and their Christian significance is indicated by the cross on one of the escutcheons from the site.

During building works in Glastonbury, Somerset, a censer was found datable to the later sixth or seventh century.[114] It was an import from the Byzantine world, probably of the early seventh century, and was found to contain traces of a gum resin, possibly myrrh.

English metalwork and the Continent

The finest pieces of surviving ecclesiastical metalwork in Anglo-Saxon style come from parts of the Continent which were spared Viking raids. Although there is reason to suppose that several English objects must have reached Continental monasteries that were founded by English monks or which maintained close links with England, most of the finest pieces seem to have been produced abroad and display both English and Carolingian features. Fine examples are the chip-carved Tassilo Chalice from Kremsmünster, Austria, datable to 777–88, or the cover of the Lindau Gospels, datable to around the end of the first quarter of the ninth century.

Totally English in spirit (though possibly made by an English craftsperson on the Continent) is the Rupertus Cross from Bischofshofen in Austria.[115] Free-standing, it is of maple wood covered with gilt bronze plates and with glass studs. The narrow arms expand in a gentle curve to the squared ends, somewhat like the head of the Ruthwell Cross, but more elegant. The ornament on the front plates (there are none on the back), which is executed in repoussé work with chasing, comprises inhabited vinescroll in which a variety of birds and animals cavort. The edges have similar plates with interlace, knotwork and very stylised vinescroll. Traditionally associated with St Rupert, the

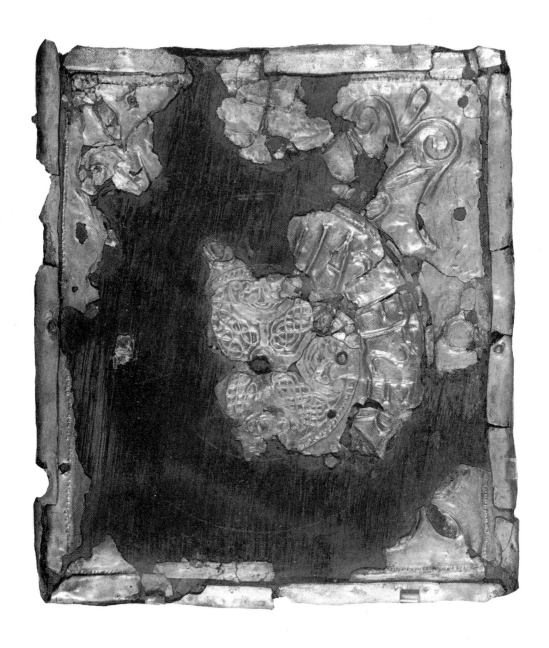

St Cuthbert's portable altar, wood and silver. H. 12.5 cm (Dean and Chapter, Durham Cathedral)

aaa

cross was made about fifty years after his time. The cross shares some similarities with the ornament on the Ormside Bowl (see p. 129).

Dating from the early years of the ninth-century, a purse-shaped reliquary was found with ninth- and tenth-century pottery in a pit in Sussex Street, Winchester, Hants., in 1976. It has a wooden core (this time beech) covered with gilt-bronze repoussé plates with chasing.[116] The base has two relic cavities, and a piece of parchment seems to be a label identifying the relics it contained. It shows the fusion of English and Carolingian work – the back has Carolingian acanthus ornament, and seems to have been taken from something else. The front shows a seated figure of Christ in Anglo-Saxon style.

Winchester reliquary, restored design, H. 17.5 cm (Winchester City Museum. Lloyd Laing)

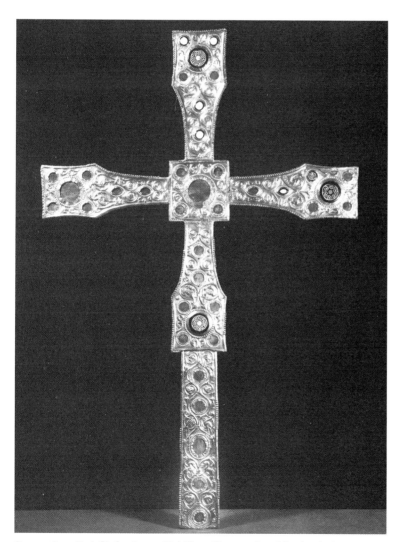

Rupertus Cross, Bischofshofen, Austria. H. 158 cm. The original is exhibited in the Dommuseum zu Salzburg (Salzburg Diocesan Museum)

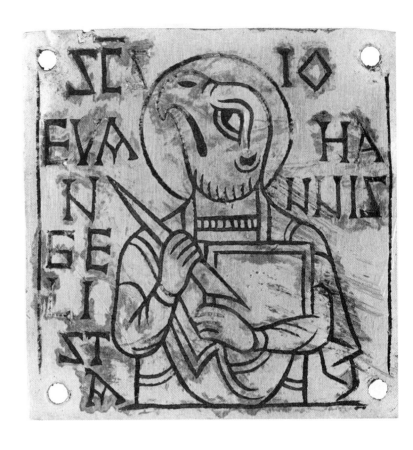

Brandon, Norfolk, gold plaque.
H. 3.4 cm (British Museum)

Of the early ninth century are a number of finds from a site at Brandon, Suffolk,[117] which may have been a monastery. The most remarkable is a gold plaque with niello inlay, 3.5 by 3.3 cm, with the symbol of St John and an inscription 'St John the Evangelist'. It has attachment holes at each corner, and the style of the symbol recalls manuscripts, most notably the Book of Cerne.

Ecclesiastical art in wood, bone and leather

Very little organic material survives from Middle Saxon England. A notable exception is the Coffin of St Cuthbert,[118] in which the remains of the saint were found. The coffin comprises a wooden chest with crudely engraved representations of Christ and the Apostles with identificatory inscriptions. Its art seems charmingly naif, but can be compared with work encountered in southern France in the same period, for example in the Hypogeum at Poitiers.

The Franks Casket takes its name from Augustus Franks, a notable collector who was also a nineteenth-century curator in the British

Cuthbert's coffin. Detail of panel depicting the Virgin and child (Dean and Chapter, Durham Cathedral)

Museum.[119] Made of whalebone, it is a rectangular box with a diversity of scenes from many different sources, Roman, Jewish, Christian and Germanic. It also bears inscriptions in Latin and runes, which betray the fact that it was probably made in Northumbria or north Mercia in the eighth century. It was produced at some centre of learning – one suggestion is that it was Ripon, though Lindisfarne is a possibility. The inspiration behind it is probably an Early Christian casket from the Mediterranean. Among the scenes depicted are Romulus and Remus with the wolf; Weland Smith; the Capture of Jerusalem by Titus; Egil; and the Adoration of the Magi. The right-hand end panel is now in the Bargello in Florence (a replica has been fitted to the casket), and for a while it seems to have been used as a workbox by a French lady. How it got to France is not known, though it was probably during the Middle Ages rather than later. Some details of the figural work recall that of Pictish stones, others Mercian animal art.

The Romulus and Remus scene on the Franks Casket is mirrored on a small bone panel from Larling, Norfolk, found in 1971.[120]

The Larling piece can be compared also to the Gandersheim or

Franks Casket. Detail showing scene with Weland Smith, and Adoration of the Magi. L. 23 cm (British Museum)

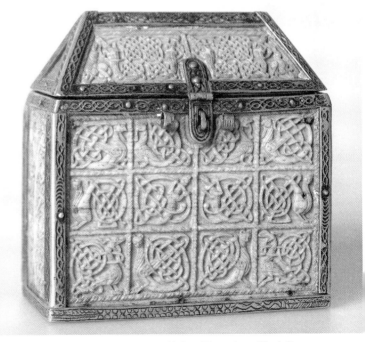

Brunswick Casket, Gandersheim, Germany. H. 12.6 cm (Herzog Anton Ulrich-Museum, Braunschweig)

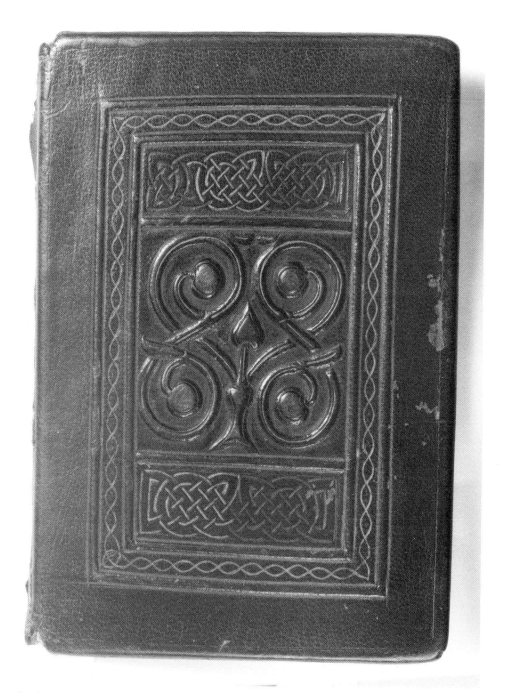

Stonyhurst Gospels (St Cuthbert's Gospels), leather binding. 13.8 × 9.2 cm (British Library)

Brunswick Casket, now in Germany but originally made in Anglo-Saxon England probably as a shrine.[121] This magnificent object is made of plates of whalebone set in a bronze frame. The high relief carving comprises animals and birds combined with interlace. It bears a runic inscription, which cannot be satisfactorily read. Datable to the late eighth century, the animal ornament shows links with creatures in a manuscript known as the Leningrad Gospels, as well to the decoration on the Headda Stone.

The Stonyhurst or Cuthbert Gospels (for long in Stonyhurst College) is the name given to a manuscript of the Gospel of St John buried with St Cuthbert.[122] Its importance lies in the fact it still retains its leather embossed binding – the earliest European binding still attached to the book for which it was made. Of red goatskin, it has a plant motif on the cover, apparently moulded over string, and an interlace design. It may have been given to Lindisfarne from Monkwearmouth/Jarrow at the time of the translation of Cuthbert's body in 698. It serves as a reminder that fine bindings must have been commonplace in Anglo-Saxon England – we know that the Lindisfarne Gospels had a cover encrusted with precious stones, and others are documented.

Textiles

Few examples of textiles have survived from pre-Viking Christian England, but the Maaseik embroideries of SS Harlindis and Relindis, now in Belgium, are of English manufacture. Dating from the late eighth or early ninth century, they are executed in silk threads (red, yellow, beige, green, light blue and dark blue, as well as spun gold). Three designs survive; one of continuous arcading containing close-packed ornament with animals and plants; secondly roundels, containing birds and animals, and thirdly monograms. Pearls or bead were added slightly later, on the Continent. The embroideries serve as an important reminder of the high quality of early Englishwomen's needlework.[123]

Secular art

There are comparatively few major pieces of secular art from the period from the later seventh century; the symbol of status was land rather than the products of the sumptuary arts. With a few exceptions, most are minor pieces of personal adornment.

The most remarkable piece of eighth-century secular art is a helmet from Coppergate, York, discovered with a spearhead in a wood-lined pit.[124] The helmet is made of iron with bronze mounts, and has hinged cheek pieces and a chain-mail neck-guard. The nose-guard is decorated with a pair of confronted, intertwined animals, and the crest, which

ends in an animal head, bears an inscription in repoussé work naming Oshere, presumably its owner. Helmets were rare possessions among the Anglo-Saxons and may have been produced as one-off commissions (most warriors probably wore hoods of leather, which has been proven to be more durable against sword attack). The extant helmets are generally descended from Roman antecedents, but display considerable variation. This one, with its cheek pieces and animal-headed crest, is in a general line of descent from that from Sutton Hoo.

A few sword pommels reveal just how splendid the panoply of an Anglo-Saxon warrior could be in the Christian period. A horn pommel from Cumbria displays gold filigree insets. The silver, mid-eighth-century sword pommel from Windsor, Berks., is adorned with gold filigree of a vinescroll with clusters of fruit (in the form of granules) in which two snakes are coiled.[125]

The silver sword pommel from Fetter Lane, London, dates from the late eighth century,[126] and with its gilding and niello inlay is a superb example of silversmithing. Only the upper part of the grip survives, and is decorated with a spreadeagled animal in a leaf-pattern background on the front and a spiral of four snakes with more leaves on the back; the style of the ornament has Mercian affinities.

Not all Middle Saxon secular metalwork is of a military nature. The Ormside Bowl is a late eighth-century descendant of hanging bowls,

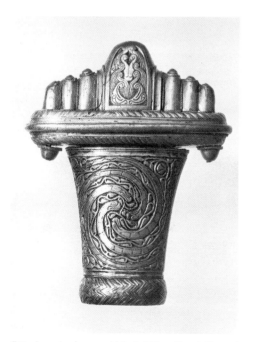
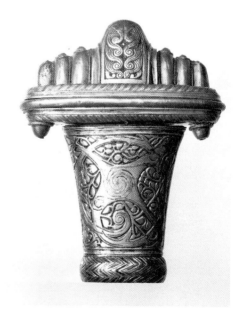

Fetter Lane, London, sword hilt. L. 8.7 cm (British Museum)

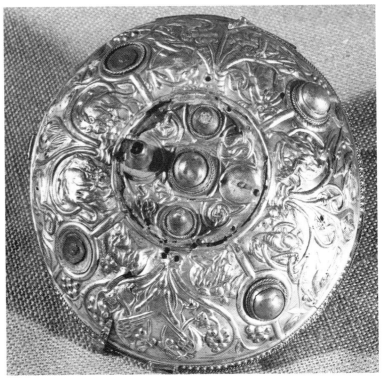

Ormside bowl, Cumbria. D. 13. 8 cm. Detail of ornament (Reproduced by courtesy of the Yorkshire Museum)

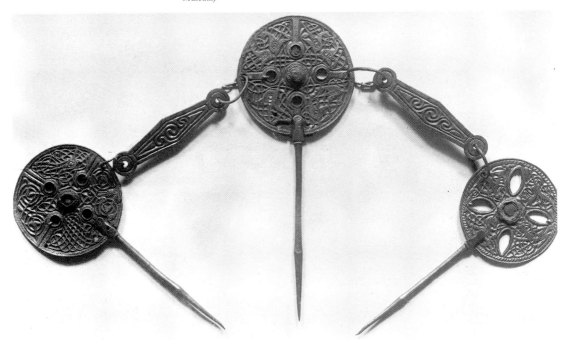

Witham pins, Lincolnshire (British Museum)

though it was never suspended. It comprises a double shell, the inner of gilt bronze, the outer of silver gilt, rivetted together and further ornamented with interior and exterior basal escutcheons and with blue glass studs.[127] Repair clips with animal heads on the rim resemble ninth-century strap ends, and the bowl, which was found in the churchyard at Ormside, Cumbria, probably came from a Viking grave. The decoration is essentially inhabited vinescroll; the animals are in a Mercian tradition. While probably a secular piece, it might equally well have been looted from a church.

The remaining extant pieces of secular metalwork are mostly items of fashion – decorated pins, hooked tags, strap ends, finger rings and brooches. Of these the three linked pins from the River Witham – two original, the third a replacement – stand out.[128] Their round, openwork heads were made separately and attached to their pins, and they display leggy, prancing animals that mark the Mercian tradition of the eighth and ninth centuries. A superb example of the style can be seen in a gilt silver disc brooch from Flixborough, South Humberside, with prancing, confronted animals related to those on the Witham pins.[129]

Notes

1. Campbell *et al.* 1982, 45–69; Mayr-Harting, 1972.
2. General account of the history in Higham, 1993.
3. Stenton, 1971, 236; Hodges, 1989, chap. 4; Wormald, P. 'The Age of Offa and Charlemagne', in Campbell, *et al.* 1982, 101–31.
4. Hope-Taylor, 1977.
5. Rahtz, in Wilson, 1976, 65–8.
6. Williams, Shaw and Denham, 1985.
7. Hodges, 1989, chap. 3.
8. Hamerow, 1993.
9. Ibid.
10. Hamerow, 1993, 17.
11. Hodges, 1986, 63; Arnold and Wardle, 1981, 145–9.
12. Hodges, 1986.
13. Bruce-Mitford, in Battiscombe, (ed.) 1956, 308–25; Coatsworth, 1989.
14. Webster, 1982.
15. Bruce-Mitford, 1974, 288–90.
16. Hawkes, 1973.
17. Jessup, 1950, 122.
18. Grierson, 1952; Werner, 1991.
19. Werner, 1991.
20. P. Brown, 1971.
21. Mayr-Harting, 1972.
22. Cramp, 1969.
23. Fletcher, 1980
24. Ibid.
25. Ibid.
26. Hodges, 1989, 71–9; Blackburn, 1984, 165–74.

27. For coinage of Offa, Blunt, 1961.
28. Hodges, 1982, 104–17.
29. Addyman and Hill, 1968; Addyman and Hill, 1969; Holdsworth, 1980.
30. Hall, 1988, 125–32.
31. Biddle, 1976.
32. Rahtz, 1977.
33. Haslam, 1987.
34. For work at Hereford, Rahtz, 1968. For Tamworth, Selkirk, 1971. Rahtz, 1977; Radford, 1970.
35. Contacts between England and the Continent in W. Levison, 1946. Artistic links summarised in Webster and Backhouse, 1991, 157–92.
36. Haseloff, 1950.
37. Webster and Backhouse, 1991, loc.cit.
38. Wormald, 1984.
39. Morris, 1983, 34–5; Fernie, 1983, 32–46.
40. The first church on the site excavated at St Paul-in-the-Bail in Lincoln seems to be of fundamental importance in studying the link between Romano-British and Anglo-Saxon church architecture. Excavation showed that this building originally had a stilted apse with quadruple chancel arch and was built in the forum area of the Roman town. It was replaced with a mausoleum, which was supplanted by two later Anglo-Saxon churches.

 A burial with a seventh-century hanging bowl was found belonging to either the first or second phase, and bones from the site were dated by radio-carbon to between the fourth and seventh centuries. Four material samples produced dates from the earliest 'apsidal structure' – two may belong to pre-structure burials, but two came from burials made after the first church had gone out of use, and confusingly suggest a deposition in the first half of the sixth century. If the radio-carbon dates are accepted, the first church pre-dates Paulinus and represents a Roman or post-Roman structure. If this is the case, the burial with the hanging bowl may have been made at a time when the site was abandoned.

 The plan of the first church at Lincoln, however, might suggest it was a transplant of the type of plan employed in Kent, and thus may date back to the time of Paulinus rather than earlier. Commentators who prefer to reject the evidence pointing to a sub-Roman church see the first church as that constructed by Paulinus, and have pointed out that while there are differences between the Kentish and Northumbrian churches, features of Kentish churches (the stilted apse and porticus) are on occasion found in Northumbria.
41. Jenkins, 1965.
42. Blockley, 1993; full publication forthcoming as K. Blockley, *Canterbury Cathedral: Excavations in the nave and south-west transept*, 1993.
43. Blockley, 1993, 126.
44. Taylor and Taylor, 1965, 694.
45. Fernie, 1983, 38; Taylor and Taylor, 1965, 92–3.
46. Webster and Backhouse, 1991, 34.
47. Hope-Taylor, 1977.
48. Cramp and Daniels, 1987.
49. Fernie, 1983, 54–5; Taylor and Taylor, 1978, 1062; Pocock and Wheeler, 1971.
50. Fernie, 1983, 48–50; Cramp, 1969, 21–66.
51. Fernie, 1983, 50–52.
52. Higgitt, 1979.
53. Fernie, 1983, 59–63.
54. General studies in Fernie, 1983, and Taylor and Taylor, 1965; 1978.

55. Biddle, 1966b; Kjolbye-Biddle, 1986.
56. Blockley, 1993, 127.
57. Fernie, 1983, 65–8; Stones 1980, 37–63.
58. Parsons, 1980.
59. Fernie, 1983.
60. The cross carries a poem (*The Dream of the Rood*) in runes. Recently it has been argued that each half of the poem relates to the iconography on the relevant broad face of the cross. The iconography begins with the Crucifixion at the foot on the east side and ends with the evangelists and their beasts at the top on the west. Further, it is argued, the whole scheme was designed for contemplation while moving sunwise round the monument, as this enabled the poem (which runs from north to south), and the iconography (which runs from east to west), to be correlated. The iconography related to the liturgy. If this was not complex enough, patristic tradition held that Christ faced west on the cross, and thus Eucharistic images were placed to face west at Bewcastle and almost certainly at Ruthwell also, though since the cross has been moved there is an element of doubt about its original orientation. Conversely, however, the Crucifixion scene on Ruthwell comes at the bottom of the side which probably faced east. This feature, which is also found on other Northumbrian crosses of the period, was designed to stress the apocalyptic significance of Christian Majesty, rather than the suffering Christ. In the depiction of the Crucifixion, two circular objects flank the cross, representing (it has been assumed) sun and moon. The Anglo-Saxons believed the Crucifixion and Annunciation took place on the same day, the spring equinox, 25 March (of the Julian calendar), and Bede commented on how Christ, the Light of the World, chose to be conceived and to die on the day that light overcame the darkness. These points are only some that might be made about the iconography of the Ruthwell Cross, which serves to emphasise that such monuments were intended to be read at different devotional levels by the onlookers. O'Carragain, 1983, 64.
61. Lang, 1988, chap. 4 on iconography. Shelford, 22.
62. Bailey, 1992.
63. Webster and Backhouse, 1991, 58.
64. Cramp and Daniels, 1987.
65. Webster and Backhouse, 1991, 231.
66. Webster and Backhouse, 1991, 280.
67. Budny and Graham-Campbell, 1981.
68. Lang, 1991, 9.
69. Cramp, 1984, 120–21.
70. Cramp, 1974.
71. Cramp, 1974, 119.
72. Dodwell, 1982, 84–8.
73. Quoted in Dodwell, 1982, 85.
74. Dodwell, 1982, 84.
75. Dodwell, 1982, 129f on textiles generally.
76. For Northumbrian art generally, Neuman de Vegvar, 1984.
77. Henderson, 1987, 27–9; Nordenfalk, 1947 for all pre-Durrow manuscripts.
78. Literature enormous. Accessible accounts in Backhouse, 1981 and Henderson, 1987, chap. 4. Detailed account in Kendrick *et al.*, 1956–60.
79. Dark, 1994, 185–6.
80. A colophon of the mid-tenth century explains that it was the work of Eadfrith, Bishop of Lindisfarne Church, and that the binding (which does not survive) was done by Ethelwald, Bishop of the Lindisfarne Islanders. The decoration of the

binding, in gold, silver and gems, was the work of Billfrith. We are told that the English glosses were the work of Aldred, 'unworthy and most miserable priest'. It is likely that it was executed by Eadfrith before he became bishop in May 698. Backhouse, 1981, 14.

81. Backhouse, 1981, 51.

82. Henderson, 1987, 57f.

83. The composition is not dissimilar in its treatment to that found on the Rinnigan (Athlone) Crucifixion plaque from Ireland, arguably of slightly later date. The main initial of John also survives, with animal interlace and with relatives of the birds found in the Lindisfarne Gospels.

84. Henderson, 1987, 71f; Bruce-Mitford, 1989.

85. Bruce-Mitford, 1969.

86. Alexander, 1978, no. 30.

87. Alexander, 1978, 29.

88. Aethelwald was concerned to introduce some ecclesiastical forms along lines found in the Carolingian world, and the Book of Cerne is by the same scribe who copied the text of a Carolingian Mass (Alexander, 1978, 66). Both Cerne and the Royal Bible (the Royal I E vi) seem to have drawn upon a Carolingian model, though it is possible that the Royal Bible was produced in Canterbury then copied in Lichfield. The Royal Bible is unfortunately fragmentary, its purple pages touched with gold and silver, scattered through several libraries. See also Wheeler, 1977.

89. Backhouse, 1981, chap. 5; Brown, 1991, 46–51. See also Alexander, 1992 and Brown, 1994 for illumination techniques generally.

90. Brown, 1991, 46.

91. Brown, 1991, 46.

92. Stevick, 1995 discusses the mathematics behind page layouts, and has suggested that similar concepts of form can be found in manuscripts, ivories, metalwork and poetry.

93. Kendrick *et al.*, 1956–60.

94. Brown, 1991, 50.

95. Brown, 1991, 51.

96. Literature on Ruthwell enormous. See particularly Saxl, 1943; O'Carragain, 1987 and Cassidy (ed.), 1992.

97. Bewcastle almost as extensively discussed. See especially Cramp, 1965; Mercer, 1964.

98. Maclean, 1992, 70.

99. Wilson, 1984, 55.

100. Cramp, 1974.

101. Dodwell, 1982, 114–19.

102. Lang, 1988, chapter 2 useful summary.

103. Cramp (ed.), 1984, 97–101; Herebericht Stone in Bailey, 1992.

104. Tweddle, 1983, 30.

105. Discussed by Wilson, 1984, 70–71. See also Tweddle, 1983, 30–32.

106. Cramp, 1977, 191–234; Clapham, 1928; Jewell, 1986.

107. Hicks, 1993, 134–5.

108. Cramp, 1977.

109. Headda Stone in Cramp, 1977 and Lang, 1988, 36–7. Cult of relics and types of reliquaries in Thomas, 1972.

110. Biddle and Kjolbye-Biddle, 1985; Hicks, 1993, 135–6.

111. Coatsworth, 1989.

112. Peers and Radford, 1943. Individual pieces in Wilson, 1964, and Backhouse and Webster, 1991.

113. Gilmour, 1979.
114. Cramp, 1989, no. 49; Webster and Backhouse, no.68.
115. Wilson, 1984, 134.
116. Hinton, Keene and Qualmann, 1981.
117. Webster, 1980; Carr, Tester and Murphy, 1988; Backhouse and Webster, 1991, 81–88.
118. Battiscombe, 1956.
119. Webster, 1982b; Kendrick, 1938; Wood, 1990.
120. Green, 1971.
121. Wilson, 1984, 64.
122. T.J. Brown (ed.), 1959; Binding in Webster and Backhouse, 1991, 121.
123. Owen-Crocker, 1986, 192–3; Budny and Tweddle, 1984.
124. Tweddle, 1984.
125. Webster and Backhouse, 1991, no. 180.
126. Wilson, 1964, no. 41.
127. Wilson, 1984. 64–5; Yapp, 1990.
128. Wilson, 1984, 67.
129. Webster and Backhouse, 1991, 96, no. 69c.

The Late Saxons

c. 800–1066 (THE VIKING ERA)

The end of the eighth century saw a major break in the development of Anglo-Saxon England with the arrival of the Vikings. The first documented raid was in 787 at Portland in southern England, though there is some doubt as to whether this is correctly dated.[1] An entry for the year 793 in the *Anglo-Saxon Chronicle*, states dramatically:

> In this year terrible portents appeared in Northumbria and miserably afflicted the inhabitants: these were exceptional flashes of lightning, and fiery dragons were seen flying in the air, and soon followed a great famine, and after that in the same year the harrying of the heathen miserably destroyed God's church in Lindisfarne by rapine and slaughter.

A grave-slab from the monastery appears to depict the event.

As happened in the fifth to sixth centuries, it is difficult to evaluate the impact of the Scandinavian raids and settlements in England because the commentators in extant sources were primarily clerics. Monasteries and churches were prime targets of raids by the pagan Vikings[2] and an awareness of the partisan nature of the documentary sources has in recent years led to an attempt to redress the balance by emphasising the positive contribution the Scandinavians made to the development of England, and to their constructive impact on trade and art. The term Vikings includes both types of people, and for better or for worse they acted as a catalyst in the formation of late Saxon England. In particular they seem to have stimulated the increase in urbanisation and commercially based wealth.

The Anglo-Saxons and Vikings shared much in common: a North European ancestry, a farming economy and a social structure which depended on loyalty to one's lord and on family bonds. Like the Saxons, the Vikings had sophisticated law codes and a thriving artistic tradition in which animal forms were important.

The Vikings are probably best viewed in terms of the overall pattern

of migrations in early medieval Europe, though they are prominent because their activities are so well documented. The period of the Viking raids was one of rapid social and political development in Scandinavia. Population expansion combined with detrimental climatic factors probably resulted in pressure on land, and in internal disputes for supremacy. The Scandinavians were essentially farmers and fishermen, and they now sought new lands elsewhere, their travels aided by light, fast, ocean-going boats.

The Swedes played a minor role in events in England, but were *par excellence* the models of the 'Viking as trader', establishing trading bases along a trade route through Russia to Constantinople and beyond. In the Celtic North and West the Norse (originally from Norway) were of paramount importance, extensively settling in the Northern and Western Isles of Scotland, the north Scottish mainland, the Isle of Man and Ireland.[3] They were also active in northern England, which was settled as a result of secondary activity from the Norse kingdom based on Dublin. From here they colonised from the Wirral to Carlisle in the north-west, from where offshoots were established in the north-east. The Norse arrived through southern Scotland, to capture York from the Danes in 919. The kingdom of York reverted to the Anglo-Saxons in 927, but until the death of Eric Bloodaxe in 954 there was always a threat that a Norse kingdom might be forged to extend from Dublin to York.[4]

The main arena of Danish activity was the south, the most active raiding being between 865 and 954. The first prolonged attack is documented in 850, when the Danish army wintered for the first time in England. In the years up to 880 the Danes made considerable inroads in Northumbria, east Mercia and East Anglia. London was held for a while, and advances were made into Wessex.

The Danelaw

In Wessex the Danish advance was halted by Alfred the Great.[5] He drove them back with a resounding victory at Edington, and established a frontier along what had been Watling Street, which ran from Chester through Shrewsbury and Lichfield to Hertford and London. East of this line the Danes under their leader Guthrum were permitted to settle, by the terms of the Treaty of Wedmore, signed in 878. Within this Danish occupied area – the Danelaw – the Five Boroughs were established: Nottingham, Lincoln, Stamford, Derby and Leicester. Within Northumbria, Anglo-Saxons still held Bernicia.

Following Alfred's death in 899, the first phase of Viking England ended with the activities of his son, Edward the Elder, in reclaiming land from the Danes. By 920 Edward had recovered all England south of the

Humber. At Bakewell (Derbys), Edward accepted the submission of Raegnald of the Viking-held York, the Northumbrians, the Strathclyde Britons and Constantine king of the Scots. Meanwhile, Edward's sister Aethelflaed, the 'Lady of the Mercians', had acquired rights in Mercia through marriage to an ealdorman of London, and began the process of reclaiming this territory from Scandinavian control.

Aethelstan of All England

Edward the Elder's successor, Aethelstan, ruled both Danes and Saxons, but had to contend with trouble in Northumbria, which he successfully quelled. By 927 he had extended his kingdom to include Lancashire and Westmorland, and in 934 he invaded Scotland, reaching as far north as Kincardine. The king of the Scots, the king of Strathclyde and the Norse king of Dublin retaliated with an invasion of England, but they were defeated by Aethelstan and his brother at Brunanburh, an event commemorated in a stirring epic poem.

Aethelstan, regarded as the first king of All England, died in 939, his demise being followed by a period of further troubles in the north.

The Second Viking Age

Aethelred II, the Unready (the title means 'unwilling to accept advice'), came to the throne in 979, following his murder of his half-brother, Edward the Martyr.

With the accession of Aethelred II England passed into what has been termed the Second Viking Age.[6] During his reign there were fresh Danish attacks, of which the most notable were those of Swein Forkbeard. After two swift raids, in 1013 Swein made a base at Goldsborough, Yorkshire, where he was hailed as king by the Danes of eastern England and by the Anglo-Saxons of Northumbria. He advanced on Mercia and into Wessex, where Oxford and Winchester submitted to him. London surrendered, and Aethelred fled to Normandy. Swein's triumph was brief, however: he died in 1014, to be succeeded by his son Cnut.

Aethelred returned, Cnut withdrew to Denmark but was back in 1015 at the head of a huge army. Cnut triumphed over Aethelred's son Edmund Ironside in 1016 in the battle of Ashingdon, and became the first Danish king of All England. He ruled England successfully until his death in 1035, maintaining peace with a standing army and fleet and introducing a law code based on the Anglo-Saxon model.

After a dispute over rulership on Cnut's death, Edward the Confessor, the son of Aethelred II, was elected king and crowned at Winchester in 1042. For a brief period, until the arrival of the Normans in 1066, England was once more ruled by an Anglo-Saxon.

The Viking impact on England

The Vikings were rapidly assimilated into the population of England, particularly after their conversion to Christianity in the tenth century. The numbers involved in the settlements may not have been as great as suggested by some of the sources. The *Anglo-Saxon Chronicle* leads us to believe that the fleets of the raiders numbered at most eighty vessels, and some comprised no more than two or three boats. If a ship contained about fifty men, the raiding parties may have comprised fewer than a thousand men, and the Danish army was probably only a few thousand men.[7]

As the name suggests, Danish law prevailed in the Danelaw.[8] Law differed particularly in relation to land transactions and in the methods of assessing fines and penalties.[9] In the Danelaw land was measured in terms of carucates, oxgangs and bovates, and the English villein was known as the sokeman, for example.

Large numbers of place-names of Scandinavian origin are found in the Danelaw areas of England.[10] Most are Danish, but in the Wirral, Lancashire and parts of Yorkshire Norse names predominate. The Scandinavian incomers spoke Old Norse, which was similar to Anglo-Saxon. A thirteenth-century Icelandic writer commented that prior to the introduction of French by the Normans, the language spoken in Norway, Denmark and England was the same. The language spoken in England by 1100 was Anglo-Scandinavian, and even Wulfstan of York (1002–23), an archbishop who spoke 'correct' or 'Wessex' English, used a writing style which contained elements of Old Norse derivation. Gradually, however, down to the twelfth century Old Norse became corrupted by English. Although Anglo-Saxon eventually predominated in speech, many basic modern words (e.g. egg, bread, cake, fellow, knife, gift, odd, call, take, die, husband and take) are of Viking origin.[11]

Viking settlements

Despite their social and political impact, the Vikings have left comparatively few archaeological remains. It is extremely difficult to distinguish between late Saxon and Scandinavian buildings, and Viking burials are notably rare. Even stray finds are comparatively uncommon.

Although the Danes are known to have established camps when they progressed from tip-and-run raids to more prolonged campaigns, these have proved fairly elusive. The site most thoroughly examined is at Repton, Derbyshire, where the *Chronicle* informs us the Vikings wintered in 873/4.[12] The earthworks comprised a D-shaped enclosure on the bank of the Trent, incorporating a church. Outside the enclosure a disused stone-built chapel was found, containing 250 disarticulated

skeletons; males outnumbered females four to one. Associated coins suggested they had been buried in the late 870s, though whether they were the victims of Vikings cannot be established; current opinion favours the view that they were plague victims. A Viking warrior buried near the church had a more ceremonious end, being interred in a wooden coffin with a sword in a fleece-lined scabbard.

Of the homes of the Vikings little more is known. An upland settlement at Ribblehead, Yorkshire, comprised a stone-built longhouse, bakery and smithy, datable by coins to the ninth century.[13] At Simy Folds in County Durham and Bryant's Gill in Cumbria similar stone-built longhouses belong to farms with subsistence-level economies.[14]

Burials are few: there is a Danish barrow-cemetery at Ingleby in Derbyshire, and a few isolated Viking burials (for example at Sonning in Berkshire), but most examples have come to light in the north of England.[15]

Hoards

Most of the evidence for the Viking raids takes the form of hoards.[16] These are fairly sparse prior to 850, but from 865 onwards comprise large numbers of Anglo-Saxon coins with a mass of 'hacksilver' – pieces of armlets, brooches and ingots of silver, clearly destined for the melting pot. Some contain Arab coins, which were a major source of supply for Viking silverwork, and flooded north to Scandinavia. They are first encountered in a hoard deposited in the 870s in Croydon.[17]

Social change in Late Saxon England

While the Vikings were actively making their presence felt, changes were occuring among the Saxons. Open-field farming was developed, for instance, eventually becoming the dominant form of agriculture in medieval Britain.[18] Two or more fields were divided into strips which were allocated to individual farmers at a village meeting. Efforts needed to be collective, since any one peasant farmer could not afford a personal ox team. Crop rotation was practised, and common grazing ground was held. Each strip was a furlong – the distance an ox team could travel before resting – and the method of turning the plough resulted in the banking up of ridges producing ridge-and-furrow cultivation. The traces of this (with reversed S-shaped ridges) from later medieval centuries are apparent all over England, but the evidence for its use in Anglo-Saxon times is generally lacking.

It is not clear when the transition to open-field farming came about, although there is evidence for ridge-and-furrow under the Norman motte at Hen Domen, Montgomery,[19] and at Sandal Castle in

Yorkshire.[20] It has been suggested that strip farming spread from the Celtic areas to the Anglo-Saxon, but although there are some pre-Norman traces for it at Gwithian, Cornwall, and more from Ireland, the evidence is sparse.

Documents dating from the tenth century onwards allude to elements of open-field farming, and there are growing signs that late Saxon villages were bigger than their Middle Saxon counterparts, perhaps occasioned by the new co-operative methods of agriculture.[21] It is very likely that the growth of open-field agriculture in late Saxon England was prompted by lords who wished to maximise the returns on now smaller estates. The effect, however, was probably detrimental for the peasant farmers tilling the fields.

Whatever the reason, in both towns and countryside, life was still short for the majority of the population. Examination of over 300 late Saxon burials at Raunds, Northamptonshire, showed that infant mortality was high – one third of all children were dead by the age of six.[22]

Palaces and manors

In the late Saxon period there is continuing evidence for regional royal palaces that catered for the itinerant lifestyle of kings. One such excavated example is at Cheddar in Somerset.[23] There is a certain amount of evidence from archaeology for manors such as that at Sulgrave, Northants, where a timber hall was set within an earthwork. This was entered through a stone-built tower. It was a foretaste of the earth-and-timber defensive sites that became common after the Norman Conquest.[24] At Raunds in Northamptonshire it has been possible to trace the development of a settlement from two seventh-century sunken-feature huts to a tenth- or eleventh-century reorganisation with an aisled hall, church and cemetery, which probably had manorial status.[25]

Towns

Paradoxically, since the Vikings had achieved such a reputation for destruction, urbanisation in the late Saxon period may have been fostered in part through their activities. From modest beginnings in the Middle Saxon period, the growth of towns in Anglo-Saxon England was in many ways more advanced than that in Continental Europe.[26]

The urban development started by Offa (see p. 85) was taken one stage further by Alfred (871–99), who founded a series of burhs in Wessex. These served both as fortifications in the time of the Danish threat, and as markets. They were laid out with grid-iron street plans. Some were

on the sites of old Roman towns, in which case the grid did not follow the Roman plan, except insofar as existing gates in Roman town walls dictated the main axes. On virgin sites they were enclosed with earth-and-timber defences which tended to a rectilinear plan.

Burhs were sited about twenty miles apart – one day's travel from the hinterland – and had mints and markets. Each burh had to put a number of men to the defence, the quota being dictated by the number of hides of land the burh covered.

The pattern of burhs in Wessex is provided by a document drawn up by Edward the Elder known as the *Burghal Hidage*. The system of burhs was extended into Mercia by Aethelflaeda, whose burhs are similarly documented in the *Mercian Register*. Within the burhs industry was zoned, and there were usually several churches. Houses were of timber, built over sunken floors, facing gravelled streets.

Coinage

Concomitant with the development of burhs came innovations in coinage.[27] In late Saxon England the monetary system was in advance of that found elsewhere in Europe, the coinage evolving by degrees, to reach its greatest elaboration with the reforms of Edgar, *c.* 973. A uniform national currency was established, with firm central control – only one type of coin was permitted to circulate in England at any one time, though these were issued by a diversity of mints, which re-struck old coin with the new types. The obverse had a conventional portrait of the king; the reverse displayed a cross with a legend naming the moneyer and the place where it was struck. Periodically the design was changed, and in the changeover period dies of a standard type were issued until the new types were introduced. Until the end of the reign of Cnut, this changeover took place every six years or so, and thereafter more frequently – for a while every two years.[28] The dies were cut centrally, and issued to local mints. Foreign coin was not permitted to circulate, and imported silver was melted down to provide the material for most coins.

Trade

With the growth of towns and a strong currency, industry and both internal and overseas trade burgeoned. In the Danelaw, pottery production (by this time wheel-thrown and sometimes glazed) began to approach the standard of that produced in Roman kilns, with substantial manufacture at centres such as Stamford, Thetford and St Neots.[29] Outside the Danelaw, production was maintained at other centres such as York and Winchester. From the Continent came a variety of imports, such as pottery, querns, and more perishable materials.[30]

Pennies of Burgred of Mercia (874–c. 880) left and Edward the Confessor (1042–1066) right (Lloyd Laing)

Alfred the Great and his successors

The new-found wealth, along with the efforts of Alfred the Great (871–899), had an immense effect on patronage and the arts and culture in general.

Knowledge of King Alfred is derived from Asser's *Life* of him, written for the edification of those living in Wales. It is unique in Anglo-Saxon England for providing a verbal portrait of a royal personnage. Although it is difficult to separate the achievements of Alfred from the myths that have grown up round him, his unique programme of burh construction and his ultimate success in dealing with the Danes are clear testimony to his success as a ruler.[31]

Alfred wished to foster civilisation in England through law and order which he established by law codes, and he was personally responsible for a revival in learning. He saw himself as a Christian leader who took inspiration from David and Solomon, and who regarded the Vikings as God's punishment for a decline in literacy in England. He was anxious

to promote the use of written language, and to that end translated Gregory's *Cura Pastoralis* and a number of psalms himself. Alfred gathered around him men of learning from Mercia, Wales and the Continent. He made gifts to churches, and founded monastic communities at Athelney and Shaftesbury, and he provided patronage for artists, craftsmen and scholars, both English and Continental.

His model was an inspiration for his successors. Edward the Elder founded the New Minster at Winchester, and completed the foundation of the Nunnaminster in the same city. Edward also reorganised the dioceses of Wessex. Aethelstan, a collector of books and relics, gave gifts to ecclesiastical foundations throughout England. Through marriage the family of Aethelstan became allied to households on the Continent – four of his half-sisters married rulers overseas.[32] Through such bonds with their Continental counterparts, the later Saxon kings opened England up still further to European influences. The court of Aethelstan in particular was a cultural melting pot that was strongly reflected in art.

Continental influence was very apparent during this period. Edward the Elder's New Minster at Winchester, for example, consecrated in 903, may have been influenced by the taste of Grimbald, a Flemish monk in Edward's court, since it was a basilican building of the type found in the Carolingian Empire.[33]

The ninth century on the Continent was a period of major architectural revival, part of the Carolingian Renaissance.[34] After a lull in the early tenth century there was another resurgence under the Ottonian emperors in Germany.[35] The Ottonian style on the Continent evolved into the Romanesque (named in the early nineteenth century because of its Classical features and then used rather loosely to denote all architecture between late Antiquity and the emergence of Gothic), which flourished in Germany, France and Italy. Active debate has centred on whether English architects participated to any extent in this movement much before the time of the Norman Conquest, but it is probably reasonable to say that Continental developments influenced traditions in Anglo-Saxon England.

Monastic reform

Rising out of this background grew a monastic reform movement[36] which originated on the Continent out of a desire to return to a strict adherence to the Rule of St Benedict. This had far-reaching influence on the development of art as well as the Church.

The movement took hold in England in the 930s, though it was fairly slow in making an impact. Two men in Aethelstan's court, however, played a major role in the development of the reform movement, Dunstan

and Aethelwold, two friends who were ordained on the same day. Dunstan became abbot of Glastonbury (*c.* 940), where the Rule of St Benedict was followed, and Aethelwold (who for a while was with him at Glastonbury) set up a Benedictine community at Abingdon (*c.* 954).[37]

The reform movement benefited from royal support, in particular from Edgar, in whose reign Dunstan was made Archbishop of Canterbury (959). In 963 Aethelwold was made Bishop of Winchester, and in 964 replaced the clergy in the Old and New Minsters at Winchester with monks. Towards the end of his reign Edgar determined to regularise customs in monastic houses in England, and at Winchester a code was formulated that was set out in the *Regularis Concordia*.

Following the example of the king, laymen began endowing monasteries and acting as patrons – they vied with one another in their generosity, and strove to secure the prayers of the monks for themselves and their families. The abbots of monasteries found themselves administering large rural estates, and influencing society. Churches were erected or improved, and the arts flourished – manuscripts and other works of art were imported, and an artistic tradition evolved that has come to be termed, somewhat loosely, the Winchester School (see p. 170). Despite Danish rule under Cnut, Viking art styles had little impact on this ecclesiastical art, though Scandinavian influence is much more apparent in northern sculpture.

Late Saxon monasteries

Late Saxon monasteries followed the organised plan of Continental Benedictine houses, set out in the surviving plan of St Gall, which dates from the early ninth century. They were claustral, though existing monasteries such as Glastonbury Abbey could be modified without necessarily destroying old buildings.

It is clear that late Saxon Winchester had no fewer than three minsters within the same enclosure: the Old and New Minsters and the Nunnaminster. Recent excavations on the site of the Nunnaminster have shown a sequence of building. In the second phase, attributed to Ethelwold in 963, the exceptional thickness of the north/south wall of the west end of the church might suggest it supported a westwork. It would seem that the three monasteries formed an enclave which ignored the layout of this part of the town, which had its own planned layout, and which may date to the first half of the ninth century.[38]

Village churches

Until this point the minsters (effectively monastic churches) had tended the spiritual needs of the people by sending out priests to the local

communities. However, they lost revenue for baptism and burial with the development of the estate village church. These were built by the lord for the people working on his land and were undoubtedly a response to the changes in farming (see p. 80). To make up for the loss of revenue, payments were made from the estate churches to the mother church. Between the tenth and twelfth centuries the former evolved into parish churches, the parishes frequently coinciding with the boundaries of the estates.[39]

Middle Saxon churches before c. 950

Most surviving Anglo-Saxon churches belong to the period *c.* 950–*c.* 1100, and there is an apparent dearth of ecclesiastical buildings from the period 800–950 – a mere 3% of the total number have been assigned to this time. Traditionally this dearth was attributed to Viking and Danish activity, but it has recently been suggested that at least some churches have been unrecognised, since a number of new architectural forms came into being in the eighth or ninth century which have been in the past regarded as features of the tenth or eleventh. These include hood-mouldings round arches, pilaster strip work, triangular headed windows and monumental wall sculptures.[40] Furthermore, it has been argued that efforts were concentrated in the period from the mid-eighth to the later ninth centuries on the production of major works of Anglo-Saxon art rather than architecture.[41]

Building techniques

Only one Anglo-Saxon timber church of any period survives above ground, at Greensted in Essex (possibly tenth century), but in recent years archaeology has brought to light the traces of a number in different parts of England. Thus excavations at Rivenhall (Essex) revealed not only Anglo-Saxon masonry behind an exterior apparently of the nineteenth century, but also a timber Anglo-Saxon predecessor.[42] At Hadstock in the same county what had been assumed to be a single-period Anglo-Saxon church was shown to have been of three builds and to have had a central timber tower which was replaced in the eleventh century.[43] In Wiltshire a timber church has also been excavated at Potterne.[44]

It is likely that stone quarrying began as early as the seventh century in England, and by the eighth quarries must certainly have supplied much building stone.

The Anglo-Saxon church building industry was well-organised, with lifting gear and other heavy machinery being used on site: some of the blocks in the late Saxon church at Bradford-on-Avon weigh about a ton. By the late Saxon period extensive quarrying and transporting can be

inferred. Builders at Bradford-on-Avon used Bath oolite, as they did at Britford near Salisbury, 35 miles away. Barnack stone was traded widely from its Northamptonshire homeland, turning up at Strethal, Essex, Reed and elsewhere in Herts, and at St Peter's, Bedford. Quarry stone from the Isle of Wight was also traded.[45] In the late Saxon period there was a quarry at Box, Wilts. In some cases stone was transported within a 70 mile (110 km) radius.[46]

Anglo-Saxon mortar was very durable. That at Brixworth was shown to have been not dissimilar to modern mortar, and the huge mortar-mixers found at Northampton, dating probably from the ninth century, show the skill and sophistication employed in its production.[47]

Roofs were of timber, and have not survived in their original form except perhaps in the case of Sompting, Sussex, where there is a German-inspired 'helm' tower. Recent work has shown that in its present form it is datable to between 1300 and 1330, but is probably a replacement for a Saxon version, since beam holes have been found.[48] Wooden roof shingles are known from Winchester, and are depicted on hog-back gravestones and in manuscripts, while Monkwearmouth employed limestone 'slates' and lead flashing.[49] Many roofs were probably thatched (a modern example is the thatched Saxon church at Beachamwell, Norfolk).

Church plans

Late Saxon church plans were very varied.[50] Some, including the very late examples at Odda's Chapel, Deerhurst, Glos., and St Gregory's, Kirkdale, Yorks., consist simply of a nave and chancel. More ambitious plans such as that found at Bradford-on-Avon, Wilts, have two cells with porticus added at the north and south. At Worth, Sussex, the same basic plan was followed, but the positioning of the porticus approximates them to later transepts and gives the church a cruciform plan.

The development of the crossing was a feature of Continental 'Romanesque' style and was taken up in English churches.[51] In rudimentary form it was apparent in some of the earliest churches, such as Winchester in its original seventh-century design, but the basic late Saxon crossing can best be exemplified by Breamore, Hants, where the eastern end of the main part of the church was a square bay with a chancel and with single-storey porticus to north and south.[52] An inscription on an arch might suggest a date at the beginning of the eleventh century for this church.

Towers

The main innovation in tenth-century church architecture was the introduction of variously sited towers, previously apparently

unknown.[53] It has been suggested that these were ultimately inspired by Italian bell-towers (campanili), though there are signs that they evolved in many cases in England out of heightened porches. It is also clear that some two-storey annexes did not start as porches – at Escomb a west annexe was built without entrance into the church, while at Ledsham (Yorks) the entrance was in the south wall of the annexe rather than the west, as it would have been had it been simply a heightened porch.[54]

Some churches, such as that recently excavated at St Oswald's Priory, Gloucester,[55] had an unaisled nave with three rectangular porticus at its east end – a traditional design – to which a western apse was added, perhaps in response to Carolingian trends. In the early tenth century it was altered: a four-column crypt (a Continental device) was constructed, while the eastern part of the nave was sectioned off with a cross wall, perhaps to support a tower.

The central tower surmounting on a crossing is even more clearly seen at St Mary's in Castro at Dover, where the Roman pharos (lighthouse) was incorporated into the design at the west end.[56] In churches of this type the choir was probably situated under the central tower, and the high altar in the eastern porticus.

Westworks

The ultimate elaboration of the tower feature can be seen in the introduction of westworks, which are widespread on the Continent, and which employed an elaborate west end with flanking towers. This was the case at Canterbury, where recent excavations have shown that the late Saxon cathedral underwent a series of developments. A deep apse, with a hexagonal stair tower to the south (presumably with a matching tower to the north) was constructed in the final phase. The apse had a polygonal external face. The end of the apse was built of large blocks of reused Roman masonry. The arcade walls of the earlier Saxon basilica were strengthened, perhaps to take an arch, and a square tower or porticus was added in the south-east corner. The date of this building is uncertain, but the period between 1013 and 1038 is favoured by the excavators.[57]

A westwork certainly seems to have been a feature in the Old Minster, Winchester, in Sherborne, Dorset, and Deerhurst, Glos.[58] These westworks housed subsidiary altars, galleries for choirs or for notables, for bells, treasuries or even judicial court rooms. Even the simpler, single towers may have served some of these functions. Certainly the use of the tower as a treasury at Peterborough is documented in 1070. The doors which open without a staircase to a vertical drop, may have been for the display of banners or other treasures on special occasions. Such apertures occur for example in the

Winchester Cathedral, reconstructed (Lloyd Laing, after Kjolbye–Biddle)

exterior of the tower at Earl's Barton, Northants.[59] Towers could also have contained chapels or provided accommodation for clergy. Single towers fall into a number of regional groups: those in Northumbria, Lincolnshire and East Anglia being the most important. The East Anglian towers are round – possibly due to the dearth of ashlar (dressed stone) for quoins necessitating flint rubble masonry.[60]

Architectural features

A number of decorative features (generally those originally used by the Romans) distinguish the architecture of many late Saxon churches.

The most distinctive feature of late Saxon architecture is probably the use of pillaster stripwork, with square-section work confined to jambs and arches on early churches such as at Britford, Wilts., and Brigstock, Northants., and more sophisticated, all-over stripwork such as at Barnack, Barton-on-Humber and Earl's Barton, which employs long-and-short stripwork on the quoins.[61] The origins of this stripwork have been intensely debated. It may be a home-grown imitation of wooden churches. An alternative argument is that the ultimate source is Roman architecture (as on the Porta Nigra at Trier), the immediate models

Canterbury Saxon cathedral plan. The small mausoleum to the south-east is now believed to relate to Phase I, and the foundations to the east located in 1895 are now thought to be part of Lanfranc's rebuilding in the 1070s (Drawing: K. Blockley)

being in Germany. Significantly, however, none of the German churches are necessarily earlier than the English, and both could be a simultaneous phenomenon.

Other features of late Saxon churches include hood-mouldings on windows and doors, half-shafts and soffit rolls, all of which seem to be features of the eleventh century.[62]

Church interiors

Buildings were probably plastered inside and out – plaster has been recovered from a number of sites, including Winchester, and stucco was probably used for ornamental details including sculpture. Window glass was used in some churches, even comparatively modest ones such as Escomb, and a glass workshop has been excavated at Glastonbury Abbey. Glass was employed in the Winchester Old Minster.

Although church bells have not survived, they are abundantly attested in literature and fragments of bell moulds have been found. At Gloucester one fragment dating to the late ninth or early tenth century had a monogram made out of an alpha and an omega (an allusion to *Revelation* 12:13 – 'I am alpha and omega, the beginning and the

Church tower, Earls Barton, Northants.
(Jenny Laing)

ending').[63] Two fragments of the late tenth century from Winchester carried letters. The Gloucester bell would have been about 30 cm in diameter, that from Winchester larger. In both instances the fragments were associated with adjacent furnaces – at Winchester a circular pit 75 cm deep had an associated draught-furnace. The Gloucester evidence shows that charcoal was used in firing the furnace.[64]

Glazed tiles have been found in late Saxon contexts, notably at

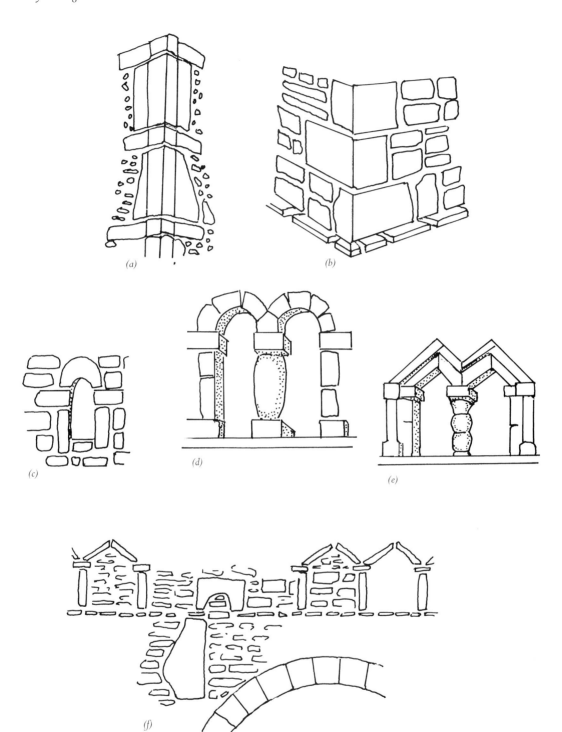

Architectural details from Anglo-Saxon churches. (a) long and short work; (b) side alternate megalitic quoining; (c) window, Jarrow, Tyne & Wear; (d) window, Worth; (e) window, Barton-on-Humber, Lincs. (f) Geddington, Northants. A, B, F after Taylor and Taylor, C–E after Kerr and Kerr.

Deerhurst, Glos., interior of St Mary's Church

Winchester Old Minster, glazed polychrome tiles (Winchester Excavation Committee)

Church of St Andrew, Dunham Magna, Norfolk, showing blocked Anglo-Saxon doorway and long-and-short work (Jenny Laing)

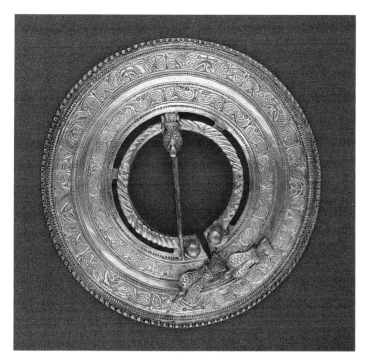

Quoit brooch, Sarre, Kent, fifth century. D. 7.8 cm (British Museum)

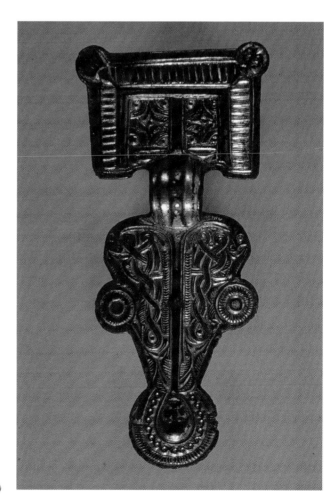

Nettleton Thorpe, Lincs, square-headed brooch, late sixth century (Scunthorpe Museum: photo Kevin Leahy)

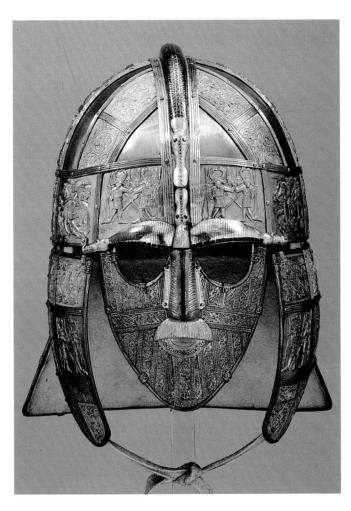

Sutton Hoo, Suffolk, helmet, later sixth or early seventh century, reconstructed replica by the Tower Armouries. H. 31.8 cm (British Museum)

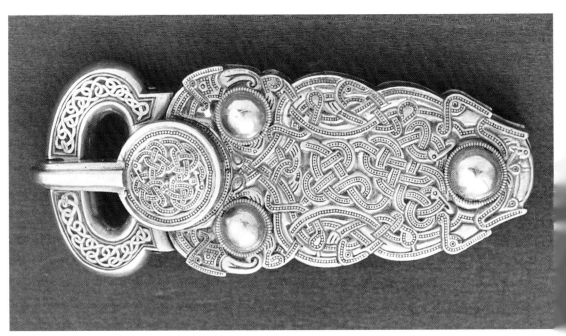

Sutton Hoo gold buckle, early seventh century. L. 13.2 cm (British Museum)

Sutton Hoo ship burial: Mound 2 being excavated
(Sutton Hoo Excavation Committee: Photo: N. Macbeth)

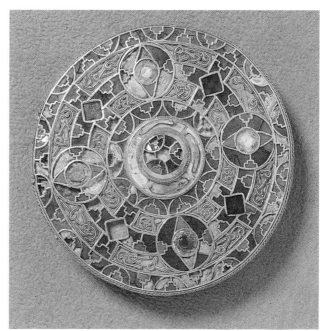

Kingston brooch, Kent, seventh century. D. 8.4 cm
(National Museums on Merseyside)

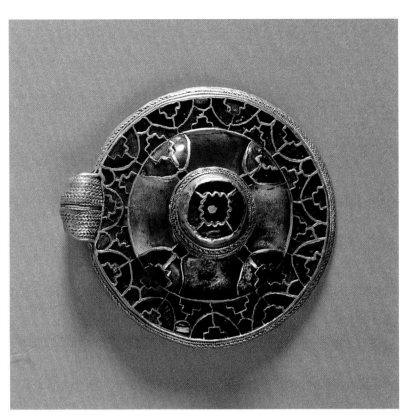

The Canterbury Pendant,
early seventh century. D. 4.0 cm
(© Collection Canterbury Museums)

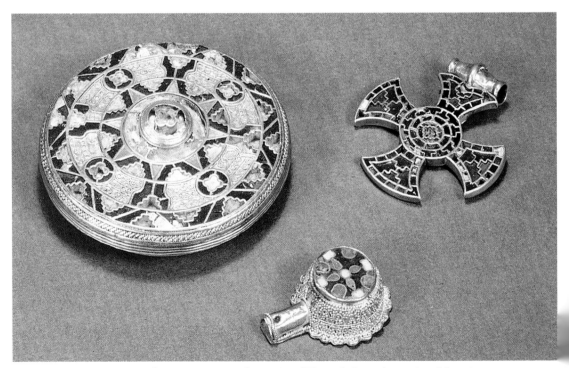

(Top right); Amherst brooch, possibly from Sarre, Kent; (top left) Ixworth, Suffolk cross (both seventh century); and (bottom)
Minster Lovell jewel, Oxon (ninth century). Length of jewel, 3.1 cm (Ashmolean Museum, Oxford)

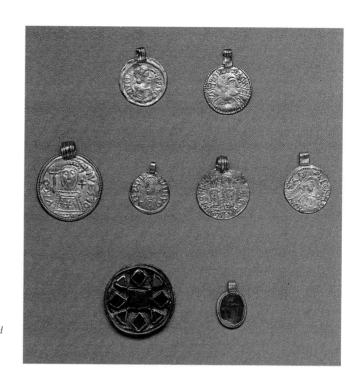

The so-called St Martin's hoard, including the Liuhard medalet, D. 1.7 cm, Canterbury, seventh century. (National Museums on Merseyside)

Monkwearmouth, Tyne and Wear. Lower part of tower late seventh century, upper part late tenth century (Lloyd Laing)

Lindisfarne Gospels, St Matthew, c. AD 698, 340 x 240 mm (British Library, Cotton Nero D iv, f 25v)

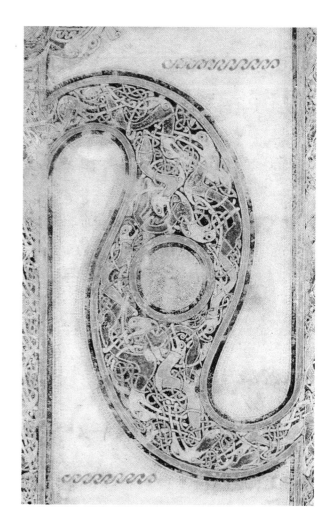

Durham Cathedral A II 17, detail of f.2, In Principio page. Early eighth century (Dean and Chapter, Durham Cathedral)

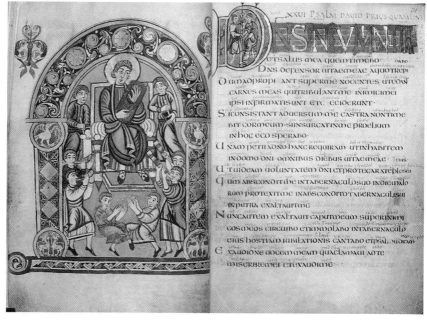

The Vespasian Psalter, King David with his scribes and musicians, c. AD 725, 235 x 180 mm (British Library Cotton Vespasian Ai, f.30b–31)

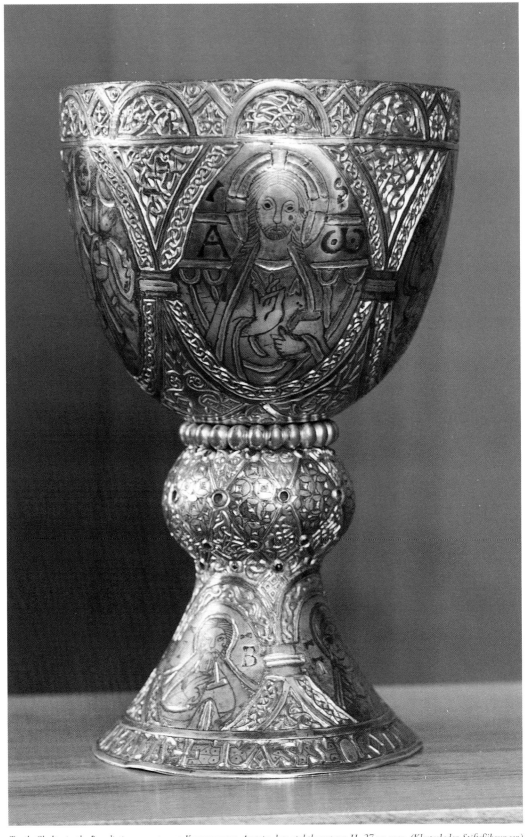

Tassilo Chalice in the Benedictine monastery at Kremsmunster, Austria, late eighth century. H. 27 cm max. (Klosterladen Stiftsführungen)

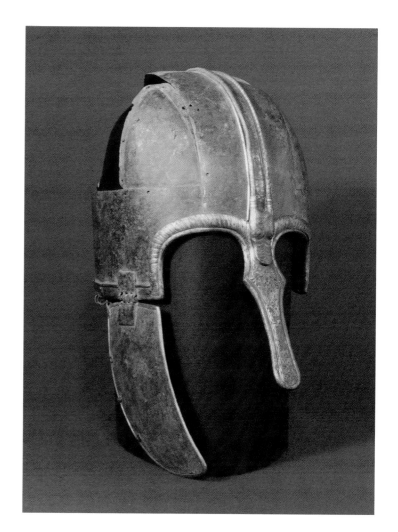

*Coppergate helmet, York, late eighth century.
H. 24.6 cm (York Archaeological Trust)*

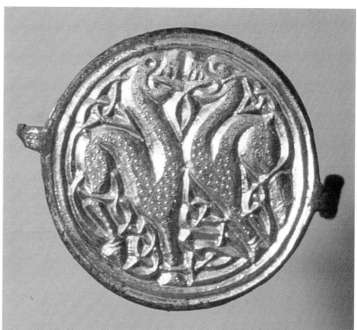

*Flixborough brooch, late eighth century,
South Humberside. D. 3.0 cm
(Scunthorpe Museum: photo Kevin Leahy)*

St Wystan's Church, Repton, Derbyshire, crypt. Outer walls mid-eighth century, columns and vault early ninth (Philip Dixon)

The Alfred Jewel, Somerset, early ninth century. L. 6.2 cm (British Museum)

Pentney hoard, Norfolk,
early ninth century.
D. of largest brooch 10.2 cm
(British Museum)

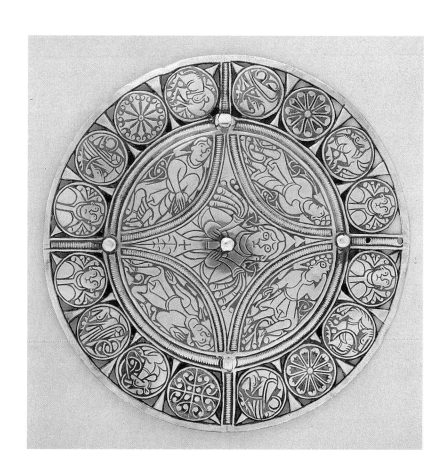

The Fuller brooch, late 9th century.
D. 11.4 cm (British Museum)

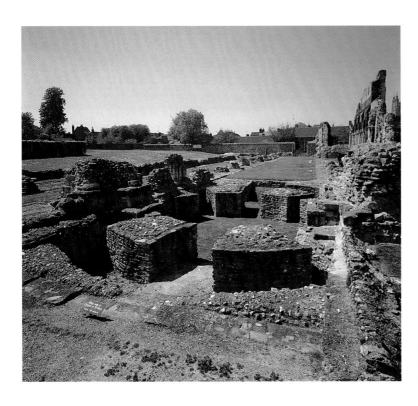

Canterbury, Kent, St Augustine's Abbey, Wulfric's rotunda, tenth century (Philip Dixon)

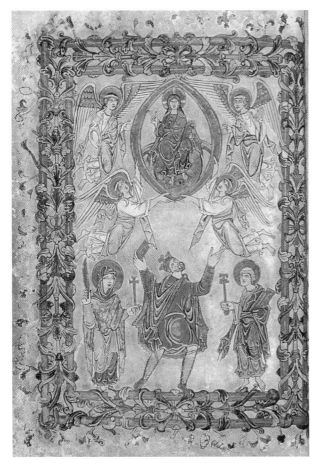

New Minster Charter, later tenth century (British Library, Cotton Vespasian A viii, f.2b)

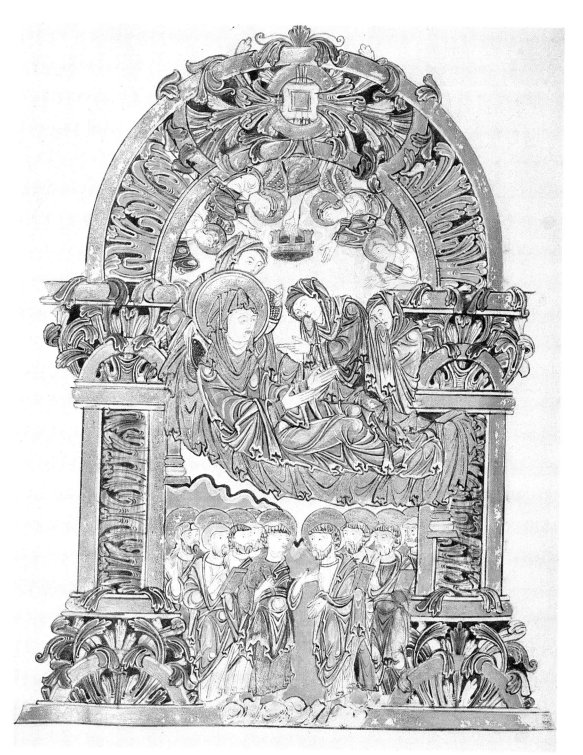

Benedictional of St Aethelwold, the Death of the Virgin, c. AD 970–80, 295 x 225 mm (British Library Additional MS 49598 f.102v)

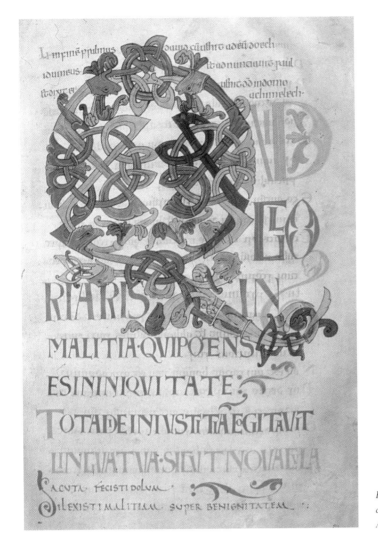

Bosworth Psalter, initial Q, last quarter of tenth century. Page size 390 x 265 mm (British Library, Additional MS 7517, f.33)

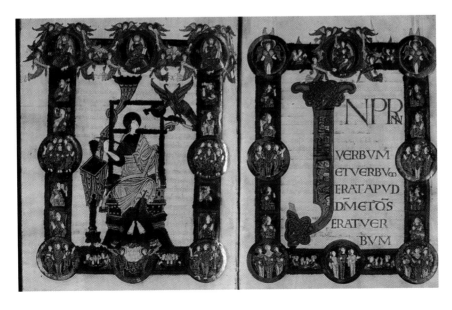

Grimbald Gospels, early eleventh century, St John the Evangelist, 320 x 245 mm (British Library Additional MS 34890, f.114b)

St Lawrence's Chapel,
Bradford-on-Avon, Wilts,
early eleventh century
(Philip Dixon)

Tiberius Psalter, Harrowing of Hell, mid-eleventh century,
248 x 146 mm (British Library Cotton Tiberius C vi, f.14)

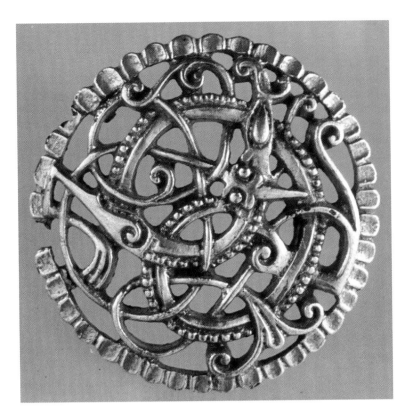

The Pitney brooch, Somerset, late eleventh century. D. 3.9 cm (British Museum)

Canterbury Cathedral, St Gabriel's Chapel, capital, c. 1120 (Philip Dixon)

Winchester and Bury St Edmunds, with relief patterns in simple designs. Sometimes there are three differently coloured glazes on the same tile,[65] a very sophisticated tenth-century technique, not found after the Norman Conquest. Glazed tiles from the church of All Saints, Pavement, York, Canterbury, Coventry, Peterborough, St Albans Abbey, and Westminster have been dated to the eleventh century.[66] Such tiles were probably used in sanctuaries or in paved areas round altars, but those in York and St Albans were probably wall tiles, as indicated by the presence of flanges. Plain structural tiles or bricks are occasionally known from Anglo-Saxon churches, the most notable being those at Brixworth, previously believed to have been Roman but recently redated.

A couple of original Saxon-type wooden doors have been claimed as surviving from the period, for example at Stillingfleet, North Yorks, where the attached iron fittings include a Viking-looking longship and a dragon head, as well as figures. Similar ironwork, with fishes and double-headed serpents, adorns a door at Staplehurst, Kent. These are now generally regarded as being of post-Conquest date, perhaps as late as the twelfth century.[67]

Church interior decoration included friezes and architectural sculpture (see p. 105).

Some important ecclesiastical foundations

A few ecclesiastical foundations are of outstanding interest and together give a flavour of the architectural achievements of the period. Here we highlight, out of many, those at Repton, Sherborne and Deerhurst.

Repton

St Wystan's, Repton, Derbyshire, was later enclosed by the Viking camp.[68] The first stage of its development was a square building, partly subterranean, partly above ground level, adjacent to a church. This crypt may have been a mausoleum. At a second stage it was incorporated into the church, the chancel being built over it. The third stage of its development was marked by the insertion of four spiral columns set in a square in what was now the crypt, and some other alterations. Finally, steps were cut down from the flanking porticus. While some scholars believe the first building was a crypt constructed for King Ethelbald of Mercia in 757, others dispute this, and have seen the mausoleum as being related to the cult of St Wystan, placing the entire constructional sequence in the tenth century.

Haddiscoe Thorpe church, Norfolk (Jenny Laing)

Sherborne Abbey

The Saxon cathedral of Sherborne Abbey has been reconstructed partly though excavation, partly through documentary sources.[69] The existing building is mostly late medieval, but it incorporates early twelfth-century work which follows the lines of the Anglo-Saxon minster. Sherborne possessed an elaborate westwork, crowned by a central tower, with a further tower on the crossing. A simpler type of building with central tower is represented by Barton-on-Humber, Lincs, which had a baptistery to the west and a chancel to the east, each entered through narrow doors.

Deerhurst

A fine Mercian church at Deerhurst, Glos, illustrates clearly how buildings were modified and developed according to the dictates of Christian worship.[70] The first church had a simple rectangular nave with a western porch, and in stage two a semicircular apse was added with two flanking porticus on north and south. The church was then heightened into a two-storey construction. In stage five a tower was added, two of the flanking porticus were demolished and the apse was replaced in polygonal form with external pilaster strips. Finally, the porticus were extended to provide a row of side chapels. This sequence spans the Anglo-Saxon period, the earliest work being datable to the late seventh or early eighth century.

Art

Concurrent with these architectural developments came major changes in English art. These may conveniently be discussed under the following heads – artists and patrons, secular art and the Trewhiddle style, the ecclesiastical art of the south and the Scandinavian styles of the north.

Artists and patrons[71]

As in earlier times, late Saxon craftsmen could be men of wealth and status. The Domesday Book, compiled by William the Conqueror but reflecting society in the time of Edward the Confessor, notes that several of Edward's goldsmiths held lands, and one, Theodric, held lands in Oxfordshire, Berkshire and Surrey. A thane in Cambridgeshire, Aelfhelm Polga, gave half a hide of land to a goldsmith, and two goldsmiths who served a lady called Eadgifu are recorded as giving two ounces of gold to Thorney, which was used to decorate with filigree-work the outside of the book in which the entry appears.

Phase I

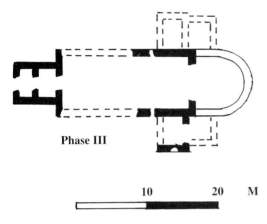

Phase III

Phase IV

10 20 M

standing walls foundations

– – – conjectural walls

Development of Deerhurst, Glos (after Taylor and Taylor)

Church tower at Forncett St Peter, Norfolk (Jenny Laing)

Stair-turret and Anglo-Saxon tower at Brigstock, Northants.

The concern with the value of gold shown earlier in the Anglo-Saxon period persisted into the later Saxon period, when accounts of works of art also provide information about their worth. For example, a reliquary given to the abbey of Ramsey in the eleventh century contained twelve marks' worth of gold, while a necklace given to a foundation at Coventry by Lady Godiva was priced at one hundred silver marks. The function of such records was partly to establish the generosity of the donors. They serve as reminders of the uses of precious metal as a means of calculating wealth in a heroic society. In the words of Professor Dodwell, 'Preciousness for the Anglo-Saxons was associated with attractiveness. In their world, what was costly was the more easily admired' (*Anglo-Saxon Art*, 1982, 25).

Not surprisingly, goldsmiths figure prominently in Anglo-Saxon records. Two Saxon poems speak of one who is 'assigned the wonderful ability of the goldsmith's art' and one who is 'cunning in gold and gems whensoever a prince of men biddeth him to prepare a jewel for his adornment'. This concern for the work of the goldsmith was not peculiar to those living within Anglo-Saxon England. Just before the Norman Conquest, Goscelin, who came from Flanders, praised English needlewomen for their skill in gold embroidery, and recorded how they decorated the garments of both clergy and kings with goldwork and gems and with English pearls that shone like stars against the metal. Even William of Poitiers, who had little liking for the English, praised their skill in the arts, by which he mostly meant the art of goldsmithery.

The major works that survive from late Saxon England appear to be for the most part objects intended for church use. Even some pieces that at first glance might appear to be secular – the Alfred Jewel, for example – on closer consideration seem to have been gifts to churches. There is nothing to prove whether the fine ivory pen box with dragons and human figures from London, now in the British Museum, was used by a layman or a cleric (a literate laity is attested by the surviving seal matrices of late Saxon date). But despite the fact that its decoration has no obvious devotional dimension, it is more likely to have been used by a monk than anyone else.

This is not to say that monasteries only produced art for the ecclesiastical community, or that specifically Christian art was not owned by laymen. In the words of Richard Gameson, 'An illustrated book could be a gift and a status symbol, a part of divine ceremonial with a symbolic value of its own, a repository of information, and a devotional aid' (*The Role of Art in the Late Anglo-Saxon Church*, 1995, 58). Three gospel-books are known to be associated with Judith of Flanders, all different, perhaps designed to reflect the piety, wealth and good taste of the noblewoman.[72]

There is no shortage of evidence that books were owned by laypeople

– Ealdorman Aethelweard and his son were patrons of Aelfric and commissioned his *Lives of Saints*, a *Catholic Homilies I* and a translation of *Genesis* for their own devotional purposes.[73] In a statement with an awesomely familiar ring to modern ears, King Alfred stated that all freeborn youths should be able to read English. Those destined for the Church he considered should also learn Latin, and he established a palace school to cater for them.[74] Works of art could also change hands between the Church and the laity. Gunhild, wife of King Harold, owned a psalter glossed in English which she gave to a church in Bruges, while Queen Edith removed from Peterborough a gospel book given to the monastery by Cynesige.[75] By the same process, secular possessions passed into the hands of the Church – Aethelgifu gave her finest wall-hanging, two silver cups and some other items to St Albans, Aelfflaed gave a torc and a tapestry of her husband's deeds to Ely.[76]

Specifically secular commissions, as in previous periods, appear to have been items of personal adornment and weaponry. As with the York Helmet in the previous chapter (see p. 128), some late Saxon weapons bear personal names. Thus a single-edged iron sword (seax) from Sittingbourne, Kent, is richly inlaid with silver, copper, brass and niello, with an inscription in Old English which translates as 'S[i]gebereht owns me' on one side and 'Biorhtelm made me' on the reverse. A knife with inlay bears the personal name 'Osmund', and a seax from the Thames at Battersea has an inscription in runes naming 'Beanoth', though whether he was the owner or maker is not clear. The fact, however, that such objects bear personal names attests the importance both of the weapon-smith and the role of individual commissions for weapons in late Saxon society – they were clearly important status symbols. Documentary sources provide further clues – the will of a certain Aethelstan mentions Wulfric who made a sword with a silver hilt. A sword pommel also has a maker's signature.[77]

Similarly, an inscription on a brooch from Beeston Tor shows that fine brooches were highly prized, and probably specially commissioned, though the inscription on this one was scratched on, either by the owner or for her. The rhyming couplet in which it is phrased shows a high degree of literacy. In late Saxon England, rings were given bearing the name of the donor – a variety of inscribed rings is known from the period, some with runic inscriptions, some with Old English. A good example is Aethelswith's (see p. 166) A ring from Lancashire has an inscription on which the name of the maker, Eanred, is rendered in letters as large as that of the owner, Aedred. Among the most remarkable objects from late Saxon England is a portable silver and gold sundial from Canterbury Cathedral, which has inscriptions requesting 'salvation to the maker' and 'peace to the owner'.

The Anglo-Saxons, in contrast to some earlier and later societies, do

not seem to have despised artists and craftsmen.[78] A font in Little Billing parish church, Northants, has an inscription in which the name of the mason is writ large – Wigberhtus. On a memorial stone in Stratfield Mortimer church, Berks, the mason, Toki, inscribed his name as large as that of the person commemorated.

In an ecclesiastical context documentary sources provide the names of artists and craftsmen, though they furnish few other clues about them, as humility was an important virtue. Thus at Winchester New Minster, records refer to goldsmiths called Wulfric, Brytelm and Byrnelm, and painters called Aelfnoth, Aethelric and Wulfric. Also mentioned is Alwold, a churchwarden, who made a shrine. Leofwine, a tenth-century prior of Ely, seems to have made a silver crucifix. Bede narrated a story about a smith who was tolerated by his brethren despite the fact that he preferred alcohol and loose living to prayer, 'for, in the smith's craft, he was excellent'.

So highly was goldsmithery esteemed, that monks skilled in the craft continued it even when they became abbots, and travelled round to execute commissions.[79] Thus Spearhafoc, Abbot of Abingdon in the first half of the eleventh century, travelled to Canterbury to make figures in metal for St Augustine's, Canterbury, and in the time of Edward the Confessor, Mannig, Abbot of Evesham, was asked to make objects 'at Canterbury, in the church at Coventry, and in many other places'. A chronicler of Evesham seems to have regarded Mannig as the greatest craftsman of his time, and lamented the paralysis that afflicted him in the last seven years of his life. One of his main works was a gold, silver and gemmed shrine for St Odulph, which was upgraded to serve as a shrine for Evesham's patron saint, Ecgwine. Mannig supervised the work with a master craftsman called Godric, who was not a monk but a layman. Godric injured his left hand with his chisel, but it healed miraculously rapidly, and twenty years later he became a monk.[80]

The craftsmen who worked under Godric were also laymen, and appear to have been a team of professionals. Godric also used a lay team while working at Coventry, and the same group accepted a commission from Lady Godiva to convert her gold and silver into art objects for the Church. When King Edgar wanted a shrine for the translation of the relics of St Swithun at Winchester in 971, he gathered a lay team in his own residence, possibly at King's Sombourne, to make it. The laymen working for Cnut on a shrine for the relics of St Edith were blinded and turned out when it was found they were adulterating the precious metals.

The fact that by late Saxon times monasteries were major landowners meant that considerable maintenance work necessitated the employment of laymen. At the time of Domesday Book, Bury had seventy-five lay dependants. Even manuscripts were not always copied by monks. A

scribe in Worcester held land on condition he copied books for the monastery there.

Of the great clerics reputedly famous as artificers, St Dunstan and St Aethelwold are outstanding. The accounts of St Aethelwold make it clear he was a great scholar and teacher.[81] The authenticity of the references to his skill as a craftsman is more dubious. He was claimed as having 'made' gold and silver crosses, a gold and silver altar retable with figures of the twelve apostles, a gold (or gold plated) revolving wheel with bells and lamps and an organ 'with his own hands', but no contemporaneous account of him refers to these skills. St Dunstan, we are told, played the harp and practised crafts. A contemporaneous chronicler noted that Dunstan practised calligraphy and had skill in painting, a fact which is clearly demonstrated by his surviving drawing of Christ (see p. 172). Soon after his death a chronicler noted that he 'could make whatever he liked from gold, silver, bronze and iron' – on one occasion, we are told, he seized the Devil by his nose with his white-hot tongs.

Women are rarely mentioned in historical sources as involved in arts or crafts. St Edith, a contemporary of Dunstan, is outstanding, however, in being reported as skilled at embroidery in gold thread and precious stones, and gifted in music, calligraphy and painting.[82]

Techniques and workshops

Although the stone used by sculptors usually seems to have been local, there is some evidence that materials were transported some distance. Thus the Codford shaft seems to have been carved from imported Bath stone and the Milton Bryan slab (Beds.) was carved from Barnack stone, to take but two examples from the south. In the north, a hogback from Barmston, Humberside, is carved from a type of stone found around Lythe, fifty miles further south, where similar ornament is found on hogbacks. Was there a coastal trade in finished monuments from a workshop at Lythe?[83] Several sculptures at York were carved from millstone grit, which is found thirty miles further west. It has been suggested that a group of sculptors in Cumbria were using one, or possibly two quarries for their raw materials.[84]

In blocking out the basic shapes, templates were probably used – a group of 'plate headed' crosses at Brompton, Yorks., Kirklevington, Cleveland, and Northallerton, Yorks., all have the same curve between the arms though the lengths of the arms may vary.[85] Some crosses were carved from a single block, others were composites, joined with tenon-and-mortice fastenings, lead being run between the joints, as on the Bewcastle cross, to secure the parts. Some cross shafts seem to have ornament down to their bases, suggesting they stood neither in the

ground nor in a stone base. They may have been erected on paving, where they would have been stable. Blocking out of the design was done before detailed carving. Some sculptors may have used standard sizes for panels, for example at Middleton, Yorks.[86]

Study of sculpture is providing insights into the 'schools' that operated, particularly in the north of England.[87] It has been suggested that templates were used to build up the ornament on crosses, and groups of sculptures have been recognised that share common templates – for example in a group of churches in Yorkshire and County Durham that includes Sockburn. In some cases the churches concerned are very widely scattered.

It has been suggested that churches in Lancaster and Aspatria in Cumbria (eighty miles apart) share the same templates. This view has been disputed, and an alternative suggestion is that a grid with a series of drilled holes was marked out, and the designs copied on to that, in the way that grids were constructed in manuscripts. Of course, the use of grids does not rule out the use of templates. The original grid holes were covered over with gesso, which was then painted.

Grid holes are apparent at York and at Brompton in Yorkshire, and their use, along with technical idiosyncrasies of carving, has led to the recognition of a 'York Master'. Both techniques seem to be derived from an Anglo-Saxon tradition of measured patterns, well exemplified by the grids and compass layout pricked out on pages of the Lindisfarne Gospels prior to drawing (see p. 113). The use of guide points has not fully been considered in metalwork, though it can be found employed in the laying-out of designs in eighth-century brooches in Scotland.[88]

Finishing was done with a variety of tools, including chisels, punches and drills. Metal strips may have been attached to the Reculver cross – small drill holes survive that are not explicable in terms of laying out the design.[89]

Certainly the monotonous appearance of most Anglo-Scandinavian sculptures in the north of England should not blind us to the fact that they would have looked very different when richly painted. Pigment is apparent on the St Paul's Churchyard stone in London (see p. 188), and traces of paint on a number of the northern Anglo-Scandinavian stones are being found where it was thought to be non-existent. Sculptures with traces of paint include examples at Burnsall, Stonegrave, Kirklevington, and Lancaster in the north, and Deerhurst, Reculver and Ipswich in the south.[90] The font at Wells originally seems to have had figures painted under its arcades. Some blank panels, for example on Masham and Otley I in Yorkshire, may have had painted inscriptions. Aelfric in his *Colloquy* comments that stone crucifixes were coloured, and from the eighth century onwards, there are other references to sculptures that appear to have been painted.[91]

Little information is obtainable at present about the relationship between the patron and the sculptor in late Saxon England, but at Gosforth, Cumbria, there is evidence that a sculptor produced a number of works for the same patron, who probably dictated the choice of subject matter.[92]

As in previous periods, no metalworker's workshops survive, nor, with the exception of the bell moulds noted above (see p. 150), do we have moulds for castings from late Saxon England. From Southampton has come an unfinished strap-end of the ninth century,[93] and from Sevington, Wilts., has come a hoard of strap-ends of the same date in various stages of completion.[94] A number of new techniques, however, became fashionable, including the use of niello and other inlays, and the revival of enamel work, which is not only seen in the Alfred and Minster Lovell jewels but in a series of enamelled disc brooches.[95]

By the ninth and tenth centuries native supplies of silver were being augmented by Arab dirhems, which the Vikings obtained in vast numbers and which are common in Viking Age hoards.

Secular art

Of the purely secular art of the late Saxon period items of metalwork are the most important. Two of the finest pieces stand apart from the general artistic trend. The first is known as the Alfred Jewel, because of its Old English inscription explaining that 'Alfred had me made'.[96] The jewel was found near Athelney in Somerset in 1693, and is believed to be the head of a reading pointer, though this has been debated. Certainly it was attached to a rod or staff which fitted into the socket in the shape of a filigree and granular animal head. The jewel is pear-shaped, with an enamelled figure behind a plate of rock crystal on the front, and a symmetrical plant motif on the back. It has been suggested that as the figure compares with that on the Fuller Brooch (see below), which represents Sight, the Alfred jewel personage is just such a personification. More recently, however, it has been suggested that it represents Christ, as Wisdom of God, with the back plate representing Wisdom, the Tree of Life. The Minster Lovell Jewel from Oxfordshire is a similarly mounted and enamelled piece, but with an abstract design.

Trewhiddle style

During the ninth century a new ornamental style emerged, known as Trewhiddle, after a hoard of silverwork found in Cornwall, deposited *c.* 868 and containing mostly secular pieces, apart from the chalice, mentioned above, and a scourge.[97] By this time gold was scarce, and silver was used instead, often combined with inlays of niello which gave an attractive 'black

and white' effect. The dominant element in Trewhiddle metalwork is a small, often contorted animal, squeezed into an irregularly shaped void. Such animals are the descendants of creatures such as those on the Witham pins (see p. 130), and those found in some contemporary manuscripts.

The Trewhiddle style was predominant in most items of personal adornment. There are regional versions; in the north there are, for example, a series of swords with hilts decorated in a more geometric style, along with comparable rings and strap-ends. There are a very large number of decorated strap-ends, with split ends and rivets for attachment to the strap and an animal head at the extremity, that were probably used for a variety of purposes in the ninth century, and which display regional variation. The best were of silver, the majority of bronze, and the ornament ranges through animals to interlace. Hooked tags, used presumably as dress-fasteners, also display this varied art, as do some pins and finger rings.

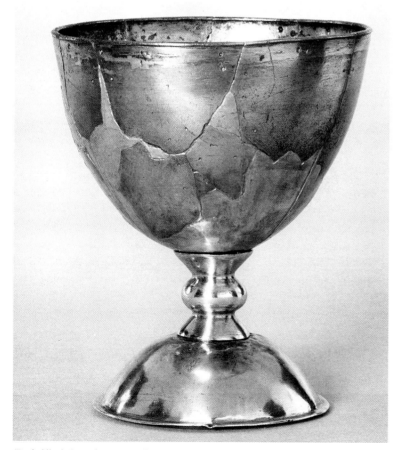

Trewhiddle chalice, silver, Cornwall. H. 12.6 cm (British Museum)

Trewiddle hoard, Cornwall, animal ornament (Lloyd Laing)

Ornament on Aethelwulf's ring (Lloyd Laing)

In the south, notably in Wessex, it would seem that kings, including Alfred, gave gifts of rings to their followers. The finest extant examples (such as Aethelswith's ring found at Aberford in Yorkshire, which has niello inlay) are of gold.[98] In Trewhiddle style, it was a gift from the queen of Burgred of Mercia, and bears the name of the donor.

Mention may also be made of swords, such as that from the River Witham at Fiskerton, Lincs, with a tripartite iron pommel[99] and Trewhiddle mounts, or that from Gilling Beck, West Yorkshire, found in 1976. These, and drinking horn mounts, such as that from Burghead, Moray, far from its place of manufacture,[100] serve as reminders of the use of Trewhiddle ornament to decorate status symbols in late Saxon England.

A silver cup from Halton Moor, Lancashire, found with coins of Cnut, has acanthus foliage and roundels with animals that have been seen as showing Oriental influence, though this is unlikely. It is probably Carolingian, and shows one avenue through which motifs were disseminated.[101]

Gilling Beck sword, Gilling Beck, N. Yorkshire. Max. L. 83.8 cm (Reproduced by courtesy of the Yorkshire Museum)

Halton Moor cup, Lancashire (British Museum)

The finest pieces of late Saxon metalwork are the disc brooches; silver descendants of the gold and garnet exemplars of the seventh century.[102] Openwork is a feature of several of these, the finest of which can be seen in a hoard found at Pentney, Norfolk, dating from the first half of the ninth century.[103] The hoard came to light in 1977, during the digging of a grave, and comprised six silver openwork brooches, four with niello inlay. Two form a pair, generally similar in style, but with minor differences. They are likely to have been made in East Anglia, and the hoard may have been concealed at the time of the first Viking raids. Interlace and animals are combined, the animals representing the first stage in the evolution of Trewhiddle style.

Of the other brooches in the same tradition, those from a cave at Beeston Tor, Staffordshire were perhaps concealed at the time of the Viking advance on Repton. The superb Fuller Brooch has

personifications of the Five Senses and roundels with humans and animals representing the different aspects of the Creation.[104]

Art in the tenth and eleventh centuries

The period from the mid-tenth to mid-eleventh century in particular witnessed a creative flourish which had not been seen before and which stands out as a golden age of English art. Decorative motifs were employed in secular and ecclesiastical art alike, particularly foliate designs and details of animal ornament,[105] and monasteries sometimes produced manuscripts for the lay market. In this period it is possible to trace a growing divergence between this monastic art of the south and the Viking-influenced art of the north.

Art in the south

As well as the developments in ecclesiastical architecture, monastic reform stimulated an artistic Renaissance in England. Manuscripts, line drawings, wall paintings, sculpture, ivories, textiles and metalwork were all produced in abundance. They use an iconography which is no less problematic than that of earlier periods.

One factor is that artists were very familiar with the writings of the Fathers of the Church, such as St Augustine of Hippo, St Gregory, St Jerome, St Ambrose and Cassiodorus. Another is the fact that iconographic models were derived from a great diversity of sources, many of which are probably lost. Through studying the models and the interpretation of the symbols, it is sometimes possible to determine which sources were available to the artist and in which intellectual climate particular works were created.

Parallels were drawn between episodes in the Old Testament and the New, for example (they were known as 'Types' and 'Antitypes'), and Old Testament figures were used to teach elements of Christian doctrine: in the words of St Augustine 'The Old Testament is but the New concealed'. Thus Daniel in the Lion's Den could be seen a symbol of Deliverance, while the Sacrifice of Isaac was seen as a forerunner of Christ's Passion.

One element which can be used to illustrate the complexity of iconographic thinking is the use of the image of the 'Rough Hewn Cross' or the 'Cross as a Tree'. This stems from the final chapter of Revelation, which alludes to the Tree of Life, itself a symbol in Early Christian art. This could be linked in the mind of the viewer with both the tree in the Garden of Eden, and the tree which was used to form the Cross. The Cross as a tree appears on an Anglo-Scandinavian sculpture from Kirkby Wharfe, Yorkshire, and careful examination reveals leaves

Bronze strap end with niello and interlace, Ipswich, Suffolk. L. 4 cm (Lloyd Laing)

on the branches of the cross in the Romsey, Hants., rood. In Winchester School work (see below) the hewn Cross appears in a series of manuscripts of *c.* 1000–20 at Canterbury, where it is shown without leaves. It first appears in the Harley 603, without the figure of Christ, and occurs in the Tiberius Cvi and other manuscripts. Study has shown the complexity of thought that lies behind the apparently simple image, and one which develops ideas expressed in words in *The Dream of the Rood*, an Anglo-Saxon poem which is inscribed on the Ruthwell Cross. It is essentially a Tree of Life which is also a Tree of Death.[106]

In interpreting such iconography the Anglo-Saxon art historian finds that the symbolism, at first perhaps apparently fairly clear, is much more complex than first supposed. Late Saxon artists seem to have found conventional contemporary iconography lacking in finesse, and to have developed their own idiosyncratic imagery to symbolise a more specific idea. They carefully connected specific words and visual images, illustrating the text is a literal form. This tendency is exemplified in the manuscript Harley 603, where the model, the Utrecht Psalter, was not always copied exactly. Thus the illustration for Psalm 2, verse 9, in the Utrecht Psalter ('Thou shalt rule them with a rod of iron and shall break them in pieces like a potter's vessel') shows a crock broken by Christ's rod. In the Harley 603 the vessel is unbroken, as the picture appears on the previous page to the text, and thus when drawn the vessel was still unbroken.[107] Similarly, while normal imagery of the Trinity demands all figures to be of equal size, the Harley 603 shows Christ smaller than the other two figures, literally illustrating *John* 14:28 'the Father is greater than I'.[108]

Anglo-Saxon iconography was notable for its innovatory character. Features include its use of literal illustration and the skilful integration of pictures with text, so that the latter could be seen to be a commentary on the former. To this end, great care was taken to ensure that integrated pictures appeared at the same point as the text to which they related.[109] Inscriptions, too, were used to explain or draw attention to particular details of the imagery.[110]

Winchester School

The unprecedented artistic flowering of this period is usually termed the Winchester School, though this city was only one of the centres involved in its production.[111] It is remarkable for being first discernible in embroideries – traditionally the province of women. There is no record of who lay behind the design, but if female, this would be a rare example of a major art style having been pioneered by a woman or women.

Whoever lay behind the inspiration, the Winchester style was the

outcome of many influences, including that of the Carolingian and Ottonian Empires, and ultimately, through these intermediaries, the Byzantine world.[112] By the early eleventh century there was a reverse flow of influences from England to France, and to a lesser extent Scandinavia. One medium through which ideas were transmitted was manuscript art.

There is evidence that foreign manuscripts were brought to England, where they acted as models and inspirations. Some seem to have been gifts to Aethelstan or members of his court – the king is known to have received a late Carolingian Gospel book from Otto I, perhaps in 929. A Continental psalter belonging to Aethelstan survives (Cotton Galba A xviii), with inserted pictures copied by at least two English artists from Continental models.[113] Another miniature in a manuscript in Trinity College, Cambridge (Ms B.16.3) seems to be a close copy made in England of a Continental work probably executed in Fulda. This is a text of *De Laude Crucis* by Rabanus Maurus, and the frontispiece shows the author giving the book to Pope Gregory, a type of presentation picture which, as will be seen, was taken up later in England.[114]

The beginnings of the Winchester art style are traceable in embroideries made in the time of Aethelstan as a gift to the shrine of St Cuthbert at Chester-le-Street, and probably presented in 934.[115] The Cuthbert vestments comprise a stole, maniple and girdle embroidered in coloured silks with some gold thread on a whitish silk ground. Although now faded to a dark tone, the colours were dark green, dark brown, blue, red and brownish-red. Inscriptions on them show that they were made on the orders of Queen Aelflaed, Aethelstan's stepmother. The figural work depicts saints. The style is very individual and stately, with acanthus foliage and formal rocks on which the figures stand. They are without obvious Carolingian parallel, and without immediate precursors in England, either.

The first phase of the Winchester style in manuscript art is marked by a copy of Bede's *Life of Cuthbert*, now in Corpus Christi College, Cambridge, which is prefaced by a page portrait showing Aethelstan presenting the book to the saint.[116] The lettering of the text suggests strongly that it was produced in Southumbria, probably at Winchester, and it seems to have been made for the shrine of St Cuthbert at Chester-le-Street, around 934. The presentation picture is a novelty in English art, as indeed is the frame drawn on the page to represent the real frame (with chamfered corners) in which panel paintings would have been set. This frame was probably copying an ivory, and is decorated with a popular Carolingian motif – the acanthus foliage scroll – that gained great vogue in England. Alongside the acanthus, however, is a more traditionally English plant scroll inhabited by birds and animals. The colours are fairly dull (predominantly brown, yellow and blue), the

St Cuthbert stole, Durham, detail of embroidery showing Jonah (Dean and Chapter, Durham Cathedral)

Drawing attributed to St Dunstan, 24.5 × 17.9 cm (Oxford, Bodleian MS Auct. f.4.32)

figures not dissimilar to the nearly contemporaneous figures on the Cuthbert embroideries from Durham (see below). Traditional too are some of the decorated initials.

The penmanship in the Corpus Christi book is heavy-handed, in stark contrast to the light assurance of a drawing of Christ by St Dunstan himself.[117] The sketch appears as a later embellishment of a blank page in a ninth-century and later manuscript (Oxford, Bodleian Ms Auct f.4.32). Christ is depicted holding a rod and a book, not totally unlike a Byzantine Pantokrator, with a small figure of a monk (a self-portrait by Dunstan) kneeling at the foot of his robe. The drawing is in brown ink, with a touch of red on Christ's halo. An inscription above the figure of Dunstan in his own hand records, in Latin, 'I pray thee, Christ, protect me Dunstan'; above the drawing a scribe has later added that, 'The picture and writing on the page below are by St Dunstan's own hand'. The closest models are to be found in the Court School of Charlemagne, and this work was probably executed at Glastonbury before 956; it is one of a series of distinguished line drawings that are among the hallmarks of the Winchester style.[118]

In marked contrast to the stiff figures and dull colours of the Corpus Christi Bede is the greatest of all the Winchester manuscripts, the Benedictional of St Aethelwold,[119] produced probably after 971 with a prefatory poem explaining that it was made for St Aethelwold by Godeman the scribe (probably his chaplain). It was perhaps made following the translation of the relics of St Swithun, for it alludes to miracles performed at the shrine. The book is comparatively small (29.3 x 22.5 cm), the colours sumptuous. Gold and silver are applied lavishly, and the palette ranges from subtle pinks and greens to rich blues and reds. The full-page pictures (of which twenty-eight survive) are set within frames of luxuriant acanthus, both rectangular and arched. The text is ornamented, and nineteen pages of text are set within decorative frames. Originally it probably had another fifteen full-page illuminations. The subject matter relates to various feasts. There is nothing even remotely comparable as a Continental fore-runner.

Two other manuscripts are closely related: the Benedictional (Pontifical) of Archbishop Robert (probably of Jumièges), now in Rouen,[120] and another, simpler Benedictional now in Paris.

The Grimbald Gospels, produced at Christ Church, Canterbury, by a scribe called Eadui Basan are even more sumptuous in some respects than the Benedictional of St Aethelwold. The work is named after the supposed founder of the Winchester New Minster.[121] Gold, silver and rich colouring predominate, but the drawing is sensitive. The same scribe probably produced the Bury Gospels (for the newly founded monastery at Bury St Edmunds, around 1020), which has similar colours and some fine drawing.

The New Minster Charter of Winchester (the Cotton Vespasian A viii) was a book rather than a simple document, made probably some time after the foundation of the Minster in 966.[122] The frontispiece is the main decorative feature, and shows King Edgar, flanked by the Virgin and St Peter, offering his charter to Christ on a mandorla supported by four angels, the whole within a rectangular frame. There are important innovations here. The frame appears to be openwork, made of twigs round which acanthus has been twined. The angels seem to be flying out of it, their wings and feet overlapping it. Edgar himself is ambitiously drawn in a curious corkscrew – his legs and feet appear to be from a figure facing us but turning slightly to the right. His buttocks and back however are clearly of someone with his back to the observer, turning right. His head is craned at an unnatural angle to try to see Christ. The colours are quite rich, and Edgar's curious pose is reminiscent of Ottonian manuscripts.

The tradition of line drawing that started in Dunstan's sketch (above) is further developed in a series of manuscripts. The Ramsey Psalter (Harley Ms 2904) is a book which contains a magnificent depiction of the Crucifixion, executed in the late tenth century.[123] Christ is in reddish-brown with His hair and draperies accented in black. The mouth, wounds and halo are touched with red and the foot support is blue. The figure of Christ is very expressive, as are the flanking figures of the Virgin and John. As Margaret Rickert has noted, 'The effect is that of a sketch with colour notes for painting . . . the Harleian Crucifixion could only be the work of a consummate original artist who was creative enough to be able to grasp the essentials of the modelled form and to translate them into this effective outline style' (*Painting in Britain: the Middle Ages*, Harmondsworth (1965), 35).

The Harley Psalter is a major derivative made at Christ Church, Canterbury, of the Utrecht Psalter, a product of the Rheims School of Carolingian art of *c.* 820 that was brought to England at the end of the tenth century. It illustrates the psalms with a light but sure penmanship that transcends the quality of the original, and was perhaps made for Aethelnoth, Archbishop of Canterbury 1020–38.[124] It was produced over a long period of time, by one scribe, but the work of three or four artists is apparent in the work. One has been identified as Eadui Basan, by this time an old man with less firm hand than he displayed in his masterpieces of thirty years earlier. There are over a hundred multicoloured drawings in the manuscript, executed with short lines and full of action. Draperies flutter, actions are dramatic.

Two other manuscripts with line drawings show the versatility of Winchester School artists. The first is the Bodleian Junius II, an illustrated version of the early books of the Bible rendered in English by Caedmon.[125] For the archaeologist, it is a mine of interesting detail, with illustrations of everyday items such as hinges, axes and so on.

hic est NAZARE
N IHC REX IUDEOR

Crucifixion, Ramsey Psalter. 285 x 242 mm (British Library, Harley 2904, f.3v)

Particularly noteworthy is Noah's ark, with its dragon-headed prow and fish-tailed stern, and its three-storey cabin and towers crowned, seemingly, by cock weather vanes.

Archaeological detail is also observable in the Cotton Julius A VI (which contains month-by-month scenes of farming), and in a text of Aelfric's Metrical Paraphrase of the Pentateuch (Cotton Claudius Biv).[126] Fine detail also characterises the Cotton Tiberius Cvi, a late psalter which is datable to around 1050. The Harrowing of Hell, with its demons, represents a foretaste of a subject which became very popular on Romanesque tympana.[127]

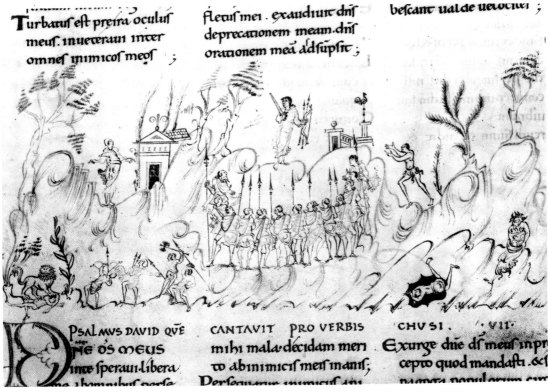

Turbatus est pretra oculus meus. inueteraui inter omnes inimicos meos ;

fletus mei . exaudiuit dñs deprecationem meam. dñs orationem mea adsupsit ;

bescant ualde uelociter ;

PSALMUS DAVID QVE ñe os meus inte speraui. libera

CANTAVIT PRO VERBIS mihi mala. decidam men to abinimicis meis manis; Persequitur inimicus an

CHVSI . VII. Exurge dñe dñ meus in pr cepto quod mandasti . &

Harley Psalter, detail. Page size 380 x 310 mm (British Library, Harley 603, f.4)

Wall paintings

It is clear that wall paintings were executed in the same style as that of manuscripts. A fragmentary wall painting in the nave of a church at Nether Wallop (Hants) depicts angels supporting a mandorla,[128] and has on stylistic grounds been assigned to the tenth century. A block of stone from the Old Minster at Winchester[129] shows the upper part of a group of three figures with a curtain and an abstract border. It must date from before 903, since it was reused in the foundations of New Minster, but on stylistic grounds it need not be much earlier. Occasional references to wall paintings occur in Anglo-Saxon literature, usually because of their association with particular figures. Examples of this include St Wilfrid at Hexham and St Edith at Wilton (where we are informed there were paintings of Christ's Passion and the church's patron saint, St Denis). These also attracted attention because of the expensive pigments (gold and azure) used in them. Gold was also used in pre-Conquest paintings at York, which is probably why they came to the attention of writers. At Glastonbury, William of

Wall painting of angels, Nether Wallop, Hants. (RCHME © Crown copyright)

Winchester Old Minster, wall painting. L. 58.6 cm (Winchester Excavation Committee)

Malmesbury recorded that there were paintings of abbots – a certain Stiward of the ninth or tenth century was depicted with a scourge or a birch.[130]

Sculpture

Architectural sculpture is more common in the later Saxon period than in the earlier. As well as the continuing custom of erecting sundials, there are carved roods, tympana and panels. A sundial from Kirkdale, Yorks, bears an inscription noting both that 'This is the day's sun marking at every hour' and the fact that the church was rebuilt by Orm in the days of Edward the King and Tosti the Earl. 'Edward' refers to the Confessor, giving it a date of *c.* 1055–65.[131] Such dedication inscriptions are rare. One from Odda's Chapel, Deerhurst, has a long text explaining that 'Earl Odda ordered this royal hall to be built and dedicated in honour of the Holy Trinity for the soul of his brother Aelfric which [was] taken up from this place. And Eadred was the bishop who dedicated the same on the second of the Ides of April and in the fourteenth year of the reign of Edward, king of the English.' This is a reference to Edward the Confessor, who was apparently a kinsman of Earl Odda of Devon, Somerset, Dorset and Cornwall. We are informed that Odda was a 'lover of churches'.[132]

Friezes continued to be made. One Bath stone fragment from the Old Minster crypt at Winchester appears to have come from a huge example some 24.38 m long and 1.19 m wide.[133] The fragment has an enigmatic scene which has been interpreted as an episode from the story of Sigmund in the *Volsunga* saga. The panel depicts a chain-mail clad figure walking to the left, and a man is lying on his back, bound round the neck and right wrist. A wolf (of which only the head

Codford St Peter, cross shaft, Wilts, H. c. 1.25 m (Lloyd Laing)

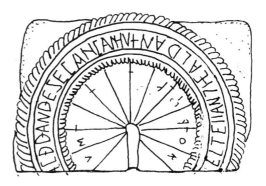

Kirkdale, Yorkshire, sundial (Jenny Laing)

Old Minster, Winchester, Hants, frieze.
W. 53 cm (Winchester Excavation
Committee)

survives), has its tongue in the man's mouth. It has been suggested that
the Sigmund story may have formed part of the lore of the royal houses
of Wessex and Denmark, and that the frieze may have been erected to
commemorate the marriage of Cnut (of Denmark) and Emma (of
Wessex), both of whom were buried in the Old Minster, and may have
been married there in 1017.[134] The frieze is a stone foretaste of the
Bayeux Tapestry.

Among the most remarkable panels are those on the jambs of a
door at Britford, Wilts, with vinescroll and interlace.[135] A foliage
scroll also appears on a panel from Barnack, Northants.,
surmounted by a cock, while another panel from the same place has

an openwork interlace design, presumably intended to let sound out of the belfry. Animal heads occasionally appear as sculptural details built into walls, for example at Deerhurst and Barnack. Original fonts are rare, but examples survive at Potterne, Wilts., and Little Billing, Northants., datable by the lettering of inscriptions in tenth-century style.[136]

Very few stone sculptures of any note survive in the Winchester style. The flying angels from the church at Bradford-on-Avon and from the church at Winterbourne Steepleton, Dorset, are in a Winchester tradition. The Winterbourne Steepleton example is a far cry from the sophistication of Winchester manuscript art.[137] A rood, with the Crucifixion surmounted by the Hand of God emerging from a cloud, adorns the church at Romsey Abbey, Hants, and shows some similarities to a group of Carolingian ivories. A cross shaft from Codford St Peter, Wilts, has a man holding a branch.[138] The draperies are crude and tubular, but with his curiously-angled head he is faintly reminiscent of Edgar in the New Minster Charter (see p. 174). Some scholars, however, prefer to date this piece to the late eighth or early ninth century.[139]

Ivories

A remarkable assemblage of ivories reflects the two major trends also found in manuscript and sculptural art: some are majestic (i.e. depict Christ in Majesty) and Classical, others display the agitated draperies and drama of the Harley 603.[140] The first type seems to have been inspired by Carolingian ivories of the kind known to have been produced at Metz; the second seems to draw inspiration from Rheims manuscripts, though undoubtedly there were other influences at work. During the eleventh century the carving becomes more formal and less sensitive. Figures assume a solidarity and ponderousness.

A few examples illustrate the diversity of styles. A triangular panel of walrus ivory of the later tenth century from Winchester depicts two angels pointing downwards (it probably came from the gable of a house-shaped reliquary). This is clearly strongly influenced by Metz models, and the angels are closely comparable with those in the New Minster Charter.[141] Equally Carolingian is a rectangular panel now in the National Museums on Merseyside, of walrus ivory, depicting the Nativity, which just begins to show a fascination with the abstraction of draperies.[142]

The Crucifixion in the Harley 2904 can be compared with a Crucifix reliquary in the Victoria and Albert Museum, London. This has a walrus ivory majestic Crucifixion on a gold-covered cedar-wood cross with enamels, which contained a relic – a human finger.[143] The

Ivory panel with angels, Winchester, later tenth century. H. 7.6 cm (Winchester Museum)

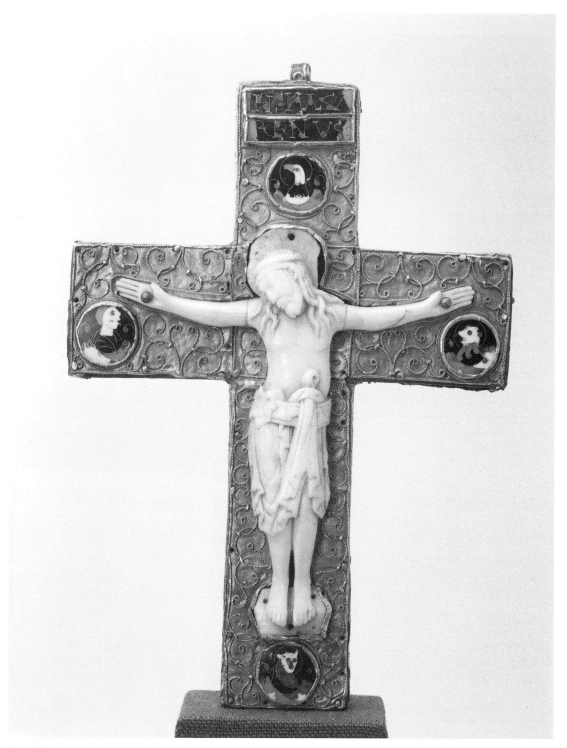

Ivory of Christ on metal-covered wooden cross with enamels. Early eleventh century. H. 18.5 cm (Victoria & Albert Museum)

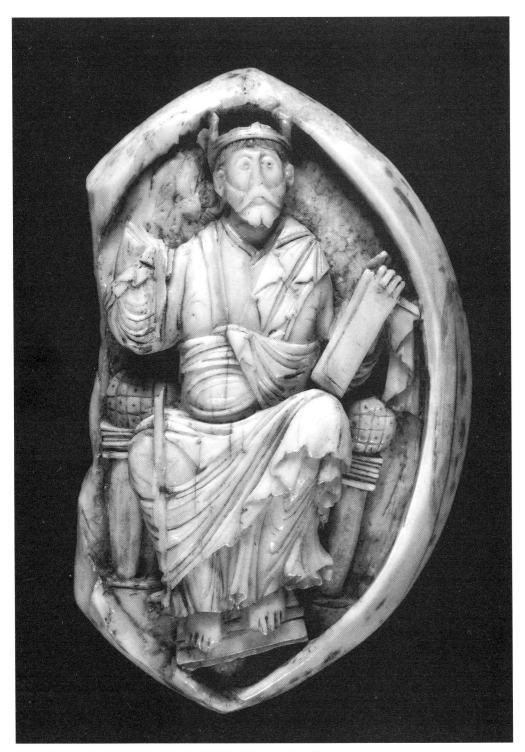

Ivory of Christ in Majesty, early eleventh century. H. 9.6 cm (Victoria & Albert Museum)

wooden core may have been believed to be a piece of the True Cross. No doubt surrounds the ivory, which is clearly Anglo-Saxon and datable to around 1000. Much more problematic is the Crucifix, which in the past has been seen as entirely a German product. Growing opinion, however, favours the view that the Crucifix too is Anglo-Saxon, but that it was remodelled in England using a German back panel and possibly sides. The enamels, once believed to be German because late Anglo-Saxon enamels were comparatively unknown, are increasingly accepted as English. The importance of this piece lies in the clue it provides for the apperance of church fittings in the later Saxon period. It may have been intended to hang over an altar.

Of the Rheims type of ivory, mention may be made of an oval panel in the Victoria and Albert Museum, with a Christ in Majesty on a mandorla, probably from a portable altar or reliquary. In style it can be compared to work in the Sacramentary of Robert of Jumièges.[144]

To illustrate the later, coarser style an example may be taken carved not out of ivory but of wood. This is a house-shaped casket of boxwood

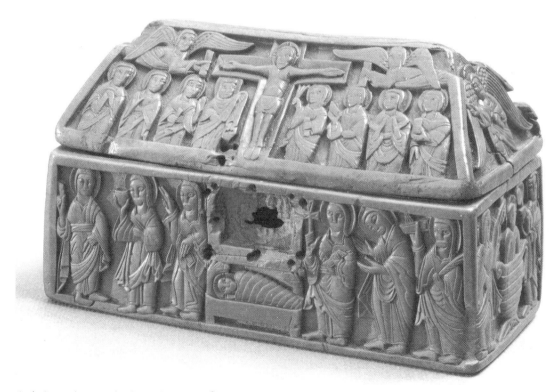

Anglo-Saxon reliquary casket, boxwood, c. 1050. (© The Cleveland Museum of Art 1995. Purchase from the J.H. Wade Fund 53.362)

now in the Cleveland Museum of Art, Ohio, datable to the mid-eleventh century, and decorated with scenes from the Life of Christ.[145] It may have been a reliquary, and the two halves, which turned up in Cheshire and Uttoxeter, might point to a West Midlands origin.

Textiles

Although there is plenty of documentation for textiles in late Anglo-Saxon England, little has survived. Among the recovered fragments are scraps of material from the tomb of Edward the Confessor in Westminster Abbey. These were from an imported Byzantine shroud of gold-coloured silk, with roundels containing birds and conventional plants. Imported too was the 'Rider' silk from the coffin of St Cuthbert, added in the tenth or eleventh century, and probably of Persian origin. Silk was certainly being imported in some quantity in late Saxon England – a silk cap has been found in York, and there are others from London and Lincoln.

Purely native, however, were the embroideries produced by English needlewomen for St Cuthbert's coffin, which are embroidered in silk (see p. 171).

Ecclesiastical metalwork[146]

The Victoria and Albert Crucifix (see p. 180) introduces the small corpus of late Saxon ecclesiastical metalwork. Most is fragmentary, having been torn off other objects at varying times in the past, but a few pieces extend an understanding of church furnishings. A tiny spouted jug of gilt bronze now in the British Museum probably dates from the first half of the tenth century and is decorated with animals and foliage. It has been identified as a cruet – the vessel from which wine and water were poured into the chalice in Mass.

Art in the north – Scandinavian impact

The Vikings had their own art styles which evolved out of earlier antecedents in Scandinavia.[147] In recent years much attention has been focused on the study of Anglo-Scandinavian sculpture, and as a result a better understanding of the hybrid culture is being achieved.[148] Regional groups of sculptures and of ornamental devices have been isolated, and patterns of influences discerned. (Thus, for example, crosses with circle-heads can be seen as predominantly north-western, while north-east England displays other regional forms.)[149]

Sculptures can also be used to study settlement patterns in the ninth and tenth centuries, and to point to sites which were, to judge by the

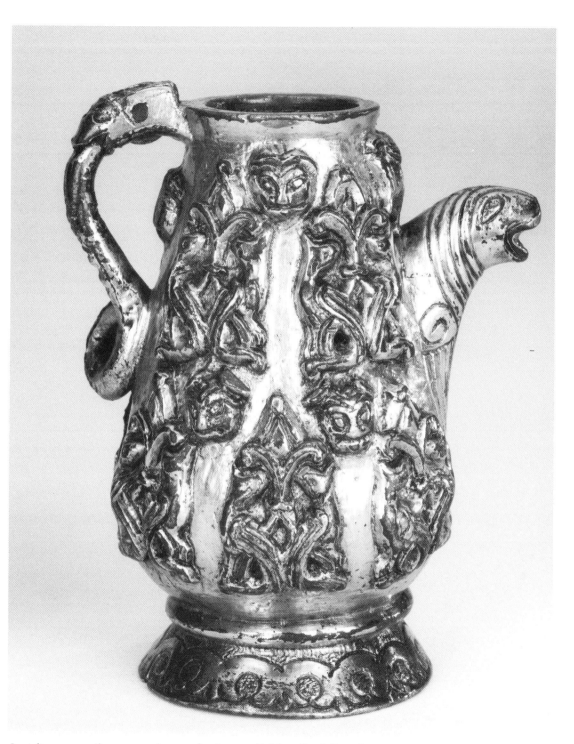

Spouted jug or cruet, gilt copper, second quarter of tenth century. H. 7.2 cm (British Museum)

quantity and quality of their sculpture, of greater importance in the period than might be surmised from documentary sources. Advanced workmanship may well point to richer communities. Similarly, stylistic links between the Isle of Man and the north of England hint at connections otherwise undocumented, primarily with a small area of western Yorkshire. The distribution of hogback monuments along the north-east coast, with a general absence between the Tweed and Tees, seems to point to a flourishing seaborne trade between eastern Scotland and part of Yorkshire, otherwise unattested.

The styles [150]

The succession of styles which had an impact on England begins with the Borre, which employed a type of ring-chain ornament. It is rare in metalwork (though it is found on a strap-end and mould from York), but well represented in sculpture from the end of the ninth century, into the first half of the tenth.

The Jellinge style is named after the royal centre in Jutland and began in the late ninth century, continuing in vogue for just over a century. It was probably introduced to England through the Viking-controlled towns such as York, and the Danelaw. The basic element was an animal with double outline, pigtail and lip-lappet. The style evolved in the early eleventh century into the Ringerike style, which is typified by an animal from which tendrils of acanthus-like foliage extend. This style gained popularity in the time of Cnut. The Urnes style, named after the carving on a wooden church in Norway, has the foliage tendrils extended until their plant origins are lost and they become asymmetrical interlace. This begins around 1050.

These styles are seen in both sculpture and in metalwork and manuscripts, the former in northern England, the latter in the south. The impact was to last until after the Norman Conquest. It was a two-way current, for Anglo-Saxon designs were copied in Scandinavia.

A few pieces of metalwork may be used to demonstrate the assimilation of Viking styles into English art. A tenth-century strap-end from Winchester has a Jellinge animal with a foliate tongue derived from Anglo-Saxon manuscript art.[151] In Jellinge style too is a fine sword chape from York. Related to it is the Mammen style, current in mid-tenth century Scandinavia. It is represented from London on a bone playing piece which shows a warrior in chain-mail.[152] There is a copper alloy plaque from Winchester, which was originally gilded, probably from a casket which is also in Ringerike style.[153] It has engraved and low key punched animal ornament. It could have been an import from Scandinavia, though its use of acanthus foliage points to its manufacture in England. A bronze plaque from Hammersmith, London, has been

(a)

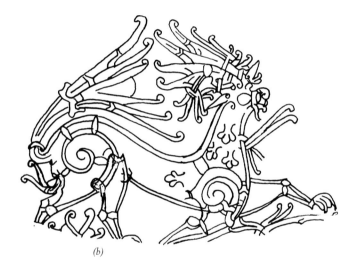

(b)

(c)

Viking art styles: (a) Mannen, Harald Gormsson's monument, Denmark; (b) Ringerike, vane for ship, Heggen, Norway;
(c) Urnes, runestone, Ytterselö, Sweden (Lloyd Laing)

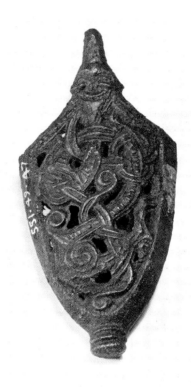

Viking chape, York, Jellinge style. L. 8.6 cm (Reproduced by courtesy of the Yorkshire Museum)

variously identified as a model tombstone and more convincingly as a die for stamped foils.[154] It is decorated with a design which is basically Ringerike, on to which Urnes tendrils have been grafted. It dates from the eleventh century. To this date too belongs a silver disc brooch in the tradition of the Fuller Brooch but with very different ornament. This was found at Sutton, Isle of Ely, and combines Anglo-Saxon features with Scandinavian Ringerike motifs. It was made by an Anglo-Saxon, since an inscription on it explains in Old English that it was owned by a lady called Aedwen and puts a curse on anyone who steals it.[155]

The finest example of Urnes style work in metal in England is the Pitney Brooch, from Somerset, found in the churchyard.[156] Of gilt bronze, it depicts a coiled animal locked in a struggle with a snake.

In southern England, a few pieces of sculpture reflect Scandinavian taste. The grave-slab from St Paul's churchyard, London,[157] for example, has a Ringerike stag and snake on the front and bears a runic inscription proclaiming that, 'Ginna and Toki had this stone set up'. When found, it retained its original paint, the snake being painted brownish-red, the stag black, with brownish-red details.

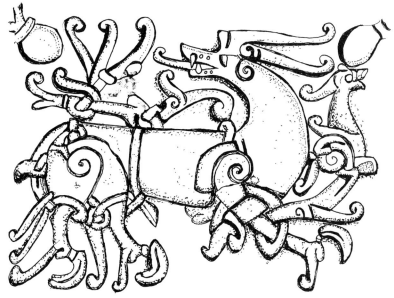

St Paul's churchyard stone, detail, London. W. 57 cm (Lloyd Laing)

Due to the general similarity between Rinkerike tendrils and the acanthus fronds fashionable in England, Ringerike elements were assimilated into the decoration of some manuscripts. Pure Ringerike appears for example in details in the Junius II (Caedmon) manuscript (see p. 174), and in a manuscript known as the Winchcombe Psalter. The Urnes style made its impact on manuscripts after the Norman Conquest.

Anglo-Scandinavian sculpture

A wide array of northern English sculpture demonstrates the Scandinavian impact on art: it combines elements of traditional Northumbrian sculpture with new motifs and styles.[158]

The Borre style is represented by the Gosforth Cross, from Cumbria. This tall column stands 14 ft (4.2 m) high, carved out of a single piece of sandstone and crowned by a Celtic-looking wheel head. The iconography on the cross is complex (see below). A female figure with pigtail may be a Valkyrie. Other examples in the same style are to be found in Cumbria.[159]

The Jellinge style is best exemplified by a series of sculptures from York, where a flourishing school of sculptors was located. Typical of the tradition is a slab from Coppergate, with an animal with double contour, lip-lappet and pigtail in classic style. Jellinge is generally confined to Yorkshire and Teesside.

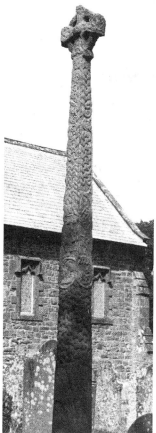

Gosforth Cross, Cumbria, early tenth century, H. 4.4 m (Andrea Crook)

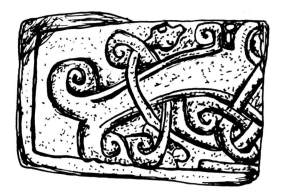
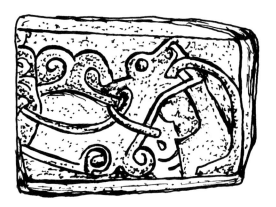

Levisham slab, Yorkshire (Lloyd Laing, after W.G. Collingwood)

Mammen style is as rare in sculpture as it is in other media, but appears on a slab from Levisham, Yorks.

Most of the northern sculpture does not belong to any one of the Scandinavian styles, but comprises an assortment of motifs and designs of both English and Scandinavian derivation. The most common monuments are of traditionally Anglo-Saxon form – cross-shafts and recumbent slabs. The hog-back stone was an innovation – it imitated the roof of a shrine, frequently displaying animal terminals and interlace among other designs. A late example at Hickling, Notts, has almost lost all its resemblance to the roof of a shrine. Slightly coped, it has a central cross with small animals.

Iconography and Anglo-Scandinavian sculpture

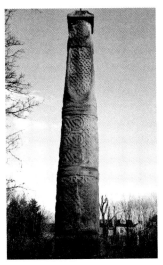

Stapleford cross, Nottinghamshire (Susanne Farr)

The iconography of the Anglo-Scandinavian sculptures has interested commentators, who have often read meanings into scenes which are extremely difficult to interpret.[160] The Vikings introduced secular figures into their sculptural art, and also characters from Scandinavian mythology which intrigued nineteenth-century antiquaries intent on finding evidence for the Germanic past. Warriors are depicted at Nunburnholme, Yorks, and mounted warriors with lances appear on a slab from Sockburn, County Durham. Also from Sockburn is a shaft decorated with a stag, and a warrior in a pointed helmet with a sword and spear. Hunt scenes are known, and in Yorkshire and Lancashire episodes are illustrated from the Sigurd cycle and from the story of Wayland the Smith, a legend already well-known before the Viking Age. Episodes from the story appear on the Leeds crosses and on fragments from Sherburn and Bedale in Yorkshire. Of particular interest is the depiction of Wayland's flying machine at Leeds, where the pagan story may have been used to make a Christian point.[161]

Sigurd the dragon-slayer was also known in pre-Viking England, and appears on a number of Anglo-Scandinavian stones, notably from Kirby Hill, Ripon and York. It has been argued that Sigurd epitomised a hero, and was seen as appropriate for honouring the dead.[162] There was also, however, a Christian dimension to Sigurd, who was a counterpart to the St Michael slaying the dragon who appears on later tympana (for example at Hoveringham, Notts) and symbolised either the triumph over a monster, or of good over evil. Similarly, Sigurd's feast may have been seen as a counterpart to the Eucharist.

It is on the Gosforth cross that the finest use of pagan ideas for Christian purposes can be seen. Here, apart from a depiction of the Crucifixion, is Ragnarok, the overthrow of the gods. Essentially the subject is the end of three worlds, that of Odin, that which Christ redeemed by his death, and the final end of Doomsday.[163]

Also at Gosforth is a stone which shows Thor fishing from a boat. This panel seems to have been part of a frieze or a wall panel from a church. Here again we may be seeing a pagan scene used to Christian purpose, the triumph of good over evil in the guise of a monster. Above the fishing scene is a panel in which a horned snake coils round the legs of an animal, part of the common scene of a hart attacking a snake, symbolising the triumph of good over evil.[164]

Christian subject matter, however, predominated on the stones. The symbolism was often complex – thus a roundel with five bosses on a cross head from Lancaster represents the Five Wounds.[165] The Crucifixion appears in Northumbria, but in an archaic form, while other subjects include David, Isaiah, the Fall and Isaac.

The hybrid culture represented by Anglo-Scandinavian artistic styles was given very little chance to develop due to the coming of the Normans.

Notes

1. Loyn, 1977 discusses the historical evidence for the raids on England, as does Richards, 1991, chap. 2.
2. Sawyer, 1971 and Sawyer, 1982 assess the Scandinavian impact on Europe. See also Foote and Wilson, 1970, and Roesdahl, 1991, for a balanced account of the Vikings in Europe.
3. Crawford, 1987; Ritchie, 1990.
4. Smyth, 1977; Loyn, 1977.
5. Keynes and Lapidge, 1983.
6. Smyth, 1977; Loyn, 1977.
7. Richards, 1991, 15.
8. Loyn, 1977, 125f.
9. Ibid.
10. Geipel, 1971, 110–64.
11. Loyn, 1977, 118; Geipel, 1971.

12. Hall, 1990, 14–19.
13. Richards, 1990, 40–41.
14. Simy Folds: Coggins, Fairless and Batey, 1983; Bryant's Gill: Dickinson, 1985.
15. Wilson, 1976b.
16. Richards, 1991, 16–18; Phillpott, 1990 for an accessible account of Cuerdale.
17. Richards, 1991, 16.
18. Hodges, 1989.
19. Barker and Lawson, 1971. There is also some evidence for ridge and furrow from Gwithian, Cornwall; see Fowler, 1976.
20. Jones, 1983.
21. Hodges, 1989.
22. Webster, 1986, 131.
23. Rahtz, 1979.
24. Davison, 1969.
25. Cadman and Foard, 1984; Cadman, 1983.
26. Biddle, 1976, 99–150 summarises the extensive literature. See also Hodges and Hobley, 1988 for the wider context.
27. Petersson, 1969; Dolley (ed.), 1961; Dolley, 1965; Dolley, 1976.
28. Some dispute about the frequency of the changes – Spufford, 1988, 93 summarises the arguments.
29. Hurst, 1976; Myres, Dunning and Hurst, 1959.
30. Dunning, 1956.
31. Keynes and Lapidge, 1983. But see Smyth, 1995, for the view that Asser's *Life* is a medieval forgery.
32. Campbell *et al.*, 1982, 165.
33. Fernie, 1983, 93.
34. The Carolingian renaissance was led by Charles the Great (Charlemagne), who gathered to his court at Aachen men who were conversant with the traditions of Rome, Ravenna, Milan, Trier and England. He modelled himself on a Roman emperor, and his palace chapel at Aachen was inspired by the Byzantine Chrysotriclinion of Justin II (565–78).

 In the Carolingian court several schools of manuscript art grew up, which drew upon a range of sources. The Court School was traditional, and in such works as the Evangelistary of Godescalc can be seen the influence of both Classical and Insular traditions. This was produced for Godescalc's visit to Rome at Easter 781, and reflected in some measure the contemporary style found for example in Santa Maria Antiqua in Rome. By the early ninth century the Palace School at Aachen was producing more consciously Antique-style manuscripts and ivories, the latter sometimes imitating the consular diptychs of the late Roman Empire. The Ada School, as it has been termed, borrowed elements from Anglo-Saxon England and from late Classical sources, which were blended and leavened perhaps with some Byzantine taste – certainly there were Byzantine artists working in Charlemagne's court.

 At Rheims, somewhat later, under Archbishop Ebbo (816–35) a new style developed, in which light, flickering lines were paramount. As John Beckwith has observed, 'the new, and no doubt northern artists began at once to inject into these calm forms a kind of palsy by which everything to do with the subject, space, landscape, evangelist, desk and pen quivers and vibrates' (*Early Medieval Art*, London, 1964, 43). One of the finest products of the Rheims school is the Utrecht Psalter, which came to Canterbury and inspired a distinguished copy in the Harley 603 (see p. 170). A more solid style prevailed under the influence of the English monk Alcuin, Abbot of Tours from 796 to 804. Tours specialised in

Bibles, probably all modelled on a fifth-century original commissioned by Pope Leo V.

These Carolingian styles continued to develop during the later ninth century, with influence from Insular sources. The successors of the Carolingians, the Ottonians, favoured a dramatic manuscript style, with extravagant gestures and vivid colouring and the lavish use of gold. The manuscripts produced in Regensburg, for example, share features in common with the finest English works, such as the Benedictional of St Aethelwold.

35. Conant, 1974, general survey.
36. Stenton, 1971, chap. XIII; Blair, 1956, 173–8; Campbell *et al.*, 1982, 181–91; Gameson, 1995, chap. 8.
37. Campbell *et al.* 1982, chap. 7.
38. Qualmann, 1986.
39. Hodges, 1989.
40. Gem, 1993, 56.
41. Gem, 1993.
42. Rodwell and Rodwell, 1973.
43. Rodwell, 1978.
44. Taylor and Taylor, 1965, 734.
45. Jope, 1964.
46. Jope, 1964.
47. Kerr and Kerr, 1983, 31–2.
48. Aldsworth, 1989, 221–4.
49. Eleventh-century shingles from Winchester in Biddle and Quirk, 1961, 193–4; Kerr and Kerr, 1983, 35.
50. Cherry, 1976; Fernie, 1983; Taylor and Taylor, 1978.
51. On crossings, Fernie, 1983, chap. 8 and refs.
52. Fernie, 1983, 113–14.
53. Fernie, 1983, 110.
54. Kerr and Kerr, 1983, 22.
55. Heighway *et al.*, 1978, 103–32.
56. Fernie, 1983, 125.
57. Blockley, 1991.
58. Kerr, 1983, 22.
59. Fernie, 1983, 144.
60. Fisher, 1962b.
61. Kerr and Kerr, 1983, 45; Taylor and Taylor, 1965.
62. Fernie, 1983, chap. 9.
63. Heighway *et al.*, 1978, 108.
64. Heighway, loc. cit.
65. Backhouse, Turner and Webster, 1984, 127.
66. Keen, 1993.
67. Talbot Rice, 1952, 237.
68. Taylor, 1979; Taylor, 1971, 351–89. See also Fernie, 1983, 116–19 for another interpretation.
69. Gibb and Gem, 1975, 71–110.
70. Rahtz, 1976b.
71. Dodwell, 1982, chap. 3.
72. Gameson, 1995, 59.
73. Gameson, 1995, 54.
74. Gameson, 1995, 55.
75. Gameson, 1995, 252.

76. Gameson, 1995, 253.
77. Dodwell, 1982, 75.
78. Dodwell, 1982, 47.
79. Dodwell, 1982, 46–7.
80. Dodwell, 1982, 65–6.
81. Dodwell, 1982, 49–50.
82. Dodwell, 1982, 53–5.
83. Bailey, 1980, 238.
84. Bailey, 1980, 239.
85. Bailey, 1980, 240.
86. Bailey, 1980, 242.
87. Bailey, 1980, 242–54.
88. Graham-Campbell, 1987, 145–6.
89. Bailey, 254.
90. Burnsall and Lancaster: Collingwood, 1915, 289. Stonegrave and Kirklevington: Collingwood 1907, 269. Others Bailey, 1980, 26.
91. Dodwell, 1982, 121.
92. Bailey, 1980, 255.
93. Addyman and Hill, 1969, 70.
94. Wilson, 1964, 72–80.
95. Buckton 1986.
96. Clarke, 1961; Bakka, 1966; Howlett, 1974.
97. Wilson and Blunt, 1961.
98. Wilson, 1964, no. 1; Backhouse, 1984, 30, no. 10.
99. Wilson, 1965, 33–5.
100. Graham-Campbell, 1973.
101. Talbot Rice, 1952, 231.
102. Bruce-Mitford, 1956b.
103. Wilson, 1984, 96; Webster and Backhouse, 230, no. 187.
104. Bruce-Mitford, 1956.
105. Gameson, 1995, 254.
106. O'Reilly, 1987; Bailey, 1980, 146–8.
107. Henderson, 1992, 240–1.
108. Henderson, loc. cit. 243.
109. Gameson, 1995, 35–41.
110. Gameson, 1995, chap. 2.
111. For early roots of Winchester School, Wormald, 1971.
112. Beckwith, 1964, 39 on Byzantine artists working in the Carolingian court.
113. Rickert, 1965, 31.
114. Rickert, 1965, loc. cit.
115. Battiscombe, 1956; Wilson, 1984, 154–5.
116. Temple, 1976, no. 6; Backhouse *et al.*, 1984, 27.
117. Temple, 1976, no. 11.
118. For drawings in Winchester style generally, Wormald, 1952.
119. Temple, 1976, no. 23. Deshman, 1995, for a recent assessment.
120. Temple, 1976, no. 24.
121. Temple, 1976, no. 22.
122. Temple, 1976, no. 16.
123. Temple, 1976, no. 41.
124. Temple, 1976, no. 64; Backhouse *et al.*, 1984, 74–5; Noel, 1995.
125. Temple, 1976, 58.
126. Henderson, 1968.

127. Temple, 1976, no. 98.
128. Gem and Tudor-Craig, 1980.
129. Wormald, 1971; Biddle, 1967.
130. Dodwell, 1982, 93.
131. Taylor and Taylor, 1965, 209; Kerr and Kerr, 1983, 52.
132. Taylor and Taylor, 1965, 209–11.
133. Biddle, 1966.
134. Ibid.
135. Taylor and Taylor, 1965, 107; Kerr and Kerr, 1983, 53.
136. Kerr and Kerr, 1983, 54.
137. Taylor and Taylor, 1966.
138. Kendrick, 1938, 179–81; Cramp, 1972, 140–1.
139. Suggested, for example, in Webster and Backhouse, 1991, 243.
140. Beckwith, 1972.
141. Lasko, 1984.
142. Wilson, 1984, 190.
143. Backhouse *et al.*, 1984, 117–18 and refs.
144. Ibid, no. 123.
145. Nelson, 1937.
146. Backhouse *et al.*, 1984, 88.
147. Wilson and Klindt-Jensen, 1966; Wilson, 1978 on chronology; Lang, 1983; Lang, 1986.
148. Lang, 1988, 42–4 and refs.
149. Bailey, 1980, chap. 8.
150. For succession of styles, Bailey, 1980 provides a convenient summary. For Urnes, Moe, 1955. Ringerike has posed some problems – for an English origin for the style, Brondsted, 1924 and Holmqvist, 1952. For an alternative, Fugelsang, 1980. See also Wilson and Klindt-Jensen, 1966.
151. Backhouse *et al.*, 1984, 106.
152. Kendrick, 1949, pl. LIX, 2.
153. Backhouse *et al.*, 1984, no. 102.
154. Kendrick, 1949, 117; Backhouse *et al.*, 1984, no. 104.
155. Backhouse *et al.*, 1984, no. 105.
156. Wilson, 1964, no. 60.
157. Wilson, 1984, 209.
158. Bailey, 1980; Lang, 1980.
159. Lang, 1988, 42–4 and refs.
160. Lang, 1988, chap. 4.
161. Bailey, 103f.
162. Bailey, 116–24.
163. Bailey, 129–31.
164. Bailey, 1980, 132.
165. Bailey, 146–9.

CHAPTER FIVE

The Saxo-Norman Overlap

The development of Saxon civilisation was abruptly interrupted by the Norman invasion. Starting on 14 October 1066, it brought about major changes in society, some of which lasted to the present day. The sudden, dramatic takeover from the top was quite unlike the slow, piecemeal infiltration of the Anglo-Saxons over the Romano-British some six hundred years earlier.[1] It was a conscious, military invasion the like of which England has never since experienced. Authority from this time stemmed from the Normans not the Anglo-Saxons.

A new royal line was established, and new aristocracy and clergy of Norman-French derivation were put in place. Only one of the sixteen bishoprics in England was held by an Englishman by 1090, and at the time that Domesday Book was compiled in 1086 less than six of the 180 great landlords in England was English – nearly all the lands were held by the king or his Norman-French supporters.[2]

Colonies were established in English towns – Nottingham, for example, was in effect two boroughs, with different laws operating in the English and French quarters.[3] Castles were built, sometimes literally on top of existing villages (for example at Oxford, where excavation has shown intact dwellings used as foundations), sometimes on fresh sites.

Resistance was strong in some areas. Between *c.* 1068 and 1071 William carried out a series of violent campaigns in the north of England – 'The Harrying of the North' – which were regarded with opprobrium even by Norman loyalists. The rotting bodies on the roads of the area were vividly chronicled by Symeon of Durham.[4] Plague was rife, and the *Anglo-Saxon Chronicle* baldly noted that William had 'laid waste all the shire' of Yorkshire.

Despite the thoroughness with which the political takeover was made, the basic population remained Anglo-Saxon/Viking/British Celtic and it is possible to trace the survival of the hybrid cultures well into the Norman period. The effect and influence of the Anglo-Saxon period may have been diluted, but it can be traced in a variety of ways. The population remained basically English (an estimated 1.5–2 million English compared with 10,000 Norman incomers), and many important aspects of English life and society persisted, including facets of trade,

coinage and art, though the latter was increasingly permeated by new ideas from the Continent.[5]

It is difficult to evaluate to what extent certain movements, including artistic, were the outcome of the Norman Conquest, or to what extent they were existing trends that were merely accelerated by it. In the nineteenth century it was felt that the Normans brought European civilisation to a backward Anglo-Saxon nation, but increasingly as greater understanding of Anglo-Saxon England has been achieved, it has become apparent that in many respects English culture was superior to that of the Normans, and that the latter were in fact the greater beneficiaries. In general terms, the current perspective on the Norman conquest is that it acted as a catalyst for trends that were already developing.

The most notable features of Norman England, namely feudalism and its physical manifestation, castle building, can be seen to have already been developing in the England of Edward the Confessor. The feudal system, so often seen as a major phenomenon of the later Middle Ages, was based on the European system of land tenure. Of considerable antiquity, it had been developed in the last days of the Roman Empire[6] and in essence depended on land tenure in return for military service. Although not strictly speaking feudal, Anglo-Saxon England had a social structure dependent on just such ties. The essence of feudalism was the tenure of a fief, a unit of land, in return for service, usually military, with the grantee owing the grantor homage and fealty. Where the Norman institution differed from the Anglo-Saxon lay in the fact that it was formalised, and control was maintained at the top by restricted ownership of land.

Fortifications

The main impact of the Normans lay in the development of fortifications. It is intensively debated to what extent castles existed before the Norman Conquest, and to what extent they were a response to it.[7] There are some indications that contact with Normandy in the time of Edward the Confessor had set in motion the process of castle building. For example, two 'castles' (earth-and-timber constructions) seem to be documented in the Welsh Marches at this period, at Ewyas Harold and Richard's Castle. A 'castle' is documented as having been erected by 'foreigners' at Hereford in 1051.

The vast majority of Norman castles were earth-and-timber works of the type known as 'motte and bailey' — they comprised an earth mound crowned with a timber tower, enclosed within an earth-and-timber outwork, the bailey. About 700 mottes were built in England and Wales between 1066 and 1215. Another type of earth-and-timber

castle was the ringwork, in which timber buildings were enclosed by ramparts. Stone castles were rare before the twelfth century, but examples include the towers or keeps that form the nucleus of fortifications such as the Tower of London and at Colchester (Essex) and Chepstow (Monmouth). The stone-built Norman gateway at Exeter displays a pointed window that resembles a survival from an Anglo-Saxon church.

Society and the Normans

The Normans did not effect major changes in the material world of the English. The pattern of settlement remained basically unaltered from the late Saxon period into the later eleventh century, but real changes in the rural landscape came during and after the twelfth and thirteenth centuries.[8] The feudal system meant that a huge gap opened between the land-owning minority and the rest of the population. Fundamental to it was the concept of the manor, on which the work was done by tenants, who held their lands from the lord and were given his protection in return. The term 'manor' could mean different things; usually it meant a village, but it could comprise several villages. It usually but not invariably, had a manorial hall and court. Open-field farming, established probably in the Middle Saxon period, continued, and ridge-and-furrow cultivation increased. Changes in village layout are well exemplified by Goltho, Lincs, where the timber halls and associated buildings of the tenth century were replaced by a manor house, with a new village developing to the north-west of it from the eleventh or even tenth century. It remained occupied until the fifteenth century.[9]

Debate has surrounded how the record of England preserved in Domesday Book should be interpreted. In the past it was assumed that the place-names given in it were of the villages which assumed the names in later centuries. Now it is seen that they were the names of manors, and that they represented dispersed settlement in the late eleventh century.[10] Nucleated villages evolved later, from the twelfth century onwards. Nor did the creation of villages happen all over England – in the south-west, for example, dispersed settlement remained the norm.

Three processes have been seen as underlying the growth of villages from the twelfth century onwards; steady growth, due to an expanding population; nucleation, as the inhabitants of dispersed farms came together; and deliberate village foundations, by an 'improving' landowner. The spread of villages in the north of England may have happened in the wake of the Harrying of the North. The parish boundaries, however, were probably established in late Saxon England.

Many place-names continued to be used, with the addition of such new examples as Tolleshunt D'Arcy. Some Norman names incorporated French words such as *bel* or *beau* to produce Beaulieu, Bewley and Belvoir.[11] Such Norman names are rare, however. More commonly, Norman scribes changed the spelling of English names where they were unfamiliar with the original spelling or pronunciation. The Norman scribes too added their own Latinisations to produce places such as Dunham Magna and Parva in Norfolk, and so on. French became the language of the influential, and French taste began permeating society, reaching a zenith under the Normans' successors, the Angevins (1154–1272). Although the majority of basic everyday words persisted through this and later upheavals, the language became enriched with words of French derivation, and French was the language of polite society and commerce. A few French words had made their appearance in the English language before the Norman Conquest, such as 'capon' and 'bacon', but the Conquest brought an additional military vocabulary including *castel* (castle) and *prisun* (prison) as well as *curt* (court), *duc* (duke) and *clerc* (learned man).[12]

The Norman impact on late Saxon urban development was not great, though programmes of castle and church building made their mark on many pre-existing towns. England remained predominantly rural – as late as 1500 probably as many as 95% of the population lived in the countryside. The Normans, however, practised some limited town colonisation, establishing communities of traders and merchants there. The Norman towns were controlled by the Anglo-Norman lords, the king and the bishops, who often held extensive lands within them. This patronage probably brought about a boom in the luxury trade in wine and fine cloth.[13] In the twelfth century the first urban building in stone is attested, for example in Lincoln, Norwich and Southampton. The patterns of trade with the Continent that had existed before the Conquest continued, though the trade with Normandy intensified.

The monetary system employed in late Saxon England was as well developed as any in Europe, and the Norman kings took it over. The money issued by William I was on the whole of good quality, and Anglo-Saxon names figure as well as Norman French among the moneyers.[14]

Some fine pottery continued to be imported, especially red-painted wares from Normandy, but the native Saxo-Norman pottery industry persisted, producing fine glazed 'developed Stamford ware'. The descendants of coarser late Saxon wares such as Torksey ware continued to dominate the markets in much of England. South of the Thames, coarser pottery derived from older Middle Saxon traditions of stamped, spouted pitchers, continued to be produced and used.[15]

Ecclesiastical architecture

One of the main difficulties in dealing with the period of the 'Saxo-Norman overlap' as it has been termed has been the tendency to consider it under two heads: the last gasp of Anglo-Saxon architecture and the first flourish of Norman Romanesque. This is misleading since 1066 does not mark any real break in the development of English architecture, which was undergoing changes from the time of Edward the Confessor onwards, and in which time the roots of English Romanesque can be seen. Edward was already appointing foreign bishops to English sees, a factor which was paving the way for influences from the Continent that were to accelerate the development of the English Romanesque.

Edward's most imposing building was Westminster Abbey, which was consecrated in 1065.[16] The abbey was only fractionally shorter than its present length (95.75 m or 314 ft), and appears to have been modelled on the abbey church at Jumièges, near Rouen in Normandy. From the plan of Jumièges, surviving fragments of masonry and documentary sources, it is possible to reconstruct the appearance of Edward's Westminster Abbey, which was a monument to Norman influence in England before the Conquest. Like its French counterparts, it was begun anew on a cleared site, and had six double bays to its nave, an eastern arm of two bays with pilasters and attached half-shafts on bases with chamfered and moulded plinths. Crossing and transept arms were located where the present ones are. At the east end were triple chapels with apses. At the west end there was a tower at the end of each aisle, while the crossing had a lantern tower.

The stone for the abbey came from Reigate, and large numbers of blocks of similar size and shape were used in it, heralding the transition from the irregular masonry of the Anglo-Saxon period to the carefully coursed ashlar of the Norman. Edward's palace at Westminster, also known from records rather than surviving remains, was a similarly large edifice.[17]

Another pre-Conquest structure datable to the time of the Confessor is the rotunda begun but not finished by Wulfric at Canterbury, where it destroyed the east end of St Augustine's abbey church and the west end of St Mary's church, in an attempt to integrate the two. The rotunda is an octagon externally and circular internally, with a flight of steps up to the floor level of the abbey church – it was partly a crypt. The models may have been centralised buildings found on the Continent at Dijon and Charroux.[18]

Many elements of Anglo-Saxon architecture survived the Norman Conquest to influence later medieval English architecture. It has been suggested that the western towers of the Norman churches at

Winchester, Ely and Bury are derived from Anglo-Saxon church designs, and that Durham Cathedral was the design of an Anglo-Saxon architect.[19] The treatment of the crossing in Anglo-Norman buildings, for example at St Albans, where the transept is wider than the nave, has also been seen as an Anglo-Saxon feature.[20] Complex stripwork of the type found at Earl's Barton survived to be employed in the otherwise Norman church at Strethall. Internal hood mouldings are a feature of Anglo-Saxon and Anglo-Norman churches, but are not found on the Continent.

The Norman Conquest saw an explosion of building activity. Old churches were pulled down and replaced by Norman buildings (nearly all the old cathedrals and abbey churches were rebuilt), while castles both in earth and timber and in stone represent the comparable secular building activity. Nevertheless, by far the greatest number of surviving churches displaying Anglo-Saxon work belong to the second half of the eleventh century, attesting the tenacity of Anglo-Saxon church building traditions.

Several hundred existing churches display at least some work from the period of Saxo-Norman overlap. Some, such as Bosham (Sussex), St Peter-at-Gowts (Lincoln), Corhampton (Hampshire), Odda's Chapel (Gloucestershire; built 1056) still display substantial portions of such work. Nonetheless, far more English parish churches display Norman rather than Saxon work, and the architectural designs, with new Continental influences, were copied across the country.

The design employed by William the Conqueror in his abbey built at La Trinité, Caen, was used in the architecture of the rebuilt Canterbury Cathedral (*c.* 1070) and the replacement for St Augustine's Abbey Church in the same city. Winchester Cathedral (begun in 1079), which replaced its late Saxon predecessors, was similarly modelled on Caen.[21] The same model served for Ely (begun in the 1080s), Norwich (begun 1096) and Peterborough (begun 1118).[22]

The essence of these churches was the focus of the high altar, set in an apse, and the choir stalls for the clergy, set to the west with a lantern tower over its crossing with the transepts, which provided side chapels. The nave was separated from the choir by a screen, and the west front had a pair of flanking towers which balanced the crossing tower. The churches were monumental in scale, with soaring elevations and fine, even ashlar.

Monasticism too, saw a new phase of expansion under the Normans, who introduced new Continental orders, as well as reinforcing the Benedictine movement with the construction of new monasteries.[23] Of the other orders introduced by the Normans, the Cluniac was not particularly popular in England. This movement started at Cluny in Burgundy in the tenth century, and from 1049 the Abbot of Cluny was

an English monk, St Hugh. Thirty-two Cluniac priories were built in England, of which the first was at Lewes, Sussex, built with the patronage of William de Warenne, a close supporter of William I.[24] More significant was the Cistercian order, named after Citeaux, again in Burgundy, founded in 1098.[25] The Augustinians, named after the fifth-century St Augustine of Hippo, did not make any impact on England until the late eleventh century, but then the order spread rapidly. The different orders had different monastic layouts, and some, particularly the Cistercians, were very influential artistically in England.[26]

Artistic trends

Despite the political, linguistic and architectural impact of the Normans, Anglo-Saxon culture was not obliterated and no clearer demonstration of its survival can be brought forward than the Bayeux Tapestry. Made on the orders of William's brother, Bishop Odo of Bayeux in Normandy, it chronicles the conquest of England, and was designed to hang in Bayeux Cathedral. For long regarded as a unique example of Norman art, it can now be seen as one of the most remarkable surviving examples of Anglo-Saxon Winchester style artistic achievement.[27] It is also an unusual example of a major artistic achievement of this period known to have been executed by women.

Many problems still surround the historial interpretation of the Tapestry – or more correctly, embroidery. It has a central narative strip, with borders filled with animal and figural ornament. There are some 530 animals in all, inspired by English line drawing of the tenth and eleventh century and imported woven silks from Byzantium and Persia.[28] The main narrative seems to have drawn heavily on Canterbury Biblical iconography, in a tradition that goes back to Roman triumphal columns and the chronologically closer column of Bernward of Hildersheim of around 1020. This has led one scholar to suggest that the whole tapestry was a subtle political statement, which uses oblique Biblical allusion to cast doubt on the rectitude of William's campaign, even while it appears to glorify his achievement.[29]

Despite the tenacity of Anglo-Saxon styles, the Norman period saw the full emergence of the Romanesque style of art and architecture in England and France. Patronage was provided by the feudal lords and by the Church.[30] The ordered form of Romanesque architecture has been seen as the counterpart of the ordered form of society, and Romanesque art turned away from the representation of nature (which became more important again with the emergence of Gothic, in the late twelfth century in England).[31] Human figures are flat and treated as pattern, delight being taken in the 'nested V-folds' of garments.

Before the Conquest, the Normans were already familiar with the

Bayeux Tapestry, detail, late eleventh century (Reproduced by special permission of the City of Bayeux)

Winchester School of English art, and Norman styles on the Continent had already been subtly pervaded by Anglo-Saxon elements. The art of Normandy, however, had not assimilated anything of Scandinavian styles, despite the fact that the Normans were themselves of Danish origin, and an innovation to the Norman repertoire in England was Ringerike and Urnes ornament. This can be seen in a variety of different contexts, from the tendrils decorating the doorway of the church at Kilpeck, Hereford, datable to around 1140, to the ornament on the crozier of Ranulf Flambard in Durham cathedral.[32]

The Winchester style of acanthus foliage persisted in English art after the Conquest. It has been seen how the last flourish of Winchester style art was moving away from the light, flickering draperies that had been inspired by the Rheims school to more solid compositions. The trend continued,[33] though there is a post-Conquest lightness of touch in English Romanesque drawing that is at variance with that on the Continent.

To existing traditions other influences were added during the twelfth century. Through the travels of clerics and through the agency of the Crusades motifs and ideas came from the East as well as other parts of Europe. In particular exotic animals, perhaps sometimes derived from

Jamb, south door, Kilpeck, Herefordshire, twelfth century (Philip Dixon)

Eastern textiles, began to cavort through the English Romanesque. This may have been a factor in the development of a narrative tradition in English art, expressed frequently in the decoration of Bibles.[34] The Normans, however, moved away from the full-page biblical illustration to develop the historiated initial, which had been used only on occasion in Anglo-Saxon art.

At first strongly influenced by Norman French innovations, as time wore on the uniform style of English Romanesque art developed into local traditions, and Anglo-Norman art became an important force in European art generally. The Cistercians in Burgundy, for example, produced fine books under English influence, and it has been argued that Anglo-Norman experiments were influential in the emergence of Continental Gothic art.[35]

Painting

Manuscripts display the greatest degree of continuity from Anglo-Saxon into Norman work. Already before the Conquest changes were afoot. Ornate Gospel books, written and decorated in the first decade of the eleventh century, were going out of fashion in the second. By the middle of the eleventh century, however, a new type of book was coming to the fore, with elements of the Romanesque style. This was apparent in the Tiberius Psalter (the Cvi), in the Hereford Gospels, which had richly-coloured evangelist portraits with lavish use of gold, and the Troper, a book of tropes or musical and textual addenda to liturgical texts, illustrated by the same hand.[36]

There is a hiatus in the decoration of sumptuous books after the production of these manuscripts in the mid-eleventh century until the St Albans Psalter, produced in the early twelfth.[37]

A tradition of less grand books, however, grew up on either side of the English Channel in the later eleventh century, strongly influenced by Anglo-Saxon work. This is known as the 'Channel style'. The Continental Channel style works are concentrated in northern France and the Low Countries, and their English counterparts on the south coast, particularly in Kent and Sussex. Both sculptures and manuscripts were produced in the style.[38]

By the early twelfth century another overseas influence was being felt, usually termed the 'Damp Fold style'.[39] The Damp style originated in an attempt to follow Classical models in treating draperies and the human forms under them more naturalistically. It was developed in the Byzantine world, and was transmitted via Italy to the rest of Europe. It was used particularly in fresco painting, but is found in a variety of other media, particularly sculpture. In England it appears to have been introduced by Master Hugo of Bury St Edmunds in the second quarter

Carilef Bible, Durham A II 4, 1576. P initial, late eleventh century (Dean and Chapter, Durham Cathedral)

of the twelfth century, where he painted the pages of the Bury Bible, as well as making bronze doors for the abbey and a wooden crucifix which have not survived. Byzantine influence was felt in twelfth-century English art in a number of different ways, including the use of heavy ochres and greys for faces and in some monumental figures in manuscripts (such as the Winchester Psalter).

The device of coloured line drawing was taken up by the Normans in the early twelfth century. It can be seen in the Durham *Life of St Cuthbert* (Oxford, University College, Ms 165).[40]

The historiated initial rather than the full-page picture was favoured on both sides of the Channel after the Conquest. Some of these decorative initials seem to draw upon Anglo-Saxon traditions of penmanship, particularly in manuscripts produced in Canterbury.[41]

At Canterbury, too, can be observed a series of wall paintings executed in the chapel of St Gabriel prior to 1130, with Christ surrounded by four angels with rhythmic movements that are descended from Winchester tradition. The sides of the apse have narrative scenes, rather less Anglo-Saxon and more 'Romanesque' in style.[42]

Anglo-Saxon influence was virtually non-existent, however, in the later developments of Romanesque painting. In Durham Cathedral library a series of major manuscripts mark highlights of twelfth-century manuscript art.[43] Of these the Carilef Bible (Durham A II 4) is of particular importance. The Albani Psalter from St Albans and the Bury and Winchester Bibles take English Romanesque to its magnificent apogee,[44] and leave behind the Anglo-Saxon legacy.

Sculpture

Anglo-Norman sculpture is mostly fragmentary, due to wholesale destruction in later periods.[45] It was at first distinguished by the copious use of small decorative details in architecture, for the Normans integrated their sculpture with their buildings in a way that had not been seen before the Conquest. They produced distinctive carved doorways, corbels and string courses, capitals, screens and fonts. In England, in contrast to Normandy, a type of cubic capital, perhaps of German inspiration, was favoured in contrast to the simplified Corinthian capital widespread in Normandy.[46] This English style of capital was ideal for figural carving.

In addition, they developed the tympanum, a panel set in the arch of a doorway, which in classic Romanesque architecture on the Continent carried a Last Judgement. Sometimes Caen stone was imported for sculpture, and from the twelfth century Tournai marble, but much English work was in native materials.

Canterbury in the early twelfth century was a major centre of

creativity.[47] The choir of the cathedral, put up by the distinguished Lanfranc, was demolished and replaced by a larger work in the years up to 1107. A notable feature of the new building was a crypt with columns crowned with richly carved capitals.[48] Some are comparatively simple, but one group is adorned with a series of music playing animals, griffins, monsters, jugglers and men fighting lions. The carving is bold. Typical of the style is the central capital of the crypt which depicts animals playing instruments – a goat sitting on a dragon plays a recorder, while a winged half-ram half-woman plays a viol. A fox plays a recorder, while a griffin plays a harp. There is also a fawn between two dragons, and two confronted griffins. Such imagery is exotic, and can be matched in contemporary Canterbury manuscript art, in which Winchester School traditions continue in the light lines, sketchy drawing and elegant poses. By the late eleventh century a new stage in the development of sculpture, strongly rooted in an Anglo-Saxon past, was underway.

Two magnificent panels in Chichester Cathedral serve to illustrate the developments from Anglo-Saxon roots.[49] The panels depict Martha and Mary greeting Christ at the gates of Jerusalem, and the Raising of Lazarus, and may have been taken to Chichrester from Selsey. Debate has raged over whether they are Anglo-Saxon works or Norman, for in their gestures and draperies they display a Saxon past, while their monumentality is more Romanesque. They are probably best regarded as examples of the Channel style, and German influence has been detected.

The Viking legacy to Norman England is well exemplified by the tympana in Southwell Minster and at Hoveringham, Notts, which were products of the same workshop, if not sculptor. The Southwell monument depicts St Michael fighting the dragon and David rescuing the lamb. The lion's tail has Urnes interlacing, as does the treatment of the dragon. These works were claimed in the past as pre-Conquest,[50] but current opinion suggests a date closer to 1120.[51] Viking traditions also contributed to the two tympana at Ipswich carved around the same date – one with St Michael and the dragon has an Old English inscription and displays Ringerike influence.[52] At St Bees, Cumbria, a lintel has St George and the dragon with interlace that is perhaps borrowed from Viking-age Ireland.[53]

Metalwork

A considerable quantity of metalwork appears to have been melted down at the time of the Conquest. At Ely for example, on William's orders crosses, shrines, chalices, patens, basins, buckets, fistulas, goblets, dishes, altars and a figure of the seated Virgin and Child all went into the melting pot.[54]

Southwell Minster, Nottinghamshire, started before 1114 (Jenny Laing)

Southwell Minster tympanum, probably twelfth century, depicting St George and the dragon (Susanne Farr)

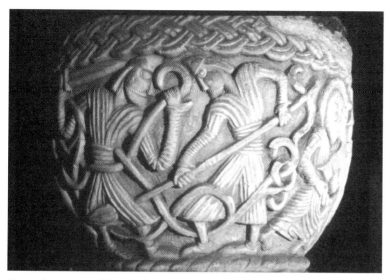

Font, with warriors, Eardisley, Herefordshire, c. 1150 (Prof. R.A. Markus)

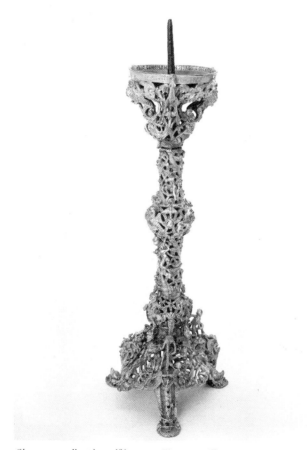

Gloucester candlestick, twelfth century (Victoria & Albert Museum)

There is little in Norman metalwork that recalls the achievements of Anglo-Saxon artists, though enamelwork (which was beginning to enjoy a come-back just before the Conquest in disc brooches and on more ornate pieces such as the Brasenose disc with its roundels of birds), represents a tradition that was to be developed.[55]

Although eclipsed at first after the Conquest, the Winchester style reappears in metalwork in the time of Henry I, though with a stronger line. It can be seen for example in the Unshaw College (Durham) mourning Virgin. Most surviving metalwork, however, belongs in the mainstream of Romanesque developments.[56]

No finer example of the Anglo-Saxon legacy to later medieval English metalwork can be seen than the Gloucester Candlestick, made for the monks of Gloucester in 1107–13. The decorative details are mostly derived from contemporary Canterbury manuscripts, and it is almost an historiated initial in metal and one of the greatest masterpieces of European Romanesque art.[57]

Postscript

The amalgamation of Norman-French and Anglo-Saxon, which in turn was heavily dependent upon Romano-British influence, formed the basis for later English culture. From this period on, there were many influences from overseas, but English culture retained an integrity and unity that endures to the present day. In art, the tradition of Anglo-Saxon penmanship continued in the work of Matthew Paris in the thirteenth century, and perhaps is echoed in the drawings of Hogarth and Blake in the eighteenth century. English art has always been seen at its best in line and subtle tinting. The legacy of the Anglo-Saxons, traditionally initially the handful of men who came over the Channel in three keels, is possibly the single most enduring aspect of English society. As we have seen, language, place-names, the rural landscape and to a certain extent urban distribution, structure of society and some legal precepts can be traced back to this time. Perhaps most significant, however, is the fact that the Anglo-Saxons never inhabited Wales or Scotland and moved into the south-west peninsula only late in their history. While it is true that the Romans occupied what became England with more assurance and vigour than the Celtic lands, their presence in Wales in particular was strong. To this day the south-west peninsula, Wales and Scotland are characterised by a Celtic spirit and culture and England retains and maintains a separateness. These regional differences are more than merely modern whims or fashions. They are deep-rooted distinctions which, despite the strong emphasis on 'British' unity during most of the past three hundred years, can be traced back into prehistory, and were consolidated in the Anglo-Saxon period.

Notes

1. Background to Normans in Davis, 1976; R.A. Brown, 1976; Loyn, 1982; Rowley, 1983; Lindsay, 1974.
2. Rowley, 1983, 19.
3. Rowley, 1983, 97–8.
4. Rowley, 1983, 25–9.
5. For a general summary, Laing and Laing, 1995b.
6. Hollister, 1965.
7. The literature is considerable. Summaries in Clarke, 1984, chap. 4 and Steane, 1985, chap. 2. More detailed study in Brown, 1976b and King, 1991.
8. C. Taylor, 1983.
9. Beresford, 1975.
10. Taylor, 1983, summarises thought on the subject. See also Clarke, 1984, chap. 1; Steane, 1985, chap. 5 and Hallam, 1981.
11. Cameron, 1977.
12. Serjeantson, 1935, chap. 5.
13. Town development in Rowley, 1983, chap. 5, and Platt, 1976.
14. Brooke, 1950, 79.
15. Myres *et al.*, 1959; Dunning, 1968.
16. Fernie, 1983, 154–7.
17. Rahtz, 1976, fig. 2/8 for reconstructed plan contrasted with earlier Anglo-Saxon halls.
18. Fernie, 1983, 157.
19. Boase, 1968, 13–18; Webb, 1956, 36–8.
20. Gem in Zarnecki, 1984, 31.
21. Ibid.
22. Boase, 1968, 123–5; Webb, 1956, 40–1.
23. Clarke, 1984, 94–5; Gilyard-Beer, 1966.
24. Clarke, 1984, 96–8.
25. Ibid, 98–101.
26. Ibid, 102.
27. Wilson, 1985 is a recent summary account with good illustrations.
28. Hicks, 1993, 252f; Hicks, 1992.
29. Bernstein, 1986. His arguments are complex, and have not won widespread acceptance. They are based on the belief that William was compared to Nebuchadnezzar, who in the Old Testrament had an ambivalent position as God-sent conqueror and evil despot. The scene with Harold pierced in the eye should be interpreted, according to Bernstein, as a symbol of Divine returibution for perjury, rather than a depiction of an event.
30. Patronage in Macready and Thompson, 1986.
31. Zarnecki, 1984, 16–26.
32. Kendrick, 1949, chap. XII; Flambard crozier, Ibid, 117; Kilpeck, Ibid, 140.
33. Wormald, 1944.
34. Kauffmann, in Zarnecki, 1984, 84.
35. Zarnecki, 1984, 15; Beckwith, 1964, 192.
36. Troper: Temple, 1976, 97; Hereford: Kauffmann, 1975, no. 33.
37. Pacht, Dodwell and Wormald, 1960.
38. Sculpture: Stone, 1955, 64–5; manuscripts: Rickert, 1965, 94–5.
39. Boase, 1968, 163 and passim.
40. Baker, 1978.
41. Backhouse, Turner and Webster, 1984, 195.

42. Boase, 1968, 47; Zarnecki, 1966.
43. Boase, 1968, 24–9.
44. See especially Boase, 1968, chap. VI. The finest of the Bibles is perhaps the Winchester Bible: Oakeshott, 1945; Donovan, 1993.
45. Zarnecki, 1951; Saxl, 1954 general surveys.
46. Zarnecki, 1984, 20.
47. Kahn, 1990.
48. Zarnecki, 1951, pls. 47–57; Zarnecki, 1966; Boase, 1968, 35–8.
49. Kendrick, 1949, 52; Stone, 1955, 65; Zarnecki, 1953.
50. For example by Kendrick, 1949, 121.
51. Zarnecki, 1984, 165.
52. Galbraith, 1968; Galbraith, 1973.
53. Zarnecki, 1984, 160.
54. Zarnecki, 1984, 232.
55. Hinton, 1974, no. 27.
56. Zarnecki, 1984, no. 231.
54. Zarnecki, 1984, no. 247.

Sources for the Anglo-Saxons

At the end of the first century AD, the Roman writer Tacitus mentions a number of Germanic tribes, including the Angles. In the second century the geographer Ptolemy also mentions Angles, and documents Saxons for the first time, placing them in the vicinity of modern Holstein. The Angles were differently located by these two Classical sources, but probably lived to the north of the Saxons, in Jutland. The Saxons seem to have spread south-west along the North Sea littoral, where they were established in the fourth century, and where their raiding seems to have been a serious problem for the Romans.

The pagan Saxons possessed a strong oral tradition, and at least some elements were handed down and committed to writing from the seventh century onwards. At this time literacy was mainly confined to the clergy who concentrated almost exclusively on the affairs of the Church and events which impinged on the lives of the clerics. As as result, almost none of the material relating to the pagan fifth and sixth centuries can be confidently regarded as firm fact and much is regarded as totally spurious.[1] In all our sources there are no dates that can be accepted for the fifth century, and few that are reliable for the sixth. With the exception of Bede's *Ecclesiastical History*,[2] written in the north of England in the eighth century, and its anonymous sequel, the *Baedae Continuatio* (*Continuation of Bede*), there is no narrative history as such.

Because the Venerable Bede, for his time, was a careful scholar, his work has enjoyed an enviable reputation with more recent historians, but increasingly there is an awareness that he was very selective – his concern was with the early spread of Christianity among the English. Sometimes he was misinformed.[3]

Bede drew on a number of sources, among them a sermon on *The Ruin and Conquest of Britain* by an early sixth-century British monk called Gildas. In contrast to Bede, Gildas has not been popular with historians, who, repelled by his flowery language and vitriolic attack on individual British kings, have doubted many of his assertions. Yet Gildas was close

to many of the events he was describing, and members of his congregation would have known if what he saying was total fabrication, at least for the period from the later fifth century onwards, and recently his credibility has increased. This is not to imply, however, that all events he gives are in the correct order, or chronicled within the correct time-scale.[4]

The *History of Britain* compiled by a ninth-century monk called Nennius has also been widely utilised by historians. It is a compilation of assorted texts of different dates and value, which modern scholarship has gone a long way to disentangling.[5]

Further available sources include Annals (year-by-year accounts of events in the form of short entries which were originally used as an *aide-mémoire* in calcuating the date of Easter). The *Anglo-Saxon Chronicle* was compiled in the court of Alfred the Great in early ninth-century Wessex.[6] Annals tend to give the superficial impression of being 'real' history, but even a cursory glance at the sequence of dates shows that events in the *Chronicle* had a suspicious habit of occuring every four years since the annals were compiled to make leap years memorable. Furthermore, the *Chronicle* has a hidden agenda – its real purpose is to glorify the line of Alfred the Great in Wessex, and to this end fact is incorporated with myth.

Other sources include saints' Lives (which sometimes contain historical information but which were intended for the edification of their readers and contain liberal chunks of stock miracles attributed to many saints); Law Codes (which tell us something about Anglo-Saxon society); and Charters which are usually land-grants add to the list of sources.

Epic poems occasionally describe historical events, though clearly with poetic licence, and these have coloured viewpoints on the Anglo-Saxons to an overwhelming degree. The most outstanding of these is *Beowulf*. Although claims have been made that this classic text was composed in the tenth century and reflected the relationship between Anglo-Saxons and Vikings at that time, current opinion favours the view that it was composed in the eighth century in an Anglian area, drawing upon much earlier material.[7] It describes the activities of the hero Beowulf, and his defeat of the monster Grendel. The poem *Widsith* (of which 142 verses survive in a text set down around 1000), may have been composed in seventh-century Mercia, and reflects a remote, heroic period of the Anglo-Saxon past.[8]

Events in Anglo-Saxon England are occasionally mentioned in European records. Although typically brief, these can often be used as cross-references in order to put firm dates on information in native sources. A few inscriptions, particularly those on coins, also give written information about Anglo-Saxon England.

The development of Anglo-Saxon studies

Until the late eighteenth century, the historical sources remained the only ones available, thus ensuring that Anglo-Saxon studies were virtually static for around 1000 years.[9] The dynamic impetus that kick-started interest began with the (for the time) meticulous excavations of the Revd Bryan Faussett in Kent between 1759 and 1773, in particular of the cemeteries at Kingston Down and Crundale.[10] Faussett believed his finds were Roman, but his friend the Revd James Douglas appreciated that they must be Anglo-Saxon and in 1793 recorded his own discoveries in *Nenia Britannica*.[11] Much of the problem in identifying them was that the Anglo-Saxons were deemed incapable to producing high-quality work.

Another landmark came in 1819 with the publication of the second edition of Thomas Rickman's *An Attempt to Discriminate the Styles of Architecture*, in which he was able to demonstrate that the lower part of the tower at Barton-on-Humber, Lincs, was Anglo-Saxon quite simply because the upper part was Norman and in a totally different style. By 1834 he had compiled a list of twenty buildings that were 'supposed Anglo-Saxon'. Faussett's diaries, published by Charles Roach Smith (*Inventorium Sepulchrale*, 1856), and the comparative study by J. Kemble of Anglo-Saxon urns from England and from Stade in Germany in 1855, once more focused attention on Anglo-Saxon grave-goods which were increasingly recognised for what they were.[12] In 1904, Bernhard Salin published *Altgermanische Thierornamentik*, a study of Germanic art styles and artefacts in northern Europe, which proved a stimulus to studies in England.

Two figures dominated Anglo-Saxon archaeology in the early part of the twentieth century, E.T. Leeds, who was Keeper in the Ashmolean Museum, Oxford, and G. Baldwin Brown, Professor of Fine Art at Edinburgh University. Both were concerned with the study of artefacts and art, and both set their studies in an historical framework. Baldwin Brown's *The Arts in Early England* (1903–37) published in six volumes included the pioneer studies of Anglo-Saxon architecture and sculpture; E.T. Leeds was more concerned with brooches as evidence (as he saw it) of the progress of the Anglo-Saxon incomers through England. His *Archaeology of the Anglo-Saxon Settlements* (1913) was a pioneering study, as was his *Early Anglo-Saxon Art and Archaeology* (1936).

Although Leeds carried out the first extensive excavations of an Anglo-Saxon settlement site (at Sutton Courtenay, Berks) in the 1920s, he was not distinguished as an excavator, and artefact studies dominated Anglo-Saxon archaeology until the 1980s (and in some measure still do), fanned perhaps by the discovery of the royal burial at Sutton Hoo, Suffolk.

Increasingly since the 1970s, however, Anglo-Saxon archaeologists have addressed themselves to wider issues, and have focused attention on the evidence archaeology provides for social organisation and economy rather than with trying to use archaeology to 'prove' or 'disprove' historical assertions.[13]

Dating

Dating poses a number of problems in Anglo-Saxon archaeology as a whole. In the pagan period there were no coins or mass-produced objects, so dates have traditionally been derived by comparing metalwork (particularly brooches) and pottery with similar material in Continental cemeteries, and by arranging developmental sequences (typologies) of particular artefact types. As a rough yardstick, it was generally assumed that objects that are identical in England and on the Continent belonged mostly to the time of the settlements, but that types of objects that are only found in England belong to a later period when Anglo-Saxon culture was diverging from that of the Continental homelands. This approach has occasionally led to some material, particularly pottery, being dated in England too early.

More exotic imports from the Mediterranean also provide fixed points in constructing dating sequences.

Apart from such traditional methods, radio-carbon dating, which depends on the rate of decay of the carbon-14 isotope, is sometimes helpful, though for the Anglo-Saxon period is less often applicable than for prehistory. Dendrochronology, based on tree-rings, can provide absolute dates, and is currently proving very useful for dating Anglo-Saxon sites, though it depends on well-preserved and substantial timbers and is still a relatively young study. It has been productively employed in the early Anglo-Saxon town of Hamwic (Southampton).[14]

From the later seventh century, when they were reintroduced, coins are also valuable clues to date, though few come from archaeological contexts.

The dating frameworks and terminology

Despite the difficulties of dating, the Anglo-Saxon period readily falls into three periods – the pagan Saxon (fifth, sixth and seventh centuries), the Middle Saxon (seventh and eighth) and the late Saxon (ninth to the eleventh, into the Norman period). Pagan and Christian overlap since the conversion to Christianity began in 597 with the mission of Augustine to Kent, but paganism survived in other areas through the seventh century and later.

The terms by which the people are referred to during this period are

more complex. Romano-Briton and Briton tend to be interchangeable. The term Anglo-Saxon is used to cover virtually all the many groups of Germanic settlers. The term Saxon is sometimes used specifically (as opposed to Angle, Frank, Frisian and so on), and confusingly sometimes as a general blanket term to include them all. The terms Saxo-Roman and Romano-Saxon, coined by Myres, have considerable appeal for use in the fifth century in particular.

Notes

1. For problems of assessing documentary sources, Morris, 1973, chap. 2; Myres, 1986, chap. 1; Stenton, 1947, 679–96.
2. Wallace-Hadrill, 1988.
3. Higham, 1992, 153–68, and Wallace-Hadrill in n.2 above.
4. Winterbottom, 1978; Sims-Williams, 1983; Lapidge and Dumville, 1984.
5. See introduction in Morris, 1978.
6. Dumville and Keynes, 1983–6; see also Introduction in Garmonsway, rev. ed. 1960.
7. Newton, 1992.
8. M. Alexander, 1956, 33–6.
9. No book dealing exclusively with antiquaries and Anglo-Saxon studies exists, but Arnold, 1984, 1–16 is useful, as is the brief discussion in Dixon, 1976, 22–34 which sets Anglo-Saxon studies in a European context.
10. Various studies of Faussett in Southworth (ed.), 1990.
11. Jessup, 1975 is a good study of Douglas.
12. Wiley, 1979; Hodges, 1986, chap. 2.
13. Reviews of recent trends in Anglo-Saxon archaeology in Webster, 1986; Hills, 1980; Dickinson, 1983.
14. Fletcher and Tapper, 1984, review the situation.

Bibliography

Aberg, N., 1926, *The Anglo-Saxons in England*, Uppsala

Addyman, P. and Hill, D., 1968, 'Saxon Southampton: a review of the evidence, Part I', *Proceedings Hants Field Club*, XXV, 61–93

Addyman, P. & Hill, D., 1969, 'Saxon Southampton: a review of the evidence, part II', *Proceedings Hants Field Club*, XXVI, 61–96

Addyman, D., Leigh, D. & Hughes, M.J., 1972, 'Anglo-Saxon houses at Chalton, Hants,' *Medieval Archaeology*, XVI (1972), 13–31

Ager, B., 1984, 'The smaller variants of the Anglo-Saxon quoit brooch', *Anglo-Saxon Studies in Archaeology & History*, 4, Oxford, 1–58

Ager, B., 1990, 'The Alternative Quoit Brooch: an Update', in Southworth, E. (ed.), *Anglo-Saxon Cemeteries, a Reappraisal*, Stroud, 153–61

Alcock, L., 1971, *Arthur's Britain*, London

Alcock, L., 1972, *By South Cadbury is that Camelot . . .*, London

Alcock, L., 1982, 'Cadbury-Camelot: A Fifteen-Year Perspective', *Proceedings British Academy*, 68, 355–88

Aldsworth, F., 1989, 'Sompting Church', *Current Archaeology*, 114, 221–4

Alexander, J.J.G., 1978, *Insular Manuscripts 6th to 9th Century*, London

Alexander, J.J.G., 1992, *Medieval Illuminators and their Method of Work*, Yale

Alexander, M., (trs) 1956, *The Earliest English Poems*, Harmondsworth

Allen, J.R., 1887, *Early Christian Symbolism in Britain and Ireland before the Thirteenth Century*, London

Allen, J.R., 1898, 'Metal bowls of the late-Celtic and Anglo-Saxon periods', *Archaeologia*, 56, 30–56

Anstee, J.W. & Biek, L., 1961, 'A study in pattern welding', *Medieval Archaeology*, V, 71–93

Arnold, C.J., 1983, 'The Sancton-Baston potter', *Scottish Archaeological Review*, 2, 17–30

Arnold, C.J., 1984, *From Roman Britain to Saxon England*, London

Arnold, C.J., 1988, *An Archaeology of the Early Anglo-Saxon Settlements*, London

Arnold, C.J. & Wardle, P., 1981, 'Early medieval settlement patterns in England', *Medieval Archaeology*, 25, 145–9

Arrhenius, B., 1971, 'Gramatschmuck und Gemmen aus nordischen Funden des frühen Mittelalters', *Acta Universitatis Stockholmiensis, Studies in Northern European Archaeology*, Series B, Stockholm

Arts Council, 1974, *Ivory Carvings in Early Medieval England 700–1200*, London (Exhibition Catalogue, with Victoria & Albert Museum)

Ashe, G., 1968, *The Quest for Arthur's Britain*, London

Attenborough, F.L., 1922, *The Laws of the Earliest English Kings*, London

Avent, M., 1975, *Anglo-Saxon Garnet Inlaid Disc and Composite Brooches*, Oxford, BAR 11

Avent, M. & Leigh, D., 1977, 'A study of cross-hatched gold foils in Anglo-Saxon jewellery', *Medieval Archaeology*, 21, 1–46

Backhouse, J., 1981, *The Lindisfarne Gospels*, Oxford

Backhouse, J., *et al.* (eds), 1984, *The Golden Age of Anglo-Saxon Art*, London

Bailey, R.N., 1974, 'Anglo-Saxon Metalwork from Hexham', in Kirby, D.P. (ed.), *St Wilfrid at Hexham*, 141–67

Bailey, R., 1980, *Viking-Age Sculpture in Northern England*, London

Bailey, R., 1993, 'Sutton Hoo and Seventh-Century Art', in Farrell, J. & Neuman de Vegvar, C. (eds), *Sutton Hoo Twenty Five Years After*, Miami, 31–42

Baker, M., 1978, 'Medieval illustrations of Bede's life of St Cuthbert', *Journal Warburg & Courtauld Institute*, 41, 16–49

Bakka, E., 1958, *On the Beginnings of Salin's Style I in England*, Bergen

Bakka, E., 1966, 'The Alfred Jewel and Sight', *Antiquaries Journal*, XLVI, 277–82

Baldwin Brown, G., 1903–37, *The Arts in early England*, London, 6 vols

Bannard, H., 1945, 'Some English Sites of Ancient Heathen Worship', *Hibbert Journal*, 44, 76–9

Barker, P. & Lawson, J., 1971, 'A pre-Norman field system at Hen Domen, Montgomery' *Medieval Archaeology*, XV, 58–72

Bassett, S. (ed.), 1989, *The Origins of Anglo-Saxon Kingdoms*, Leicester

Bateson, J.D., 1981, *Enamel-working in Iron Age, Roman and Sub-Roman Britain*, Oxford, BAR 93

Battiscombe, C.F. (ed.), 1956, *The Relics of St Cuthbert*, Oxford

Beckwith, J., 1964, *Early Medieval Art*, London

Beckwith, J., 1966, 'A re-discovered English reliquary cross', *Victoria & Albert Museum Bulletin*, 2, no. 4, 117–24

Beckwith, J., 1972, *Ivory Carvings in Early Medieval England*, London

Beresford, G., 1975, *The Medieval Clay-land Village: Excavations at Goltho and Barton Blount*, London, Soc. Med. Arch. monograph 6

Bernstein, D., 1986, *The Mystery of the Bayeux Tapestry*, London

Biddle, M., 1966, 'A late Saxon frieze sculpture from the Old Minster', *Antiquaries Journal*, 66, 329–32

Biddle, M., 1967, 'Excavations at Winchester, 1966; Fifth Interim report', *Antiquaries Journal*, 66, 329–32

Biddle, M., 1976, 'Towns', in Wilson, D. (ed.), *The Archaeology of Anglo-Saxon England*, 99–150

Biddle, M. & Quirk, R.N., 1961, 'Excavations near Winchester cathedral, 1961', *Archaeological Journal*, 119, 150–94

Biddle, M. & Kjolbye-Biddle, B., 1985, 'The Repton Stone', *Anglo-Saxon England*, 14, 233–92

Bimson, M., 1984, 'Dark Age Garnet Cutting', *Anglo-Saxon Studies in Archaeology & History*, 4, 125–8

Bimson, M., La Niece, S. & Leese, M., 1982, 'The Characterisation of Mounted Garnet', *Archaeometry*, 24, 51–8

Binns, J.W., Norton, E.C. & Palliser, D.M., 1990, 'The Latin inscription on the Coppergate helmet', *Antiquity*, 64, 134–9

Blackburn, M., 1984, 'A Chronology for the sceattas', in Hill, D. & Metcalf, D. (eds), *Sceattas in England and on the Continent*, Oxford, BAR, 165–74

Blair, P.H., 1956, *An Introduction to Anglo-Saxon England*, Cambridge

Blockley, K., 1991, 'Canterbury Cathedral', *Current Archaeology*, 136, 124–30

Blunt, C.E., 1961, 'The Coinage of Offa', in Dolley, M. (ed.), *Anglo-Saxon Coins*, London, 39–62

Boase, T.S.R., 1968, *English Art 1100–1216*, Oxford, rev. ed.

Branston, B., 1974, *Lost Gods of England*, London

Brenan, J., 1991, *Hanging Bowls and Their Contexts*, Oxford, BAR 220

Brondsted, H., 1924, *Early English Ornament*, Copenhagen/London

Brooke, G.C., 1950, *English Coins*, London, 3rd ed.

Brown, D., 1981, 'Swastika Paterns', in Evison, V. (ed.), *Angles, Saxons and Jutes*, Oxford, 227–40

Brown, D., 1982, *The Lichfield Gospels*, London

Brown, M., 1991, *Anglo-Saxon Manuscripts*, London

Brown, M., 1994, *Understanding Illuminated Manuscripts: A Guide to Technical Terms*, London/Malibu

Brown, P., 1971, *The World of Late Antiquity*, London

Brown, R.A., 1976, *The Normans and the Norman Conquest*, London

Brown, R.A., 1976b, *English Castles*, London

Brown, T.J. (ed.), 1959, *The Stonyhurst Gospel of St John*, London

Bruce-Mitford, R.L.S., 1956, 'The Pectoral Cross', in Battiscombe, C.F. (ed.), *The Relics of St Cuthbert*, Oxford, 308–25

Bruce-Mitford, R.L.S., 1956b, 'Late Saxon Disc Brooches', in Harden, D.B. (ed.), *Dark Age Britain*, London, 171–201

Bruce-Mitford, R.L.S., 1969, 'The art of the Codex Amiatinus', *Journal British Archaeological Association*, 32, 1–36

Bruce-Mitford, R.L.S., 1974, *Aspects of Anglo-Saxon Archaeology: Sutton Hoo and other Discoveries*, London

Bruce-Mitford, R.L.S. (ed.), 1975–83, *The Sutton Hoo Ship Burial*, London, 3 vols, vol 1 (1975), vol 2 (1978), vol 3 (1983)

Bruce-Mitford, R.L.S., 1989, 'The Durham-Echternach Calligrapher', in Bonner, G., Rollason, D. & Stancliffe, C. (eds), *St Cuthbert, his cult and community to AD 1200*, Woodbridge, 175–88

Buckton, D., 1986, 'Late 10th and 11th century Cloisonné Enamel brooches', *Medieval Archaeology*, 30, 8–18

Budny, M. & Graham-Campbell, J., 1981, 'An Eighth Century Bronze Ornament from Canterbury and Related Works', *Archaeologia Cantiana*, XCVII, 7–25

Budny, M. & Tweddle, D., 1984, 'The Maaseik Embroideries', *Anglo-Saxon England*, 13, 65–96

Cadman, G.E., 1983, 'Raunds 1977–1983', *Medieval Archaeology*, 27, 107–22

Cadman, G. & Foard, G., 1984, 'Raunds: Manorial and Village Origins', in Faull, M. (ed.), *Studies in Late Anglo-Saxon Settlement*, London, 81–100

Cameron, K., 1968, 'Eccles in English Place-names', in Barley, M. & Hanson, R.P.C. (eds), *Christianity in Roman Britain AD 300–700*, Leicester, 87–92

Cameron, K., 1977, *English Place-Names*, rev. ed., London

Campbell, E. & Lane, A., 1993, 'Celtic and Germanic Interaction in Dalriada: the 7th century metalworking site of Dunadd', in Spearman, M. & Higgitt, J. (eds), *The Age of Migrating Ideas*, Stroud, 52–63

Campbell, J., John, E. & Wormald, P., 1982, *The Anglo-Saxons*, Oxford

Capelle, T. & Vierck, H., 1971, 'Modeln der Merowinger- und Wikingerzeit', *Frühmittelalterliche Studien*, 5, 42–100

Carr, R.D., Tester, A. & Murphy, P., 1988, 'The Middle Saxon Settlement at Staunch Meadow, Brandon', *Antiquity*, LXII, 371–7

Carver, M., 1986, 'Anglo-Saxon objectives at Sutton Hoo, 1985', *Anglo-Saxon England*, 15, 139–52

Carver, M., 1988, 'Anglo-Saxon discoveries at Sutton Hoo, 1987–8', *Bulletin of the Sutton Hoo Research Committee*, 6, 5–7

Carver, M., 1992, 'The Anglo-Saxon Cemetery at Sutton Hoo: an interim report', in Carver, M. (ed), *The Age of Sutton Hoo*, Woodbridge, 343–72

Casey, J. (ed.), 1979, *The End of Roman Britain*, Oxford, BAR 71

Casey, P.J., 1980, *Roman Coinage in Britain*, Princes Risborough

Cassidy, B. (ed.), 1992, *The Ruthwell Cross*, Princeton

Chadwick, H.M., 1959, 'Vortigern', in Chadwick, H.M. *et al.* (eds), *Studies in Early British History*, Cambridge, 21–46

Chadwick, N.K., 1959, 'Intellectual Contacts between Britain and Gaul in the Fifth Century', in Chadwick, H.M. *et al.* (eds), *Studies in Early British History*, Cambridge, 189–263

Chadwick, S.C., 1958, 'The Anglo-Saxon cemetery at Finglesham, Kent', *Medieval Archaeology*, II, 1–71

Cherry, B., 1976, 'Ecclesiastical architecture', in Wilson, D. (ed.), *The Archaeology of Anglo-Saxon England*, London, 151–200

Christie, H., Olsen, O. & Taylor, H.M., 1979, 'The wooden church of St Andrew at Greenstead, Essex', *Antiquaries Journal*, LIX, 92–112

Clapham, A.W., 1928, 'The carved stones at Breedon-on-the-Hill', *Archaeologia*, LXXVII, 219–40

Clapham, A.W., 1930, *English Romanesque Architecture*, I, Oxford

Clarke, H., 1984, *The Archaeology of Medieval England*, London

Clarke, J.R., 1961, *The Alfred and Minster Lovell Jewels*, Oxford

Cleary, J.E., 1989, *The Ending of Roman Britain*, London

Clutton-Brock, J., 1976, 'The animal resources', in Wilson, D. (ed.), *The Archaeology of Anglo-Saxon England*, London, 373–92

Coatsworth, E., 1989, 'The Pectoral Cross and Portable Altar from the Tomb of St Cuthbert', in Booner, G., Rollaston, D. & Stancliffe, C. (eds), *St Cuthbert, his cult and his community to AD 1200*, London, 287–300

Coggins, D., Fairless, K.J. & Batey, C., 1983, 'Simy Folds: an Early medieval settlement site in Upper Teesdale', *Medieval Archaeology*, XXVII, 1–26

Collingwood, W.G., 1907, 'Anglian and Anglo-Danish sculpture in the North Riding of Yorkshire', *Yorkshire Archaeological Journal*, XIX, 267–413

Collingwood, W.G., 1915, 'Anglian and Anglo-Danish sculpture in the West Riding', *Yorkshire Archaeological Journal*, XXIII, 129–299

Collingwood, W.G., 1927, *Northumbrian Crosses of the Pre-Norman Age*, London

Conant, K.J., 1974, *Carolingian and Romanesque Architecture, 800–1200*, Harmondsworth

Cowie, T. & Clarke, D. (eds), 1985, *Symbols of Power*, Edinburgh

Cramp, R., 1965, *Early Northumbrian Sculpture*, Jarrow Lecture, Jarrow

Cramp, R., 1969, 'Excavations at the Saxon monastic sites of Wearmouth and Jarrow, Co Durham: an interim report', *Medieval Archaeology*, XIII, 21–66

Cramp, R., 1970, 'Decorated window-glass and millefiori from Monkwearmouth', *Antiquaries Journal*, L, 327–35

Cramp, R., 1972, 'Tradition and Innovation in English stone sculpture of the Tenth to Eleventh Centuries', *Kolloquium über spätantike und frühmittelalterliche Skulptur*, III (ed. V. Milojcic), Mainz, 139–48

Cramp, R., 1974, 'Early Northumbrian sculpture at Hexham', in Kirby D.P. (ed.), *St Wilfrid at Hexham*, Newcastle (1974), 115–40

Cramp, R., 1975, 'Anglo-Saxon sculpture of the Reform period', in Parsons, D. (ed.), *Tenth Century Studies*, London/Chichester, 184–99

Cramp, R., 1977, 'Schools of Mercian Sculpture', in Dornier, A. (ed.), *Mercian Studies*, Leicester, 191–234

Cramp, R., (ed.), 1984, *British Academy Corpus of Anglo-Saxon Sculpture*, I, *County Durham and Northumberland*, Oxford

Cramp, R., (ed.), 1989, *Anglo-Saxon Connexions*, Durham

Cramp, R. & Daniels, R., 1987, 'New finds from the Anglo-Saxon monastery at Hartlepool, Cleveland,' *Antiquity*, LXI, 424–31

Cramp, R. & Lang, J., 1977, *A Century of Anglo-Saxon Sculpture*, Newcastle

Crawford, B.E., 1987, *Scandinavian Scotland*, Leicester

Crowfoot, E. & Hawkes, S.C., 1967, 'Early Anglo-Saxon gold braids', *Medieval Archaeology*, XI, 42–86

Cunliffe, B.W., 1968, *Fifth report on the Excavations at Richborough, Kent*, London, Soc. Ant. Res. Rp.

Cunliffe, B.W., 1975, *Excavations at Portchester, Hants*, II, Anglo-Saxon, London, Soc. Ant. Res. Rep. XXXIII

Cunliffe, B., 1984, *Roman Bath Discovered*, London, 2nd ed.

Curle, A.O., 1923, *The Treasure of Traprain*, Glasgow

Dark, K.R., 1994, *Civitas to Kingdom: British political continuity 300–800*, Leicester

Davidson, H.E., 1962, *The Sword in Anglo-Saxon England*, Oxford

Davidson, H.E., 1964, *Gods and Myths of Northern Europe*, Harmondworth

Davidson, H.E. & Webster, L., 1967, 'The Anglo-Saxon burial at Coombe (Woodnesborough), Kent', *Medieval Archaeology*, XI, 1–41

Davies, W. & Vierck, H., 1974, 'The contents of Tribal Hidage: social aggregates and settlement patterns', *Frühmittelalterliche Studien*, 8, 223–939

Davis, K.R., 1982, *Britons and Saxons: The Chiltern Region 400–700*, Chichester

Davis, R.H.C., 1976, *The Normans and their Myth*, London

Davison, B., 1969, 'Sulgrave', *Current Archaeology*, 12, 19–22

Deshman, R., 1995, *The Benedictional of Aethelwold*, Princeton

Dickinson, S., 1985, 'Bryant's Gill, Kentmere: Another 'Viking-period' Ribblehead?', in Baldwin, J.R. & Whyte, R.D. (eds), *The Scandinavians in Cumbria*, Edinburgh, 83–8

Dickinson, T., 1982, 'Ornament Variation in pairs of cast saucer brooches, a case study from the Upper Thames Region', in Webster, L. (ed.), *Aspects of Production and Style in Dark Age Metalwork*, London, BM Occasional Paper 34, 21–50

Dickinson, T., 1983, 'Anglo-Saxon Archaeology: Twenty-Five Years On', in Hinton, D. (ed.), *25 Years of Medieval Archaeology*, Sheffield, 38–43

Dixon, P., 1976, *Barbarian Europe*, Oxford

Dodgson, J. McN., 1966, 'The significance of the distribution of place-names in -ingas, -inga in south-east England', *Medieval Archaeology*, X, 1–29

Dodgson, J. McN., 1973, 'Placenames from "-ham" and the settlement of Kent, Surrey and Sussex', *Anglo-Saxon England*, 2, 1–50

Dodwell, C.R., 1982, *Anglo-Saxon Art: a New Perspective*, Manchester

Dolley, M. (ed.), 1961, *Anglo-Saxon Coins*, London

Dolley, M., 1965, *Viking Coins of the Danelaw and of Dublin*, London

Dolley, M., 1976, 'Coins', in Wilson, D. (ed.), *The Archaeology of Anglo-Saxon England*, London, 347–72

Donovan, C., 1993, *The Winchester Bible*, London

Dumville, D., 1977, 'Sub-Roman Britain: History and Legend', *History*, 62, 173–92

Dumville, D. & Keynes, S., 1983–6, *The Anglo-Saxon Chronicle, a Collaborative Edition*, Cambridge

Dunning, G.C., 1956, 'Trade Relations between England and the Continent in the late Anglo-Saxon period', in Harden, D.B. (ed.), *Dark Age Britain*, 218–33

Dunning, G.C., *et al.*, 1959, 'Anglo-Saxon Pottery; a symposium', *Medieval Archaeology*, III, 1–78

Dunning, G.C., 1968, 'The trade in Medieval Pottery around the North Sea', in Renaud, J.G.N. (ed.), *Rotterdam Papers*, Rotterdam, 35–58

East, K., 1984, 'Cross-hatched Foils from Sutton Hoo', in Hawkes, S., Campbell, J. & Brown, D. (eds), *Anglo-Saxon Studies in Archaeology & History*, 4, Oxford, 129–43

East, K.A., 1986, 'A lead model and a rediscovered sword, both with gripping beast decoration', *Medieval Archaeology*, XXX, 1–7

Evans, A.C., 1994, *The Sutton Hoo Ship Burial*, London, rev. ed.

Evison, V., 1951, 'The white material in Kentish disc brooches', *Antiquaries Journal*, XXXI, 197–200

Evison, V., 1955 'Early Anglo-Saxon Inlaid metalwork', *Antiquaries Journal*, XXXV, 20–45

Evison, V., 1965, *Fifth Century Invasions South of the Thames*, London

Evison, V., 1967, 'The Dover ring-sword and other sword rings and beads', *Archaeologia*, 101, 63–118

Evison, V., 1968, 'Quoit Brooch Style Buckles', *Antiquaries Journal*, XLVIII, 231–49

Evison, V., 1970, 'Supporting arm brooches and equal-arm brooches in England', in Hasser, J.H.J. (ed.), *Studien zur Sachsenforschung*, 127–47

Evison, V., 1977, 'An Enamelled disc from Great Saxham', *Proc. Suffolk Institute of Archaeology & History*, XXXIV, 1–13

Evison, V., 1978, 'Early Anglo-Saxon Applied Disc Brooches, Part II: in England', *Antiquaries Journal*, LVIII, 260–78

Evison, V., 1979, *A Corpus of Wheel-thrown Pottery in Anglo-Saxon Graves*, London, RAI Monograph

Evison, V.I., 1987, *Dover: the Buckland Anglo-Saxon Cemetery*, London, English Heritage Arch. Rep. 3

Faull, M., 1977, 'British survival in Anglo-Saxon Northumbria', in Laing, L. (ed.), *Studies in Celtic Survival*, Oxford, BAR 37, 1–56

Fell, C.E., 1980, 'Gods and Heroes of the Northern World', in Wilson, D. (ed.), *The Northern World*, 15–46

Fell, C.E., 1984, *Women in Anglo-Saxon England*, London

Fernie, E., 1983, *The Architecture of the Anglo-Saxons*, London

Filmer-Sankey, W., 1990, 'Snape', *Current Archaeology*, 118, 348–52

Filmer-Sankey, W., 1992, 'The Snape Anglo-Saxon Cemetery: the current state of knowledge', in Carver, M. (ed.), *The Age of Sutton Hoo*, Woodbridge, 29–52

Fisher, D.V.A., 1973, *The Anglo-Saxon Age, c. 400–1042*, London

Fisher, E.A., 1962, *The Greater Anglo-Saxon Churches*, London

Fisher, E.A., 1962b, *Anglo-Saxon Towers*, London

Fletcher, E., 1980, 'The influence of Merovingian Gaul on Northumbria in the seventh century', *Medieval Archaeology*, XXIV, 69–86

Fletcher, E. & Meates, G.W., 1969, 'The ruined church of Stone-by-Faversham', *Antiquaries Journal*, XLIX, 273–94

Fletcher, M. & Tapper, M.C., 1984, Medieval Artefacts and Structures Dated by Dendrochronology', *Medieval Archaeology*, XXVIII, 112–32

Foote, P.G. & Wilson, D.M., 1970, *The Viking Achievement*, London

Foster, J., 1977, 'A boar figurine from Guilden Morden, Cambs', *Medieval Archaeology*, 21, 166–7

Fowler, P.J., 1976, 'Agriculture and rural settlement', in Wilson, D. (ed.), *The Archaeology of Anglo-Saxon England*, London, 1976, 23–48

Frere, S.S., 1974, *Britannia*, London, rev. ed.

Fugelsang, S.H., 1980, *Some Aspects of Ringerike Style*, Odense

Gaimser, M., 1992, 'Scandinavian gold bracteates in Britain: Money and Media in the Dark Ages', *Medieval Archaeology*, XXXVI, 1–28

Galbraith, K.J., 1968, 'Early sculpture at St Nicholas's Church, Ipswich', *Proceedings Suffolk Institute of Archaeology*, XXXI, pt 2, 172–84

Galbraith, K.J., 1973, 'Further thoughts on the boar at St Nicholas's Church, Ipswich', *Proceedings of the Suffolk Institute of Archaeology*, XXXIII, pt 1, 68–74

Gameson, R., 1995, *The Role of Art in the Late Anglo-Saxon Church*, Oxford

Garmonsway, G.N. (trs), 1960, *The Anglo-Saxon Chronicle*, London, rev. ed.

Geipel, J., 1971, *The Viking Legacy*, Newton Abbot

Gelling, M., 1967, 'English place-names derived from the compound wicham', *Medieval Archaeology*, XI, 87–104

Gelling, M., 1978, *Signposts to the Past*, London

Gelling, M., 1984, *Placenames in the Landscape*, London

Gelling, P. & Davidson, H.E., 1969, *The Chariot of the Sun*, London

Gem, R., 1993, 'Architecture of the Anglo-Saxon Church 735 to 870 from Archbishop Ecgberht to Archbishop Ceolnoth', *J. British Archaeological Association*, CXLVI, 29–66

Gem, R. & Tudor-Craig, A., 1980, 'A "Winchester School" wall-painting at Nether Wallop, Hampshire', *Anglo-Saxon England*, IX (1980), 115–36

Gibb, D.H.P. & Gem, R.D.H., 1975, 'The Anglo-Saxon cathedral of Sherbourne', *Archaeological Journal*, 132, 71–110

Gilmour, B., 1979, 'The Anglo-Saxon church at St Paul-in-the-Bail', *Medieval Archaeology*, XXIII, 214–17

Gilyard-Beer, R., 1966, *Abbeys*, London, 3rd rev. ed.

Graham-Campbell, J., 1973, 'The 9th Century Anglo-Saxon horn mount from Burghead, Morayshire, Scotland', *Medieval Archaeology*, XVII, 43–51

Graham-Campbell, J., 1987, 'From Scandinavia to the Irish Sea: Viking Art reviewed', in Ryan, M. (ed.), *Ireland and Insular Art, AD 500–1200*, Dublin, 144–52

Green, B., 1971, 'An Anglo-Saxon bone plaque from Larling, Norfolk', *Antiquaries Journal*, LI, 321–3

Green, C., 1968, *Sutton Hoo: the Excavation of a Royal Ship Burial*, London

Gregory, C., 1984, *Gifts and Commodities*, London

Grierson, P., 1952, 'The Canterbury (St Martin's) hoard of Anglo-Saxon coin ornaments', *British Numismatic Journal*, 27, 39–51

Hall, R.A., 1988, 'York', in Hodges, R. & Hobley, B. (eds), *The Rebirth of Towns in the West, AD 700–1050*, London, 125–32

Hall, R., 1990, *Viking Age Archaeology*, Princes Risborough

Hallam, H.E., 1981, *Rural England 1066–1348*, London

Hamerow, H.F., 1991, *Mucking: the Anglo-Saxon Settlement*, London (English Heritage Monograph)

Hamerow, H.F., 1991b, 'Settlement Mobility and the "Middle Saxon Shift"; rural settlements and settlement patterns in Anglo-Saxon England', in *Anglo-Saxon England*, 20, 1–17

Harden, D.B., 1956, 'Glass vessels in Britain and Ireland, AD 400–1000', in Harden, D.B. (ed.), *Dark Age Britain*, London, 132–67

Haseloff, G., 1950, *Der Tassilokelch*, Munich

Haseloff, G., 1974, 'Salin's Style I', *Medieval Archaeology*, XVIII, 1–13

Haseloff, G., 1981, *Die germanische Tierornamentik der Volkerwanderungszeit*, Berlin

Haslam, J., 1987, 'Market and fortress in England in the reign of Offa', *World Archaeology*, 19, 76–83

Hawkes, C.F.C., 1956, 'The Jutes of Kent', in Harden, D.B. (ed.), *Dark Age Britain: Essays to E.T. Leeds*, London, 91–111

Hawkes, S.C., 1961, 'Jutish Style A; a study of Germanic art in southern England in the fifth century AD', *Archaeologia*, 98, 29–74

Hawkes, S.C., 1969, 'Early Anglo-Saxon Kent', *Archaeological Journal*, 127, 186–92

Hawkes, S.C., 1973, 'Finds from the Anglo-Saxon Cemetery at Eccles, Kent', *Antiquaries Journal*, LII, 281–6

Hawkes, S.C., 1974, 'The Monkton Brooch', *Antiquaries Journal*, LIV, 245–56

Hawkes, S.C., 1982, 'Anglo-Saxon Kent *c.* 425–725', in Leach, P. (ed.), *Archaeology in Kent to AD 1500*, London CBA Res. Rep., 48, 64–78

Hawkes, S.C., *et al.*, 1965, 'The Finglesham Man', *Antiquity*, 39, 17–32

Hawkes, S.C., 1984, 'The Amherst Brooch', *Archaeologia Cantiana* C, 129–51

Hawkes, S.C., 1990, 'Bryan Faussett and the Faussett Collection: An Assessment', in Southworth, E. (ed.), *Anglo-Saxon Cemeteries, a Reappraisal*, Stroud, 1–24

Hawkes, S.C. & Dunning, G.C., 1961, 'Soldiers and Settlers in Britain, fourth to fifth century', *Medieval Archaeology*, V, 1–70

Hawkes, S.C., Merrick, J.M. & Metcalf, D.M., 1966, 'X-ray fluorescent analysis of some Dark Age coins and jewellery', *Archaeometry*, IX, 98–138

Hawkes, S.C. & Page, R.I., 1967, 'Swords and runes in south-east England', *Antiquaries Journal*, 47, 1–26

Hawkes, S.C. & Pollard, M., 1981, 'The gold bracteates from 6th century Anglo-Saxon graves in Kent in the light of a new find from Finglesham', *Frühmitteralterliche Studien*, 15, 316–70

Hawkes, S.C., Speake, G. & Northover, P., 1979, 'A Bronze Metalworker's Die from Rochester, Kent', *Frühmitteralterliche Studien*, 13, 382–92

Hedeager, L., 1987, 'Empire, frontier and the barbarian hinterland: Rome and northern Europe from AD 1–400', in Rowland, S.M. & Kristiansen, K. (eds), *Centre and Periphery in the Ancient World*, Cambridge, 125–40

Heighway, C., *et al.,* 1978, 'Excavations at Gloucester, 4th Interim report, St Oswald's Priory, Gloucester, 1975–6', *Antiquaries Journal*, 58, 103–32

Henderson, G., 1968, 'The Joshua Cycle in B.M. Cotton Ms. Claudius B.IV', *Journal British Archaeological Association*, XXXI, 38–59

Henderson, G., 1987, *From Durrow to Kells: the Insular Gospel Books 650–800*, London

Henderson, G., 1992, 'The Idiosyncrasy of Late Anglo-Saxon religious Imagery', in Hicks, C. (ed.), *England in the Eleventh Century*, Stamford, 239–49

Henig, M., 1995, *The Art of Roman Britain*, London

Hicks, C., 1992, 'The Borders of the Bayeux Tapestry', in Hicks, C. (ed.), *England in the Eleventh Century*, Stamford, 251–65

Hicks, C., 1993, *Animals in Early Medieval Art*, Edinburgh

Higgitt, J.C., 1973, 'The Roman background to medieval England', *Journal British Archaeological Association*, 3rd ser., XXVI, 1–15

Higgitt, J., 1979, 'The dedication inscription of Jarrow and its context', *Antiquaries Journal*, 59, 343–74

Higham, N., 1992, *Rome, Britain and the Anglo-Saxons*, London

Higham, N., 1993 *The Kingdom of Northumbria, AD 350–1100*, Stroud

Hills, C., 1974, 'A runic pot from Spong Hill, North Elmham, Norfolk', *Antiquaries Journal*, 54, 87–91

Hills, C., 1980, 'The Anglo-Saxon Settlement of England', in Wilson, D.M. (ed.), *The Northern World*, London, 71–94

Hills, C., 1980b, 'Anglo-Saxon Chairperson', *Antiquity*, 54, 52–4

Hills, C., 1983, 'Animal stamps on Anglo-Saxon pottery in East Anglia', *Studien zur Sachsenforschung*, 4, 93–110

Hines, J., 1984, *The Scandinavian Character of Anglian England in the pre-Viking period*, Oxford, BAR 124

Hines, J., 1990, 'Philology, Archaeology and the *adventus Saxonum vel Anglorum*', in Bammesberger, A. & Wollmann, A. (eds), *Britain 400–600: Language and History*, Heidelberg, 17–36

Hines, J., 1992, 'The Scandinavian Character of Anglian England: an Update', in Carver, M. (ed.), *The Age of Sutton Hoo*, Woodbridge, 315–30

Hinton, D.A., 1974, *Catalogue of the Anglo-Saxon Metalwork 700–1100 in the Department of Antiquities, Ashmolean Museum, Oxford*, Oxford

Hinton, D.A., Keene, S. & Qualmann, K.E., 1981, 'The Winchester Reliquary', *Medieval Archaeology*, XXV, 45–77

Hinton, D. & White, R., 1993, 'A smith's hoard from Tattershall Thorpe, Lincolnshire: a Synopsis', *Journal British Archaeological Association, CXLVI*, 147–65

Hirst, S.M., 1985, *An Anglo-Saxon Inhumation Cemetery at Sewerby, East Yorkshire*, York (Univ. Arch. Rep. 4)

Hodges, H., 1964, *Artifacts*, London

Hodges, R., 1982, *Dark Age Economics: The Origins of Towns and Trade, 600–1000*, London

Hodges, R., 1989, *The Anglo-Saxon Achievement*, London

Hodges, R. & Hobley, B. (eds), 1988, *The Rebirth of Towns in the West, AD 700–1050*, London, CBA Res. Rep. 68

Hogarth, C., 1976, 'Structural features in Anglo-Saxon Graves', *Archaeological Journal*, 130, 104–19

Holdsworth, P., 1980, *Excavations at Melbourne St, Southampton, 1971–76*, London

Hollister, C.W., 1965, *The Military Organization of Norman England*, London

Holmqvist, W., 1952, 'Viking Art in the Eleventh Century, *Acta Archaeologica*, 22, 1–56

Holmqvist, W., 1972, *Excavations at Helgö*, IV, Workshop, Pt 1, Uppsala

Hooke, D. & Bassett, S. (eds), 1989, *The Origins of the Anglo-Saxon Kingdoms*, London

Hope-Taylor, B., 1977, *Yeavering, an Anglo-British Centre of early Northumbria*, London

Howlett, D.R., 1974, 'The iconography of the Alfred Jewel', *Antiquaries Journal*, XLVI, 277–82

Huggett, J., 1988, 'Imported grave-goods and the Early Anglo-Saxon economy', *Medieval Archaeology*, 32, 63–96

Hurst, J.G., 1976, 'The pottery', in Wilson, D. (ed.), *The Archaeology of Anglo-Saxon England*, 283–348

James, E., 1977, *The Franks*, London

James, S., Marshall, A. & Millett, M., 1983, 'An early Medieval Building Tradition', *Archaeological Journal*, 140, 182–215

Jenkins, F., 1965, 'St Martins Church at Canterbury: a survey of the earliest structural features', *Medieval Archaeology*, IX (1965), 11–15

Jessup, R., 1946, 'An Anglo-Saxon Cemetery at Westbere, Kent', *Antiquaries Journal*, XXVI, 11–21

Jessup, R., 1950, *Anglo-Saxon Jewellery*, London

Jessup, R., 1975, *Man of Many Talents*, London

Jewell, R.H., 1986, 'The Anglo-Saxon friezes at Breedon-on-the-Hill, Leicestershire', *Archaeologia*, 108, 95–116

Johnson, S., 1976, *The Roman Forts of the Saxon Shore*, London

Johnson, S., 1979, *Later Roman Britain*, London

Jones, G.R.J., 1983, 'The pre-Norman field system and its implications for early territorial organization', in Mayes, P. & Butler, L., *Sandal Castle Excavations, 1964–1973*, Wakefield, 70–3

Jones, M.E., 1979, 'Climate, nutrition and disease: an hypothesis of Romano-British population', in Casey, P.J. (ed.), *The End of Roman Britain*, Oxford, BAR 71, 231–51

Jones, M.U., 1975, 'A clay piece-mould of the Migration Period from Mucking, Essex', *Antiquaries Journal*, 55, 407–8

Jones, M.U., 1977, 'Metallurgical Finds from a Multi-period Settlement at Mucking, Essex', in Oddy, W.A. (ed.), *Aspects of Early Metallurgy*, London, 117–20

Jope, E.M., 1964, 'The Saxon Building stone industry in southern and midland England', *Medieval Archaeology*, VIII, 91–118

Kahn, D., 1990, *Canterbury Cathedral and its Romanesque Sculpture*, London

Kauffmann, C.M., 1975, *Romanesque Manuscripts, 1066–1190*, London

Keen, L., 1993, 'Pre-Conquest Glazed Relief Tiles from All Saints Church, Pavement, York', *Journal British Archaeological Association*, CXLVI, 67–86

Kendrick, T.D., 1938, *Anglo-Saxon Art to AD 800*, London

Kendrick, T.D., 1949, *Late Saxon and Viking Art*, London

Kendrick, T.D., *et al.*, 1956–1960, *Evangeliorum quattuor codex Lindisfarnensis*, 2 vols, Olsen and Lausanne

Kent, J.P.C., 1979, 'The end of Roman Britain: the literary and numismatic evidence reviewed', in Casey, J. (ed.), *The End of Roman Britain*, Oxford, BAR 71, 15–27

Kent, J.P.C. & Painter, K.S., 1977, *Wealth of the Roman World, Gold and Silver AD 300–700*, London

Kenyon, K.M., 1948, *The Jewry Wall Site, Leicester*, London, Soc. Ant. Res. Rep. 15

Kerr, A. & J., 1983, *Anglo-Saxon Churches*, Princes Risborough

Kershaw, N., 1922, *Anglo-Saxon and Norse Poems*, Cambridge

Keynes, S. & Lapidge, M., 1983, *Alfred the Great*, Harmondsworth

King, J.D.C., 1991, *The Castle in England and Wales*, London

Kjolbye-Biddle, B., 1986, 'The Seventh-century Minster at Winchester interpreted', in Butler, L.A.S. & Morris, R.K. (eds), *The Anglo-Saxon Church*, London, 196–209

Klinck, A., 1982, *Anglo-Saxon Women and the Law*, London

Laing, L., 1990, 'The beginnings of Dark Age Celtic Art', in Bammesberger, A. & Wollmann, A. (eds), *Britain 400–600: Language and History*, Heidelberg, 37–50

Laing, L., 1993, *A Catalogue of Celtic Ornamental Metalwork in the British Isles, c. 400–1200*, Oxford & Nottingham

Laing, L. & Laing, J., 1990, *Celtic Britain and Ireland, AD 200–800*, Dublin

Laing, L. & Laing, J., 1993, *Ancient Art: the Challenge to Modern Thought*, Dublin

Laing, L. & Laing, J., 1995, *Celtic Britain and Ireland, Art and Society*, London

Laing, L. & Laing, J., 1995b, *Britain's European Heritage*, Stroud

Lang, J., 1978, 'Continuity and Innovation in Anglo-Scandinavian Sculpture', *Anglo-Saxon and Viking-Age Sculpture*, Oxford, BAR 49, 145–55

Lang, J., 1983, 'Recent Studies in Pre-Conquest Sculpture of Northumbria', in Thompson, F.H. (ed.), *Studies in Medieval Sculpture*, London (Soc. Ant. Occ. Papers III), 177–89

Lang, J., 1986, 'Viking Colonial Sculpture', in Szarmach, P.E. (ed.), *Sources of Anglo-Saxon Culture*, Kalamazoo, 243–60

Lang, J., 1988, *Anglo-Saxon Sculpture*, Princes Risborough

Lang, J., 1991, *British Academy Corpus of Anglo-Saxon Sculpture*, 4, York and Eastern Yorkshire, Oxford

Lapidge, M. & Dumville, D. (eds), 1984, *Gildas: New Approaches*, Woodbridge

Lasko, P., 1971, *The Kingdom of the Franks*, London

Lasko, P., 1984, 'Anglo-Saxon or Norman? Observations on some ivory carvings in the English Romanesque exhibition at the Hayward Gallery', *Burlington Magazine*, 128, 216–25

Leeds, E.T., 1912, 'Distribution of the Anglo-Saxon saucer brooch in relation to the Battle of Bedford, AD 571', *Archaeologia*, 63, 159–202

Leeds, E.T., 1913, *The Archaeology of the Anglo-Saxon Settlements*, Oxford

Leeds, E.T., 1936, *Early Anglo-Saxon Art and Archaeology*, Oxford

Leeds, E.T., 1945, 'The Distribution of the Angles and Saxons Archaeologically Considered,' *Archaeologia*, 91, 1–106

Leeds, E.T., 1946, 'Denmark and Early England', *Antiquaries Journal*, XXVI, 22–37

Leeds, E.T., 1949, *A Corpus of Early Anglo-Saxon Great Square-Headed Brooches*, Oxford

Leeds, E.T. & Chadwick, S.C., 1957, 'Notes on Jutish Art in Kent between 450 and 575', *Medieval Archaeology*, I, 5–26

Leigh, D., 1984, 'Ambiguity in Anglo-Saxon Style I art', *Antiquaries Journal*, 64, 34–42

Leigh, D., 1984b, 'The Kentish Keystone-Garnet Disc Brooches: Avent's Class 1–3 Reconsidered', *Anglo-Saxon Studies in Archaeology & History*, 3, 65–74

Leigh, D., 1990, 'Aspects of Early Brooch Design and Production', in Southworth, E. (ed.), *Anglo-Saxon Cemeteries, a Reappraisal*, Stroud, 107–24

Levison, W., 1946, *England and the Continent in the Eighth Century*, Oxford

Lindsay, J., 1974, *The Normans and their World*, London

Loyn, H., 1955, 'Gesiths and thegns in England from the seventh to the tenth centuries', *English Historical Review*, 70, 529–49

Loyn, H., 1974, 'Kinship in Anglo-Saxon England', *Anglo-Saxon England*, 3, 197–209

Loyn, H., 1977, *The Vikings in Britain*, London

Loyn, H., 1982, *The Norman Conquest*, 3rd ed., London

Loyn, H., 1992, 'Kings, Gesiths and Thegns', in Carver, M. (ed.), *The Age of Sutton Hoo*, Woodbridge, 75–9

Macready, S. & Thompson, F.H., 1986, *Art and Patronage in the English Romanesque*, London (Soc. Ant. Occ. Paper 8)

Mackreth, D.D., 1978, 'Orton Hall Farm, Peterborough: a Roman and

Saxon Settlement', in Todd, M. (ed.), *Studies in the Romano-British Villa*, Leicester, 209–28

Maclean, D., 1992, 'The date of the Ruthwell Cross', in Cassidy, B. (ed.), *The Ruthwell Cross*, Princeton, 1992, 71–94

Mayr-Harting, H., 1972, *The Coming of Christianity to Anglo-Saxon England*, London

Meaney, A., 1964, *A Gazetteer of Early Anglo-Saxon Burial Sites*, London

Meaney, A., 1981, *Anglo-Saxon Amulets and Curing Stones*, Oxford, BAR 96

Meaney, A. & Hawkes, S.C., 1970, *Two Anglo-Saxon Cemeteries at Winnall, Winchester, Hampshire*, London, Soc. Med. Arch. Monograph 4

Meeks, N.D. & Holmes, R., 1984, 'The Sutton Hoo Garnet Jewellery', in Hawkes, S., Campbell, J. & Brown, D. (eds), *Anglo-Saxon Studies in Archaeology & History*, 4, Oxford, 143–58

Meeks, N.D. & Holmes, R., 1985, 'Gold backing foils', *Anglo-Saxon Studies in Archaeology & History*, 4, 143–8

Megaw, J.V.S., 1970, 'Cheshire Cat and Mickey Mouse: analysis, interpretation and the art of the La Tène Iron Age', *Proceedings Prehistoric Society*, 36, 261–79

Mercer, E., 1964, 'The Ruthwell and Bewcastle crosses', *Antiquity*, 38, 268–76

Millett, M. & James, S., 1983, 'Excavations at Cowdery's Down, Basingstoke, Hampshire, 1978–81', *Archaeological Journal*, 140, 151–279

Mitchell, B., 1965, *The Battle of Maldon and other Old English Poems*, London

Moe, O., 1955, 'Urnes and the British Isles', *Acta Archaeologica*, 26, 1–30

Morris, J., 1973, *The Age of Arthur*, London

Morris, J. (ed.), 1980, *Nennius, British History and Welsh Annals*, Chichester

Morris, R., 1983, 'Coincidence and Continuity: Christianity in Britain *c.* 400–700', in Morris, R. (ed.), *The Church in British Archaeology*, CBA Res. Rep. 47, 19–48

Mortimer, C., 1994, 'Lead-Alloy Models for three early Anglo-Saxon Brooches', *Anglo-Saxon Studies in Archaeology & History*, 7, 27–33

Moss, A.A., 1953, 'Niello', *Antiquaries Journal*, XXXIII, 75–7

Musset, L., 1975, *The Germanic Invasions*, London

Myres, J.N.L., 1956, 'Romano-Saxon Pottery', in Harden, D.B. (ed.), *Dark Age Britain, Essays in Honour of E.T. Leeds*, London, 16–39

Myres, J.N.L., 1969, *Anglo-Saxon Pottery and the Settlement of England*, Oxford

Myres, J.N.L., 1970, 'The Angles, Saxons and the Jutes', *Proc. British Academy*, 56, 145–74

Myres, J.N.L., 1986, *The English Settlements*, Oxford

Myres, J.N.L., Hurst, J.G. & Dunning, G.C., 1959, 'Anglo-Saxon Pottery: A Symposium', *Medieval Archaeology*, III, 1–78

Myres, J.N.L. & Green, B., 1973, *The Anglo-Saxon Cemeteries of Caistor by Norwich and Markshall*, London (Soc. Ant. Res. Rep. 30)

Nelson, P., 1937, 'An ancient box-wood casket', *Archaeologia*, LXXXVI, 9–100

Neuman de Vegvar, C.L., 1984, *Northumbrian Renaissance*, Princeton

Neuman de Vegvar, C.L., 1992, 'Sutton Hoo Horns as Regalia', in Farrell & Neuman de Vegvar, (eds), *Sutton Hoo – Twenty-Five Years After*, 63–74

Newton, S., 1992, 'Beowulf and the East Anglian Royal Pedigree', in Carver, M. (ed.), *The Age of Sutton Hoo*, Woodbridge, 65–74

Noel, W., 1995, *The Harley Psalter*, Cambridge

Nordenfalk, C., 1947 'Before the Book of Durrow', *Acta Archaeologica*, 18, 141–74

Oakeshott, W., 1945, *The Artists of the Winchester Bible*, London

O'Carragain, E., 1987, 'The Ruthwell Cross and Irish High Crosses: some points of Comparison and Contrast', in Ryan, M. (ed.), *Ireland and Insular Art AD 500–1200*, Dublin, 118–28

Oddy, W.A., 1979, 'Gilding and tinning in Anglo-Saxon England', in Oddy, W.A. (ed.), *Aspects of Early Metallurgy*, London, 129–34

O'Reilly, J., 1987, 'The Rough-Hewn Cross in Anglo-Saxon Art', in Ryan, M. (ed.), *Ireland and Insular Art AD 500–1200*, Dublin, 153–8

Oswald, F., 1956, *The Last Days of Margidunum*, Nottingham

Owen-Crocker, G.R., 1986, *Dress in Anglo-Saxon England*, Manchester

Pächt, O., Dodwell, C.R. & Wormald, F., 1960, *The St Albans Psalter/Albani Psalter*, London

Parsons, D., 1980, 'A dated timber from Brixworth Church', *Journal British Archaeological Association*, 133, 30–6

Peers, C. & Radford, C.A.R., 1943, 'The Saxon Monastery of Whitby', *Archaeologia*, LXXXIX, 27–88

Peltret, D., 1981, 'Slave raiding and slave trading in Early England', *Anglo-Saxon England*, 9, 99–114

Peltret, D., 1995, *Slavery in Early Medieval England*, London

Petersson, H.B., 1969, *Anglo-Saxon Currency*, Lund

Philpott, F., 1990, *A Silver Saga*, Liverpool

Platt, C., 1976, *The English Medieval Town*, London

Pocock, M. & Wheeler, H.M., 1971, 'Excavations at Escomb Church, Co Durham', *Journal British Archaeological Association*, 3rd ser., XXXIV, 11–19

Qualmann, K., 1986, 'Winchester – Nunnaminster', *Current Archaeology*, 102, 204–7

Radford, C.A.R., 1970, 'The later pre-Conquest boroughs and their defences', *Medieval Archaeology*, 14, 83–103

Rahtz, P., 1968, 'Hereford', *Current Archaeology*, 9, 242–6

Rahtz, P.A., 1976, 'Buildings and rural settlement', in Wilson, D. (ed.), *The Archaeology of Anglo-Saxon England*, London, 65–8

Rahtz, P.A., 1976b, *Excavations at St Mary's Church, Deerhurst*, London, CBA Res. Rep. 15

Rahtz, P.A., 1977, 'The archaeology of West Mercian towns', in Dornier, A. (ed.), *Mercian Studies*, Leicester, 107–29

Rahtz, P.A., 1979, *The Saxon and Medieval Palaces at Cheddar*, Oxford, BAR 65

Rahtz, P., Dickinson, T. & Watts, L. (eds), 1982, *Anglo-Saxon Cemeteries 1979*, Oxford, BAR 82

Reece, R., 1987, *Coinage in Roman Britain*, London

Reynolds, N., 1976, 'The structure of Anglo-Saxon graves', *Antiquity*, 50, 140–4

Rhodes, M., 1990, 'Faussett Rediscovered: Charles Roach Smith, Joseph Mayer and the Publication of Inventorium Sepulchrale', in Southworth, E. (ed), *Anglo-Saxon Cemeteries, A Reappraisal*, Stroud, 26–64

Richards, J., 1991, *Viking Age England*, London

Richards, J.D., 1987, *The Significance of Form and Function of Anglo-Saxon Cremation Urns*, Oxford, BAR

Richards, J.D., 1987b, 'Style and Symbol: explaining variability in Anglo-Saxon cremation urns', in Driscoll, S. & Nieke, M. (eds), *Power and Politics in Early Medieval Britain and Ireland*, Edinburgh, 145–61

Richards, J.D., 1992, 'Anglo-Saxon Symbolism', in Carver, M. (ed.), *The Age of Sutton Hoo*, Woodbridge, 131–48

Rickert, M., 1965, *Painting in Britain: the Middle Ages*, Harmondsworth

Ritchie, A., 1990, *Viking Scotland*, London

Rivet, A.L.F., 1969, 'Social and Economic Aspects', in Rivet, A.L.F. (ed.), *The Roman Villa in Britain*, London, 175–216

Rivet, A.L.F. & Smith, C., 1979, *The Place-names of Roman Britain*, London

Roberts, W.I., 1982, *Romano-Saxon Pottery*, Oxford, BAR 106

Rodwell, W. & Rodwell, K., 1973, 'Excavations at Rivenhall Church, Essex, an interim report', *Antiquaries Journal*, 53, 219–31

Rodwell, W., 1978, 'The Archaeology of Hadstock Church, Essex, an interim report', *Antiquaries Journal*, 56, 55–71

Roesdahl, E., 1991, *The Vikings*, London

Rowley, T., 1983, *The Norman Heritage*, London

Salin, E., 1959, *La Civilisation Mérovingienne*, 4, Paris

Salway, P., 1981, *Roman Britain*, Oxford

Sawyer, P., 1971, *The Age of the Vikings*, 2nd ed., London

Sawyer, P., 1987, *Kings and Vikings*, 2nd ed., London

Saxl, F., 1943, 'The Ruthwell Cross', *Warburg & Courtauld Institute Journal*, VI, 1–19

Saxl, F., 1954, *English Sculptures of the Twelfth Century*, London

Scull, C., 1984, 'Further evidence from East Anglia for enamelling on early Anglo-Saxon Metalwork', in Hawkes, S., Campbell, J. & Brown, D. (eds), *Anglo-Saxon Studies in Archaeology & History*, 4, Oxford, 17–124

Scull, C., 1986, 'A 6th century Grave containing a balance from Watchfield, Oxford, England', *Germania*, 64, 105–38

Scull, C., 1990, 'Scales and weights in Early Anglo-Saxon England', *Archaeological Journal*, 147, 183–215

Seebohm, F., 1911, *Tribal Customs in Anglo-Saxon Law*, London

Selkirk, A., 1971, 'Tamworth', *Current Archaeology*, 29, 164–8

Selkirk, A., 1975, 'Mucking, the Saxon cemeteries', *Current Archaeology*, 50, 73–80

Serjeantson, M., 1935, *A History of Foreign Words in English*, London

Shephard, J., 1979, 'The social identity of the Individual in isolated Barrows and Barrow Cemeteries in Anglo-Saxon England', in Burnham, B. & Kingsbury, J. (eds), *Space, Hierarchy and Society*, Oxford, BAR 59, 47–79

Shetelig, H., 1949, *Classical Impulses in Scandinavian Art from the Migration Period to the Viking Age*, Oslo

Sims-Williams, P., 1983, 'Gildas and the Anglo-Saxons', *Cambridge Medieval and Celtic Studies*, 6, 1–30

Smyth, A.P., 1977, *Scandinavian Kings in the British Isles 850–880*, Oxford

Smyth, A.P., 1984, *Warlords and Holy Men*, London

Smyth, A.P., 1995, *King Alfred the Great*, Oxford

Southworth, E. (ed.), 1990, *Anglo-Saxon Cemeteries; a Reappraisal*, Stroud

Speake, G., 1970, 'A seventh-century coin pendant from Bacton, Norfolk', *Medieval Archaeology*, XIV, 1–16

Speake, G., 1980, *Anglo-Saxon Animal Art*, Oxford

Speake, G., 1989, *An Anglo-Saxon Bed Burial at Swalllowcliffe Down*, London (English Heritage Arch. Rep. 10)

Spufford, P., 1988, *Money and its Use in Medieval Europe*, Cambridge

Stahl, A. & Oddy, W.A., 1992, 'The date of the Sutton Hoo Coins', in Farrell & de Vegvar (eds), *Sutton Hoo: Twenty-Five Years After*, Miami, 129–39

Steane, J.M., 1985, *The Archaeology of Medieval England and Wales*, London

Steane, K., 1992, 'St Paul-in-the-Bail', *Current Archaeology*, 129, 376–9

Stenton, F.M. (ed), 1957, *The Bayeux Tapestry*, London

Stenton, F.M., 1971, *Anglo-Saxon England*, Oxford, 3rd ed.

Stevick, R., 1995, *The Earliest Irish and English Book-Arts*, Pennsylvania

Stone, L., 1955, *Sculpture in Britain: The Middle Ages*, Harmondsworth

Stones, J., 1980, 'Brixworth Church: Nineteenth and earlier Twentieth Century Excavations', *Journal British Archaeological Association*, CXXXIII, 37–63

Stratford, N., 1986, 'Niello in England in the Twelfth century', in Macready, S. & Thompson, F.H. (eds), *Art and Patronage in the English Romanesque*, London, Soc. Ant. Occ. Paper VIII, 28–49

Swanton, M. & Myres, J.N.L., 1967, 'An early Alamannic brooch from Yorkshire', *Antiquaries Journal*, 47, 43–50

Talbot Rice, D., 1952, *English Art 871–1100*, Oxford

Talbot Rice, D. (ed.), 1965, *The Dark Ages*, London

Taylor, C., 1983, *Village and Farmstead*, London

Taylor, H.M. & Taylor, J., 1965–78, *Anglo-Saxon Architecture*, Cambridge, I–II (1965), III (1978)

Taylor, H.M. & Taylor, J., 1966, 'Architectural sculpture in pre-Norman England', *Journal British Archaeological Association*, 3rd ser., 29, 3–51

Taylor, H.M., 1971, 'Repton Reconsidered: a study in structural criticism', in Clemoes, P. & Hughes, K. (eds), *England before the Conquest*, Cambridge, 351–89

Taylor, H.M., 1979, *St Wynstan's Church at Repton*, Repton

Temple, E., 1976, *Anglo-Saxon Manuscripts 900–1006*, London

Thomas, A.C., 1971, *The Early Christian Archaeology of North Britain*, Oxford

Thomas, A.C., 1984, *Christianity in Roman Britain, to AD 500*, London, rev. ed.

Thompson, E.A., 1984, *Saint Germanus of Auxerre and the End of Roman Britain*, Woodbridge

Todd, M., 1972, *Everyday Life of the Barbarians*, London

Todd, M., 1975, *The Northern Barbarians 100 BC – AD 300*, London

Todd, M., 1984, *Roman Britain 55 BC – AD 400*, London

Turville-Petre, E.O.G., 1964, *Myth and Religion of the North*, London

Tweddle, D., 1983a, 'The Coppergate helmet', *Fornvannen*, LXXVIII, 105–12

Tweddle, D., 1983b, 'Anglo-Saxon Sculpture in South-East England before *c.* 950', in Thompson, F.H. (ed.), *Studies in Medieval Sculpture*, London (Soc. Ant. Occ. Paper III), 18–40

Tweddle, D., 1984, *The Coppergate Helmet*, York, York Archaeological Trust

Voss, O., 1955, 'The Hostentorp silver hoard and its period', *Acta Archaeologica*, XXVI, 171–9

Wallace-Hadrill, J.M., 1967, *The Barbarian West 400–1100*, London

Wallace-Hadrill, J.M., 1977, *Early Germanic Kingship in England and on the Continent*, Oxford

Wallace-Hadrill, J.M., 1988, *Bede's Ecclesiastical History of the English People; a Historical Commentary*, Oxford

Watkin, J.R., 1986, 'A late Anglo-Saxon Sword from Gilling West, North Yorkshire, *Medieval Archaeology*, XXX, 93–8

Webb, G., 1956, *Architecture in Britain: The Middle Ages*, Harmondsworth

Webster, L., 1980, 'An Anglo-Saxon plaque with the symbol of St John the Evangelist', *Department of Medieval and Later Antiquities: New Acquisitions I (1976–8), part I* (British Museum Occasional Paper 10), London, 11–14

Webster, L., 1982, 'The Canterbury pendant', *Antiquaries Journal*, LVI, 203–4

Webster, L., 1982b, 'Stylistic aspects of the Franks Casket', in Farrell, R.T. (ed.), *The Vikings*, London, 20–31

Webster, L., 1986, 'Anglo-Saxon England AD 400–1200', in Longworth, I. & Cherry, J. (eds), *Archaeology in Britain since 1945*, London, 119–59

Webster, L., 1992, 'Death's Diplomacy: Sutton Hoo in the light of other male princely burials', in Farrell, R.T. & Neuman de Vegvar, C. (eds), *Sutton Hoo Twenty-Five Years After*, Miami, 75–81

Webster, L. & Backhouse, J. (eds), 1991, *The Making of England, Anglo-Saxon Art and Culture AD 600–900*, London

Welch, M., 1983, *Early Anglo-Saxon Sussex*, Oxford, BAR 112

Welch, M., 1992, *Anglo-Saxon England*, London

Werner, J., 1964, 'Frankish royal tombs in the cathedrals of Cologne and St Denis', *Antiquity*, 38, 201–16

Werner, M., 1991, 'The Liudhard medalet', *Anglo-Saxon England*, 20, 27–41

West, S., 1985, *West Stow: The Anglo-Saxon Village* (East Anglian Archaeology, 24), Bury St Edmunds

Wheeler, H.M., 1977, 'Aspects of Mercian Art: the Book of Cerne', in Dornier, A. (ed.), *Mercian Studies*, Leicester, 235–44

Wheeler, R.E.M., 1956, *Rome Beyond the Imperial Frontiers*, Harmondsworth

White, R., 1988, *Roman and Celtic Objects from Anglo-Saxon Graves*, Oxford, BAR

White, R., 1990, 'Scrap or Substitute; Roman Material in Anglo-Saxon Graves', in Southworth, E. (ed.), *Anglo-Saxon Cemeteries, a Reappraisal*, Stroud, 125–52

Whitehouse, D., 1992, 'The Mediterranean Perspective', in Farrell, R. & Neuman de Vegvar, C. (eds), *Sutton Hoo Twenty Five Years After*, Miami, 117–28

Whitelock, D., 1952, *The Beginnings of English Society*, Harmondsworth

Whitfield, N., 1987, 'Motifs and techniques of Celtic filigree: are they original?' in Ryan, M. (ed.), *Ireland and Insular Art AD 500–1200*, Dublin, 75–8

Wickham-Crowley, K., 1992, 'The Birds on the Sutton Hoo Instrument', in Farrell, R. & Neuman de Vegvar, C. (eds), *Sutton Hoo Twenty Five Years After*, Miami, 43–61

Wiley, R.A., 1979, 'Anglo-Saxon Kemble, the life and works of John Mitchell Kemble, 1807–1857', in Brown, D. *et al.* (eds), *Anglo-Saxon Studies in Archaeology & History*, 1, Oxford, 165–273

Williams, J., Shaw, M. & Denham, V., 1985, *Middle Saxon Palaces at Northampton*, Northampton

Wilson, D., 1985, 'A note on O.E. *hearg* and *weoh* as Place-Name Elements Representing Different Types of Pagan Worship Sites', *Anglo-Saxon Studies in Archaeology & History*, 4, 179–83

Wilson, D., 1992, *Anglo-Saxon Paganism*, London

Wilson, D.M., 1964, *Anglo-Saxon Ornamental Metalwork 700–1100, in the British Museum*, London

Wilson, D.M., 1965, 'Some neglected late Anglo-Saxon swords', *Medieval Archaeology*, IX, 32–54

Wilson, D.M., 1967, *The Vikings and their Origins*, London

Wilson, D.M., 1976, 'Craft and Industry', in Wilson, D. (ed.), *The Archaeology of Anglo-Saxon England*, London, 253–82

Wilson, D.M., 1976b, 'The Scandinavians in England', in Wilson (ed.) (above), 393–403

Wilson, D.M., 1978, 'The dating of Viking art in England', in Lang, J. (ed.), *Anglo-Saxon and Viking Sculpture*, Oxford, BAR 49, 135–44

Wilson, D.M., 1984, *Anglo-Saxon Art*, London

Wilson, D.M. (ed.), 1985, *The Bayeux Tapestry*, London

Wilson, D.M., 1992, Sutton Hoo – Pros and Cons', in Farrell, R. & Neuman de Vegvar, C., *Sutton Hoo: Fifty Years After*, Miami, 5–12

Wilson, D. & Blunt, C.E., 1961, 'The Trewhiddle Hoard', *Archaeologia*, 98, 75–122

Wilson, D.M. & Klindt-Jensen, O., 1966, *Viking Art*, London

Winterbottom, M., 1978, *Gildas: The Ruin of Britain and other works*, London & Chichester

Wood, I.N., 1990, 'Ripon, Francia and the Franks Casket in the Early Middle Ages', *Northern History*, 26, 1–19

Wormald, F., 1944, 'The Survival of Anglo-Saxon Illumination after the Norman Conquest', *Proceedings of the British Academy*, XXX, 1–19

Wormald, F., 1952, *English Drawings of the Tenth and Eleventh Centuries*, London

Wormald, F., 1959, *The Benedictional of St Aethelwold*, London

Wormald, F., 1971, 'The Winchester School before St Aethelwold', in Clemoes, P. & Hughes, K. (eds), *England before the Conquest*, Cambridge, 305–14

Wormald, F., 1984, 'The Miniatures in the Gospels of St Augustine,

Corpus Christi College Ms 286', in Alexander, J.J.G. *et al.* (eds), *Francis Wormald, Collected Writings*, 13–35

Yapp, B., 1990, 'The art of the Ormside cup', *Transactions Cumberland & Westmorland Antiquarian & Archaeological Society*, 90, 147–61

Yorke, B., 1990, *Kings and Kingdoms of Anglo-Saxon England*, London

Zarnecki, G., 1951, *English Romanesque Sculpture, 1066–1140*, London

Zarnecki, G., 1953, 'The Chichester reliefs', *Archaeological Journal*, CX, 106–19

Zarnecki, G., 1966, '1066 and Architectural Sculpture', *Proc. British Academy*, 52, 87–104

Zarnecki, G. (ed.), 1984, *English Romanesque Art, 1066–1200*, London

Index

Page numbers in italics refer to illustrations